# GRAPHIC WORKS OF
# GEORGE CRUIKSHANK

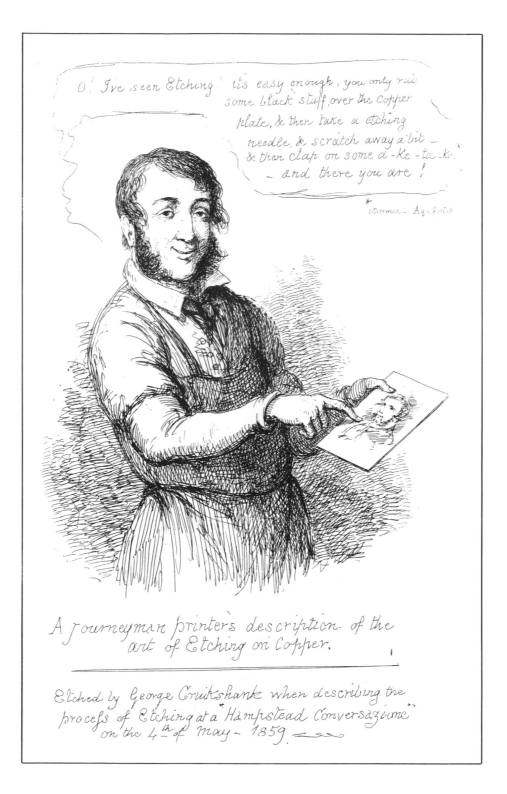

# GRAPHIC WORKS OF
# GEORGE CRUIKSHANK

Selected and with an
Introduction and Notes by
RICHARD A. VOGLER

Dover Publications, Inc.
New York

Published in Canada by General Publishing Company, Ltd., 30 Lesmill Road, Don Mills, Toronto, Ontario.
Published in the United Kingdom by Constable and Company, Ltd., 10 Orange Street, London WC2H 7EG.

*Graphic Works of George Cruikshank* is a new work, first published by Dover Publications, Inc., in 1979.

DOVER *Pictorial Archive* SERIES

*Graphic Works of George Cruikshank* belongs to the Dover Pictorial Archive Series. Up to six prints from this book may be reproduced on any one project or in any single publication, free and without special permission. Wherever possible include a credit line indicating the title of this book, editor and publisher. Please address the publisher for permission to make more extensive use of illustrations in this book than that authorized above. Photographs of the halftone illustrations can be supplied by the editor, Richard A. Vogler, Dept. of English, California State University Northridge, Northridge, California 91330. The Cruikshank drawings in the Introduction may not be reproduced without the express permission of Mr. Vogler.
The reproduction of this book in whole is prohibited.

*International Standard Book Number: 0-486-23438-X*
*Library of Congress Catalog Card Number: 77-94860*

Manufactured in the United States of America
Dover Publications, Inc.
180 Varick Street
New York, N.Y. 10014

# Preface and Acknowledgments

Great care has been taken to select fine impressions of the original graphic works included in this volume and to reproduce them carefully and whenever possible in original size.* Particular attention has also been given to the color plates: examples have been selected for having original bright, unfaded colors; originals have been compared with proofs for accuracy. In addition, for better results, both the color and the black-and-white art have been photographed directly from the originals.

In connection with states and copies of Cruikshank's graphics, two problems should be mentioned. In 1835 Thomas McLean purchased from the Humphrey firm a number of copperplates of caricatures by George and Robert Cruikshank, added a few miscellaneous items by other artists, and, after altering the original line of publication and dates, printed the whole lot in a volume titled *Cruikshankiana*. This volume was subsequently reprinted several times during the last century with the result that often Cruikshank caricatures appearing on the market are actually McLean or later impressions that have been colored in modern times. Since McLean apparently did pull some impressions before altering the imprint to "Pubd. Aug. 1st 1835 by Thos. McLean 26 Haymarket," a few later impressions on good paper were printed and hand-colored both before and immediately after the inscriptions were changed. The coloring of these impressions approximates that found on earlier ones, but the great majority of the McLean impressions appearing in color were colored in this century. In no instance has a McLean impression been used for reproduction in this volume.

The second problem concerns the facsimile copies of numerous early or rare Cruikshank graphics done by George Cruikshank's student, Frederick W. Pailthorpe. For the most part, these facsimiles are not distinguishable from the originals to an untrained eye but must be compared with known originals. Or else their paper must be examined carefully since they are usually printed on a much later paper than that used by Cruikshank himself early in the nineteenth century.

* The following illustrations are reproduced in their original sizes: Frontispiece, 25–66, 69–219, 236–253, 257, 260.

To acknowledge all of the help I have had over the years in studying and collecting Cruikshank would require lengthy enumeration, but I would like to mention a few of the persons who have been most helpful and whose assistance bears importantly on this volume. If this book were to be dedicated to anyone, it would be to Professor Ada Nisbet of UCLA, who first fostered my interest in Cruikshank. For their assistance for over a decade I should like to thank the authorities of the Print Room of the British Museum, in particular John Gere and Reginald Williams. At my own institution, California State University Northridge, I am grateful for help in typing the manuscript to the entire office staff of the English Department and to numerous student assistants, especially Laurie O'Connell. For assistance with early drafts of the manuscript I am indebted to Professors Robert apRoberts, Charles Gullans, and the late Stephen Reid; and for his continuous help in so many ways I am indebted to Professor Robert N. Essick. For major editorial assistance I am most grateful to Professor Ken Carmichael of Los Angeles Trade-Technical College. For the original suggestion for this volume, thanks go to Walter Strauss. I would also like to thank Clarence Strowbridge and Stanley Appelbaum of Dover Publications for their patience and support during all stages of preparing this book.

As a collector, I am indebted to so many dealers that it is not feasible to thank them all individually. I single out for special mention a few who have been particularly helpful. To Edward H. Spencer and Lydia Watkins of the late firm of Walter T. Spencer, for the privilege of having been a customer of that most unique establishment for over a decade, I am indebted for the rest of my life. And to London's most knowledgeable caricature dealer, Andrew Edmunds of Lexington Street, I express heartfelt appreciation for his invaluable personal attention and professional assistance. In addition, special thanks to Erika Bruce of London and Edith Finer of the Frognal Bookshop in London for their help. George Allen of Bennett & Marshall Bookshop and Stephen Weissman of Ximenes Rare Books also deserve special mention. To my wife, Marion, I am grateful for constant confidence and support in encouraging both my academic and collecting pursuits.

R. A. V.

# GEORGE CRUIKSHANK
## Caricaturist, Illustrator, and Reformer

Although George Cruikshank is one of the most catalogued artists of the last century, no one has heretofore reproduced a representative selection of works spanning his entire career. There are several reasons for this, and a brief consideration of them may serve as a propitious introduction to a man whose name many people recognize but whose background, works, and reputation few know much about.

Probably the most formidable obstacle in presenting any comprehensive yet brief survey of the graphic work of George Cruikshank is that he lived for three quarters of the last century and published over 6000 graphic designs. Thus, even with years of prodigious research and attempts to visit all major public and private collections, it would still be virtually impossible to see all of Cruikshank's incredible creative production. And clearly, no selection of only 250 illustrations can permit an in-depth penetration of the mass of material left by this highly prolific artist; but a conscientious attempt has been made in this pictorial selection to include as many representative examples as possible from the very early years of his career up to the last decade of his life. These works have been selected on the basis of their aesthetic merit, as well as their historical, topical, biographical, and technical interest. Another approach could reproduce just the caricatures or the novel illustrations or one of Cruikshank's own series of comic vignettes and thus offer a more concentrated presentation of a single aspect of the artist's *oeuvre,* but it is hoped that this volume will provide a more helpful overview and reappraisal of England's foremost illustrator.

Another major reason that no one has undertaken a truly representative pictorial survey of Cruikshank's graphics stems from the preponderant preoccupation of his admirers over the years with but one facet of his creative production and the resultant limitation this has had on his reputation. During the latter years of his life and well into the present century, Cruikshank became one of the most collected of all graphic artists. According to the eminent American bookdealer A. S. W. Rosenbach, "Someone has said that all collectors begin with Cruikshank and always end with him!" As far as I have been able to discover, that "someone" is Rosenbach himself, who made a lifetime specialty of selling expensive Cruikshank items to his wealthy customers. Rosenbach began the introductory statement for the catalogue of the Widener Cruikshank collection, the source of the previous quotation, by saying, "The illustrations by George Cruikshank seem to have a perennial charm for the lovers of books." This sentence succinctly summarizes one of the major biases shown by Cruikshank collectors over the years: he is of primary interest to "lovers of books" and his major graphics consist of "illustrations." This limited impression of the stature of the artist diminishes his considerably more significant worth as an independent wide-ranging graphic artist. Even the different organizational methods used by his three major cataloguers show this bias. In 1871 Cruikshank's first cataloguer, George William Reid, classified all of the artist's graphics by medium in chronological order, giving an entry to every etched caricature and illustration. In 1903 R. J. H. Douglas, a noted collector of Cruikshank, classified the illustrated books by author and title in a chronological presentation, emphasizing the bibliographical details of each volume while merely noting the number of illustrations. He classified the artist's caricatures and individually published visual works by subject matter and listed them in chronological sequence. In 1924 Albert M. Cohn, another noted Cruikshank collector and the artist's definitive cataloguer, listed all of the books by author in alphabetical order and included extensive bibliographical notes. He listed the caricatures and individually published graphics by title.

These methods of classification further show that over the years Cruikshank became increasingly identified as a book illustrator rather than as an independent graphic artist. Part of this emphasis has been engendered by bookdealers who, like his original publishers, have frequently used the words "illustrated by Cruikshank" to sell an uninteresting book containing no more than a single and often mediocre example of the artist's work. Thus many examples of second-rate work, usually rebound in costly morocco, have found their way into some Cruikshank collections. Furthermore, the book world's interest in rarities *per se* has caused collectors to seek items not because of the intrinsic merit of their illustrations but because of their scarcity. The present pictorial survey is itself not completely free from such prejudice: illustration 27, a not very distinguished example of the artist's work, done when he was a very young man, has been included because of its rarity and because of interesting provenance. The rebound copy from which the illustration is reproduced belonged to four different noted collectors, including two of the previously mentioned cataloguers, Douglas and Cohn. Cruikshank himself tended to foster intense bibliomania in his admirers even though such bibliomania ultimately served to prevent his reputation from having a deservedly wider appeal.

Until recently Cruikshank, like William Blake, has held little appeal for art historians, who tend to neglect popular forms of graphic art, particularly book illustration. This lack of academic interest in Cruikshank has tended to limit his standing as an artist. The few critical works that have been written about Cruikshank, mostly by individuals with a literary background and little technical knowledge of graphic art, have stressed his work as an illustrator. For many he is

above all else the illustrator of *Oliver Twist,* a fact that dominates all appraisals of the man even though this work contained only an infinitesimal fraction of his graphics and is not necessarily his *ne plus ultra* achievement. In deference to their traditional appeal, however, a disproportionately large number of the 24 *Oliver Twist* etchings are presented in this volume.

Even Blanchard Jerrold, Cruikshank's standard biographer, wrote from the library table rather than from the print cabinet, placing far too much emphasis on Cruikshank as a book illustrator (and on a number of humorous but damaging anecdotal details) in the 60 per cent of his biography not derived from other sources. He unfortunately codifies such generalizations as the belief that Cruikshank could not draw horses or women and even introduces the notion that the artist was a lamppost-climbing, gutter-wallowing alcoholic until he became a temperance fanatic. Until very recently, the controversies over whether Cruik-shank assisted Dickens in writing *Oliver Twist* have produced more heat than light, further obscuring the real merits of Cruikshank's art. Since these discussions are usually pursued by Dickens scholars, the genius of the author is asserted to the detriment of the artist.

In editing a comprehensive selection of Cruikshank's graphics, I have become aware of the pitfalls encountered in trying either to refute or ignore many often-repeated statements about Cruikshank's competence as an artist. Compromise seemed best. Thus I have dealt with some of the biographical and critical issues but have emphasized objective description of the graphics which give this volume its *raison d'être.* I trust that the reader will choose his favorites among the various types of works presented here and will arrive at his own estimate of the artist. Cruikshank deserves to be viewed afresh, unbiased by notions from the past.

The contradictory nature of the man in some ways militates against an objective appraisal of his graphic art. Self-educated and self-trained as an artist, Cruikshank depended upon commercial popularity for his livelihood. He was the possessor of a strong, idiosyncratic will, which he vigorously asserted throughout an inordinately long productive life. This combination resulted in a very complex and controversial personality. Famous at an early age, he became a living legend late in life. His most astute contemporary critic, William Makepeace Thackeray, wrote a famous laudatory essay about him in 1840—over 35 years before he died and seven years before he produced his most popular work, *The Bottle.*

The artist's lifelong struggle to escape the financial bind of doing piecework for publishers, who acquired the designs for fixed amounts and used them for decades, and his struggles to prevent inferior artists from copying his designs led to numerous controversies. Yet Cruikshank always credited the amateurs and designers with whom he collaborated in caricatures for their contributions to finished designs and failed to understand why writers did not give him what he considered proper credit for his "suggestions" to them. As he grew older he was asked by collectors to authenticate examples of his early unsigned works, and he began to comment on his career from the perspective of later years and views. There is no doubt that his conversion to the cause of temperance had a momentous effect on his later graphic works; although he had always been a reformer of sorts, the narrowing and dogmatizing of his role as a reformer caused him to view his earlier works solely as adjuncts to his later interests in temperance and social reform. In the past it was usually assumed that the artist's work suffered considerably after his conversion to the Temperance Movement, but this assessment has been questioned by some modern scholars.

With the encouragement of his second wife, Cruikshank late in life undertook an autobiography, but he completed only a few fragments of manuscript and a series of etchings on glass. Most of these illustrations apparently relate to biographical anecdotes or to philosophical truths Cruikshank held dear, but they tell us little about his work or the facts of his life. Indeed, there are many significant gaps in our knowledge of his personal life and its possible impact on his career. Cruikshank's own comments on his role as an artist and on the controversies he became embroiled in may make him seem even more eccentric and cantankerous than he actually was. Not only the biographical comments of his contemporaries and later writers but even Cruikshank's own statements about himself and his work often tend to obscure rather than clarify an objective assessment of his artistic accomplishment.

In 1940 E. H. Gombrich and E. Kris, in their monograph *Caricature,* wrote as follows:

> Comic art is, and always has been, ranked as inferior. But the reasons for this low valuation have varied: sometimes it was reproached for lack of content; sometimes it was considered incompatible with the "grand manner" proper to the dignity of an artist; to-day it is reproached for having any content at all, because a picture which tells a story is thought to be inferior to one which embodies the true artist's "pure vision."
>
> Comic art, however, could always console itself for its position as Cinderella with the knowledge that, disregarded by the dogmatic and loved by the public, it enjoyed a freedom denied to great art. . . .
>
> But if the comic artist has the great advantage of being readily understood by his contemporary public, he pays for it by being more difficult of appreciation for the generations to come.

These few truisms about caricature seem to have been written with George Cruikshank in mind. To this day very little is understood about the nature of comic art in general and in particular about the manifestations of that art during the first quarter of the last century in England. Humorous art, especially satire, is a very complex and, in its own way, serious art form. To dismiss Cruikshank as simply a "funny" artist is to do the genre and the man great injustice. Throughout his life, Cruikshank's works were repeatedly likened to those of William Hogarth, the grandfather of comic art in England. In contrast to such flattering comparisons are comments made by critics late in Cruikshank's life that he could not draw and equally grating suggestions by well-meaning friends that he should attend anatomy classes at the Royal Academy. His work as a caricaturist was unfavorably compared with that of Rowlandson and Gillray, and his work in book illustration came to be inextricably associated with the kind of comic illustration that went out of fashion during mid-Victorian times. Unfortunately, little has been written since Cruikshank's death that attempts to evaluate his role as a comic artist working during the Regency and Victorian Eras. As in the work of the greatest comic dramatists, Cruikshank's art contains images and themes worthy of serious consideration.

Cruikshank's large *oeuvre,* his long life, his critics, his personality, and the nature of the comic art he produced have all tended to take the focus off of his achievements and have even caused most of those who have written about him to fail to consider all of his graphics as essential to a full understanding of his stature. Years before Charles Dickens became known to the world as "the Inimitable Boz"—in fact when Dickens was still a small boy—George Cruikshank was repeatedly referred to in print as "the Inimitable Cruikshank." Perhaps inevitably, such encomia are attended by controversy and negative reaction.

The very lack of biographical information about Cruik-

shank is itself revealing. Despite the existence of a voluminous correspondence extending over many years, few intimate details ever surface. The picture that does emerge, though fragmentary, can be highly amusing. Perhaps some future biographer with access to as yet unpublished documents (now dispersed throughout public and private collections in England, the United States, and other countries) may tell us much more. For example, the role of women in Cruikshank's life remains an enigma. What was the influence of his strong-willed mother on her second son? How and exactly when did his first wife die? What was the character of his second wife? And what was the significance of his will, which left a large part of his estate to a third woman and her ten children, most of whom, having Cruikshank-family given names, were presumably fathered by George Cruikshank?

George Cruikshank, the second son of Isaac Cruikshank, was born in London in 1792. His parents came originally from Scotland and settled in London, where his father earned a living doing drawings for song sheets and caricatures as well as etching plates after his own and other people's designs. George's older brother Robert, who also became a graphic artist, took the name Isaac Robert Cruikshank after his father's death in 1811 and signed his caricatures and illustrations with that name. Eliza Margaret, the sister of the two brothers, also worked in at least one instance in the family profession since her initials appear on one of the caricatures reproduced in this volume (see illustration 24).

As noted previously, George Cruikshank was self-educated. We know from his holographic remarks contained on caricatures and illustrations signed by his father that he helped his father etch. As a child he produced some children's lottery prints and illustrations for chapbooks, a kind of commercial work he continued for several years. The chapbook frontispieces (illustrations 26 and 27) and lottery puffs (illustrations 28 and 32–36) included here date from after his father's death but represent the kind of work he did as a child. From 1810 on, both George and his brother Robert were forced to work as etchers to support themselves as well as their mother and sister. Although his first steady commissions were for doing etched caricature illustrations for monthly issues of magazines, George Cruikshank worked during the first ten years of his career for such a variety of book and print publishers that it is difficult to cite exactly his major means of livelihood. Perhaps his early career can best be summarized as follows: first he did etched magazine illustrations, then individual caricatures, next illustrated pamphlets (illustrations 37 through 42), and finally book illustrations, such as those for *German Popular Stories* in 1823 and 1826 (illustrations 47–62) and *Peter Schlemihl* in 1824 (illustrations 63–66). Yet there is always overlapping between projects, for he never abandoned one kind of work completely for another.

His work for William Hone, a radical publisher, gained the artist a reputation as a political radical; his work in collaboration with his brother on Pierce Egan's *Life in London* gained him a reputation as a man-about-town. It is not certain to what extent alcohol played a role in establishing this reputation. In his late years the artist did state at a temperance meeting that his father died from the ill effects of winning a wager about drinking. Whether Cruikshank himself drank to excess seems uncertain, but his tendency toward conviviality may have resulted in substantial if not excessive drinking. Sometime during this period the artist married and moved into a house adjacent to that occupied by his mother and sister. Very little is known about Cruikshank's first wife aside from the fact that contemporaries indicated she was likable and that she died childless after a prolonged illness in the latter half of the 1840s.

A discussion of Cruikshank's graphic career should begin with a recognition of the fact that throughout his life the artist worked simultaneously in different media and for a variety of employers. Thus though his early career may have centered on his etched caricatures, it should be remembered that during this same period he also did etched and wood-engraved book illustrations as well as designs for wood-engraved lottery puffs and numerous other kinds of graphic ephemera. The artist never engraved the wood blocks for which he did designs, for these were cut on the blocks by professional craftsmen. The quality of Cruikshank's wood engravings therefore varies greatly owing to the uneven skills of the journeymen involved. Furthermore, the commercial nature of his commissions inevitably influenced the amount of effort he put into his work. Each publisher of the caricatures had his own "house style," so that one sees a definite kind of subject matter and style of etching done for a publisher like Tegg in Cheapside (illustrations 5 and 8) which is contemporaneous with but very different from Cruikshank's etching done for the West End publisher Humphrey in St. James's Street (illustrations 6 and 17). The differences here are not the result of lack of skill but purposeful attempts to please a publisher and reach different audiences. Moreover, many of Cruikshank's caricatures were produced from other people's ideas or, perhaps, even from drawings of amateurs. The artist always acknowledges the designer (as did Rowlandson, Gillray, Isaac Cruikshank, and numerous other predecessors), but the success of such designs depends primarily on the artist's skill as an etcher.

During the first quarter of the last century it was possible to buy an etched caricature which was not hand-colored, but the majority were tinted before they were offered for sale. A study of numerous impressions of the same caricature makes it clear that some publishers, such as Humphrey, printed each caricature with considerable care, usually on paper bearing the watermark "J Whatman" and the date, and strove for uniform coloring. Later printings were sometimes not colored from the same master copy and show variations, but in general there is a recognizable standard house coloring in Humphrey's caricatures. Caricatures done for other publishers are more likely to show variations both in color and printing. Often the coarsest or crudest designs done for publishers like Tegg were not well printed and much more likely to be found with crude coloring on cheap paper.

From 1813 through 1817 Cruikshank produced an average of 55 caricatures each year, including those done for magazines; but this figure rose to almost 100 caricatures in 1818 and to over 70 in 1819. Thereafter, until virtually ceasing to do caricatures in 1826, he did approximately 25 each year. He did more caricatures for the firm of Humphrey than for any other publisher, but throughout his career he worked for a variety of London publishers, as many as ten each year. No doubt some of these works were commissioned by amateurs who had the ideas for the designs and captions which they brought to Cruikshank for etching. The initials on the lower left often identify the designer, followed by "inv." (for the Latin "invenit"). Cruikshank will usually indicate that he is the etcher of someone else's design by putting "fec." (for the Latin "fecit") after his name; whereas "inv." and "fec." (or some variant) after his name indicate that he both designed and etched the caricature.

In Cruikshank's time caricature had already become a complex genre that had accumulated a corpus of traditional motifs and subjects. The artist was expected not to create an entirely new idea but rather to give a new interpretation to previously established visual motifs. We still see this practice in the work of contemporary cartoonists who do designs on topical subjects based on earlier motifs—such as the Watergate cartoons showing Congress asking for more

tapes, which both compositionally and thematically suggest Cruikshank's famous etching of Oliver Twist asking for more food. The stress here is on the ingenuity of the artist's new utilization of an already established motif, just as an eighteenth-century writer did not invent a new genre or story but did an ingenious reworking of an already established literary form.

A good example of Cruikshank's reworking of a visual motif occurs in his caricature "The Peddigree of Corporal Violet" (illustration 6). This design is based on a remark by Napoleon during the Hundred Days when he was asked when he intended to return to Fontainebleau. He said he would be back by violet time. The French then did graphic designs showing a bouquet of violets with a hidden profile of the Emperor, the Empress, and their child, the King of Rome (figure 1). In England, Rowlandson and others did copies of this design (figure 2). Both the caption and the idea for the remainder of Cruikshank's design were based on Gillray's caricature of William Pitt, "An Excrescence;—A Fungus;—alias—a Toadstool upon a Dung-hill" (figure 3). This was originally published by the Humphrey firm. Later, George Humphrey, the nephew and successor to Hannah Humphrey, the original owner of the firm, suggested the idea for illustration 6 to Cruikshank. As he explains in his caption, Cruikshank gives a profile not only of the Emperor's head but of his entire figure. Thus a new design fitted to a different purpose has been created by combining one earlier motif from a well-known caricature with another more contemporary design. The complexities of such caricatures frequently elude a modern audience unaware of the tradition that produced such ingenious variations and of the contemporary events that inspired them. A viewer is expected in such cases to "read" the picture and study its levels of meaning in order to appreciate it fully.

Unlike his father, who did highly finished drawings for song sheets which were crudely engraved by craftsmen, George Cruikshank did extremely sketchy drawings of considerable interest as preparations for his graphics. They show him "thinking on paper" and can be appreciated more for their lively inventiveness than as finished compositions. Often such drawings will include the general outlines of the main design accompanied by surrounding sketches of details. Two such drawings are illustrated here to show how he worked out an idea. The first of these, "The Fiends Frying Pan," is shown next to a reduction of the finished etching for which it was done (figures 4 and 5). The verbal captions in the drawing were later incorporated into the plate. The differences in posture and composition between this drawing and the print were probably worked out in other sketches, as was often the artist's practice. The drawing dates from 1832 and the etching was published as a single page of part 4 of *Scraps and Sketches* (see illustrations 93 through 95 for other compositions in this series). Later in life, when his drawings became sought after by collectors, Cruikshank went back to such early working drawings to sign them and sometimes even add captions. Some preliminary drawings include watercolor washes that may have been added later. In his old age Cruikshank frequently also prepared sets of watercolored copies of his most famous illustrations for collectors. These copies are often markedly inferior to the original working copies which, like "The Fiends Frying Pan," contain the energetic sketches surrounding the central motif.

The second drawing reproduced here (figure 6) was done for *The Comic Almanack* of 1851. "Fellows of the Zoological Society" was later captioned, signed, and designated as an "original sketch" by the artist. Presumably this pen-and-

pencil drawing was, as he stated, the preliminary sketch for the etching reproduced in illustration 183. Once again, much of the attraction of the drawing consists in seeing how the figures evolve in the small vignettes. The stages of anthropomorphic transformation, as well as the original pencil sketch for the two crane-like creatures on the right, are still sketches on the margin and have not yet become incorporated into the finished composition.

As mentioned earlier, one sees a variety of etching styles in the caricatures, some the result of working for different publishers and suiting one's style of etching to the traditional style of the house. Thus when Cruikshank worked for Tegg, who published numerous Rowlandson caricatures, he worked in a Rowlandsonesque style; for Humphrey, he worked in the manner of Gillray. Yet even beyond these stylistic variations there is to be seen in all of Cruikshank's etchings a characteristic nervous, vibrant kind of sketchy line. These characteristics can be seen clearly in a detail from his most famous caricature, "Inconveniences of a Crowded Drawing Room" (color plate I). Figure 7 shows a detail of the etched original by Cruikshank, and figures 8 and 9 show the corresponding details of two copies by others. Figure 9 is in reverse because the copyist failed to reverse the design when he etched it on copper. But the point is clear: both copies have lost the vibrancy and genius of the original. Even the most skillful copies of Cruikshank's prints by his pupil Frederick Pailthorpe lose much of the spontaneity and vigor of the original. The sketchy background figures and details in a Cruikshank etching, which seem carelessly drawn but are an intrinsic aspect of his style, are virtually impossible to copy.

A chronological study of the etchings in this volume shows Cruikshank's growing interest in detailed, crowded compositions. It was almost as if the artist had done all that he could in a free and loose style and began to try to crowd more and more into small compositions. These later works reveal remarkable details when studied with the help of a magnifying glass. Technically, they are virtuoso performances. The best example in this volume of a crowded composition in an etching is illustration 238. Also, in "The Worship of Bacchus," reproduced in illustrations 256 and 257, one can see at full range his urge to include detail; but only the outlines of the figures in this composition were etched by Cruikshank himself. The artist's wood-engraved compositions always abounded in rich detail but it is difficult to know how much of that detail originated with Cruikshank. Often the most sketchy of original drawings related to the most refined, precisely finished wood engravings. In each instance one surmises that the artist did not use such drawings for tracing the composition on the block but subsequently did a highly finished drawing on the block itself.

The artist's interest in new or different graphic techniques prompted him in later life to work in varied media such as glyphography (see the note to illustration 220) and etching on glass (see the note to illustration 259). Interestingly enough, the artist's etchings on glass, which did not require reversing the composition, are doubtless the graphics in which the style of draftsmanship most closely resembles that seen in the majority of his extant drawings (see illustration 259). Sometimes these technical innovations were motivated by the possibility of producing more images at a lower unit cost, as is the case of *The Bottle* and *The Drunkard's Children* (illustrations 220 through 235). But at other times they were intended to reproduce graphics of better quality, as in illustration 249 with its steel-faced etching on copper (see note for this entry).

Although Cruikshank's graphics will always be associated

1

2

**Fig. 1.** One of the original French violet designs with hidden pictures of Napoleon and his family. Engraved by Jean-Dominique- Etienne Canu, Paris, 1815. **Fig. 2.** Thomas Rowlandson's copy of the violet design. Published by Fores, London, 1815.

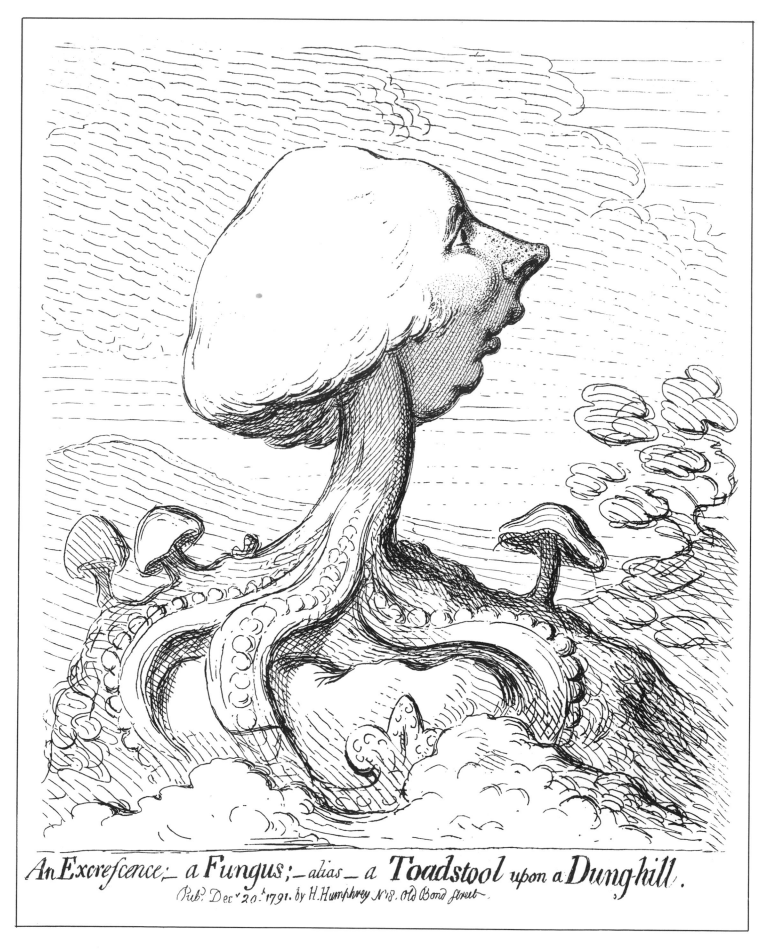

*An Excrefcence;— a Fungus;—alias— a Toadstool upon a Dung-hill.*

Pub.ᵈ Decʳ 20.ᵗ 1791. by H. Humphrey N.ᵒ 18. Old Bond Street

**Fig. 3.** James Gillray's "toadstool-rising-from-dunghill" caricature of William Pitt. Published by Humphrey, London, 1791.

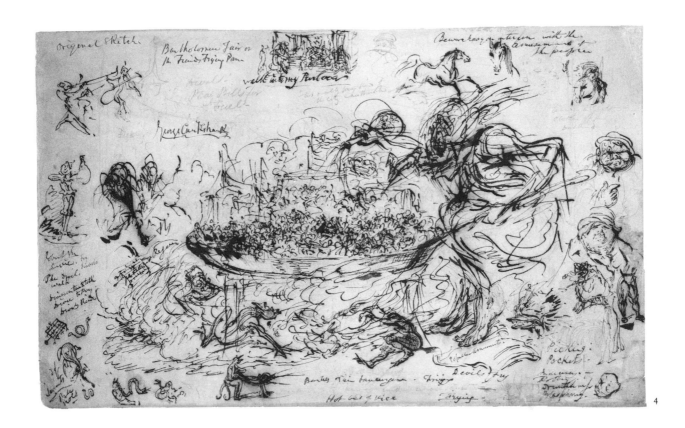

4

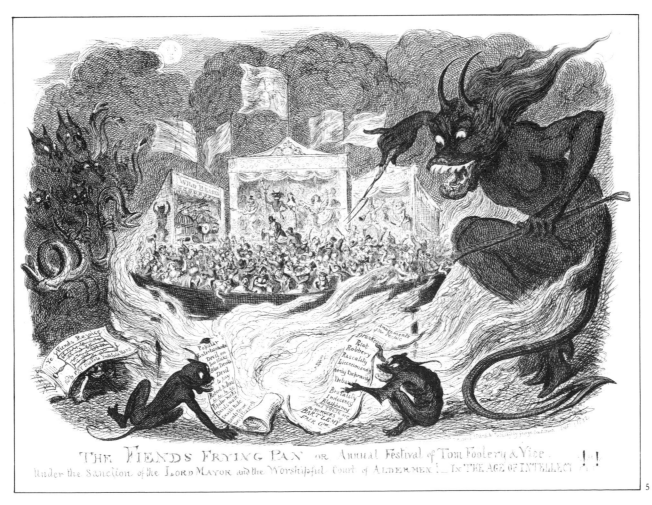

5

**Fig. 4.** Cruikshank's preliminary drawing for "The Fiends Frying Pan."    **Fig. 5.** The finished etching "The Fiends Frying Pan."
Published by the artist, London, 1832.

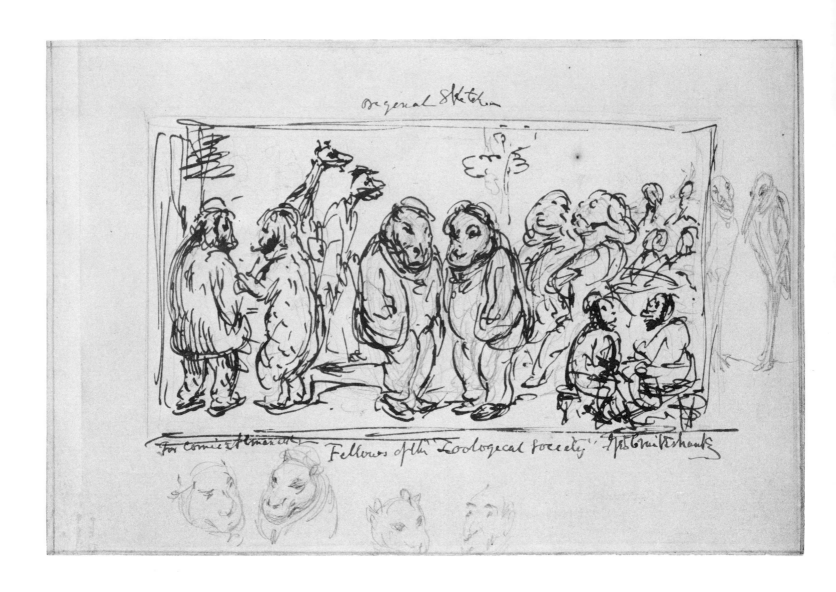

Fig. 6. Preliminary drawing for "Fellows of the Zoological Society."

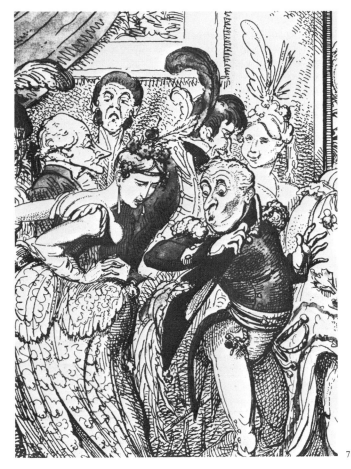

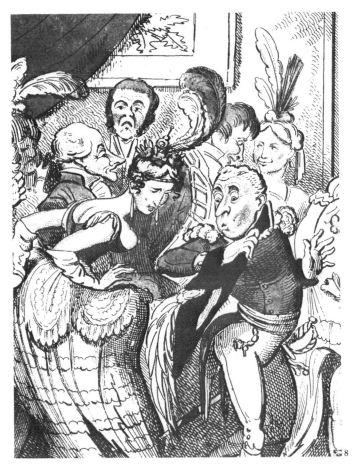

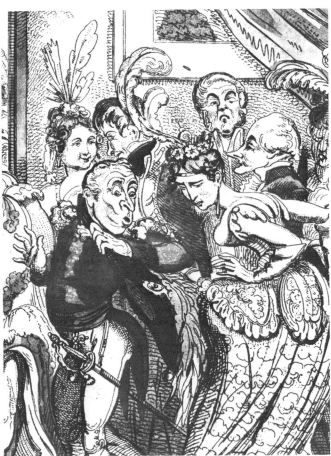

**Fig. 7.** Detail from Cruikshank's etching "Inconveniences of a Crowded Drawing Room." **Fig. 8.** Corresponding detail from a copy by another artist. **Fig. 9.** Detail from yet another copy, this one in reverse.

primarily with the medium of etching, it ought to be remembered that he also did designs for memorable wood engravings (see illustrations 69 through 74) and late in his career utilized a number of other media in innovative and interesting ways. But Cruikshank's early efforts at lithography represent, perhaps, his least successful use of a graphic medium since they show surprisingly little concern for utilizing the quality of stone with sensitivity to its potential. A proper evaluation of Cruikshank's genius as a graphic innovator requires much lengthier treatment than is possible in a brief introduction of this kind.

Any discussion of the most salient features of George Cruikshank's artistic genius should include mention of his involvement in the narrative tradition in visual art. Narrative, in contrast to decorative illustration, usually explicates a verbal text visually although it may, and traditionally often does, contain details not in the text that complement thematically what is being illustrated. A decorative illustration usually does not relate to a specific incident in a text but rather offers a generic character portrait of one of the people in a story. In their most extreme form one associates visual narrative sequences without text with William Hogarth. Such sequences necessarily contain many of the basic elements of any narrative such as explication, rising action, conflict, foreshadowing, a climax, falling action, denouement, etc. One thinks immediately of Hogarth's major graphic series—often known as progresses—beginning with *The Harlot's Progress* in 1732. Cruikshank's most pronounced nineteenth-century equivalents are *The Bottle* and *The Drunkard's Children* (illustrations 220 through 235).

The satiric and moralistic elements in both Hogarth's and Cruikshank's narrative compositions derive from continental sources going back to Hieronymus Bosch and Pieter Brueghel. In many ways Cruikshank in "The Worship of Bacchus" (illustrations 256 and 257) achieved in bourgeois nineteenth-century England what Bosch and Brueghel had accomplished for their generations in the fifteenth and sixteenth centuries. But the secularization of Cruikshank's Protestantism results in an evangelical preoccupation with the evils of alcohol. In a way Cruikshank's more immediate models, Hogarth's "Beer Street" and "Gin Lane" of 1750, offer an intermediate and less extreme step in the development of a less religious and more humanitarian approach to the alleviation of social evils.

Narrative composition had become such a part of caricature by the time Cruikshank began his career that it was almost axiomatic that in a well-constructed caricature most of the details in one way or another would complement the main themes of the composition. The artist had so fully assimilated the narrative tradition before he started doing book illustration that he perforce included details of his own invention in narrative works he was illustrating. This tendency, deriving from a visual narrative tradition and strong bent toward satire, often resulted in very complex humorous compositions. His works always have an immediate appeal; their humorous message is spontaneously perceived. Yet often certain works are so sophisticated that they border on the esoteric, containing whole echelons of topical verbal implications not readily evident to a modern viewer.

The use of language in Cruikshank's art has never been given the attention it deserves. Clever captions and a whole panoply of intricate linguistic devices derive in part from the eighteenth-century penchant for cleverness or the *bon mot*. In addition to the already well-established tradition of the use of language in humorous art, Cruikshank was exposed to this tendency through the individuals and groups of people who brought him ideas for caricatures which he was in turn to visualize for them. Thus in caricature there is a kind of collaborative effort behind some of this kind of wit. Ultimately the tendency to use language in this way became a standard part of all of Cruikshank's work. Indeed, the trait carried over in the nineteenth century to publications like *Punch,* in which the cartoon is often not understood until the accompanying text has been read. Aside from titling or accompanying text, Cruikshank's work, like Hogarth's, frequently contains numerous uses of verbal passages in the form of signs or picture captions within the designs themselves. In fact, one could almost say that Cruikshank, whose knowledge of literature and language is most exceptional for a self-educated person, is an artist who is dependent on language.

It is important to remember that an artist like Cruikshank became the nineteenth-century exponent of a visual tradition in European religious and secular art which relates symbols and language in a unique way. Pictorial traditions tend to survive more pervasively in popular art forms like caricature than in almost any other kind of art. Emblem books as well as the hieroglyph and the heraldic device became a standard part of the visual vocabulary of an artist steeped in the tradition of caricature. The recurrent use, for example, of a dunce's hat in Cruikshank goes back to the basic iconology available to artists from the time of the Renaissance. Cruikshank is a late but direct inheritor of a very complex visual language that has steadily lost its power over the modern world. Furthermore, as an English artist working in a national tradition going back to Hogarth, Cruikshank produced art inextricably linked with language and a literary tradition, a reality that only recently has begun to be explored by scholars.

One feature of Cruikshank's artistic genius—so pervasive that it is often taken for granted—consists of his use of animism or the attribution of conscious life to inanimate objects. Perhaps the most pronounced example in this volume occurs in the composition, "London going out of Town.—or—The March of Bricks & mortar!" (illustration 95), but the phenomenon is found in numerous Cruikshank designs, including some of his illustrations for *German Popular Stories* (see illustrations 50 and 53). Closely related but different from animism is anthropomorphism or the humanization of that which is not human. This trait, found in a great number of works of children's literature going back to such classics as Aesop's fables, also finds full expression in Cruikshank's graphics.

The artist's French contemporary Charles Baudelaire said, "The special merit of George Cruikshank is his inexhaustible abundance of grotesque. A verve such as his is unimaginable. . . . The grotesque flows inevitably and incessantly from Cruikshank's etching needle, like pluperfect rhymes from the pen of a natural poet." Very early in his career he manifests his own brand of distortion, both of bodily shapes and of the human face. There is something so characteristic about his use of the incongruous and the grotesque that to this day someone acquainted with his works can look at a particularly ill-featured face or misshapen body and declare it to be "Cruikshankian." The use of disproportionate size as well as bizarre, almost frenzied, exaggeration typifies his use of the grotesque and is often enhanced by his method of etching with its nervous, squiggly, almost surreal linear quality. He is often seen at his best when he does a kind of composite design that constitutes a theme and variations, such as "A Chapter of Noses" (illustration 96).

Since in this volume examples have been chosen from the

majority of key works Cruikshank illustrated, it is possible to summarize his career by giving an annotated listing of "turning-point" published works together with a few other facts. In each instance when examples are pictured in this volume the numbers of the illustrations are given, enabling the reader to consult the notes for more detailed commentaries.

1792    Born September 27 in London; second child of parents of Scottish origin.

1806–1810    Assisted his father in illustrating song sheets (illustration 25), lottery puffs (illustrations 28 & 32–36), advertisements (illustrations 29–31), and chapbooks (illustrations 26 & 27). Although the majority of the examples illustrated postdate this early period, they are indicative of the kind of work he did before the death of his father in 1811.

1811–1814    Received his first steady employment doing etched illustrations for periodical publications such as *The Scourge, Town Talk, The Satirist,* and *The Meteor.*

1812–1815    Did caricatures on Napoleon for a variety of publishers before and immediately after the fall of the Emperor in 1815 (illustrations 3–7 and color plates III–V), which helped to establish his reputation as a graphic artist.

1812–1826    Became the successor to James Gillray and Thomas Rowlandson and was considered the leading caricaturist in England, creating all kinds of political and social caricatures up until 1826, when he virtually abandoned working in this genre (illustrations 1–24 and color plates I–VIII).

1816–1820    Worked for left-wing publisher William Hone doing woodcuts which extolled the cause of Queen Caroline and the liberal political causes of the period (illustrations 37–42). This associated the artist with radical politics.

1819–1820    *The Humourist.* Earliest important etched book illustrations.

1821    Illustrated, in collaboration with his brother, Pierce Egan's *Life in London,* which became a bestseller and gave the brothers a reputation as dandies and men-about-town.

1823 & 1826    *German Popular Stories* (illustrations 47–62). Landmark illustrations accompanying the first English translation of this seminal German romantic work. Illustrations copied in several editions in other countries.

1823    *Peter Schlemihl* (illustrations 63–66). Another example of high-quality illustrations accompanying a first English translation of an important German romantic work.

1823–1824    *Points of Humour* (illustrations 43 & 44). Another early example of the kind of illustration which helped establish Cruikshank as England's leading illustrator.

1826    *Phrenological Illustrations* (illustration 91). First major attempt to break away from the format of caricature and to publish his own work. Clearly a new direction in his career.

1827    *Illustrations of Time* (illustration 92). A second effort evidencing experimentation.

1828–1832    *Scraps and Sketches* (illustrations 93–95). A third effort concerned with new approaches—on a larger scale than that of previous works.

1831–1833    *Roscoe's Novelist's Library* (illustrations 125–128). Illustrations for classic works of eighteenth-century novelists that definitively establish Cruikshank as England's premier illustrator.

1834–1836    *My Sketch Book* (illustration 96). An even more ambitious new-directions effort than *Scraps and Sketches* of 1828. Once more the artist attempted to control the sale and profits of his own works to avoid receiving only piecework payment.

1835–1853    *The Comic Almanack* (illustrations 160–187). A major graphic effort extending over 19 of the most crucial years of the century.

1836–1839    *Sketches by Boz* (illustrations 140–147). Cruikshank did two sets of illustrations for this collection of newspaper sketches by Charles Dickens.

1837–1843    *Bentley's Miscellany* (illustrations 139 and 148–159). Cruikshank was the principal illustrator for this periodical when Dickens and later Ainsworth were its editors. He illustrated *Oliver Twist* for Dickens and later three of Ainsworth's novels which originally appeared in this publication.

1842    *George Cruikshank's Omnibus* (illustrations 192–198). Another example of the artist's effort to serve in a greater role than just as an illustrator working for a publisher. Here he attempted to influence all facets of the publication and to share in profits from sales. Apparently the work did not sell well, the periodical lasting only nine months.

1845    *George Cruikshank's Table Book* (illustrations 199–211). A second attempt to become more than artist-contributor to a periodical, manifested in superb etchings and numerous woodcuts—but again publication abandoned after a year.

1846    *Our Own Times* (illustrations 216 & 217). An example of the artist's interest in social problems before his conversion to temperance. The four etchings from this little-known work are excellent commentaries on problems of the "hungry forties."

1847    *The Bottle* (illustrations 220–227). An enormously successful series becoming, perhaps, Cruikshank's most popular work and enabling him to realize his ambition to produce a popular Hogarthian progress.

1848    *The Drunkard's Children* (illustrations 228–235). Sequel to *The Bottle.* The last plate of the series regarded by some as the finest design ever done by the artist. This and the preceding series show the artist working in a serious vein. At this time Cruikshank had taken up the cause of temperance and was to remain a zealous convert for the rest of his life.

1851    Wrote his first social pamphlet and over the next 20 years would write a plethora of pamphlets and leaflets dealing with social problems and controversial issues of personal concern.

1853–1864   *George Cruikshank's Fairy Library* (illustrations 239–246). Series of four fairy tales both written (including temperance insertions) and illustrated by the artist. Another demonstration of his genius in doing children's illustrations. Reprinted often in subsequent years.

1854    *George Cruikshank's Magazine.* Last—and short-lived—attempt to publish his own periodical.

1857–1858   *The Life of Sir John Falstaff* (illustrations 250–253). Last important series of virtuoso etched illustrations done by the artist.

1864    "The Worship of Bacchus, or the Drinking Customs of Society" (illustrations 256 & 257). Large steel engraving with only outlines of figures done by Cruikshank. Composition based on his huge temperance painting.

1871    "The Leader, of the Parisian Blood Red Republic, or the Infernal Fiend!" (illustration 261). Very late graphic showing little diminution of ability as an etcher. Done as a reaction to the Paris Commune by the man who began his career doing caricatures of Napoleon.

1878    Died February 1 in London.

Aside from the previously mentioned pattern of attempting to become his own publisher, what other insights are afforded by the foregoing chronological account? For one thing, it indicates that for the last two decades of his life Cruikshank had few important commissions to do illustrations; yet it stands to reason that when a person lives to be 86 the last 20 years of his career will be less productive than his earlier years. Also, we find him repeatedly using his full name in the titles of works he illustrated; this is because as he grew older and became internationally famous, numerous imitators, even his own relatives, began to use on publications the name "Cruikshank" without a given name. The basic fact revealed by the chronology is that he became a well-known humorous artist when in his early twenties and remained England's leading comic artist for at least the first half of the last century, producing his most popular work in 1847 at age 55. Changing taste and pictorial technology in Victorian England resulted in a diminishing demand for the services of an etcher who had become a legend in his own life—a man who on one occasion, when introduced to people who thought him dead for decades, danced a hornpipe to prove he was very much alive. Perhaps his authoring of social-minded and controversial pamphlets also caused a wave of reaction to set in against him even before his death. Unfortunately this reaction, which had no effect on his popularity among collectors,

was in full force during the two decades after his death, when the majority of accounts about the artist were published. This may help to explain why he has come down to us as a figure whose life and works seem so embroiled in controversy.

William Makepeace Thackeray, the artist's most astute contemporary critic, expressed in "An Essay on the Genius of George Cruikshank" (1840) as succinct an appreciation of his work as has any critic to date. Thackeray's concluding remarks stand as an especially eloquent tribute to the artist's genius:

> Week by week, for thirty years, to produce something new; some smiling offspring of painful labour, quite independent and distinct from its ten thousand jovial brethren; . . . He has told a thousand truths in as many strange and fascinating ways; he has given a thousand new and pleasant thoughts to millions of people; he has never used his wit dishonestly; . . . how little do we think of the extraordinary power of this man, and how ungrateful we are to him! . . . Look at one of Mr. Cruikshank's works, and we pronounce him an excellent humourist. Look at all, his reputation is increased by a kind of geometrical progression; as a whole diamond is a hundred times more valuable than the hundred splinters into which it might be broken would be. A fine rough English diamond is this about which we have been writing.

Finally, it is appropriate to say a few words about the immediate delight found in Cruikshank's works. Although there is much to ponder and study in his graphic art, it is not necessary to *understand* how his art works to appreciate his genius. Rather, we should approach his art ready to enjoy it just as the child is delighted when he hears his favorite fairy tale, recites his favorite nursery rhyme, or sings his favorite song. In Cruikshank's works we are universally confronted by teeming life devoid of escapist or elitist views. The artist is most at home when using the anarchic power of comedy to attack political chicanery and social wrongs, to expose pomposity or threadbare ethics, to attack false morality, or to show man's ubiquitous struggle to combat his circumstances. Cruikshank's characters, both his recognizable London nineteenth-century types and his more universal representations of stalwart individualism, will live forever in his graphic art because they awaken in us, his viewers, a liberating sense of our own identity. But perhaps his greatest feat is stripping away smugness and self-satisfaction and cutting down his characters to Cruikshankian size. His pencil and etching needle provide a summation of permanent human qualities, a mirroring not only of frailties, conceits, self-indulgence, and deceptions but also of resourcefulness, muddling-through determination, ineffable verve, and unabashed humanity. Ultimately we recognize in George Cruikshank's human comedy the ability of his art to cleanse with mirth and laughter the wounds of injustice abounding in an imperfect world.

RICHARD A. VOGLER

*Los Angeles, California*

# GRAPHIC WORKS OF
# GEORGE CRUIKSHANK

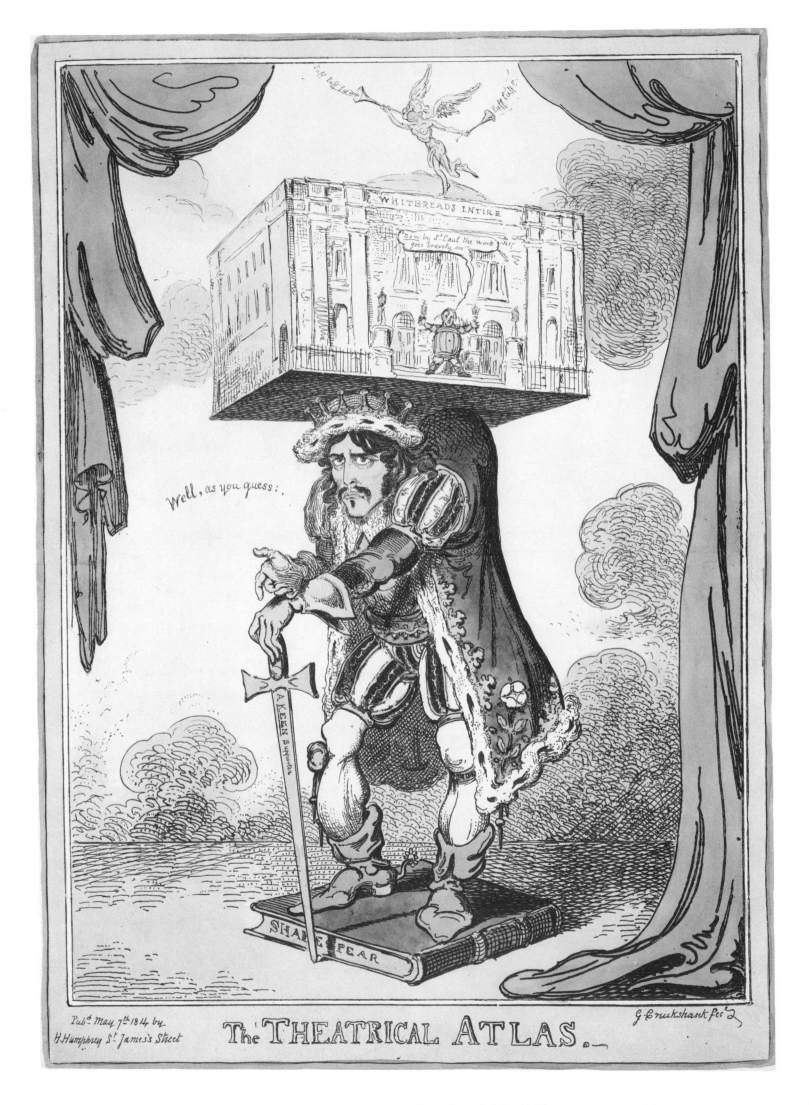

**1.** Edmund Kean supporting Drury Lane [7 May 1814].

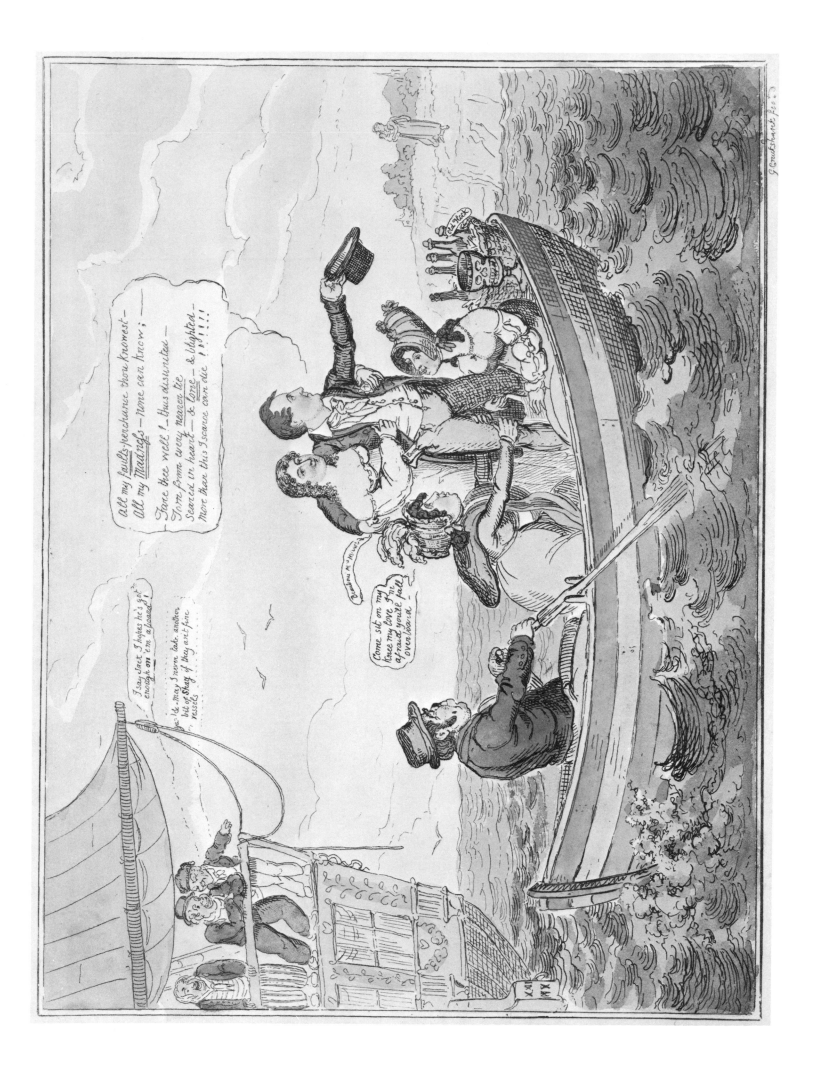

2. "Fare Thee Well." Lord Byron leaving England [April 1816].

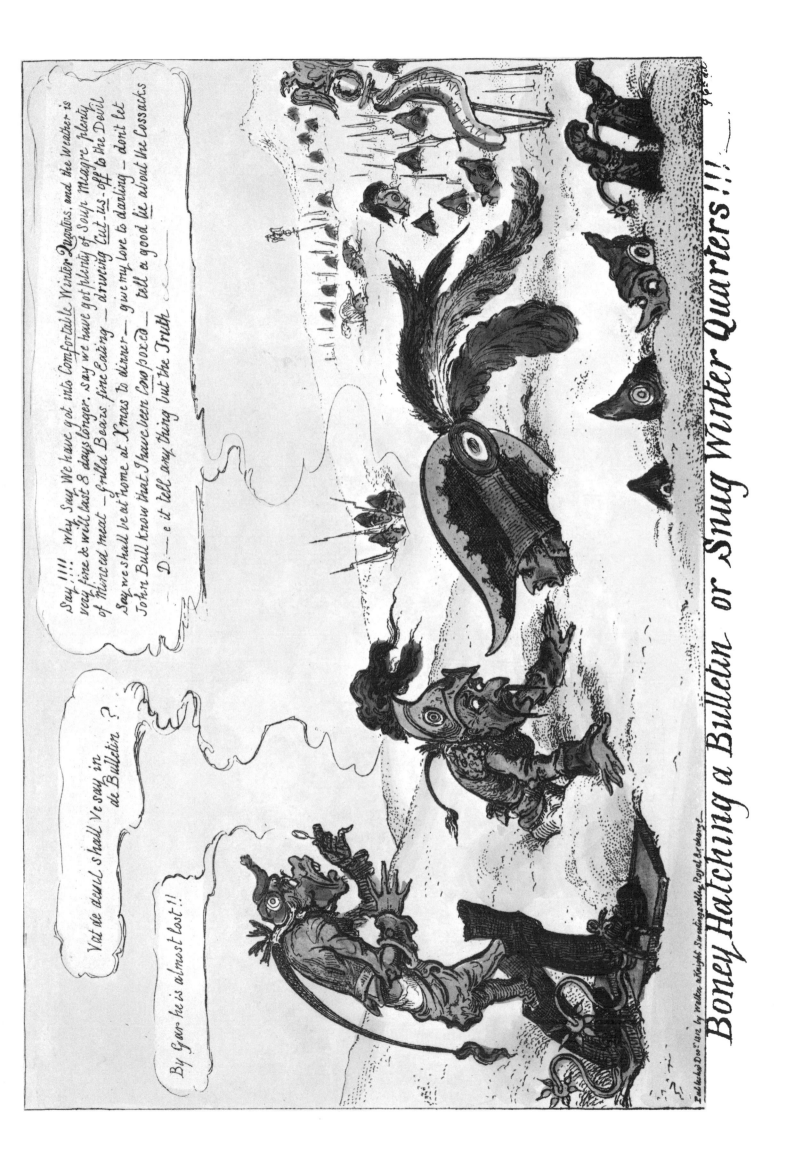

3. False French bulletins about the Russian campaign [December 1812].

3

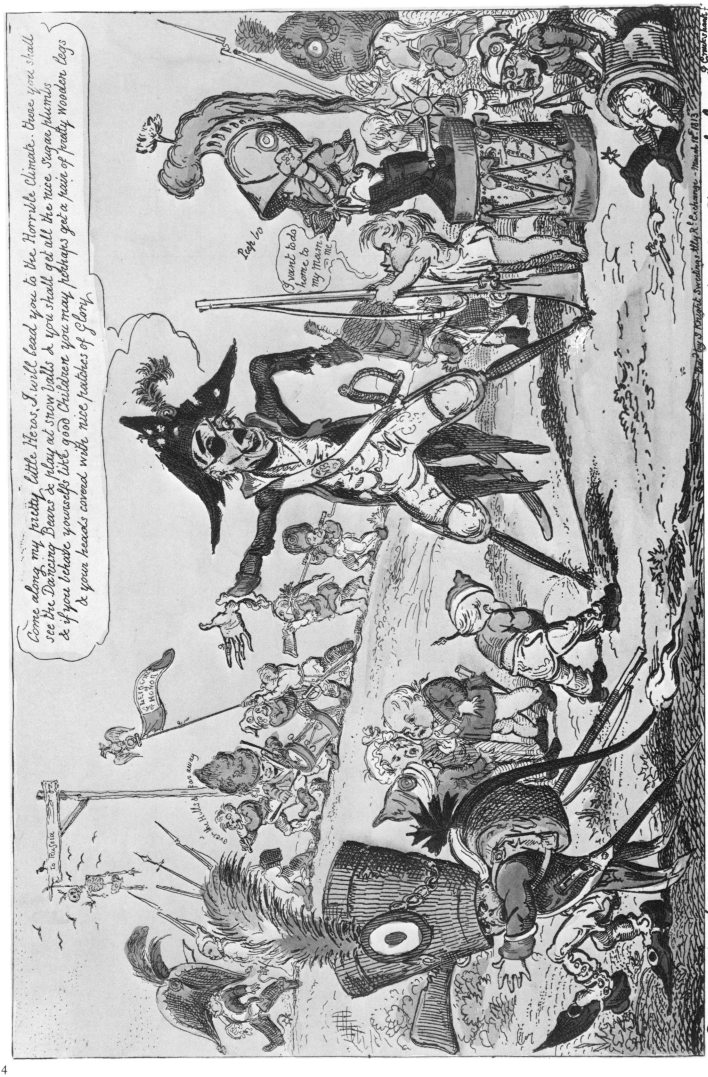

4. A recruiting officer signing up children [18 March 1813].

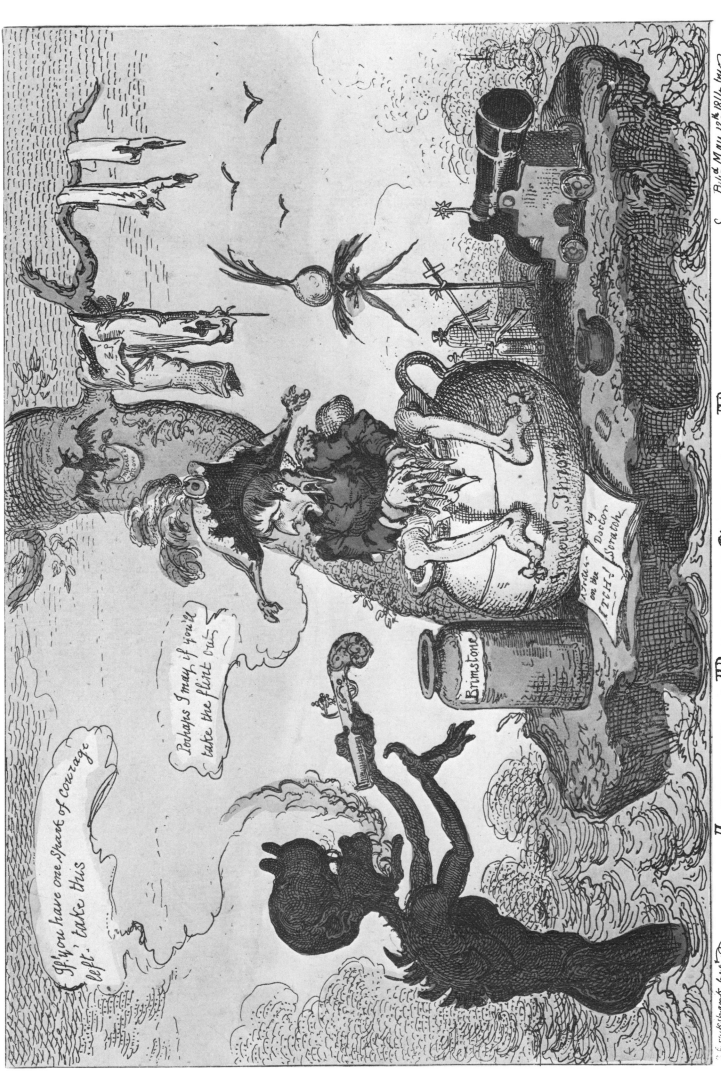

5. Napoleon in exile on Elba [12 May 1814].

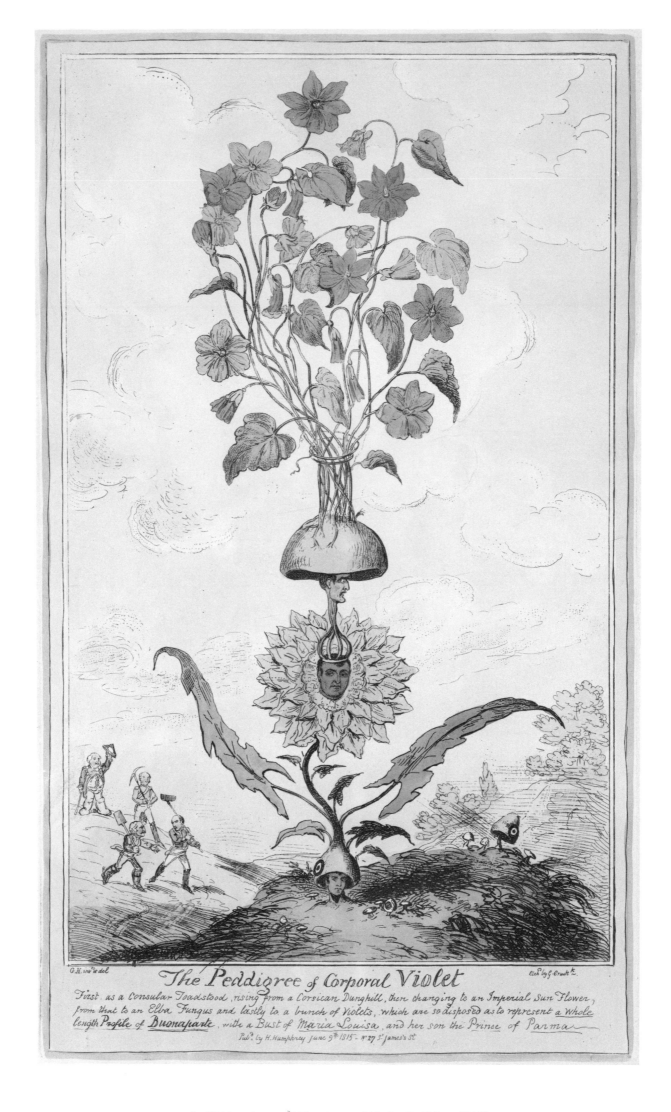

The Peddigree of Corporal Violet

First as a Consular Toadstool, rising from a Corsican Dunghill, then changing to an Imperial Sun Flower, from that to an Elba Fungus and lastly to a bunch of Violets, which are so disposed as to represent a Whole length Profile of Buonaparte, with a Bust of Maria Louisa, and her son the Prince of Parma

Pub.d by H. Humphrey June 9th 1815 - N 27 S.t James's St

**6.** Hidden pictures of Napoleon and his family [9 June 1815].

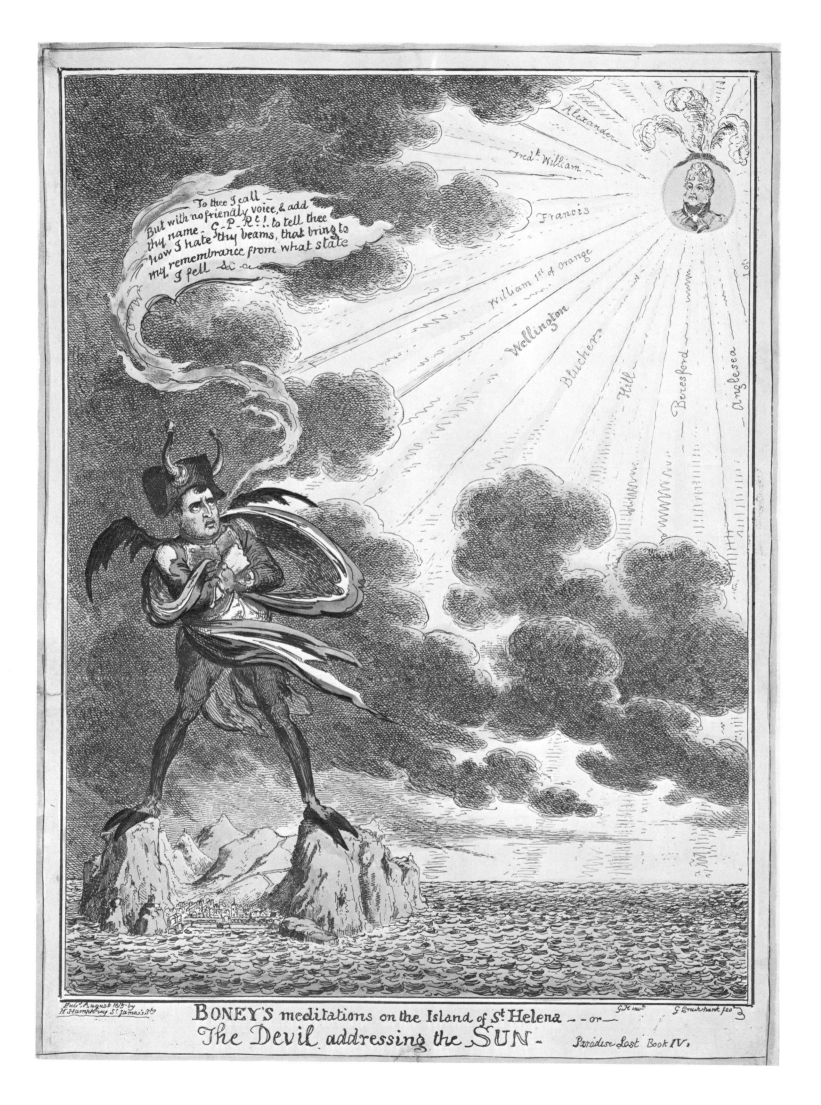

**7.** Napoleon/Satan on St. Helena reviles the Prince Regent [August 1815].

7

*Villagers Shooting out their RUBBISH. !.!.!*

8. A barrister, apothecary, and parson are expelled [15 December 1819].

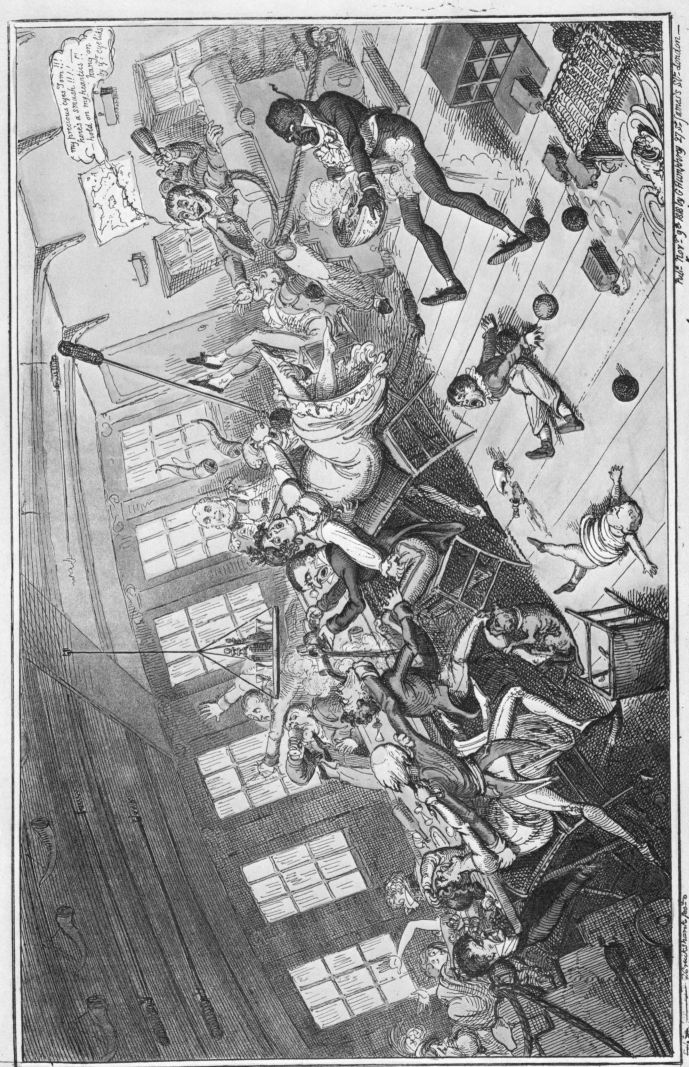

9. A scene aboard ship, after Captain Francis Marryat [9 November 1818].

10. Princess Caroline introduces her paramour to Count Metternich [15 September 1817].

*Inconveniences of a Crowded Drawing Room* —

Pubd May 6th 1818 by H Humphrey 27 St James's St

I. A reception at the Queen's House, now Buckingham Palace [6 May 1818].

II. An imaginary parade of the unemployed in London's streets [10 February 1814].

REVIEW of the FRENCH TROOPS on their returning March through SMOLENSKO.

"Altho their Dress is not gaudy, it is warm & that is the principle thing!"
Vide, the Hamburg Correspondent for 1812. Nº 180. — 14.th March

III. A way station on Napoleon's retreat from Moscow [27 May 1813].

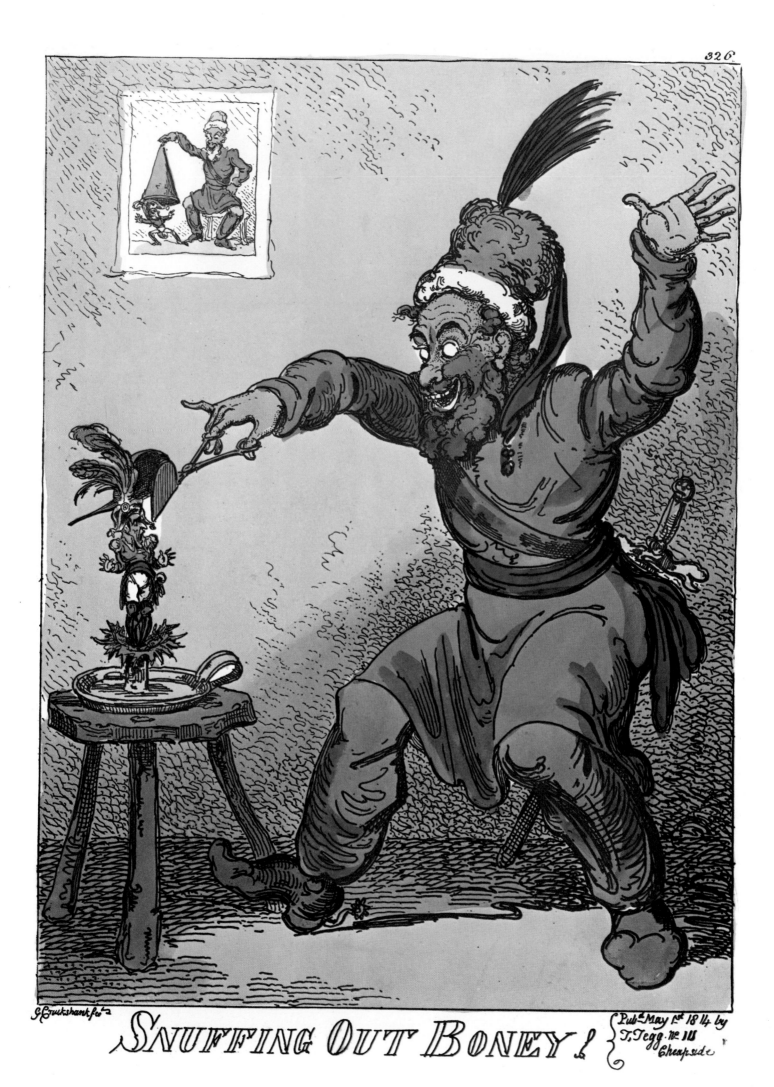

IV. Napoleon extinguished by the Russians [1 May 1814].

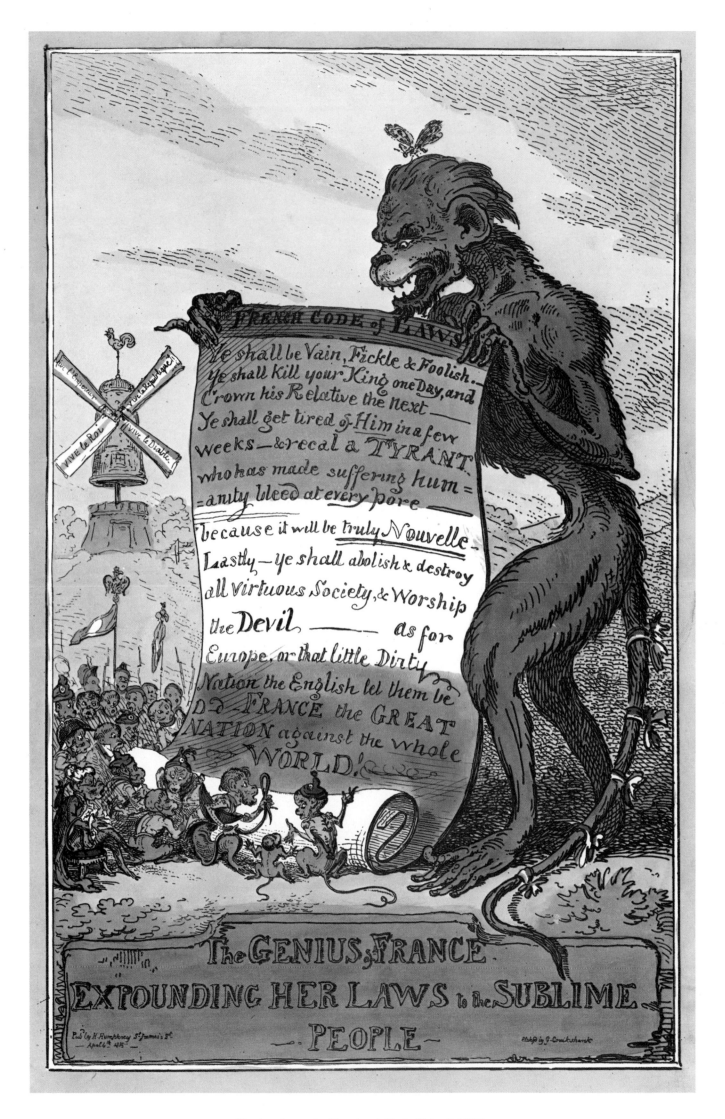

**V.** A satire on the Napoleonic Code [4 April 1815].

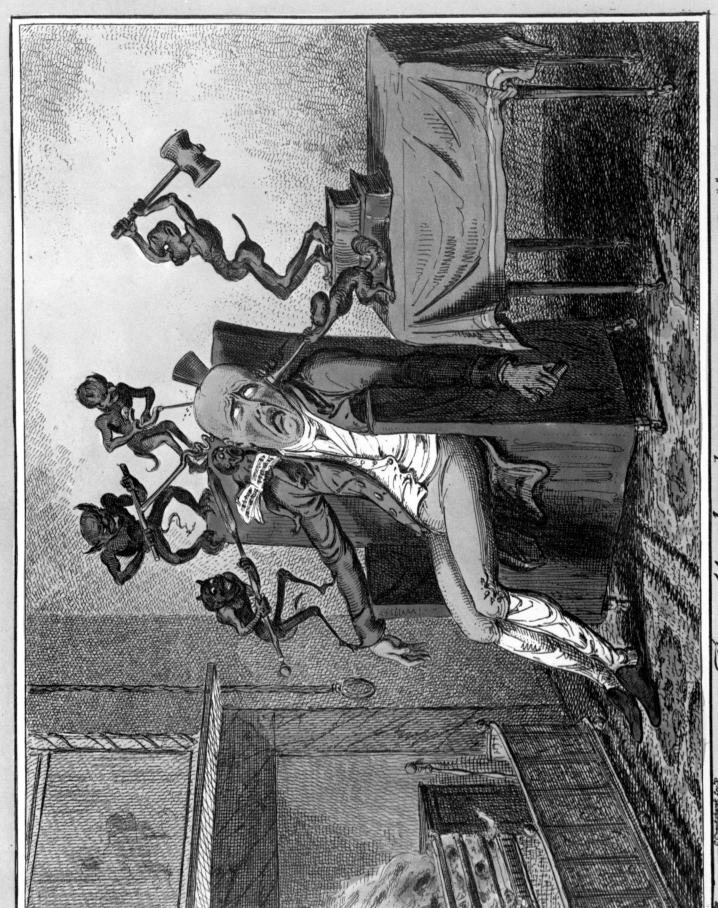

*The Head ache*

**VI.** A medical caricature, after Captain Francis Marryat [12 February 1819].

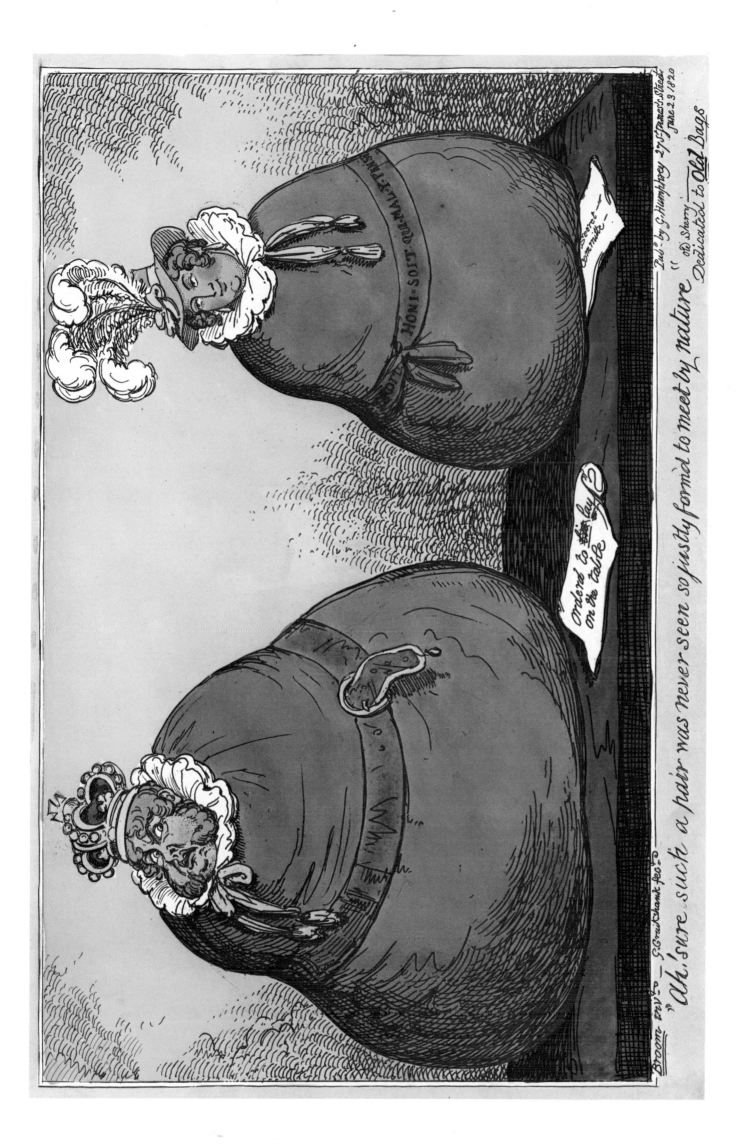

VII. King George IV and Queen Caroline, just before the Queen was tried for adultery [23 June 1820].

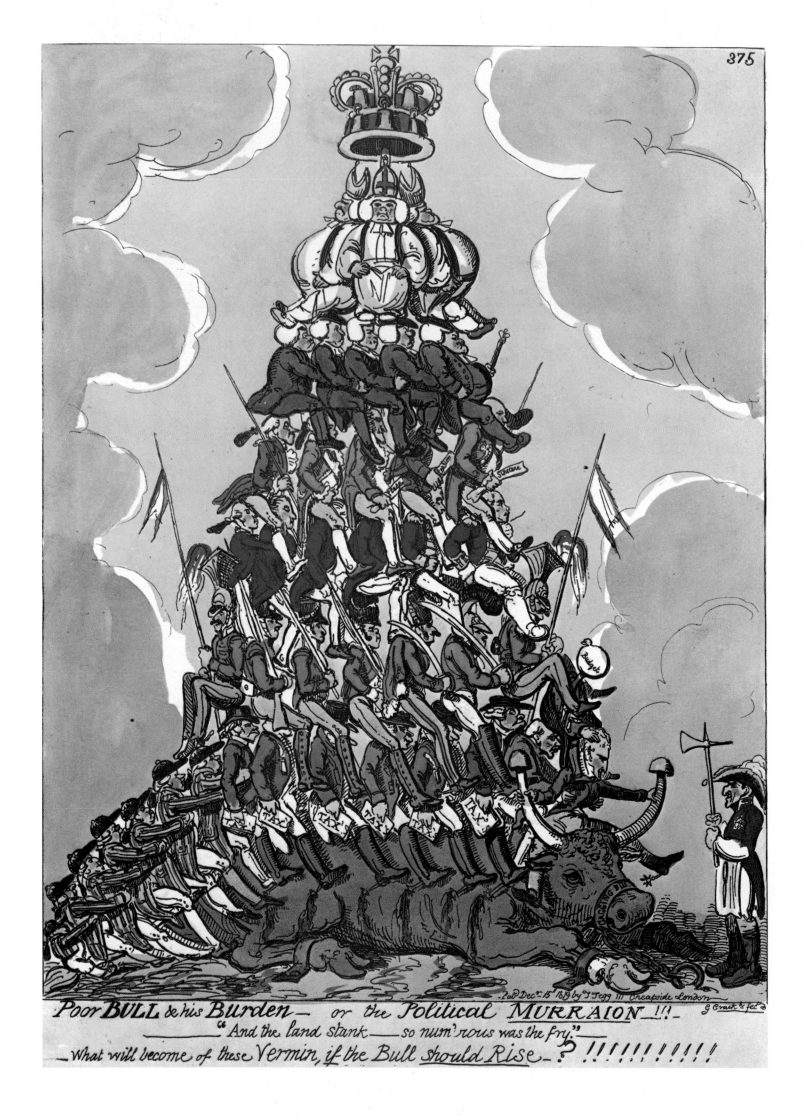

Poor BULL & his Burden — or the Political MURRAION !!! —

"And the land stank — so num'rous was the fry."

— What will become of these Vermin, if the Bull should Rise — ? !!!!!!!!!!!!

VIII. The load borne by the British public [15 December 1819].

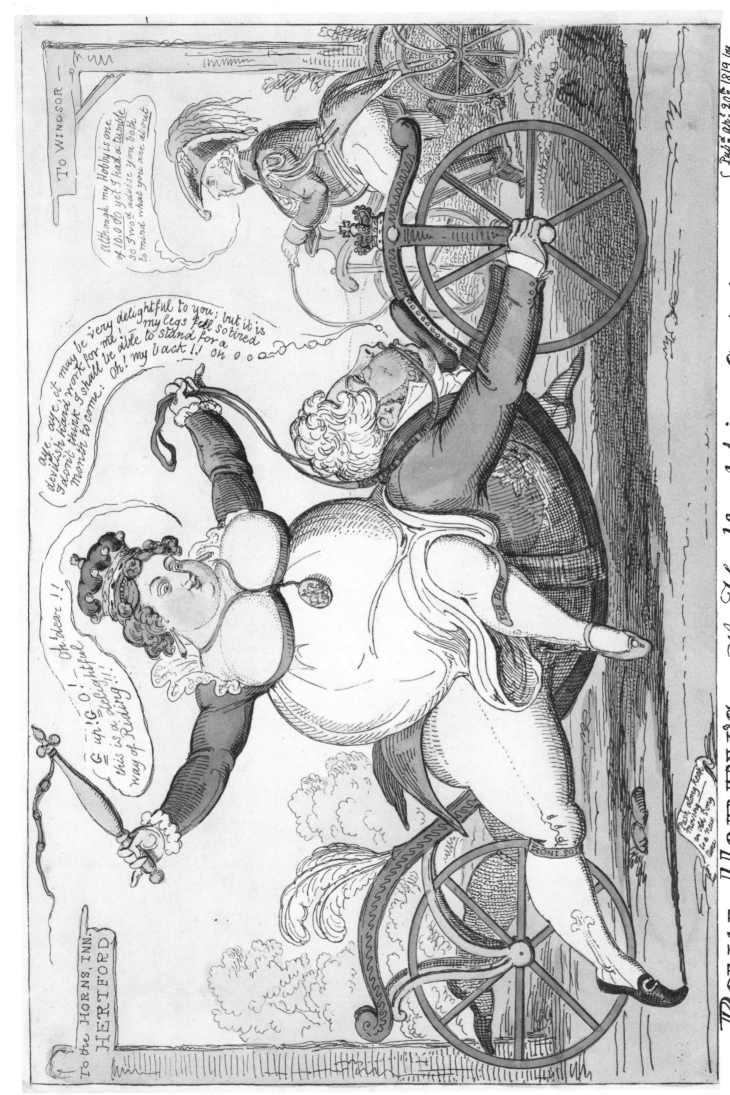

11. The Prince Regent, Lady Hertford, and the Duke of York [20 April 1819].

11

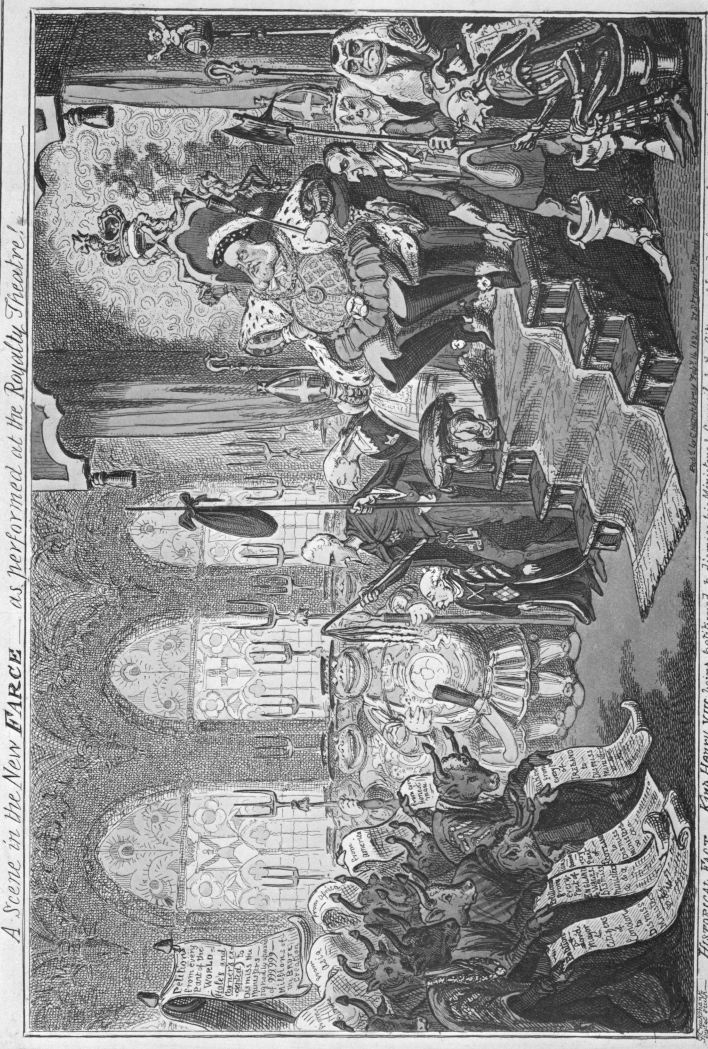

**12.** King George IV, in the guise of Henry VIII, rebuffs the London citizenry [14 February 1821].

12

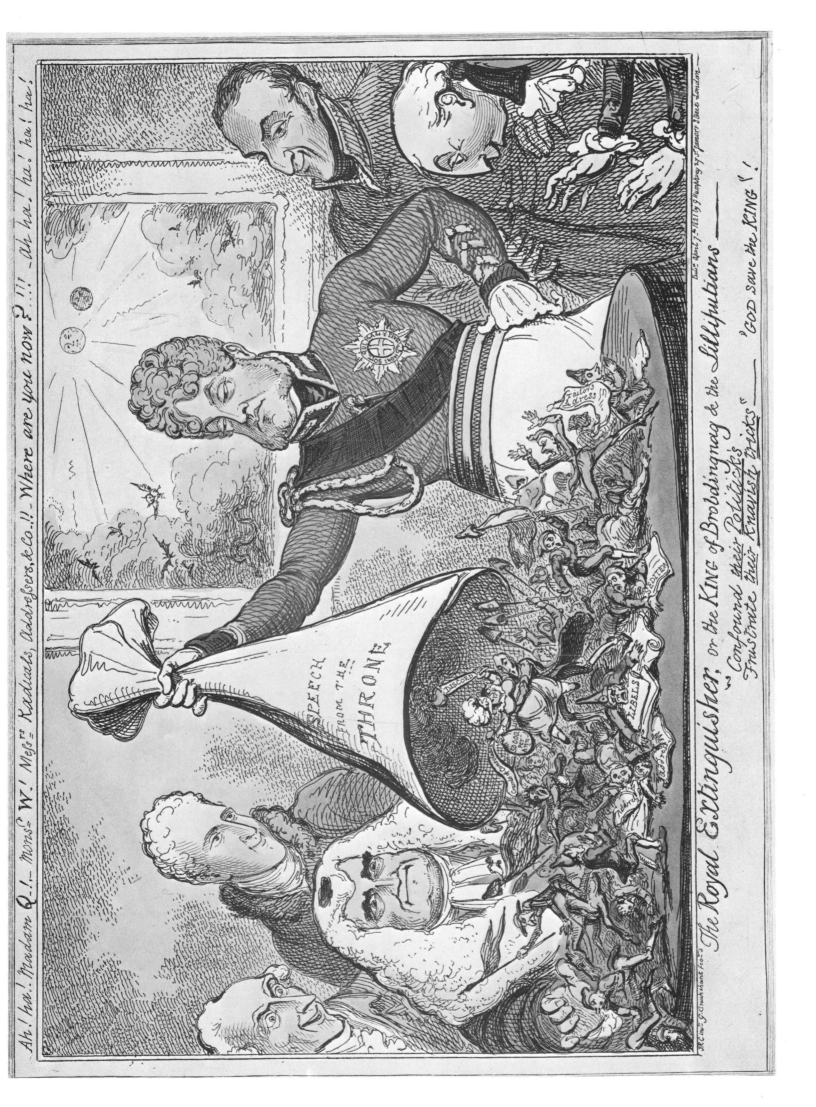

13. George IV snuffing out the pretensions of Queen Caroline [7 April 1821].

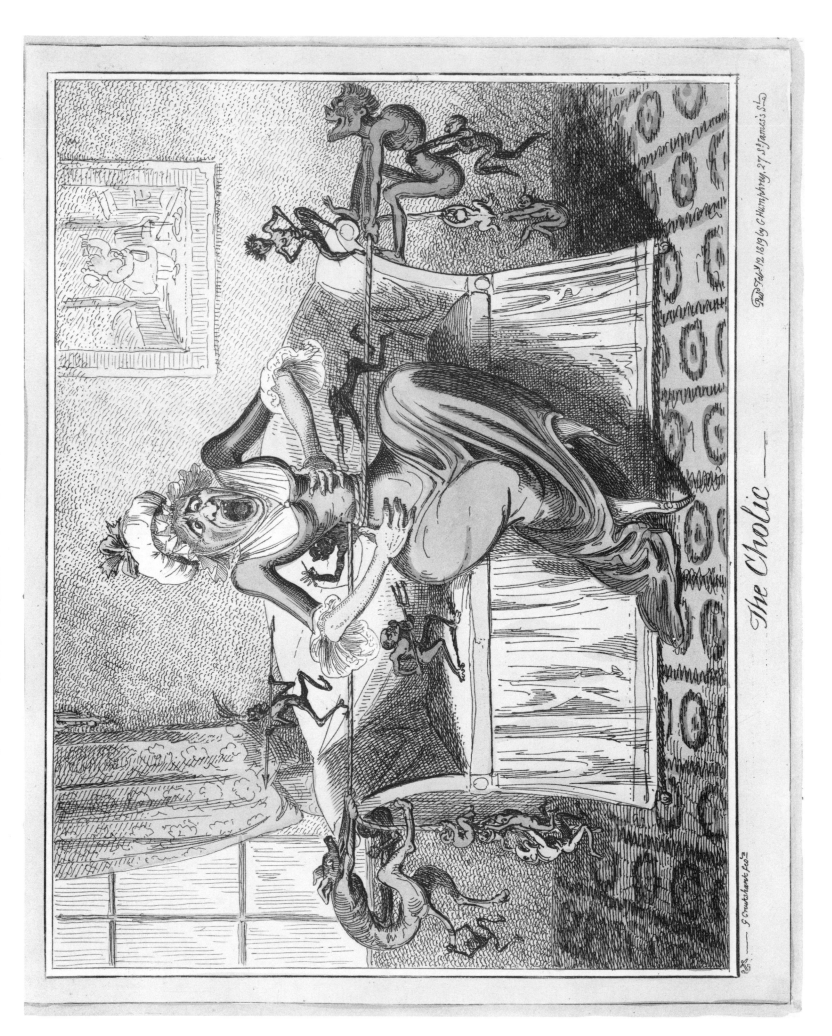

14. A medical caricature, after Captain Francis Marryat [12 February 1819].

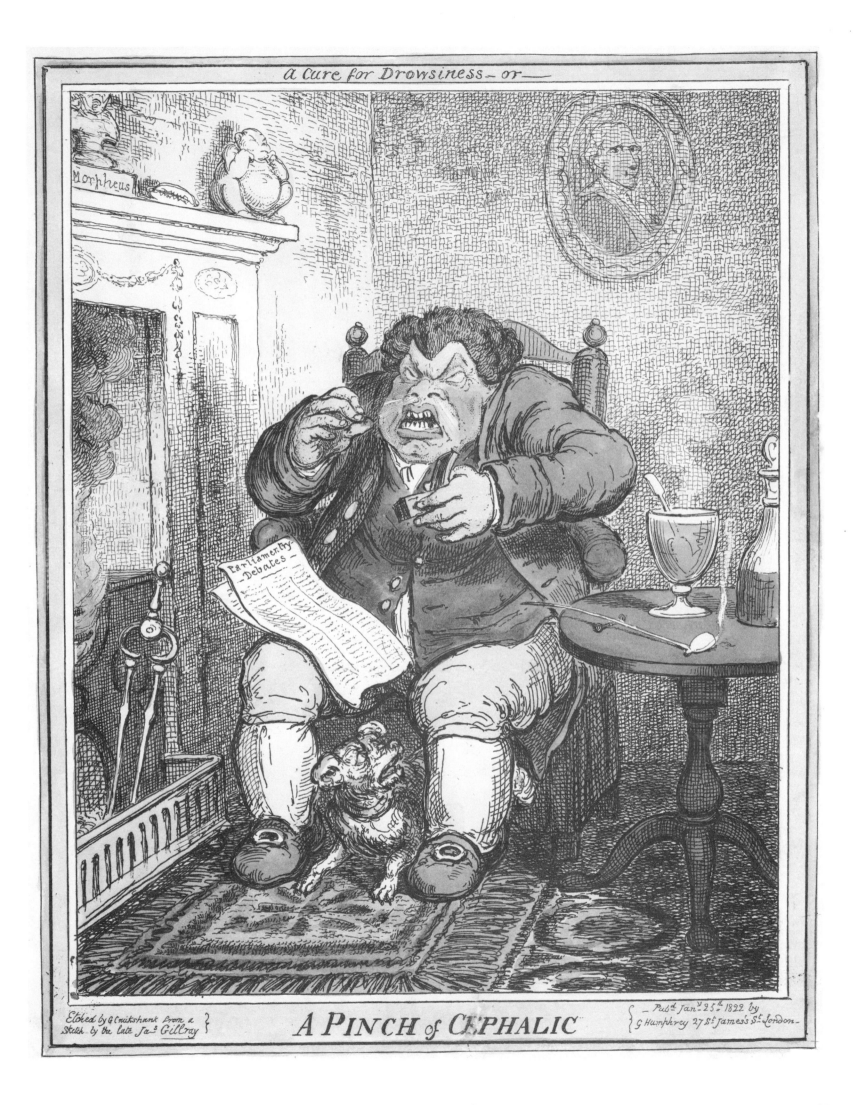

A Cure for Drowsiness _ or _

Morpheus

Parliamentry Debates

Etched by G Cruikshank from a
Sketch by the late Jas Gillray

A PINCH of CEPHALIC

Pubd Janry 25th 1822 by
G Humphrey 27 St James's St London

**15.** A medical print, after James Gillray [25 January 1822].

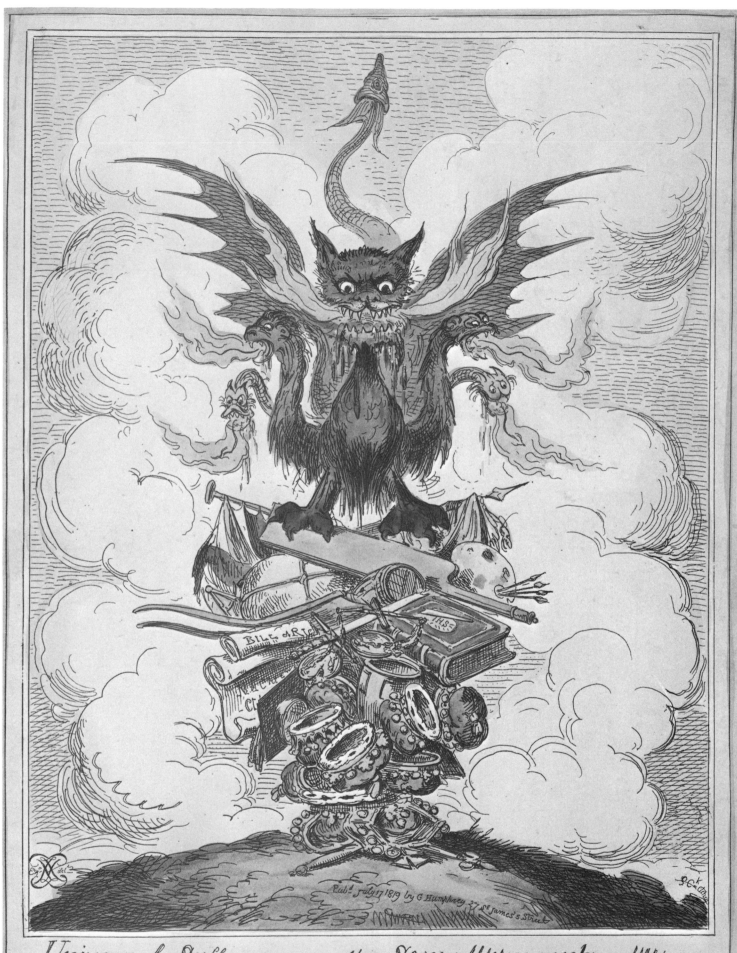

*Universal Suffrage. or— the Scum Uppermost ___!!!!!*

*an Allegory, to demonstrate the fatal consequences of "Radical Reform"*
*in plain English REVOLUTION _____*

**16.** An antiradical argument [17 July 1819].

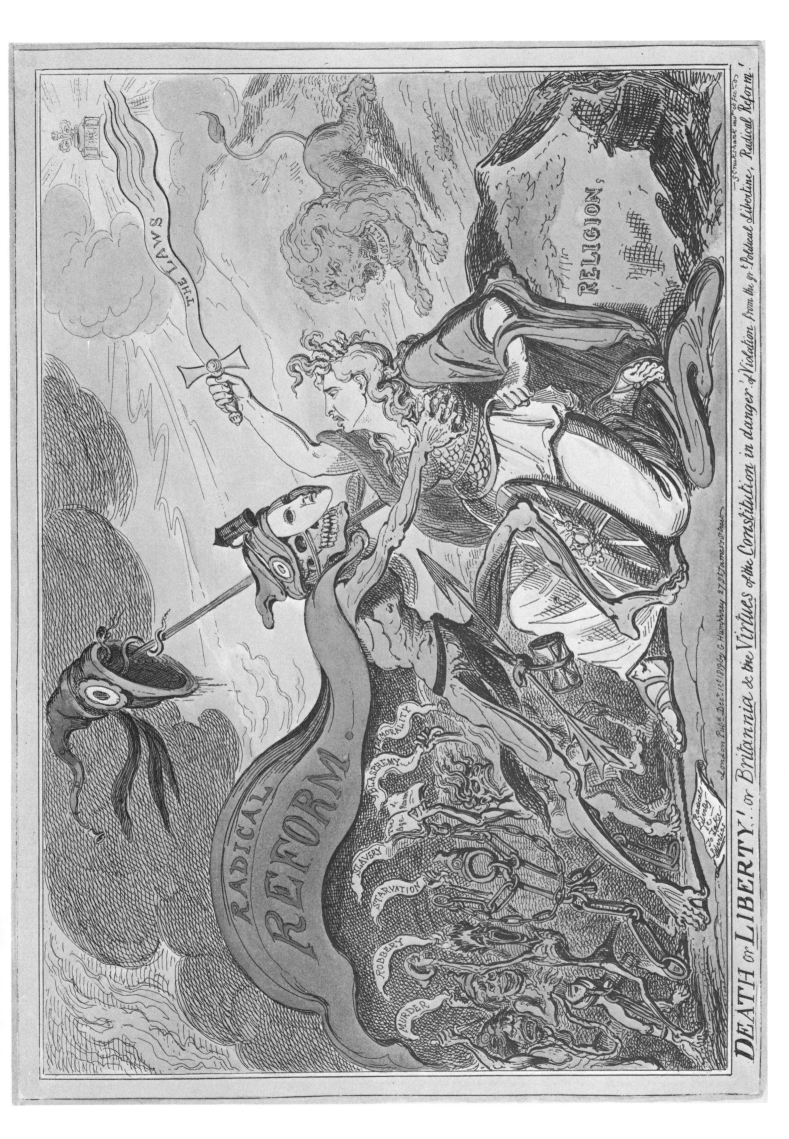

DEATH or LIBERTY! or Britannia & the Virtues of the Constitution in danger of Violation from the gr.t Political Libertine, Radical Reform!

17. The peril of changing the British constitution [1 December 1819].

17

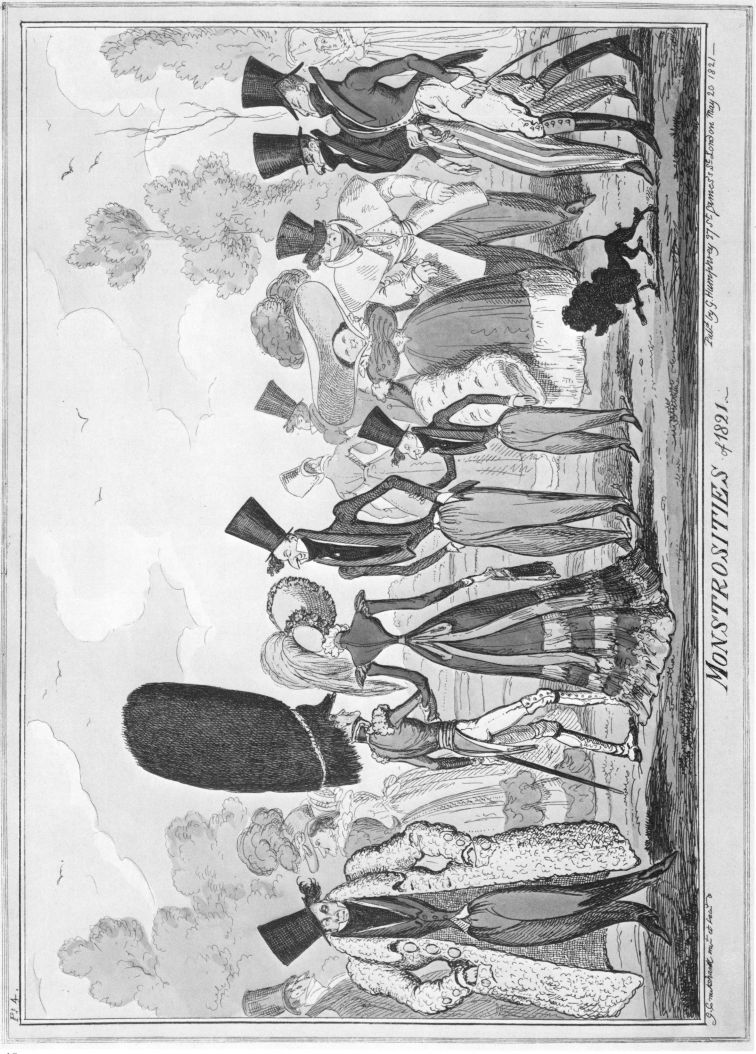

MONSTROSITIES of 1821.—

Pub.d by G. Humphrey 27 S.t James's S.t London May 20 1821.—

**18.** A satire on current fashions [20 May 1821].

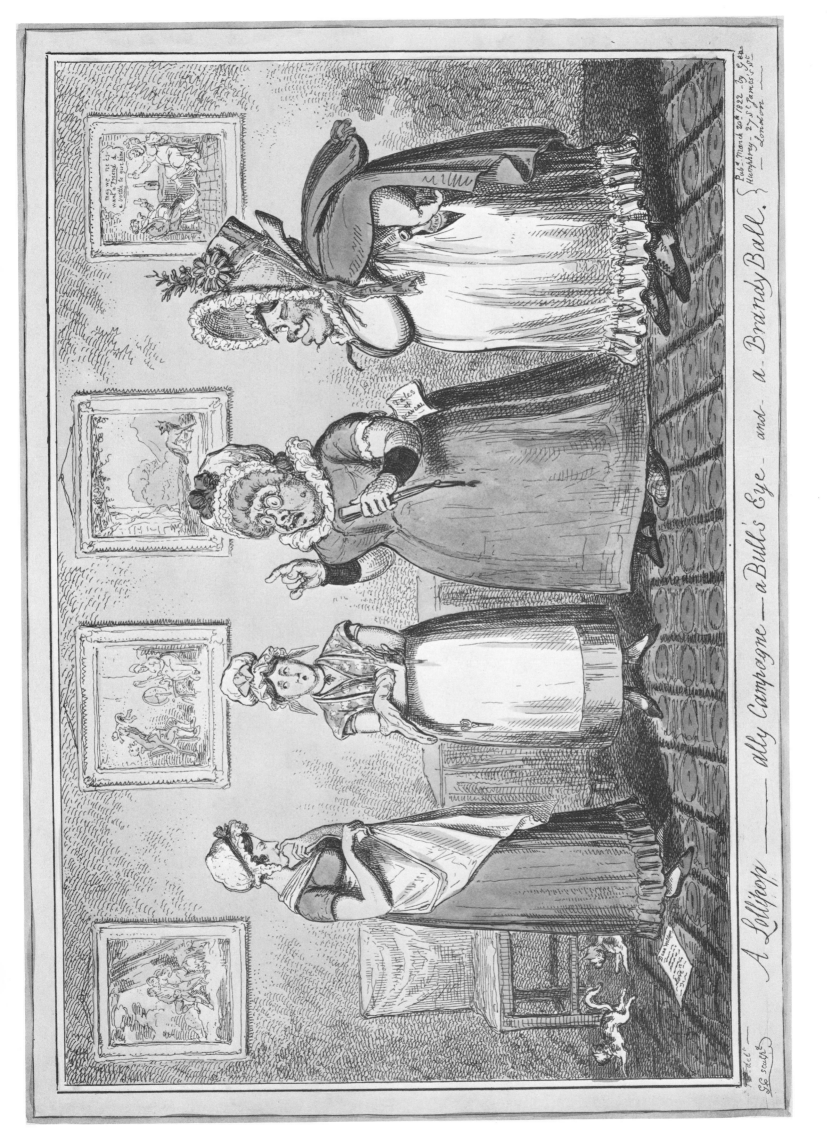

19. An unwed mother, a virtuous rural woman, a reproachful old maid, and an abortionist [20 March 1822].

19

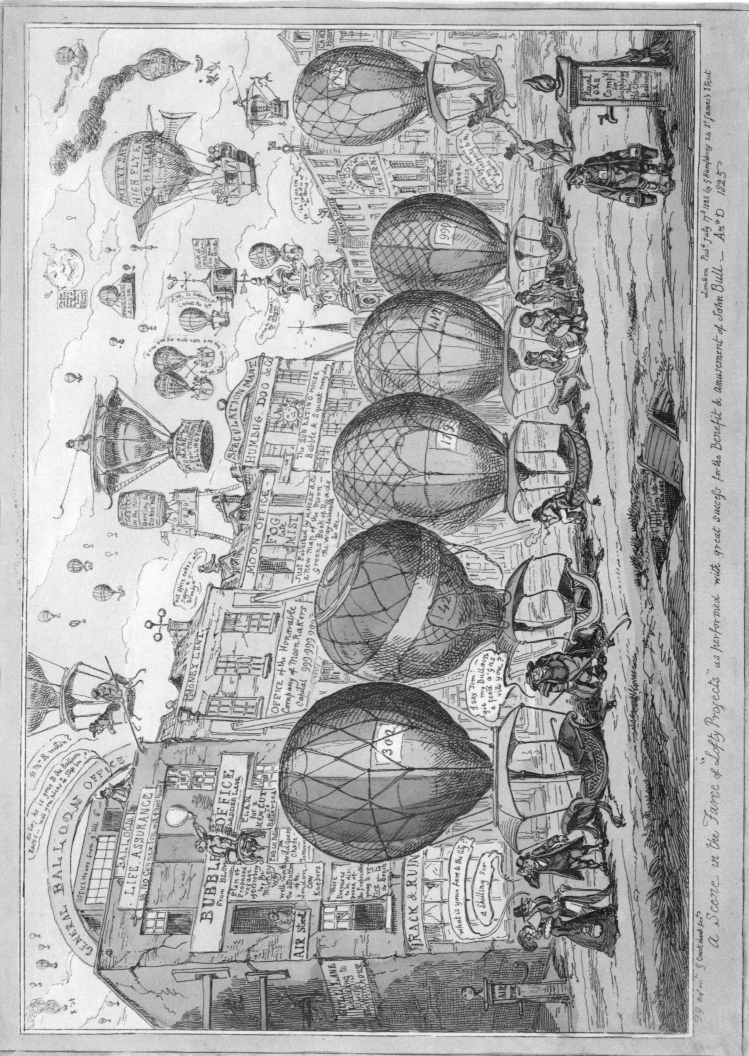

**20.** A satire on stock-market speculation [17 July 1825].

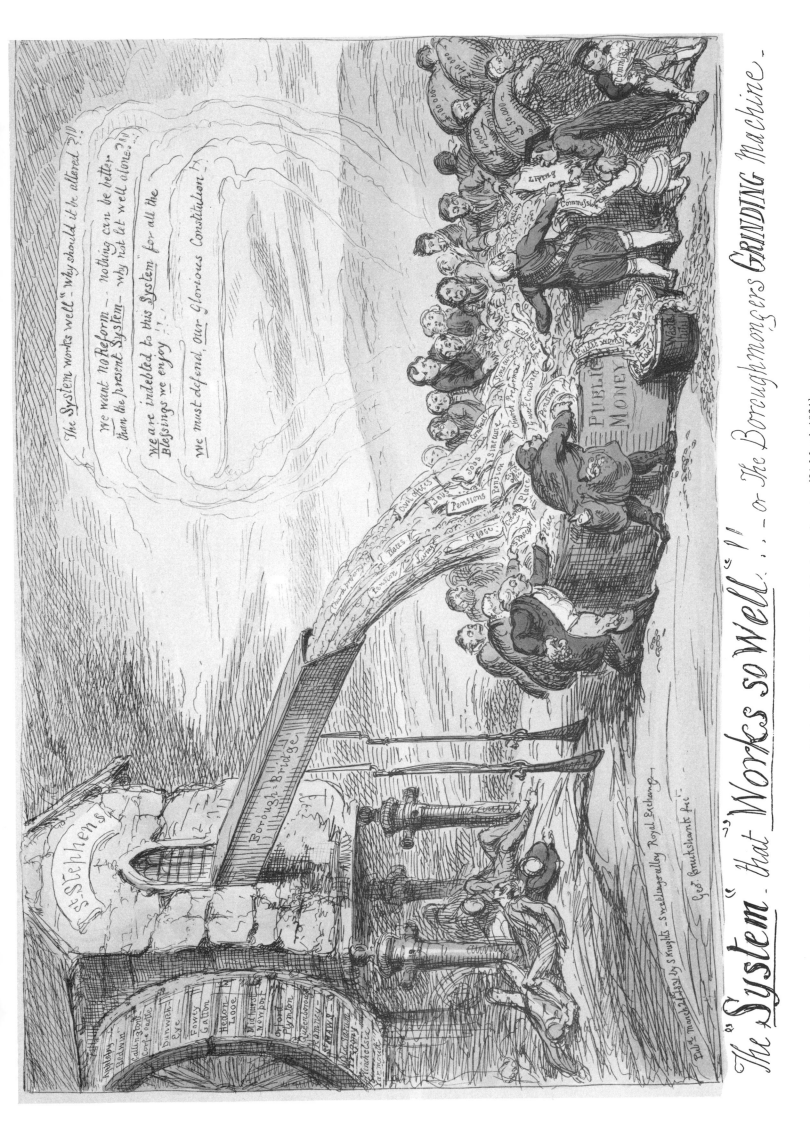

21. An attack on the defenders of the borough system [21 March 1831].

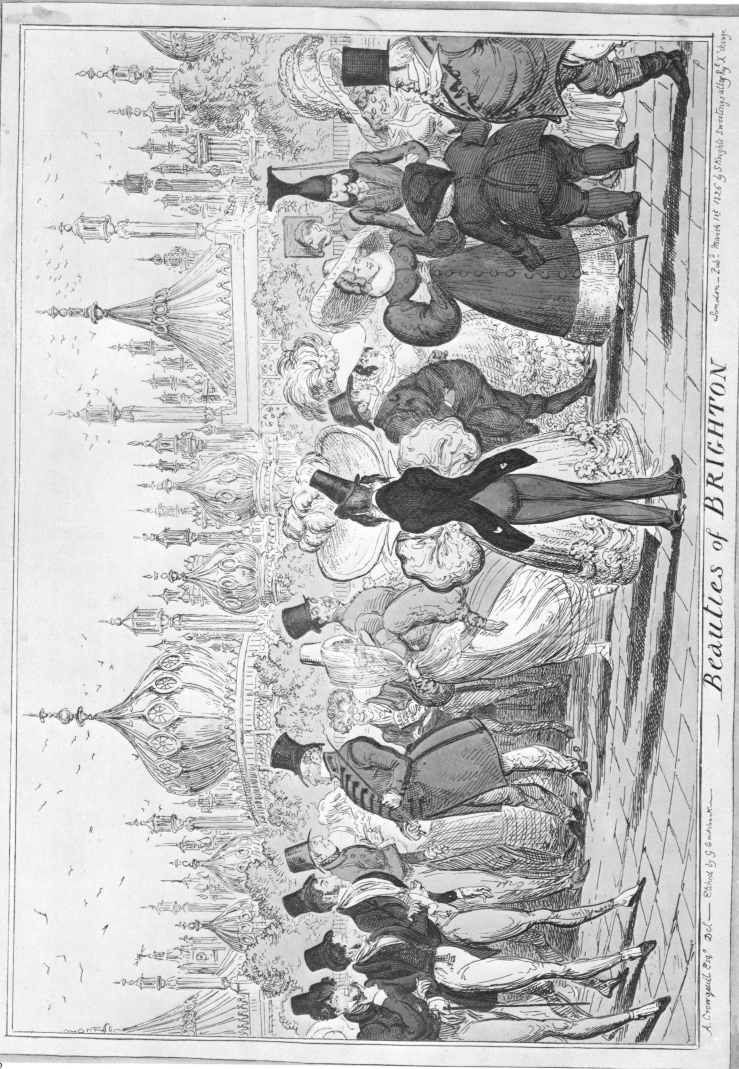

A. Cromwell Esq.r Del.t — Etched by G G mutrin N.c — Beauties of BRIGHTON — London. Pub.d March 1st 1826 by S Knights Sweetings Alley R.l X change

**22.** Promenaders outside the Brighton Pavilion [1 March 1826].

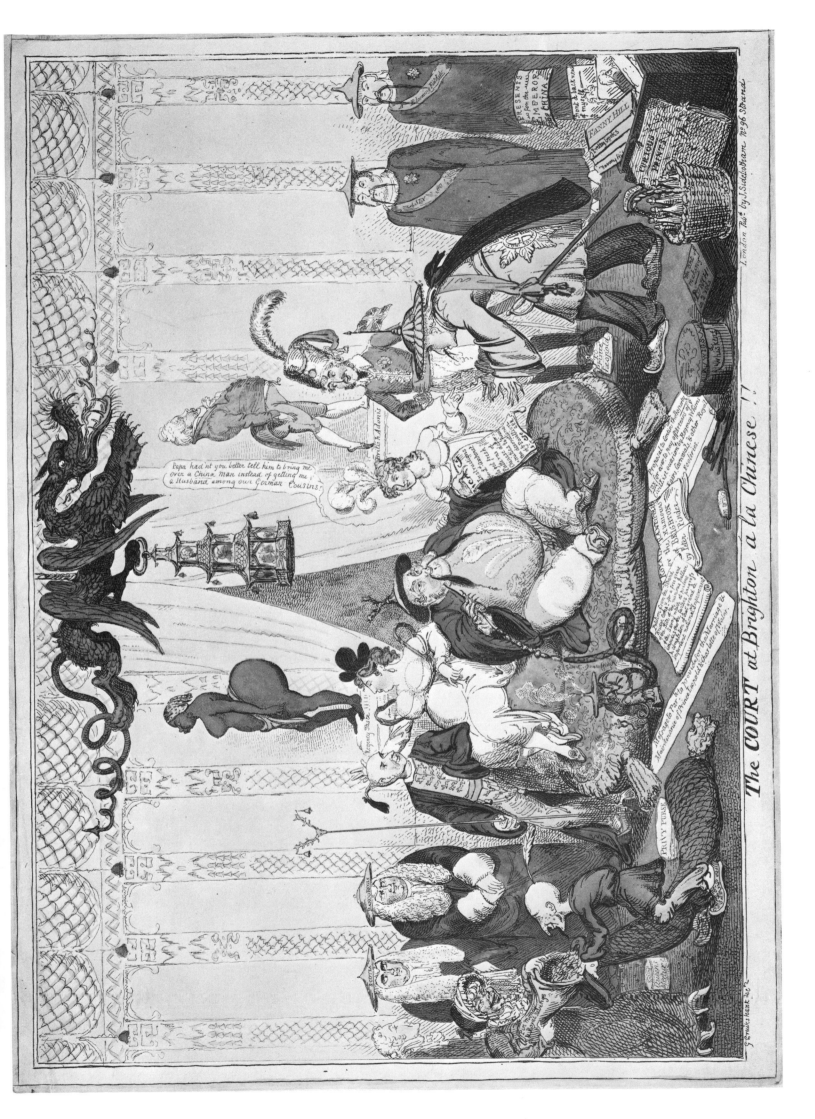

23. George IV and his entourage inside the Pavilion [March 1826].

23

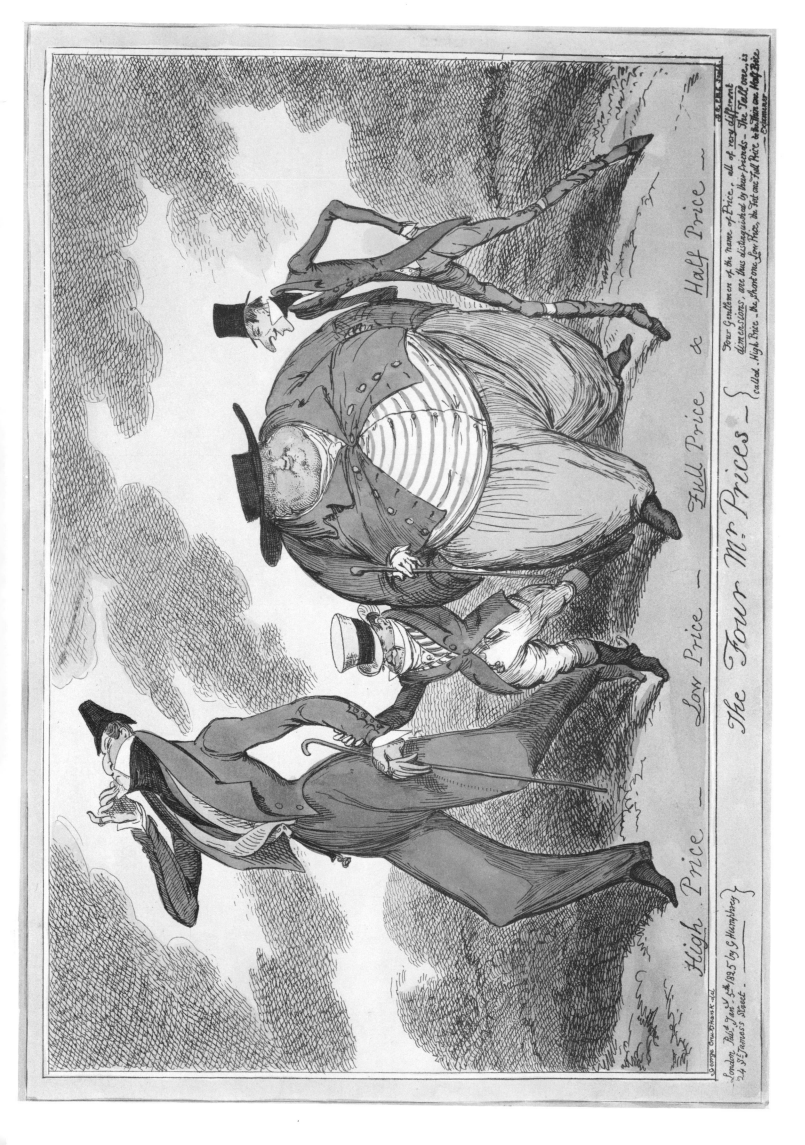

High Price — Low Price — Full Price & Half Price —

The Four Mr. Prices —

Four Gentlemen of the name of Price, all of very different dimensions, are thus distinguished by their friends — The Tall one, is called. High Price .— the Short one Low Price, to the Thin one. Half Brice — Colman

London, Pub.d Jan.y 5.th 1825 by G Humphrey 24 St James's Street.

24. A satire on fluctuating prices in an unstable economy [5 January 1825].

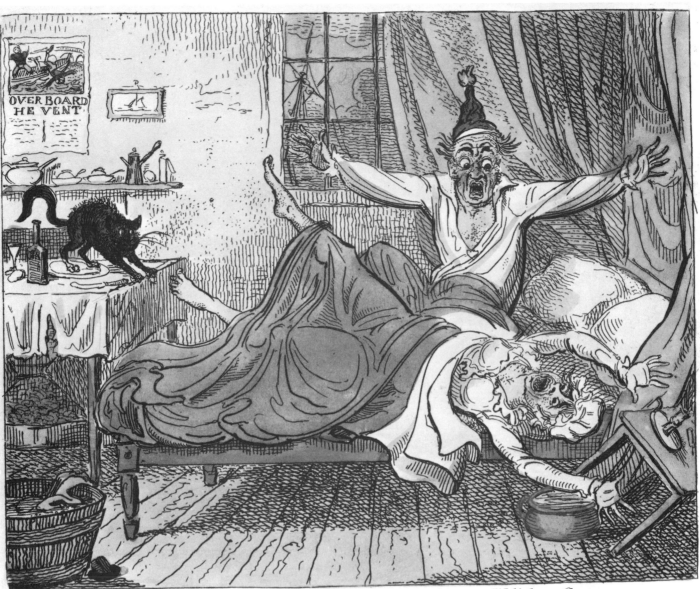

Sung by Mr. Norman, at the Royalty Theatre, Well Street, Wellclose Square.

## A New Song.
# MRS. TOPPER'S DREAM;
### OR,
### OVERBOARD SHE VENT.

*Written expressly for the Occasion, by Scriblerus Horselydownus.*

After vashing hard vun day,
Mrs. Topper vent to bed,
But as there she snoring lay,
Horrid Wisions fill'd her head;
She thought she saw a Ghost all vite,
By her vicked nephew sent,
Holding in his hand a light,
And singing—Right fol de ri di dol,
    Over board she vent !!

The ugly Ghost he look'd so grim,
His eyes as red as ferret's vere,
He swore " that she must go with him,"
And caught her screaming by the hair,

His vicked purpose he declares
He said to duck her he was bent,
And as he flew to Fountain Stairs,
Kept singing—Right fol de ri di dol,
    Over board she vent !!

Mrs. Topper bawl'd most stout,
Lord have mercy on my soul,
And struggling threw her arms about,
Vich struck Ned Topper on his pole,
Who jumping upright in his bed,
Poor spousey such a sender lent,
That rolling heels up over head,
And kicking.—Right fol de ri di dol,
    Out of bed she vent !!!

Entered at the Stamp-Office
and Stationers'-Hall.

Printed and published by Joseph Robins,
57, Tooley Street, Southwark.

25. Mrs. Topper's Dream; or, Overboard She Vent (illustrated song sheet).

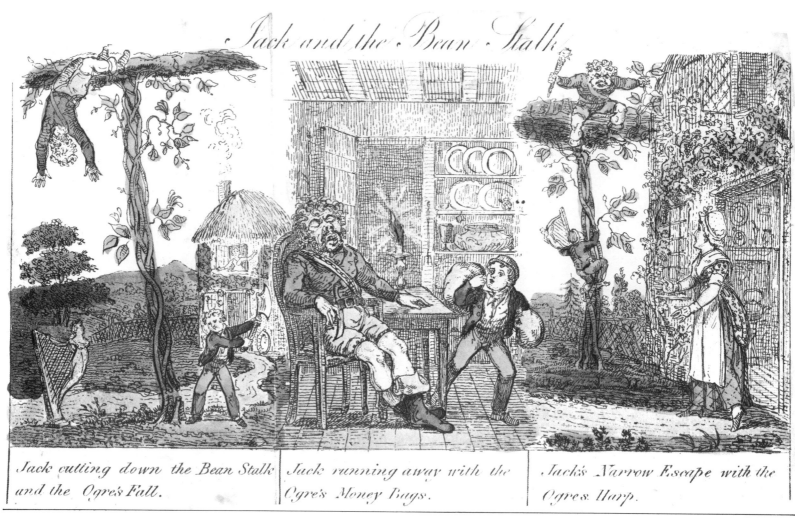

| Jack cutting down the Bean Stalk and the Ogre's Fall. | Jack running away with the Ogre's Money Bags. | Jack's Narrow Escape with the Ogre's Harp. |

26

## MOTHER GOOSE.

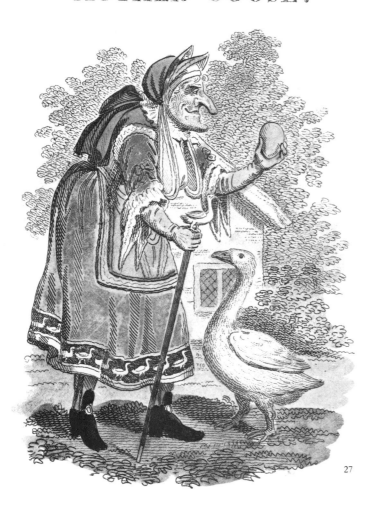

27

| 1 | The Wheel containing the Numbers | 9 | The Commissioner to check that the right Number is proclaimed |
| 2 | The Wheel containing the Prizes | 10 | The Commissioner to check that the right Prize is proclaimed |
| 3 | The Proclaimer of the Numbers | 11 | The President who knocks with his hammer when a Number is to be drawn |
| 4 | The Proclaimer of the Prizes | | |
| 5 | The Blue-coat Boy who draws the Numbers | 12 & 13 | The Two Commissioners who file the Numbers and Prizes as they are drawn |
| 6 | The Blue-coat Boy who draws the Prizes | | |
| 7 | The Commissioner to watch the Drawing of the Numbers | 14 | The Commissioners' Clerks who take down the Numbers as they are drawn. |
| 8 | The Commissioner to watch the Drawing of the Prizes | | |

28

**26.** Frontispiece to *The Surprising History of Jack and the Beanstalk*. **27.** Frontispiece to *Harlequin and Mother Goose, or the Golden Egg*. **28.** Exact Representation of Drawing the State Lottery.

## MOTHER GOOSE.

## THE CAT AND THE BOOT;
### OR, AN IMPROVEMENT UPON MIRRORS.

As I one morning shaving sat,
  For dinner time preparing,
A dreadful howling from the cat
  Set all the room a staring!
Sudden I turn'd—beheld a scene
  I could not but delight in,
For in my boot, so bright and clean,
  The cat her face was fighting.
Bright was the boot—its surface fair,
  In lustre nothing lacking;
I never saw one half so clear,
  Except by WARREN's BLACKING.
(WARREN! that name shall last as long
  As beaus and belles shall dash on,
Immortalized in every song
  That chants the praise of fashion:
For, oh! without his *Blacking,* all
  Attempts we may abolish,
To raise upon our boots at all
  The least of jet or polish.)
Surpris'd its brilliancy I view'd
  With silent admiration;
The glass that on the table stood
  Waxed dimly on its station.
I took the boot, the glass displac'd,
  For soon I was aware,
The latter only was disgrac'd
  Whene'er the boot was near.
And quickly found that I could shave,
  Much better by its bloom,
Than any mirror that I have
  Within my drawing-room.
And since that time, I've often smil'd
  To think how puss was frighten'd,
When at the boot she tugg'd and toil'd
  By WARREN's *Blacking* brighten'd.

### POMP.

### QUEEN.

Advertisements for shoe polish. 29. Pomp. / Queen. 30. The Cat and the Boot. 31. Mother Goose.

32–34. Lottery puffs.

# Fortune's Ladder,

*(TO BE READ FROM THE BOTTOM.)*

The drift of this Ladder to well comprehend, /320
Take a Paddy's advice, and *begin* at the *end*.

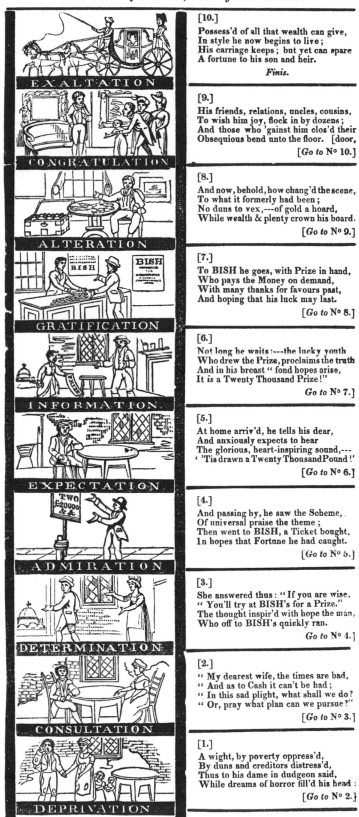

**[10.]**
Possess'd of all that wealth can give,
In style he now begins to live;
His carriage keeps; but yet can spare
A fortune to his son and heir.
*Finis.*

**[9.]**
His friends, relations, uncles, cousins,
To wish him joy, flock in by dozens;
And those who 'gainst him clos'd their door,
Obsequious bend unto the floor.
[*Go to* N° 10.]

**[8.]**
And now, behold, how chang'd the scene,
To what it formerly had been;
No duns to vex,---of gold a hoard,
While wealth & plenty crown his board.
[*Go to* N° 9.]

**[7.]**
To BISH he goes, with Prize in hand,
Who pays the Money on demand,
With many thanks for favours past,
And hoping that his luck may last.
[*Go to* N° 8.]

**[6.]**
Not long he waits :---the lucky youth
Who drew the Prize, proclaims the truth
And in his breast " fond hopes arise,
It *is* a Twenty Thousand Prize!"
*Go to* N° 7.]

**[5.]**
At home arriv'd, he tells his dear,
And anxiously expects to hear
The glorious, heart-inspiring sound,---
' 'Tis drawn a Twenty Thousand Pound!'
[*Go to* N° 6.]

**[4.]**
And passing by, he saw the Scheme,
Of universal praise the theme;
Then went to BISH, a Ticket bought,
In hopes that Fortune he had caught.
[*Go to* N° 5.]

**[3.]**
She answered thus : " If you are wise,
" You'll try at BISH's for a Prize."
The thought inspir'd with hope the man,
Who off to BISH's quickly ran.
*Go to* N° 4.]

**[2.]**
" My dearest wife, the times are bad,
" And as to Cash it can't be had;
" In this sad plight, what shall we do?
" Or, pray what plan can we pursue?"
[*Go to* N° 3.]

**[1.]**
A wight, by poverty oppress'd,
By duns and creditors distress'd,
Thus to his dame in dudgeon said,
While dreams of horror fill'd his head :
[*Go to* N° 2.]

# BISH, CONTRACTOR FOR ANOTHER LOTTERY,

To be all drawn in Two Days, 5th and 18th OCTOBER.—Two of £20,000,—Two of £10,000, &c.—All Sterling Money.—All the 4,500 Tickets drawn the First Day are sure to be Prizes—Two of £10,000 in the first Fifteen Minutes.—Only 7,600 Tickets.

Tickets and Shares are selling by BISH, Contractor, London,
**AND BY HIS AGENTS IN THE COUNTRY.**

35

# HOW To grow Fat.

*A DIALOGUE.*

BE pleas'd, good sir, to make it known
How 'tis that you're so lusty grown?

I once, sir, was as lean as you;
And you may be as lusty too.

Ah! tell me how? no pains I'd spare
If such good Fortune I could share.

The road is easy,—mark me well;
The secret I'm about to tell!

My talking shall be no detention;—
Proceed, good sir, I'm all attention.

You see that House at Charing-Cross,
Where sits King Charles upon his Horse?—

'Tis BISH's house—I know it well!—
The sequel I begin to smell.

You know his other in Cornhill?—
'Tis there you'll get a golden pill.

Your news has set my heart a dancing,
So off to BISH's I'll be prancing.

I'll take your arm,—birds of a feather,
You know, should always flock together.

With all my heart !—and he's a flat
Who'd scorn the method to grow fat.

36

38

—— "Great offices will have
Great talents."

This is THE MAN—all shaven and shorn,
All cover'd with Orders—and all forlorn;

37

" Once enslaved, farewell !

Do I forbode impossible events,
And tremble at vain dreams ? Heav'n grant I may !"

THIS IS

THE THING,

that in spite of new Acts,

And attempts to restrain it,

by Soldiers or Tax,

Will *poison* the Vermin,

That plunder the Wealth,

That lay in the House,

That Jack built.

37 & 38. From *The Political House that Jack Built.*

PRINTED BY WILLIAM HONE,
LUDGATE HILL, LONDON.
Price (with the Pamphlet) One Shilling.

THE QUEEN'S
MATRIMONIAL LADDER

# THE QUEEN'S
# MATRIMONIAL LADDER,

## A National Toy,

WITH FOURTEEN STEP SCENES;

AND

ILLUSTRATIONS IN VERSE,

WITH EIGHTEEN OTHER CUTS.

BY THE AUTHOR OF "THE POLITICAL HOUSE THAT
JACK BUILT."

The question is not merely whether the Queen shall have her rights, but whether the rights
of any individual in the kingdom shall be free from violation."

*Her Majesty's Answer to the Norwich Address.*

" Here is a Gentleman, and a friend of mine!"

*Measure for Measure.*

## Forty-third Edition.

LONDON:

PRINTED BY AND FOR WILLIAM HONE, LUDGATE-HILL.

1820.

This Pamphlet and the Toy together,
ONE SHILLING.

From *The Queen's Matrimonial Ladder.* 39. Title page of the pamphlet. 40. The "toy."

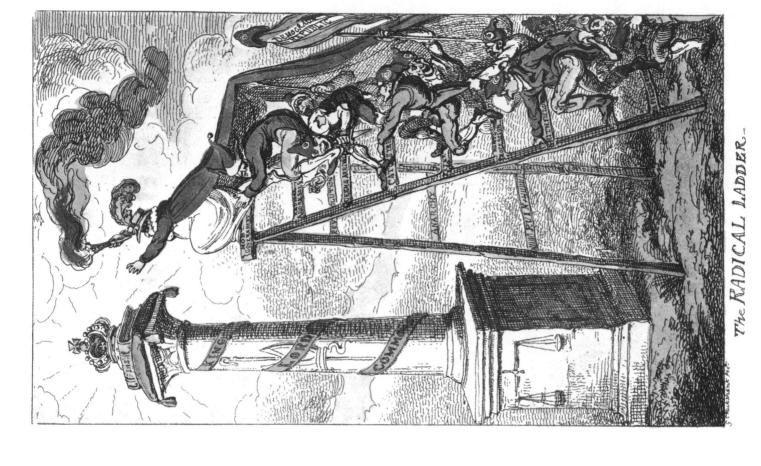

QUALIFICATION.

Give not thy strength unto women, nor thy ways to that which destroyeth kings.
*Solomon.*

In love, and in drink, and o'ertoppled by debt;
With women, with wine, and with duns on the fret.

**41.** From *The Queen's Matrimonial Ladder.* **42.** Frontispiece to *The Radical Ladder.*

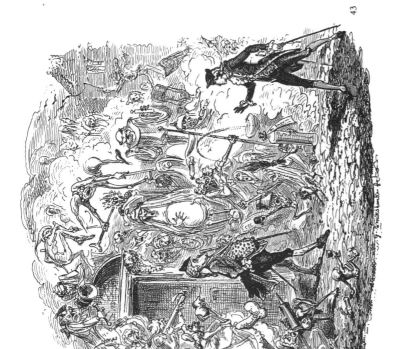

"We twa hae paidl't"—

BURNS.

OUR LIBRARY TABLE

**43 & 44.** Illustration and tailpiece from *Points of Humour*. **45.** Title-page illustration from *Facetiae and Miscellanies* (the artist with William Hone). **46.** Our Library Table (the artist with William H. Ainsworth).

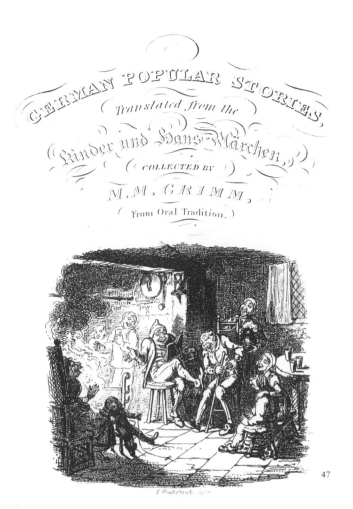

GERMAN POPULAR STORIES,
*Translated from the*
*Kinder und Hans-Märchen,*
COLLECTED BY
M. M. GRIMM,
*From Oral Tradition.*

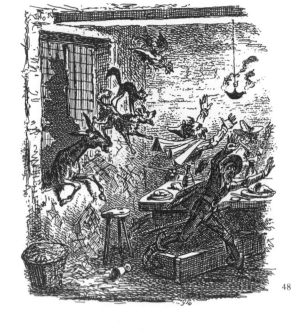

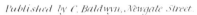
*Published by C. Baldwyn, Newgate Street.*

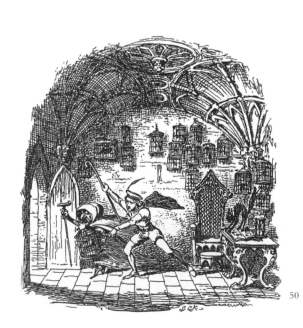

From *German Popular Stories* by the Brothers Grimm. **47.** Title page of Volume I. **48.** The Traveling Musicians or the Waits of Bremen. **49.** The Golden Bird. **50.** Jorinda and Jorindel.

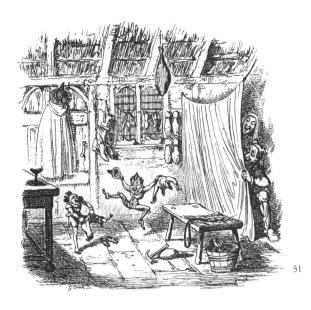

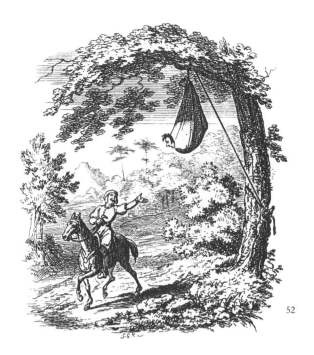

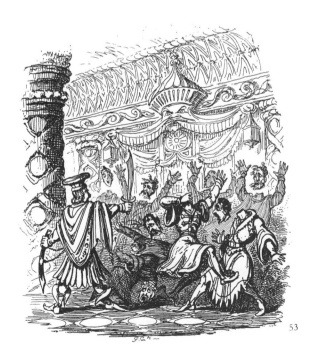

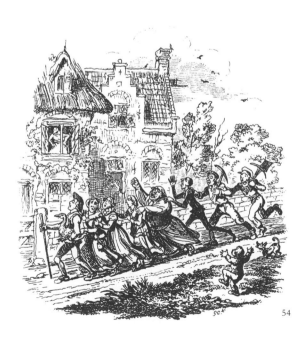

From *German Popular Stories.* **51.** The Elves and the Shoemaker. **52.** The Turnip.
**53.** King of the Golden Mountain. **54.** The Golden Goose.

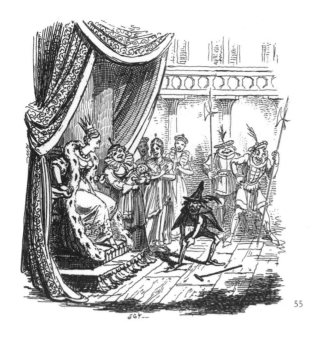

GERMAN POPULAR STORIES,

Translated from the

Kinder und Haus-Märchen,

COLLECTED BY

M. M. GRIMM,

From Oral Tradition.

VOL. II.

JAMES ROBINS & Cᵒ LONDON.

AND

JOSEPH ROBINS JUNᴿ & Cᵒ DUBLIN.

MDCCCXXVI.

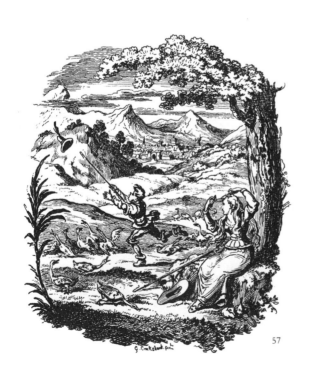

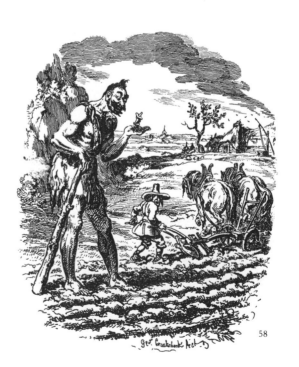

From *German Popular Stories.* **55.** Rumpel-Stilts-Kin. **56.** Title page of Volume II.
**57.** The Goose-Girl. **58.** The Young Giant and the Tailor.

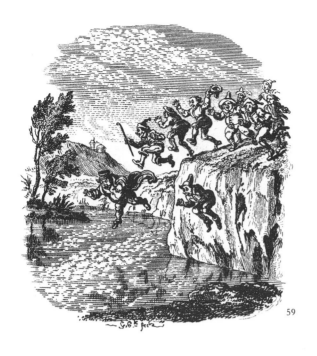

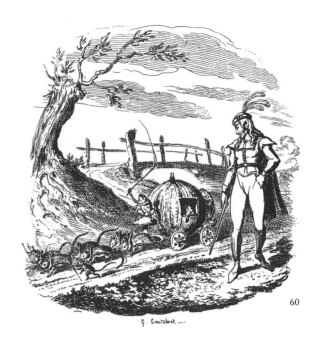

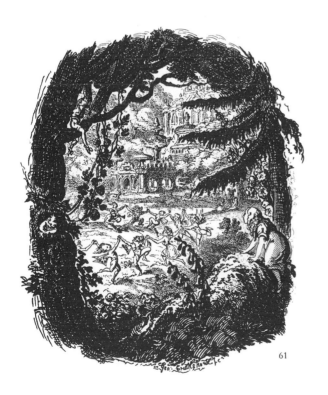

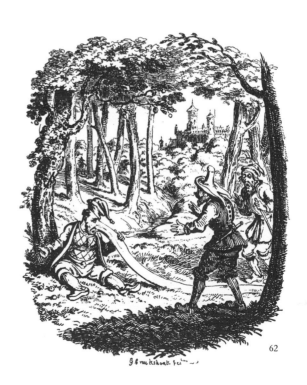

From *German Popular Stories*. **59**. Pee Wit. **60**. Cherry, or the Frog-Bride. **61**. The Elfin-Grove. **62**. The Nose.

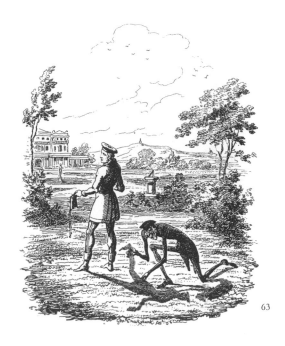

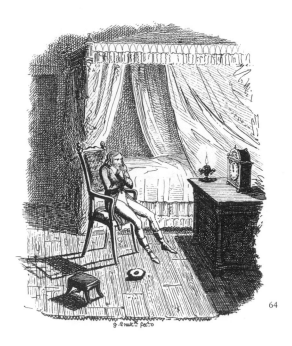

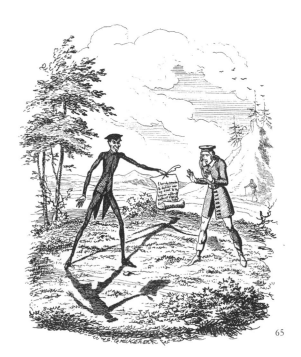

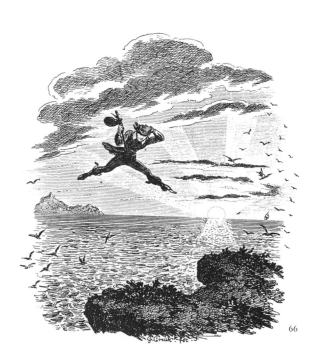

From Chamisso's *Peter Schlemihl*. **63.** Peter sells his shadow. **64.** The year of the bargain elapses. **65.** The compact for Peter's soul. **66.** Peter's flight through the world.

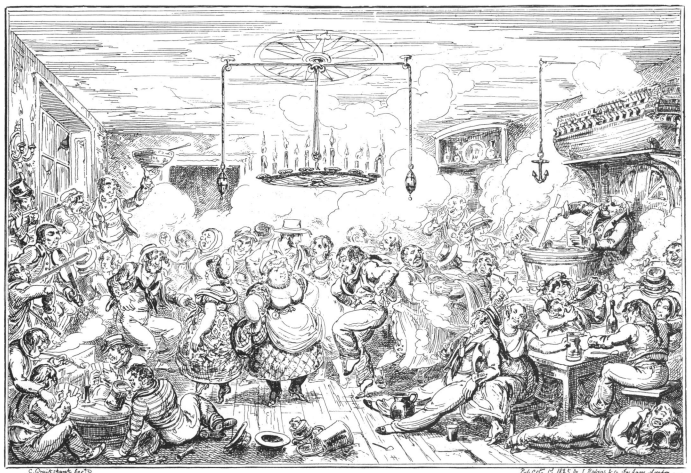

67

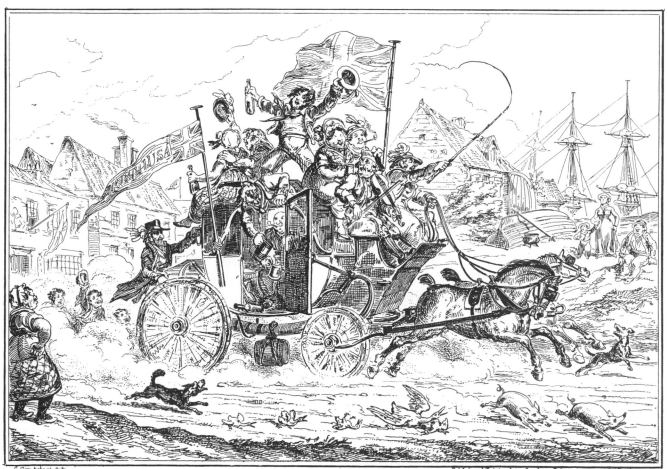

68

From *Greenwich Hospital* by M. H. Barker. **67.** Sailors Carousing, or a peep in the Long Room. **68.** Sailors on a Cruise.

From *Mornings at Bow Street* by John Wight. **69.** A Cool Contrivance. **70 & 71.** Cheap Dining. **72.** A Dun at Supper Time. **73.** Jonas Tunks. **74.** Pig Wit.

From *More Mornings At Bow Street* by John Wight. **75 & 76.** Flying Dustmen. **77 & 78.** Watching for Watches. **79.** Labour and Liberality. **80.** The Three Thimbles. **81.** Pig, Parkins, and Pipkinson. **82.** Tom the Gardener.

From *London Characters*. **83.** Old Clothes Man. **84.** Parish Beadle. **85.** Waterman.
**86.** Dustman.

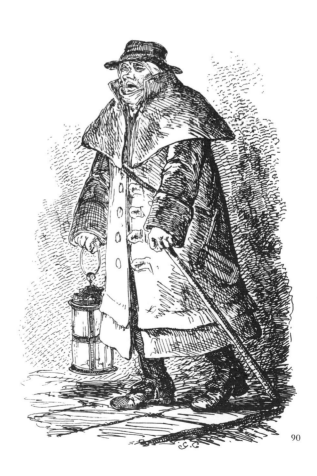

From *London Characters*. **87.** Stage Coachman. **88.** Hackney Coachman. **89.** Footman.
**90.** Watchman.

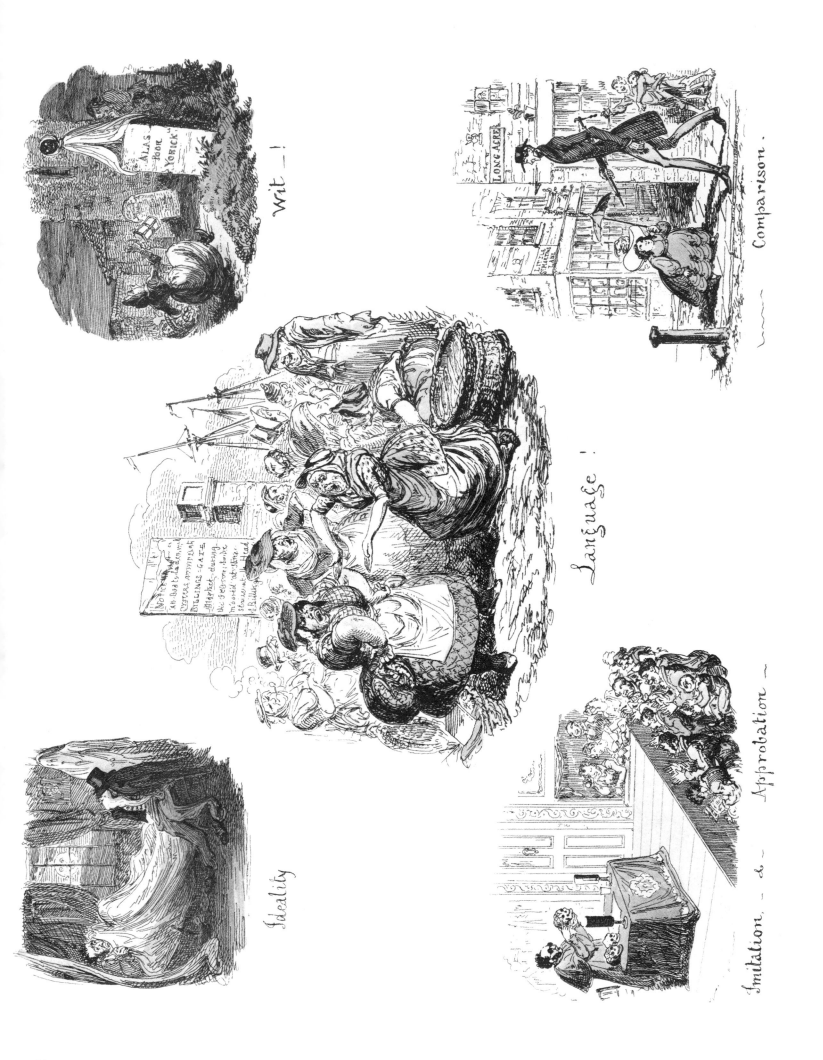

44

**91.** Folio from *Phrenological Illustrations*.

Hard Times

Term Time

Gentlemen – It was a very fine Oyster! the Court awards you a shell each.

Oh the Roast Beef of old England

BAKER

**92.** Folio from *Illustrations of Time*.

"How that I heard"

Tooth Powder —

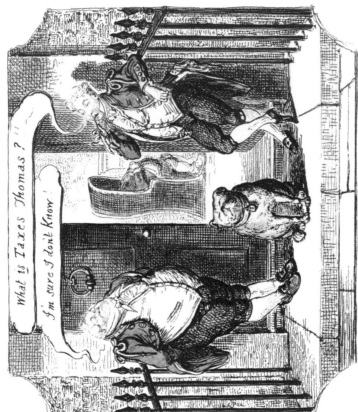

— Ignorance is bliss. —

Brobdignag Bonnet

All a blowing all a growing

93. Folio from Scraps and Sketches.

Gentility! —

A Jolly Companion —

46

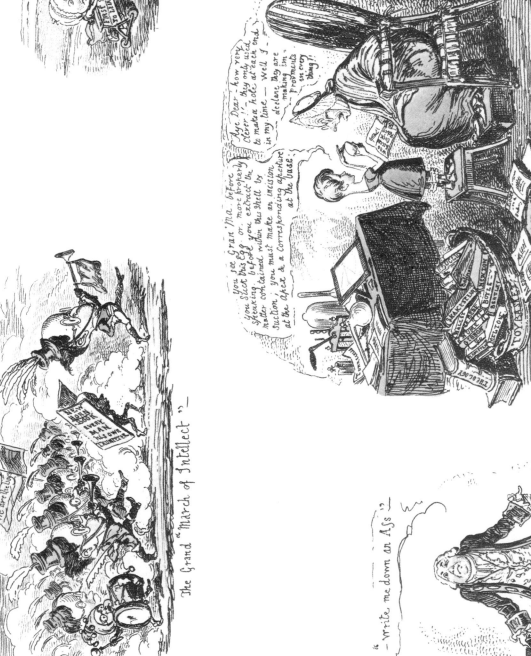

"The Pursuit of Letters" —

The Grand "March of Intellect" —

"The Age of Intellect."

"The Tutor's Assistant" —

One of the "Old School" —

A Man of Intelligence —
— "Useful Knowledge to the People" :—

**94.** Folio from *Scraps and Sketches.*

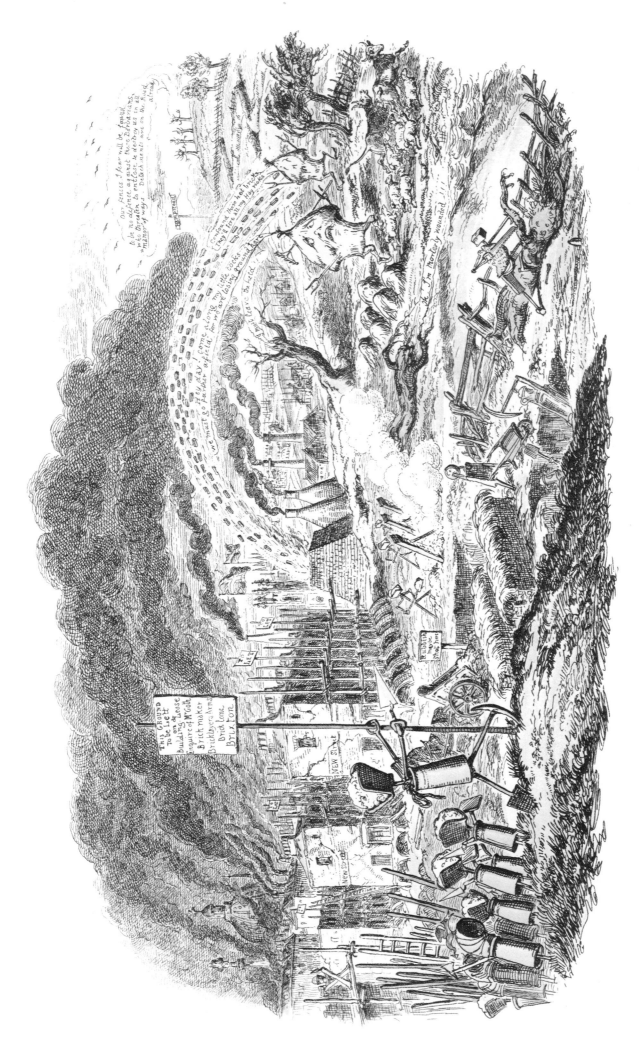

LONDON going out of Town — or — — The March of Bricks & Morter.

**95.** Folio from *Scraps and Sketches.*

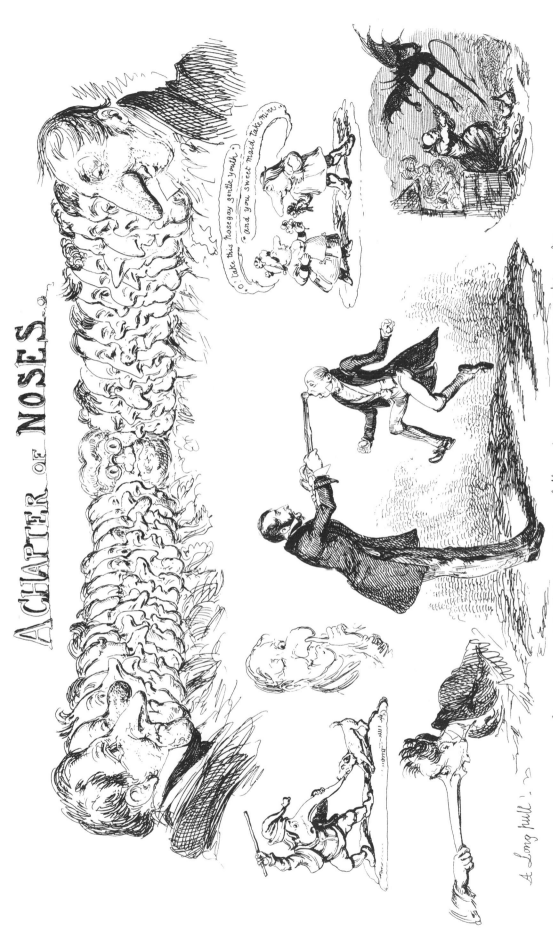

96. Folio from *My Sketch Book.*

From *Catalogue Raisonné of Select Collection of Engravings of An Amateur* by John Wilson. **97**. The Print Room in the British Museum. **98**. Connoisseurs at a Print Sale. **99**. Connoisseurs in a Print Shop. **100**. Connoisseurs at a Print Stall.

102

104

101

103

From Scott's *Letters on Demonology and Witchcraft.* **101.** The "Corps de Ballet." **102.** Elfin arrow manufactory. **103.** Fairy Revenge. **104.** Witches Frolic.

From *Three Courses and a Dessert* by William Clarke. **105.** Title-page vignette. **106.** The Counterpart Cousins. **107.** Timberleg Toe-Trap. **108.** Induction. **109.** The Native and Odd Fish. **110.** Caddy Cuddle. **111.** My Cousin's Clients.

From *Three Courses and a Dessert*. **112.** Bat Boroo. **113.** Under the Thumb. **114.** Wanted a Partner. **115.** Introduction to "The Dessert." **116.** The Mushroom. **117.** Adam Burdock. **118.** Tailpiece.

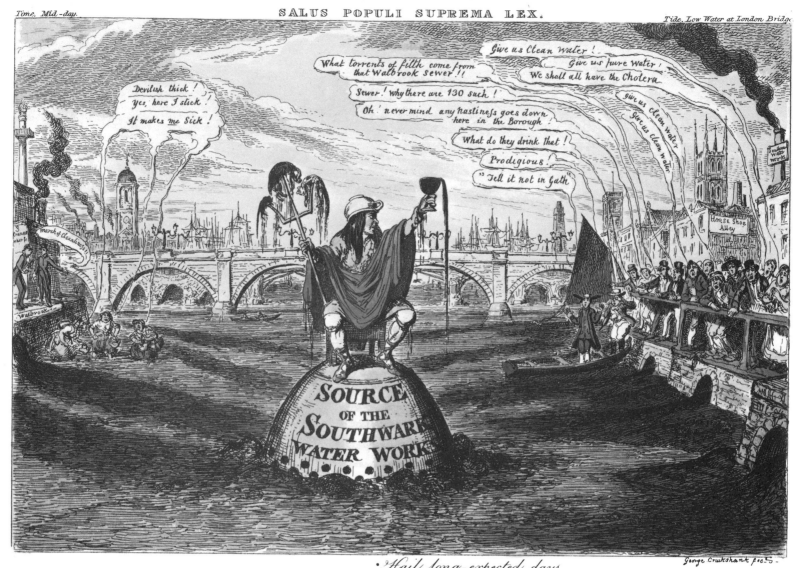

**119.** Royal Address of Cadwallader . . . (satire on polluted Thames water). **120 &**
**121.** From *Punch and Judy* by J. P. Collier: Mr. Punch; Punch and the Dog Toby.

N

*Nightmare*

123

O

*Orpheus*

124

**122.** The Voice of Humanity. **123 & 124.** From *Comic Alphabet*.

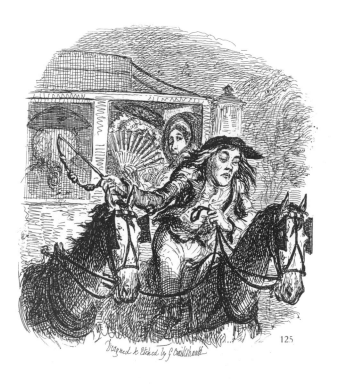

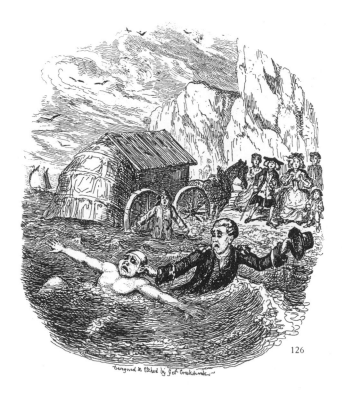

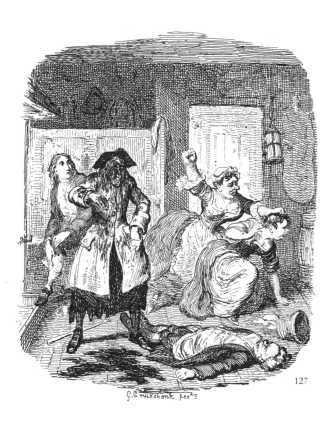

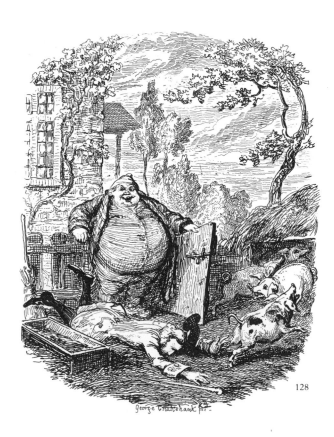

From *Roscoe's Novelist's Library*. **125 & 126.** From Smollett's *Humphrey Clinker:*
Humphrey's Introduction to the Bramble Family; Humphrey's zeal for his master. **127 &
128.** From Fielding's *Joseph Andrews:* Parson Adams & the Hog's puddings; Adam's visit
to Parson Trulliber.

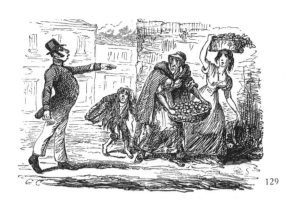

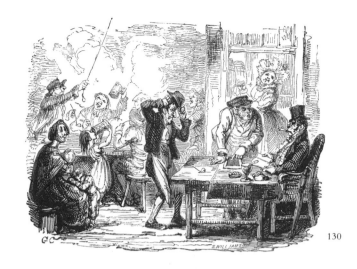

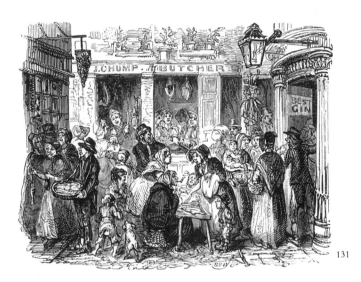

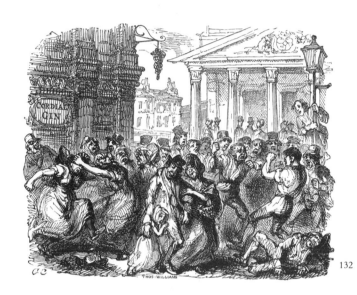

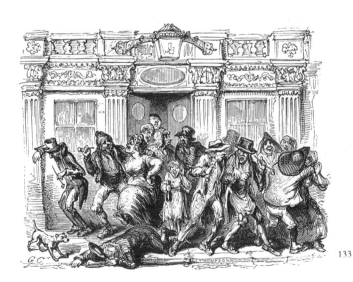

From *Sunday in London* by John Wight. **129.** Title-page vignette. **130.** The Pay-table. **131.** The Sunday Market. **132.** Cordial workings of the Spirit. **133.** Gin-temple turn-out at Church-time. **134.** "Miserable sinners!"

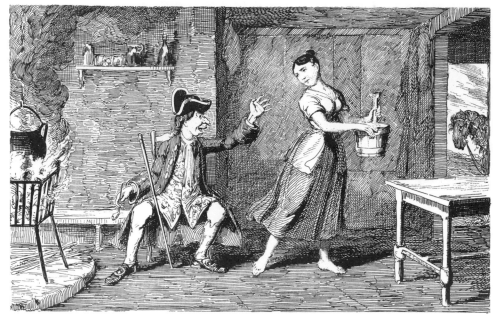

135

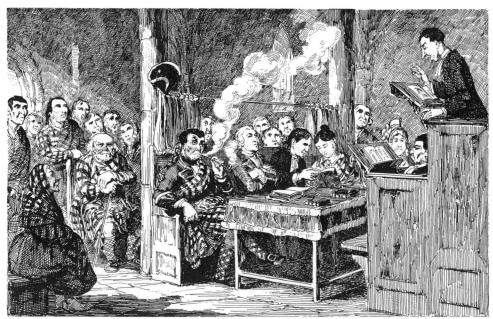

136

From Scott's *Waverley Novels*. **135 & 136.** From *The Heart of Midlothian:* "Jeanie—I say, Jeanie, woman"; The Captain of Knockdunder.

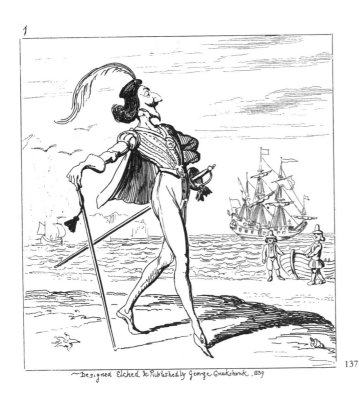

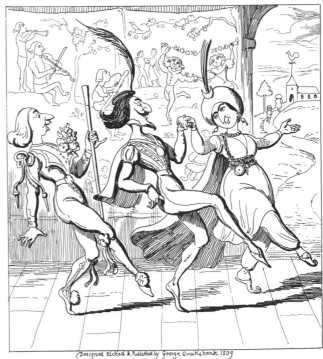

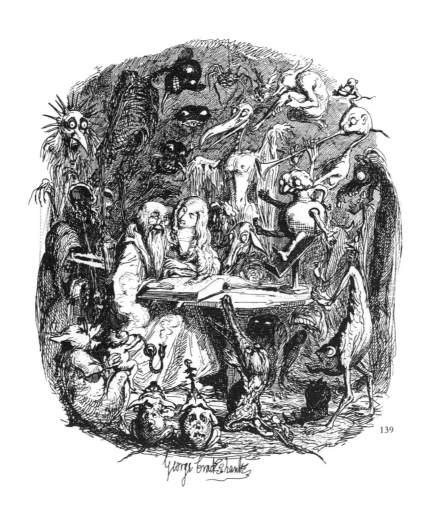

**137 & 138.** From *The Loving Ballad of Lord Bateman:* Lord Bateman as he appeared previous to his embarkation; Lord Bateman, his other bride, and his favorite domestic, with all their hearts so full of glee. **139.** From *Bentley's Miscellany:* Saint Anthony.

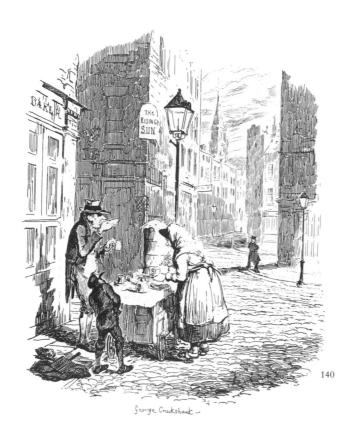

140

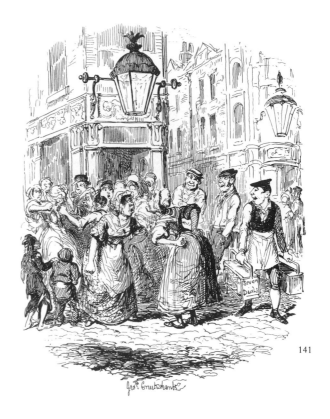

141

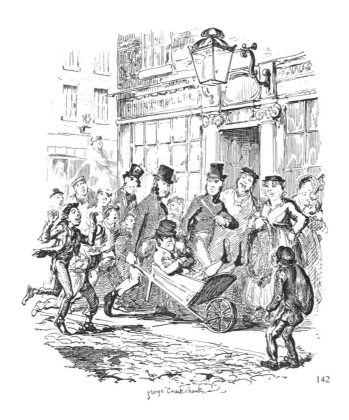

142

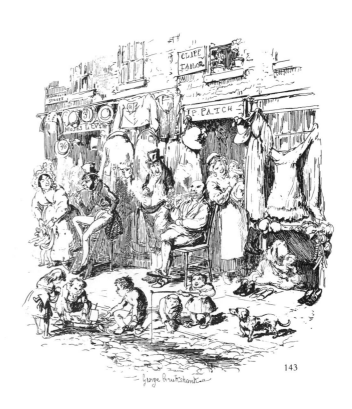

143

From Dickens' *Sketches by Boz*. **140.** The Streets—Morning. **141.** Seven Dials. **142.** A Pickpocket in Custody. **143.** Monmouth Street.

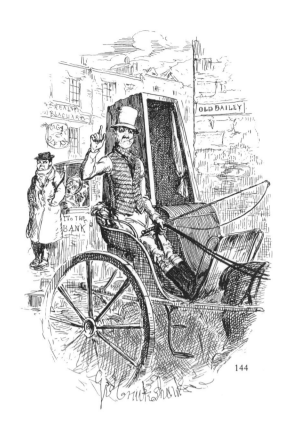

144

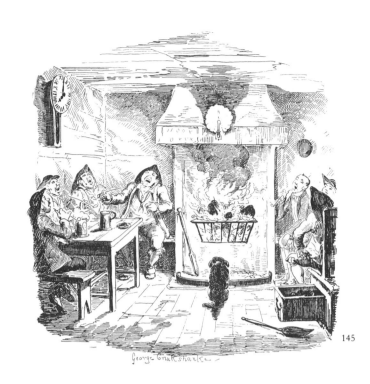

145

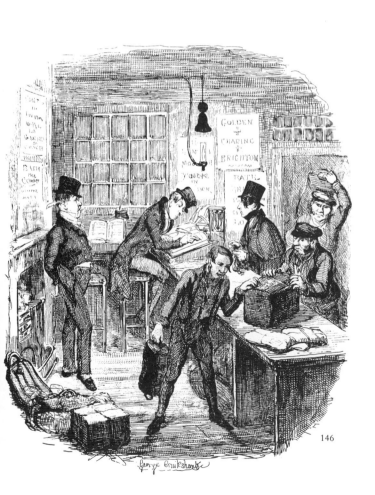

146

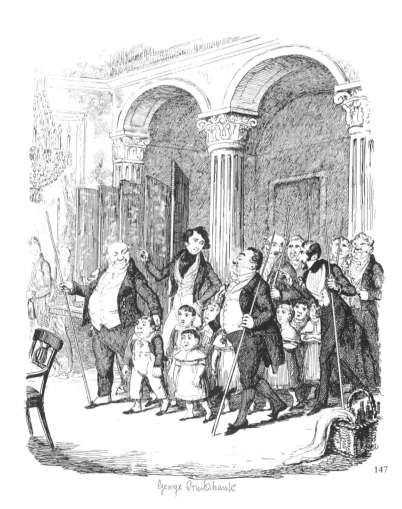

147

From *Sketches by Boz*. **144.** The Last Cab-driver. **145.** Scotland Yard. **146.** Early Coaches.
**147.** Public Dinners.

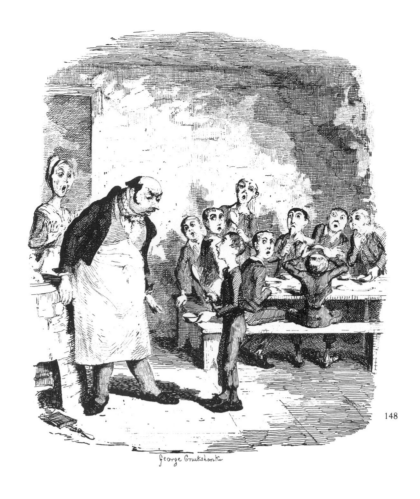

George Cruikshank

148

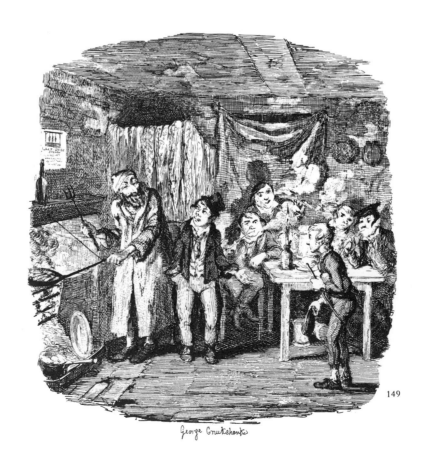

George Cruikshank

149

62          From Dickens' *Oliver Twist*. **148.** Oliver asking for more. **149.** Oliver introduced to the respectable Old Gentleman.

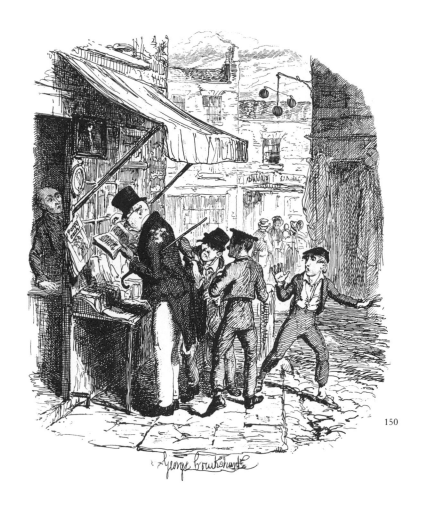

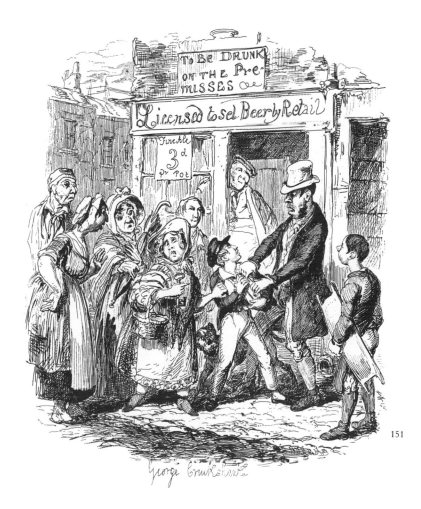

From *Oliver Twist*. **150.** Oliver amazed at the Dodger's mode of "going to work." **151.** Oliver claimed by his affectionate friends.

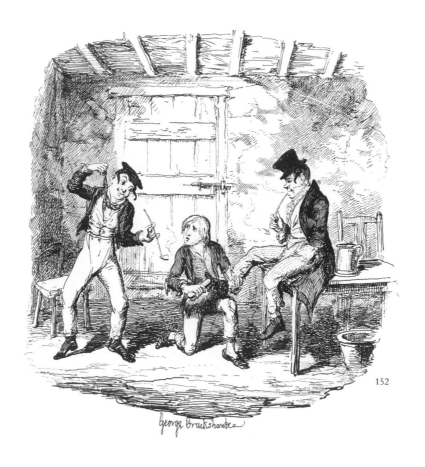

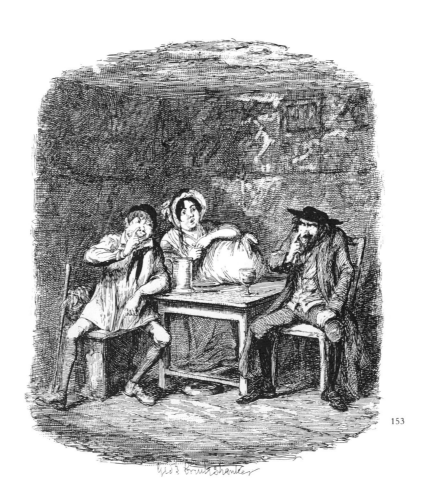

From *Oliver Twist*. **152.** Master Bates explains a professional technicality. **153.** The Jew & Morris Bolter begin to understand each other.

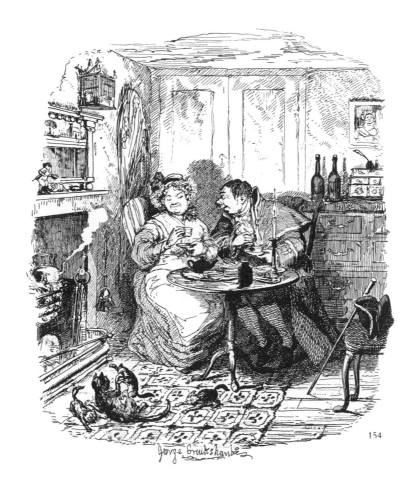

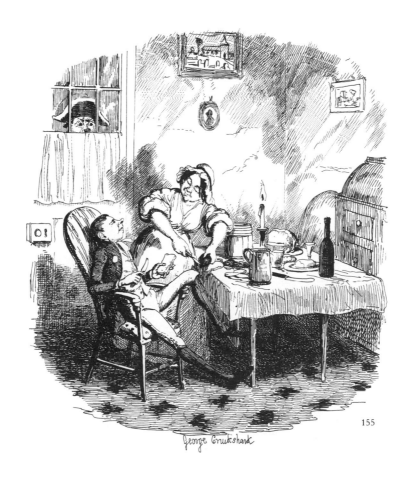

From *Oliver Twist*. **154.** Mr. Bumble and Mrs. Corney taking tea. **155.** Mr. Claypole as he appeared when his master was out.

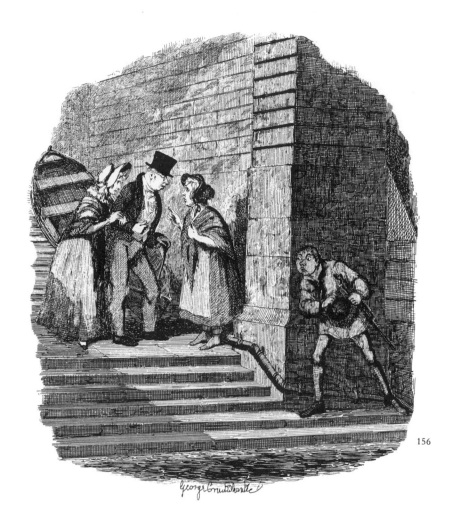

156

157

From *Oliver Twist*. **156.** The Meeting. **157.** Sikes attempting to destroy his dog.

From *Oliver Twist.* **158.** The Last Chance. **159.** Fagin in the condemned Cell.

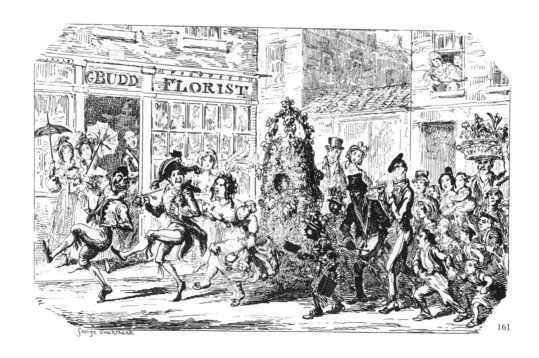

From *The Comic Almanack*. **160.** March [1835]. **161.** May [1835].

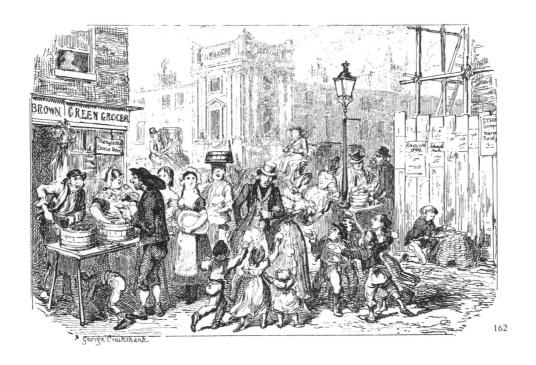

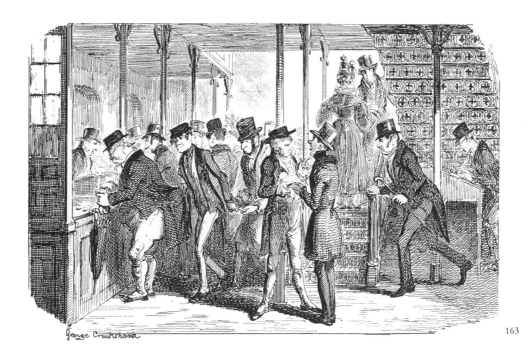

From *The Comic Almanack*. **162.** August [1835]. **163.** February [1836].—Transfer Day
at the Bank.

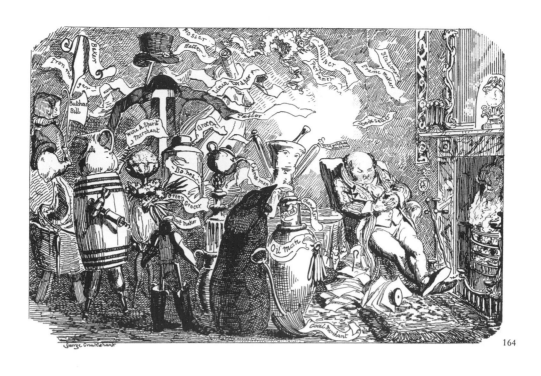

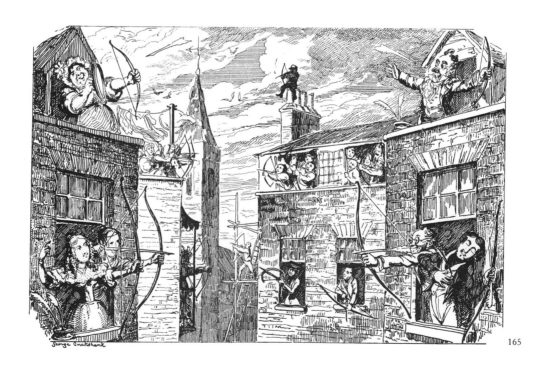

From *The Comic Almanack*. **164.** January [1837].—Last Year's Bills. **165.** February [1837].—Valentine's Day.

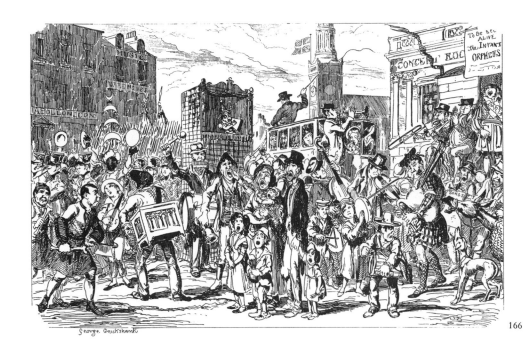

166

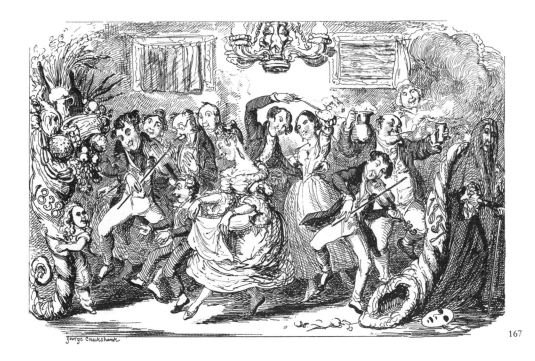

167

From *The Comic Almanack.* **166.** November [1837].—St. Cecilia's Day. **167.** January
[1838].—New Year's Eve.

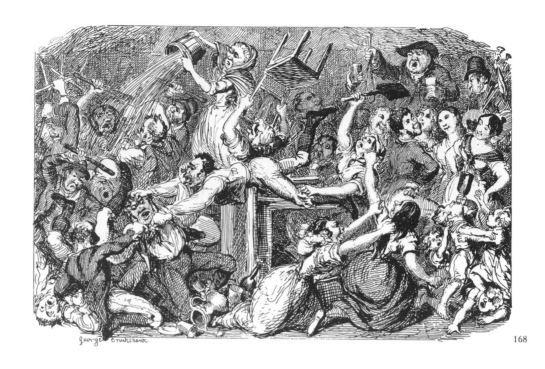

168

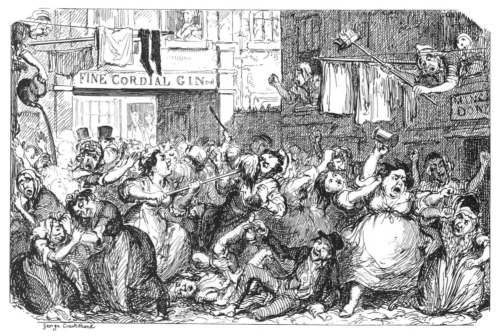

169

From *The Comic Almanack*. **168.** March [1838].—St. Patrick's Day. **169.** October [1838].—Battle of A-gin-court (Petty France).

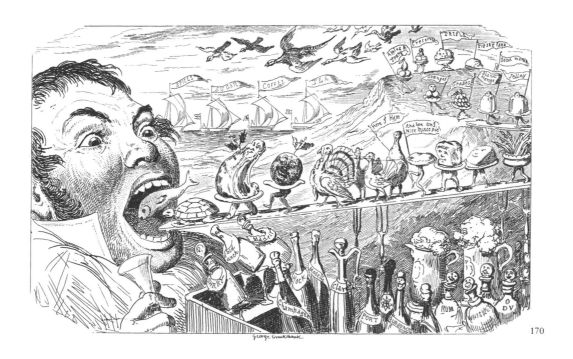

170

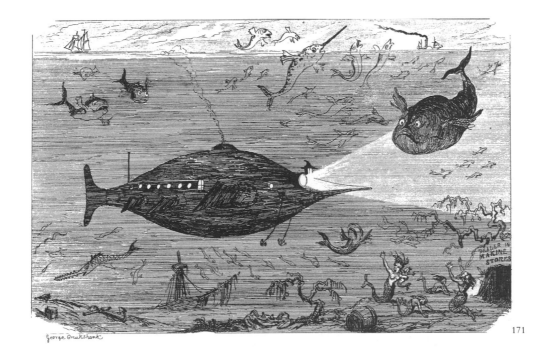

171

From *The Comic Almanack*. **170.** December [1841].—A Swallow at Christmas. **171.** Science under Divers forms [1843].

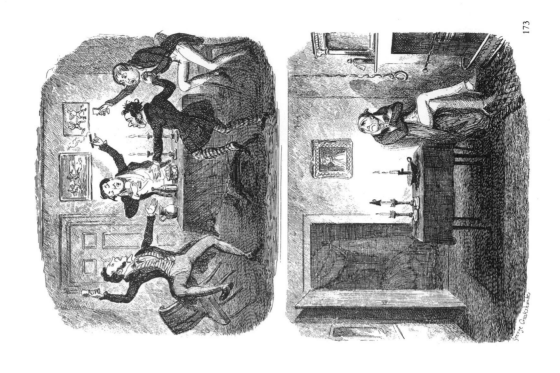

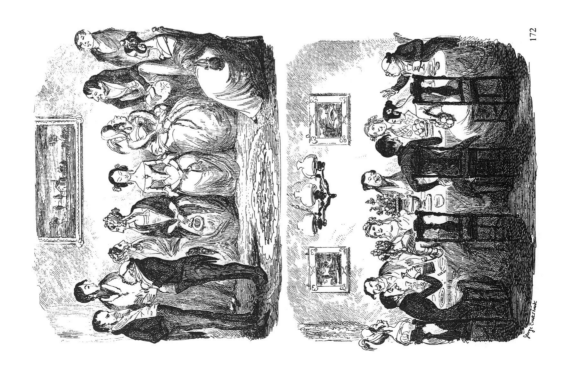

From *The Comic Almanack.* **172.** Before dinner and after [1842]. **173.** Over-head and Under-foot [1842].

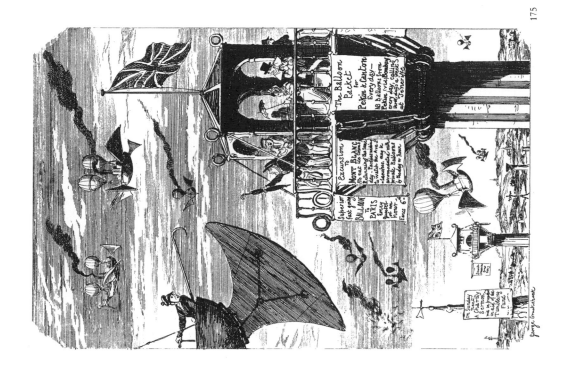

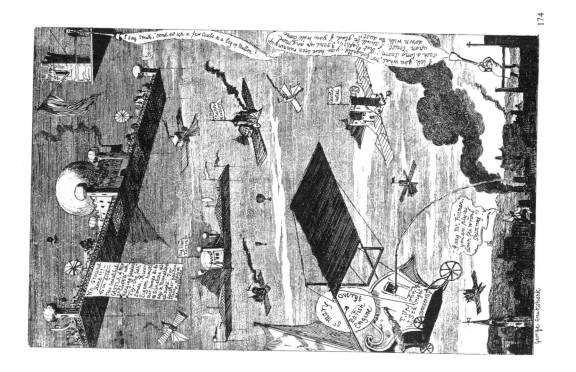

From *The Comic Almanack*. **174.** The Height of Speculation—Groundless Expectations [1844]. **175.** Air-um Scare-um Travelling [1843].

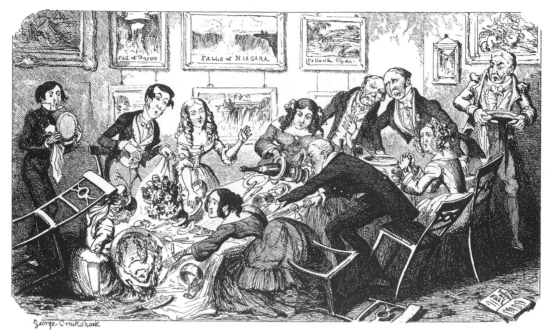

176

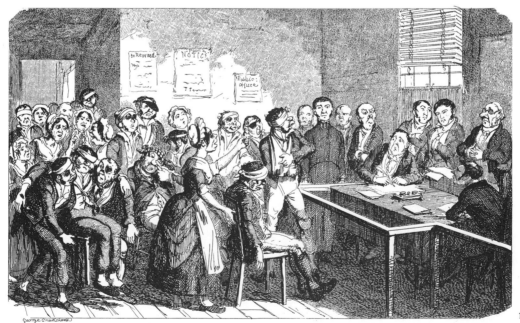

177

From *The Comic Almanack*. **176.** The Fall of the Leaf [1845]. **177.** The Day After—St. Patrick's Day in the morning [1845].

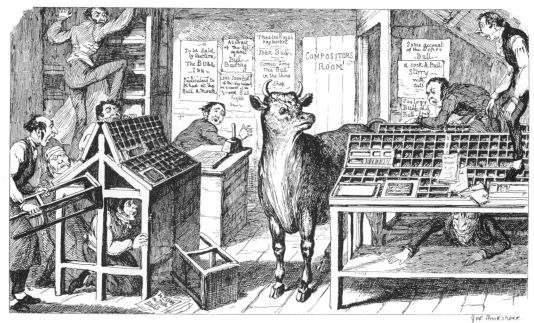

From *The Comic Almanack*. **178.** Taurus—A literary Bull [1846]. **179.** Born a Genius and Born a Dwarf [1847].

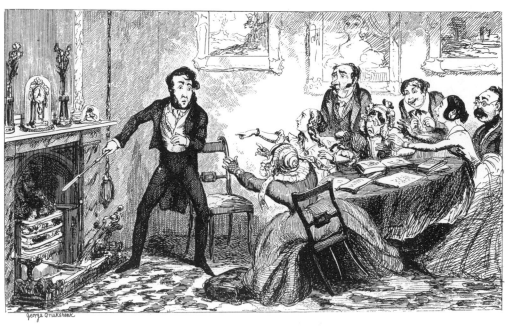

180

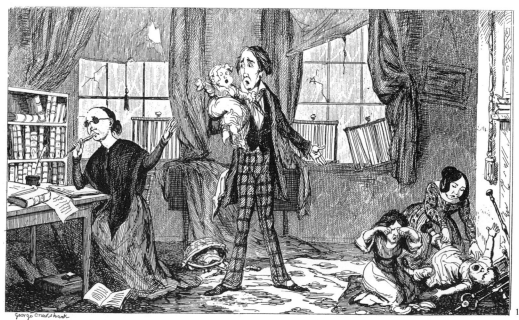

181

From *The Comic Almanack*. **180.** The Desecration of the Bright Poker [1847]. **181.** "My Wife Is a Woman of Mind" [1847].

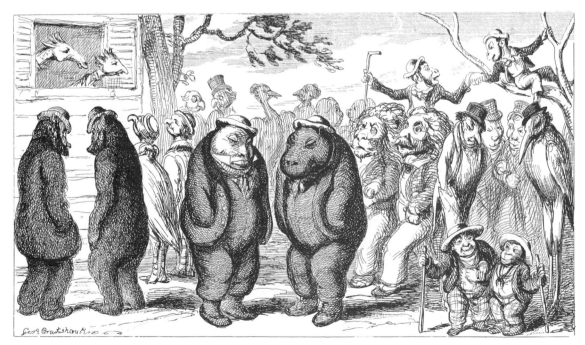

From *The Comic Almanack*. **182.** A Splendid Spread [1850]. **183.** Fellows of the
Zoological Society [1851].

From *The Comic Almanack*. **184.** Modern Balooning [1851]. **185.** Over Population [1851].

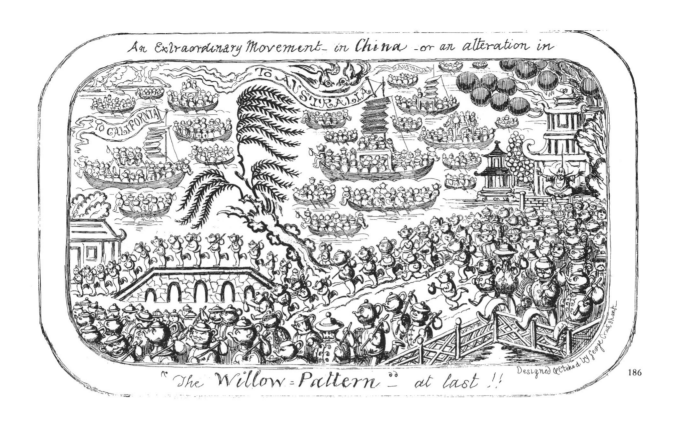

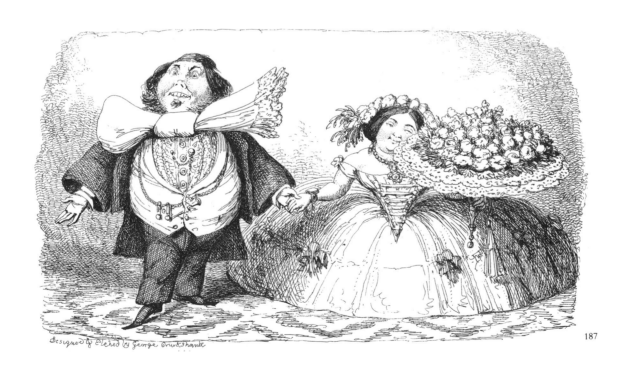

From *The Comic Almanack*. **186.** An Extraordinary Movement—in China [1853]. **187.** Will you be—our Vis à Vis? [1853].

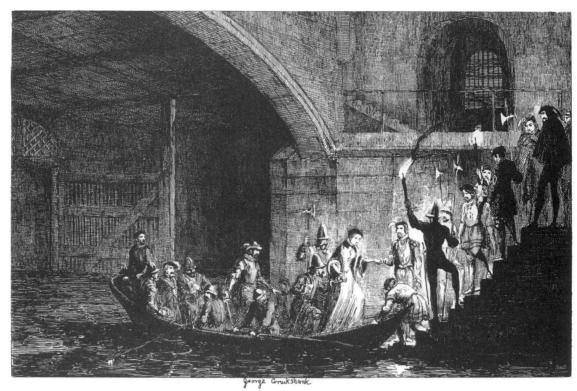

188

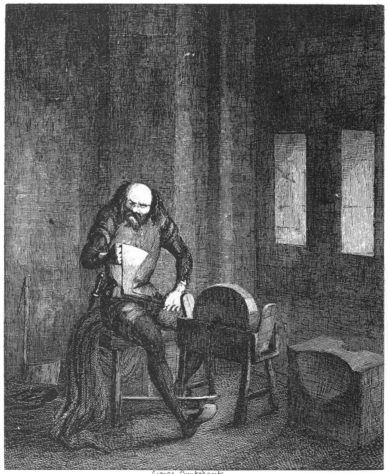

189

From Ainsworth's *The Tower of London*. **188.** Queen Jane & Lord Guilford Dudley brought back to the Tower through Traitors Gate. **189.** Monger sharpening his Axe.

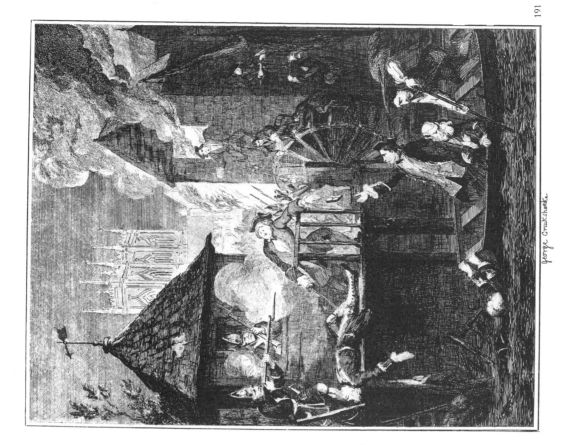

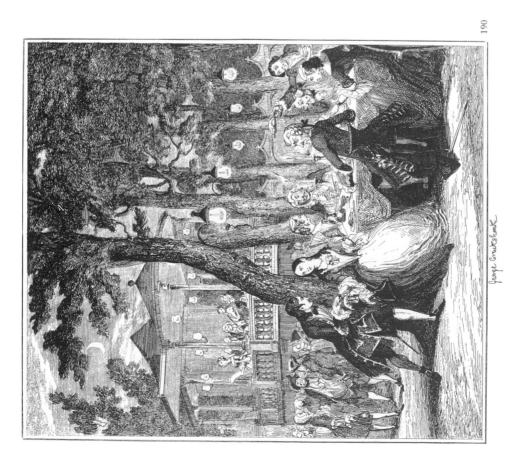

From Ainsworth's *The Miser's Daughter*. **190**. The Supper at Vauxhall. **191**. Dispersion of the Jacobite Club, and Death of Cordwell Firebras.

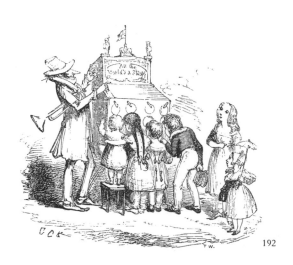

192

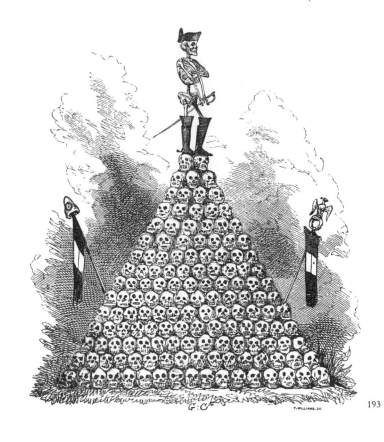

193

194

195

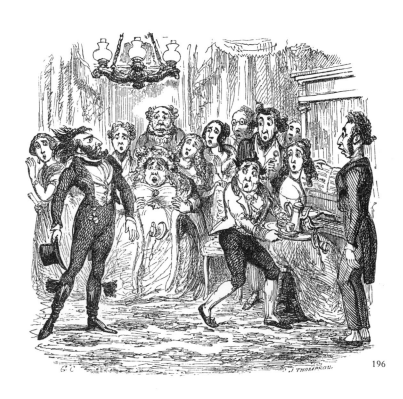

196

From *George Cruikshank's Omnibus*. **192.** Our Preface. **193.** Monument to Napoleon!
**194.** Two of a Trade. **195.** As Broad As It's Long. **196.** Untitled (the artist in a drawing
room). NOTE: Illustrations 197 & 198 appear on page 91.

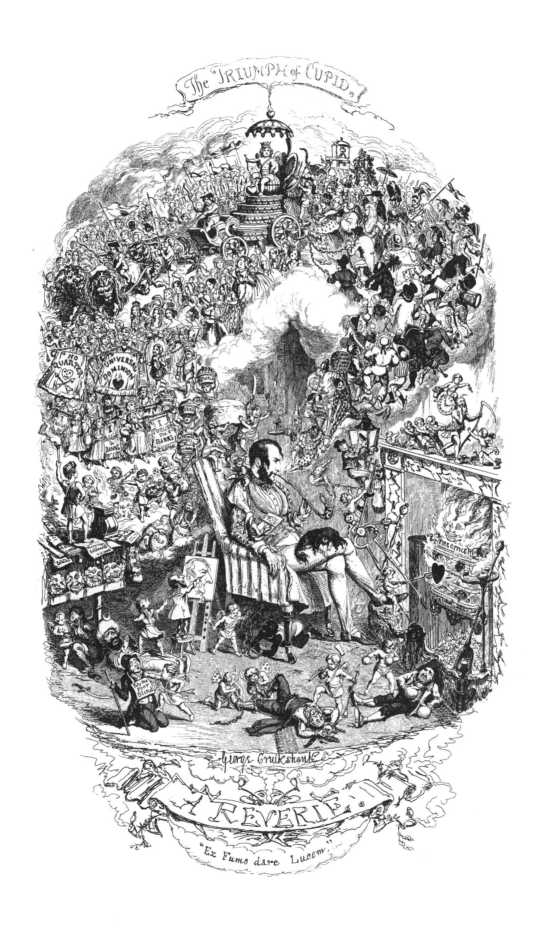

**199.** From *George Cruikshank's Table Book* (frontispiece to the first issue).

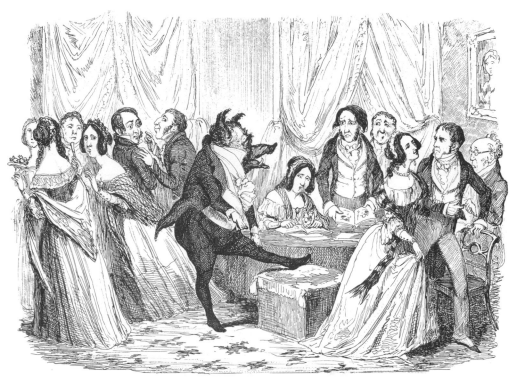

*A horrible Bore, in the Company.*

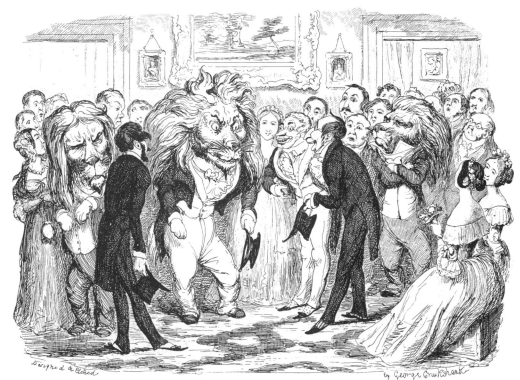

*The Lion, of the party!*

**200.** From *George Cruikshank's Table Book.*

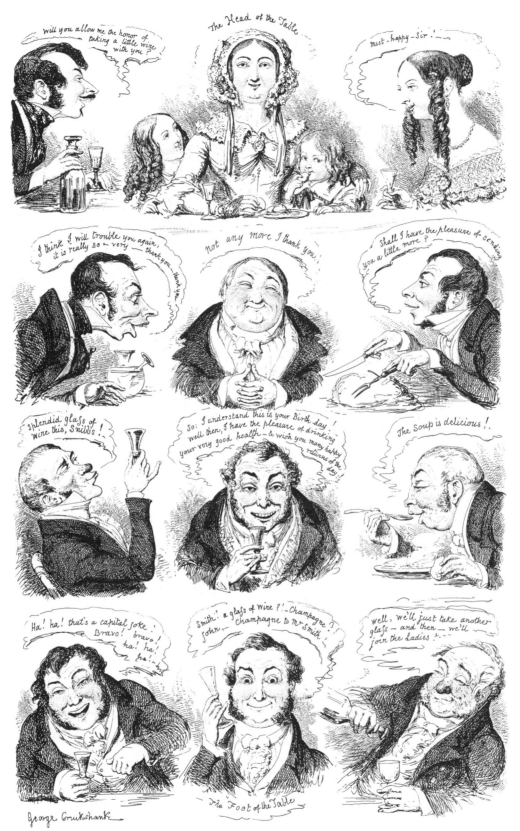

HEADS OF THE TABLE.

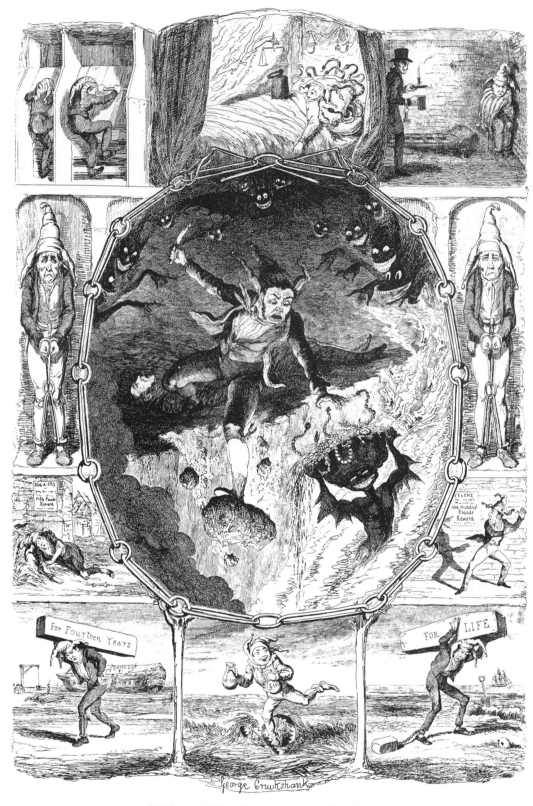

The Folly of Crime.

202. From *George Cruikshank's Table Book.*

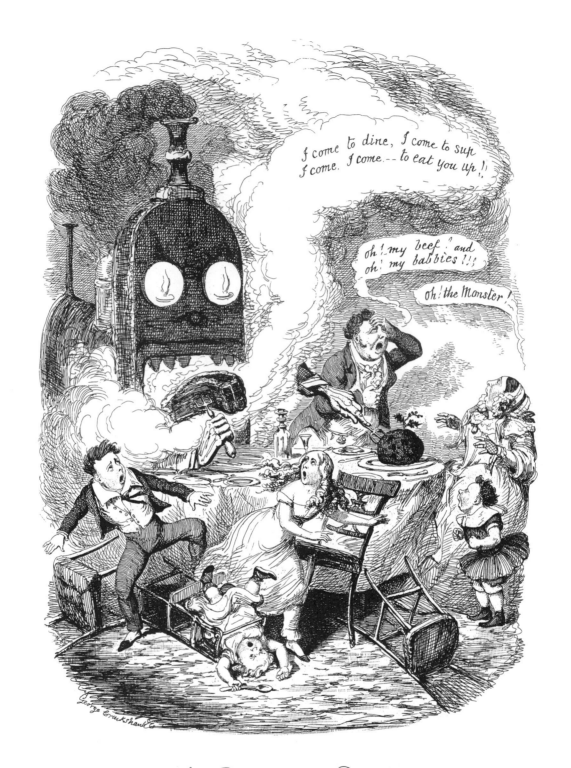

The Railway Dragon.

**204.** From *George Cruikshank's Table Book.*

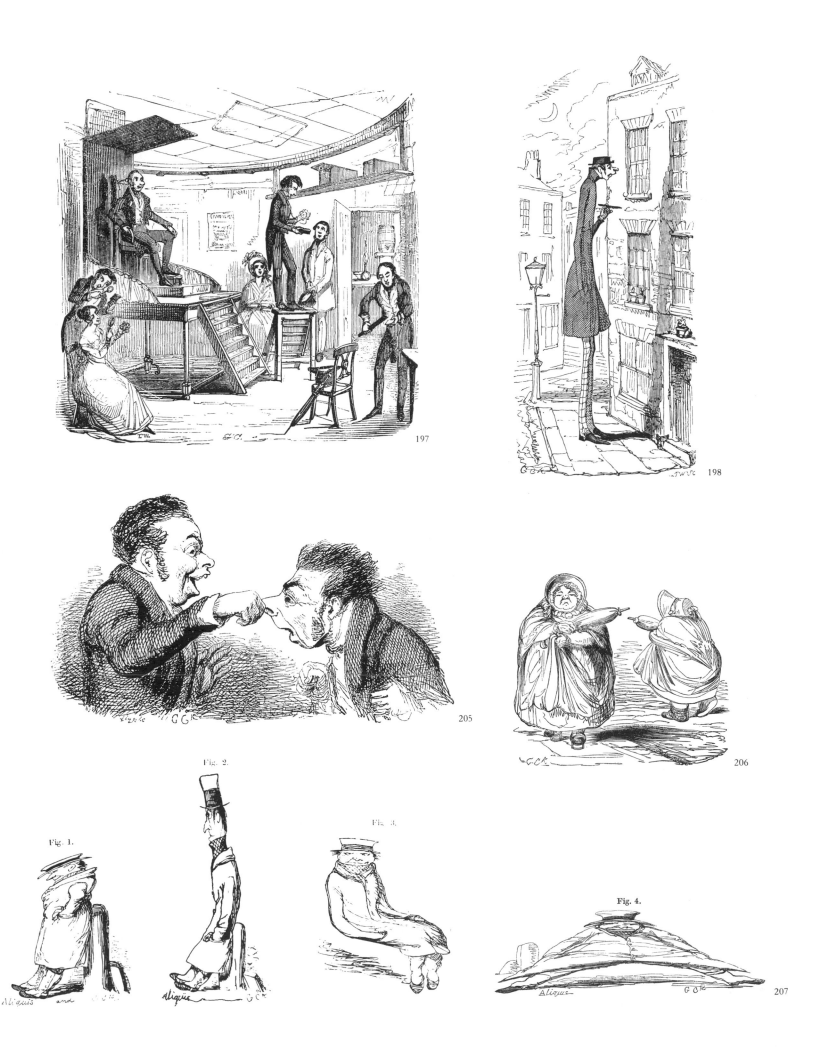

**197 & 198.** From *George Cruikshank's Omnibus:* Photographic Phenomena; The Height of Impudence. **205–207.** From *George Cruikshank's Table Book:* Practical Mesmerism; My Opinions on Umbrellas; Letter . . . for the Advancement of Science . . . Figures 1–4.

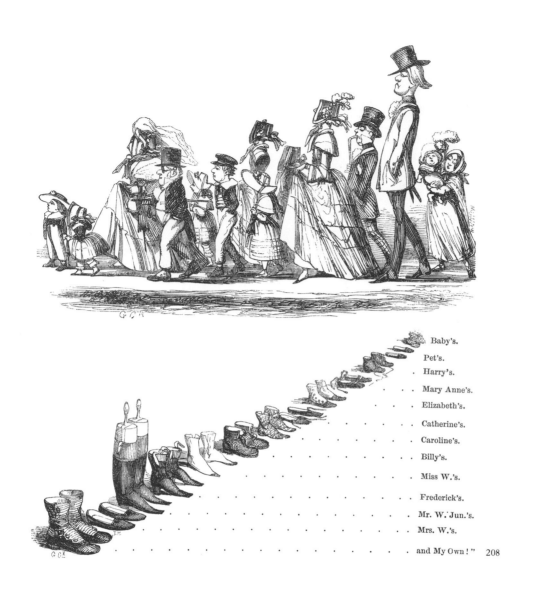

Baby's.
Pet's.
Harry's.
Mary Anne's.
Elizabeth's.
Catherine's.
Caroline's.
Billy's.
Miss W.'s.
Frederick's.
Mr. W. Jun.'s.
Mrs. W.'s.
and My Own!" 208

209

210

211

From *George Cruikshank's Table Book.* **208.** A frightful Narrative (double illustration). **209.** Guy Greenhorn's Wanderings **210.** A Cold Love Letter. **211.** Recreations in Natural History.

212

George Cruikshank

213

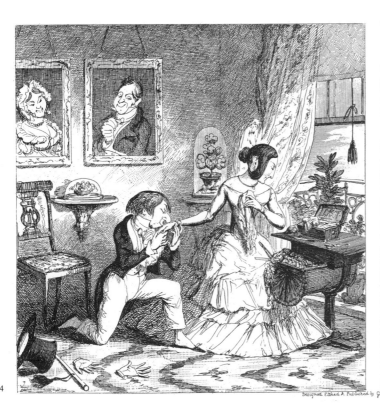

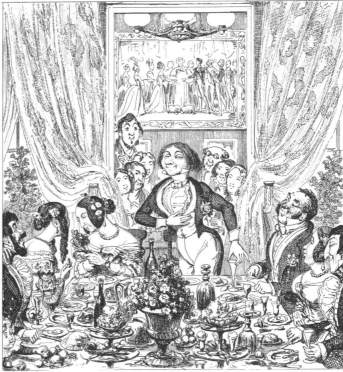

214

Designed, Etched & Published by George Cruikshank

215

From *The Bachelor's Own Book*. **212.** Mr. Lambkin ready to go wooing. **213.** Street boys play a joke on him. **214.** The lady accepts him. **215.** He orates at his wedding banquet.

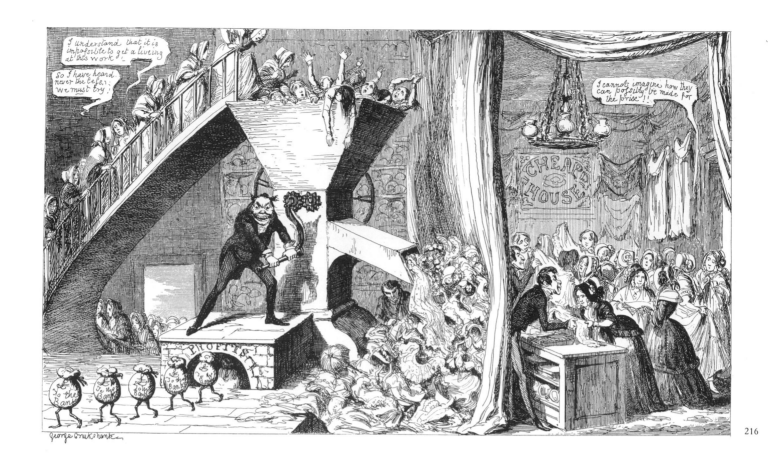

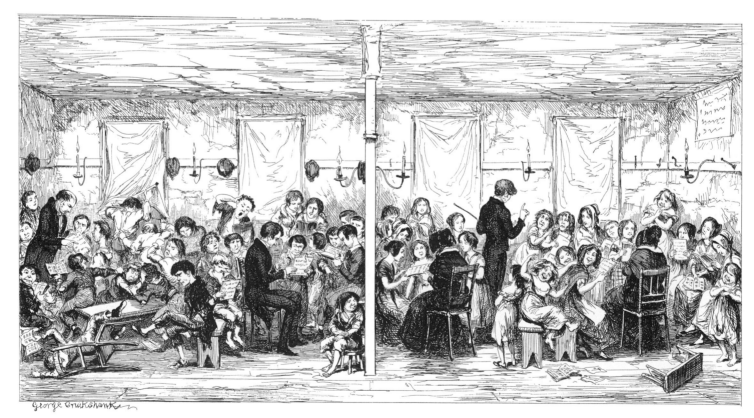

From *Our Own Times*. **216.** Tremendous Sacrifice! **217.** The Ragged School.

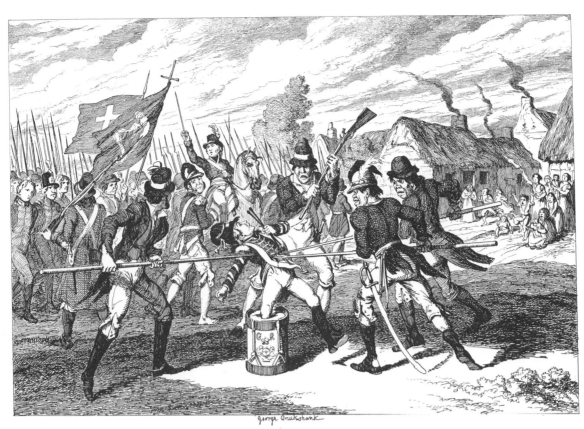

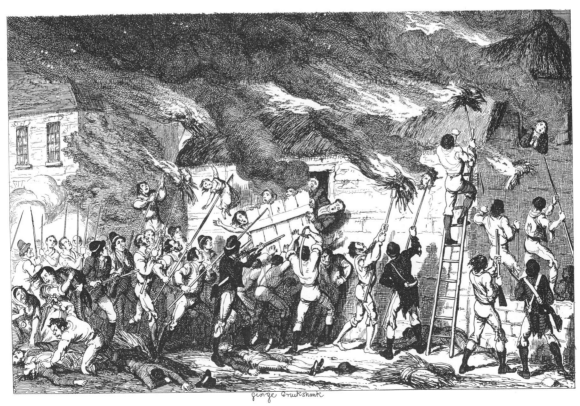

From *History of the Irish Rebellion in 1798.* **218.** The Loyal little Drummer. **219.** Massacre at Scullabogue.

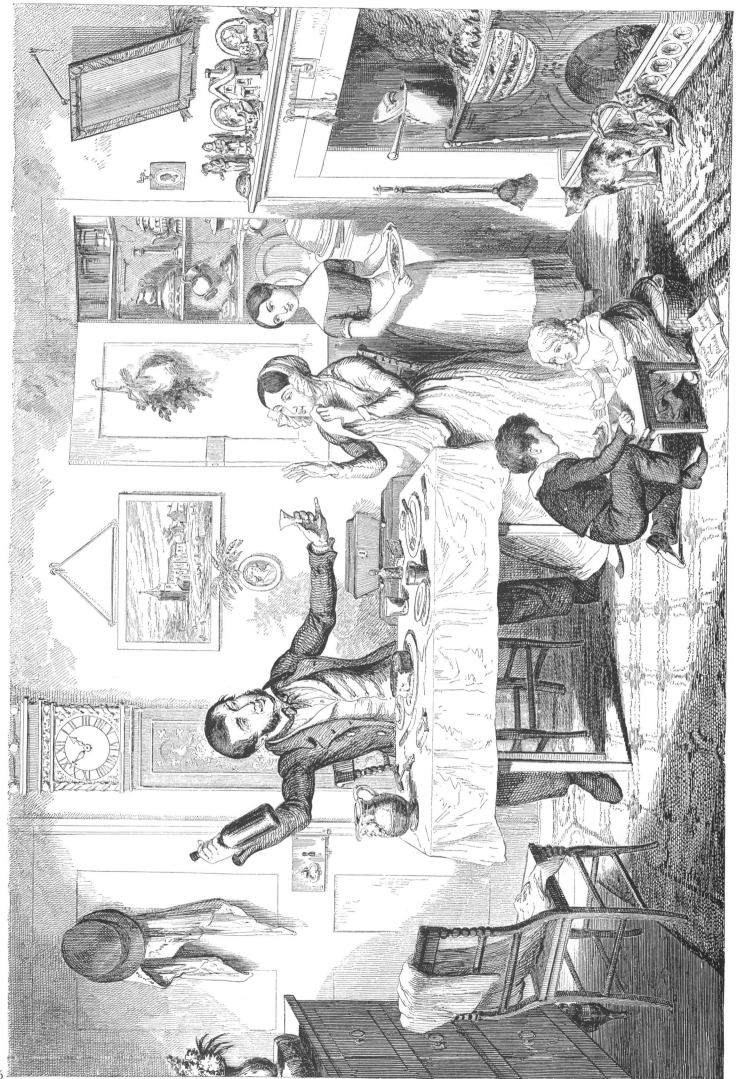

220. *The Bottle.* Plate I. The Bottle Is Brought Out for the First Time: The Husband Induces His Wife "Just to Take a Drop."

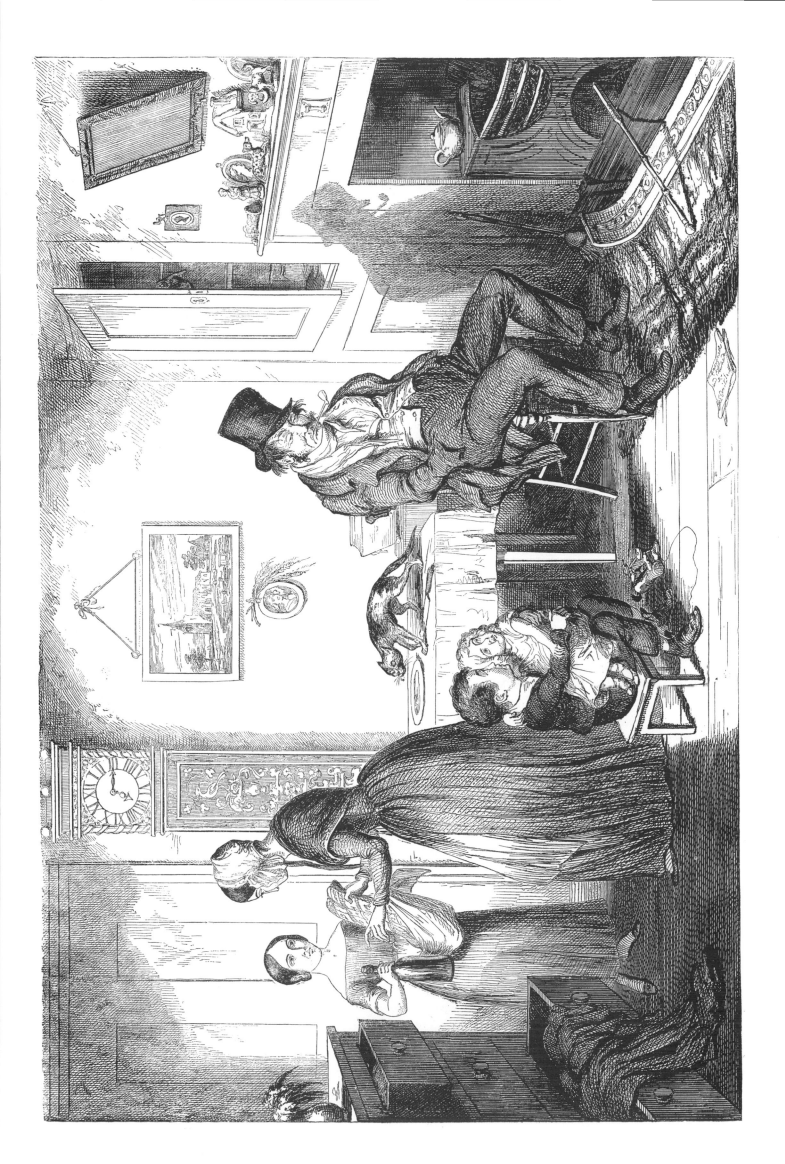

**221.** *The Bottle.* Plate II. He Is Discharged from His Employment for Drunkenness: They Pawn Their Clothes to Supply the Bottle.

**222.** *The Bottle.* Plate III. An Execution Sweeps Off the Greater Part of Their Furniture: They Comfort Themselves with the Bottle.

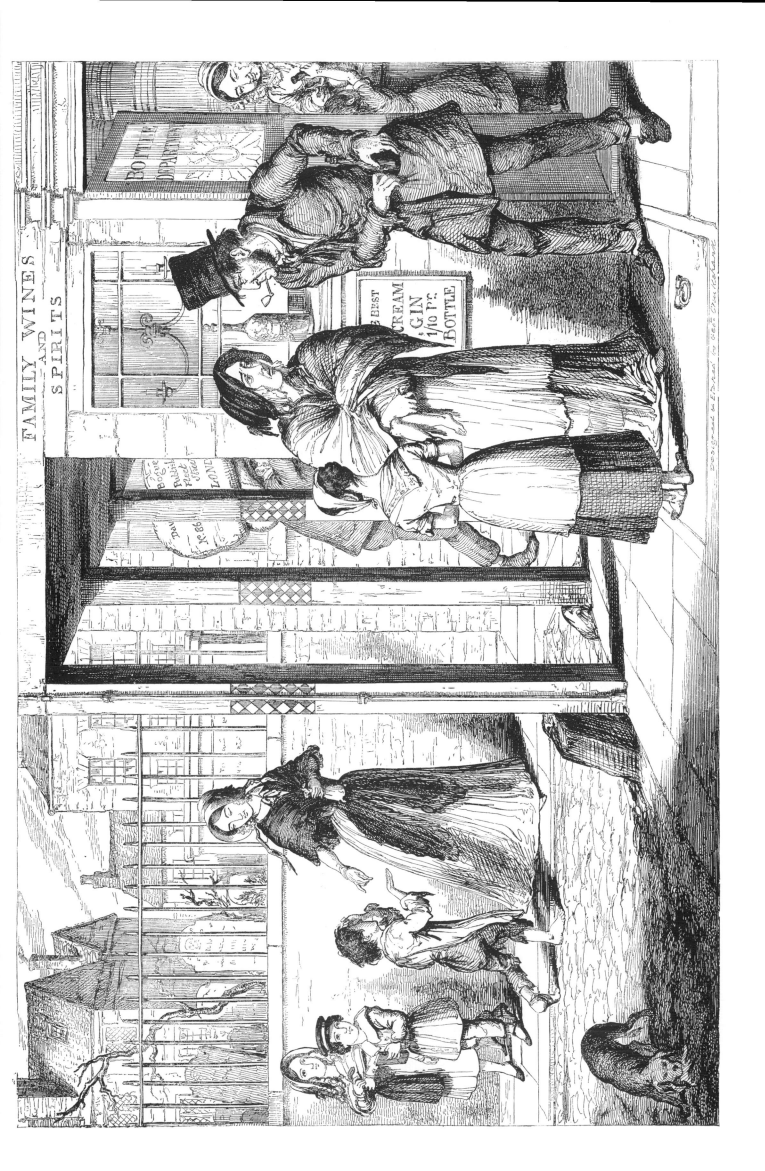

**223.** *The Bottle.* Plate IV. Unable to Obtain Employment, They Are Driven by Poverty into the Streets to Beg, and by This Means They Still Supply the Bottle.

224. *The Bottle*. Plate V. Cold, Misery, and Want, Destroy Their Youngest Child: They Console Themselves with the Bottle.

100

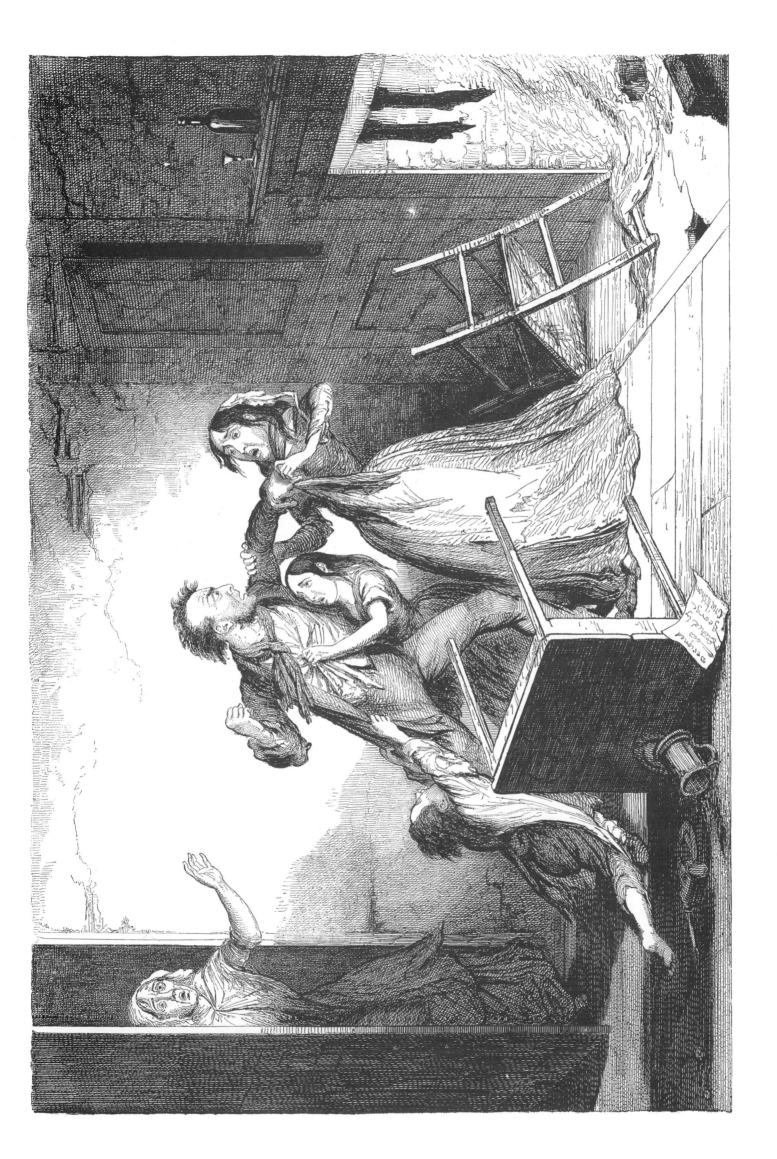

225. *The Bottle.* Plate VI. Fearful Quarrels, and Brutal Violence, Are the Natural Consequences of the Frequent Use of the Bottle.

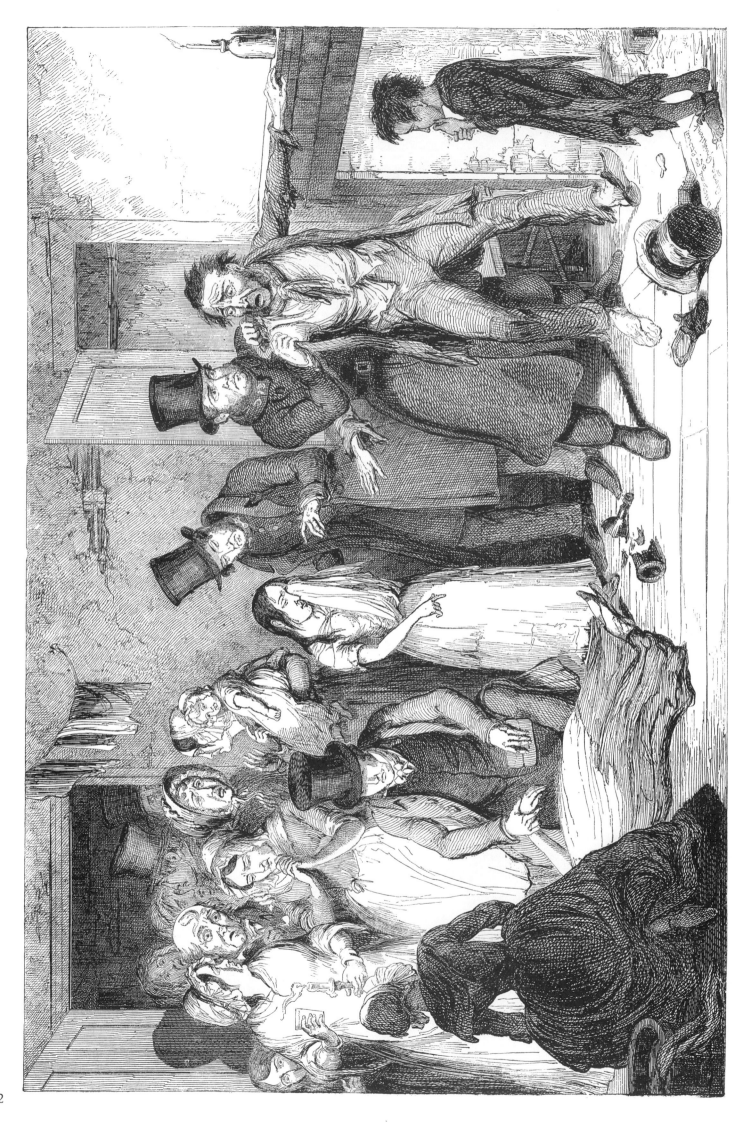

**226.** *The Bottle*. Plate VII. The Husband, in a State of Furious Drunkenness, Kills His Wife with the Instrument of All Their Misery.

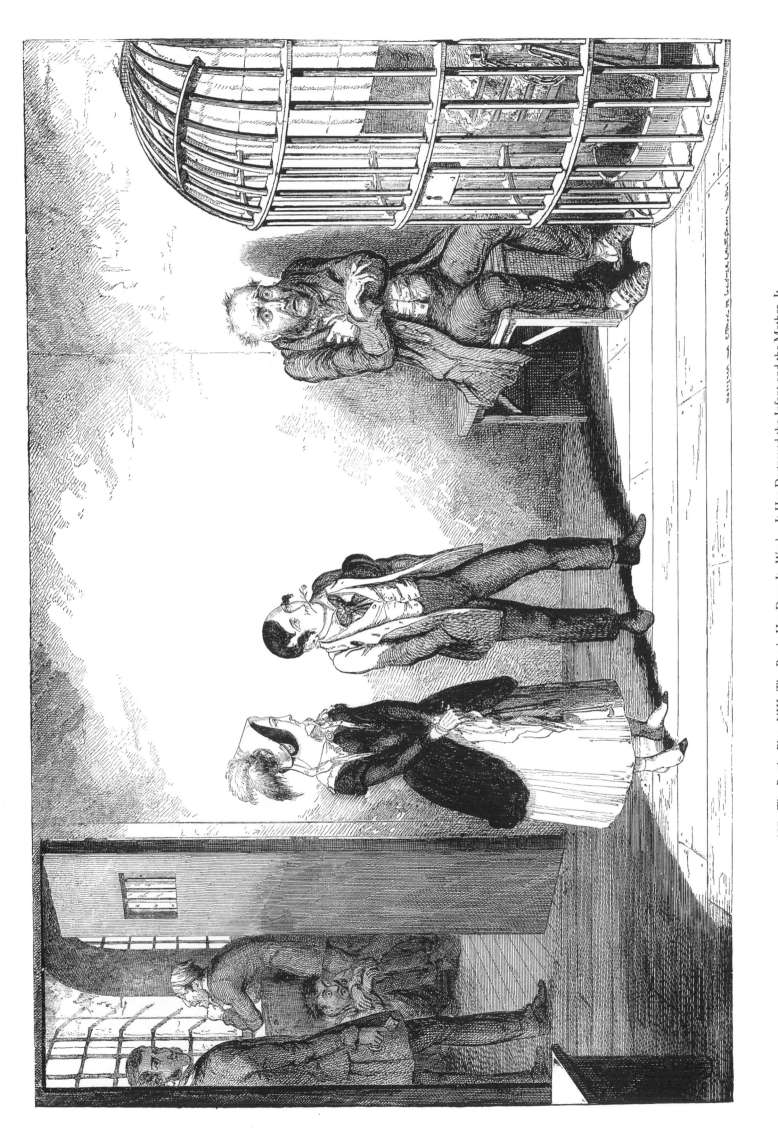

**227.** *The Bottle.* Plate VIII. The Bottle Has Done Its Work—It Has Destroyed the Infant and the Mother, It Has Brought the Son and the Daughter to Vice and to the Streets, and Has Left the Father a Hopeless Maniac.

103

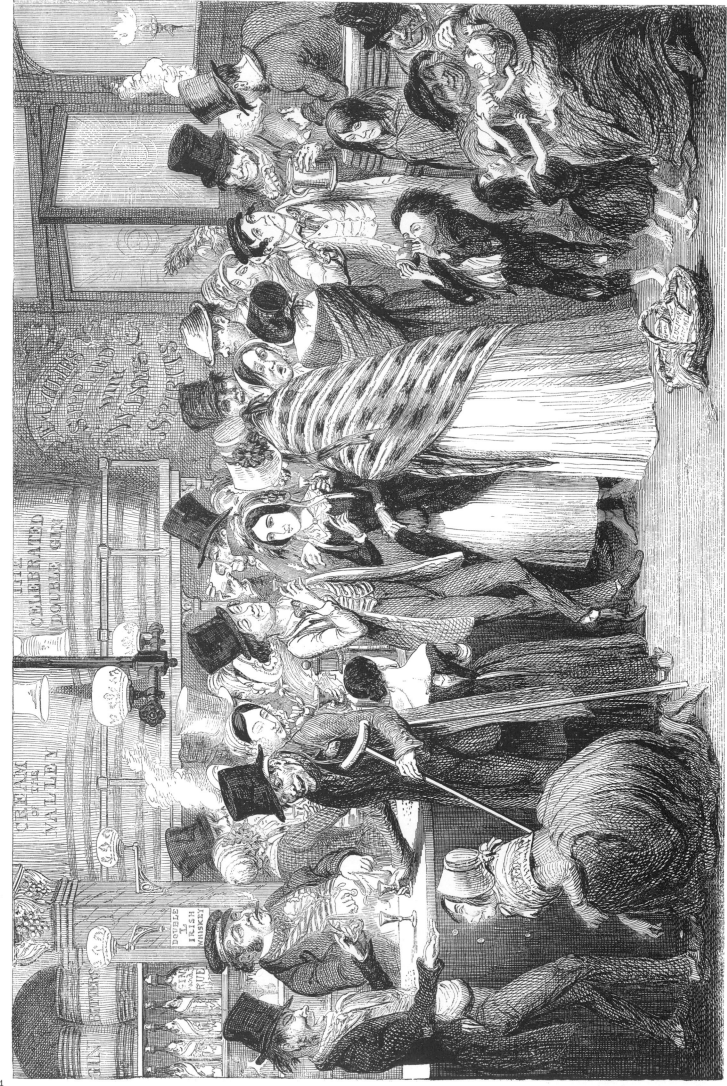

**228.** *The Drunkard's Children.* Plate I. Neglected by Their Parents, Educated Only in the Streets and Falling into the Hands of Wretches Who Live Upon The Vices of Others, They Are Led to the Gin Shop, to Drink at That Fountain Which Nourishes Every Species of Crime.

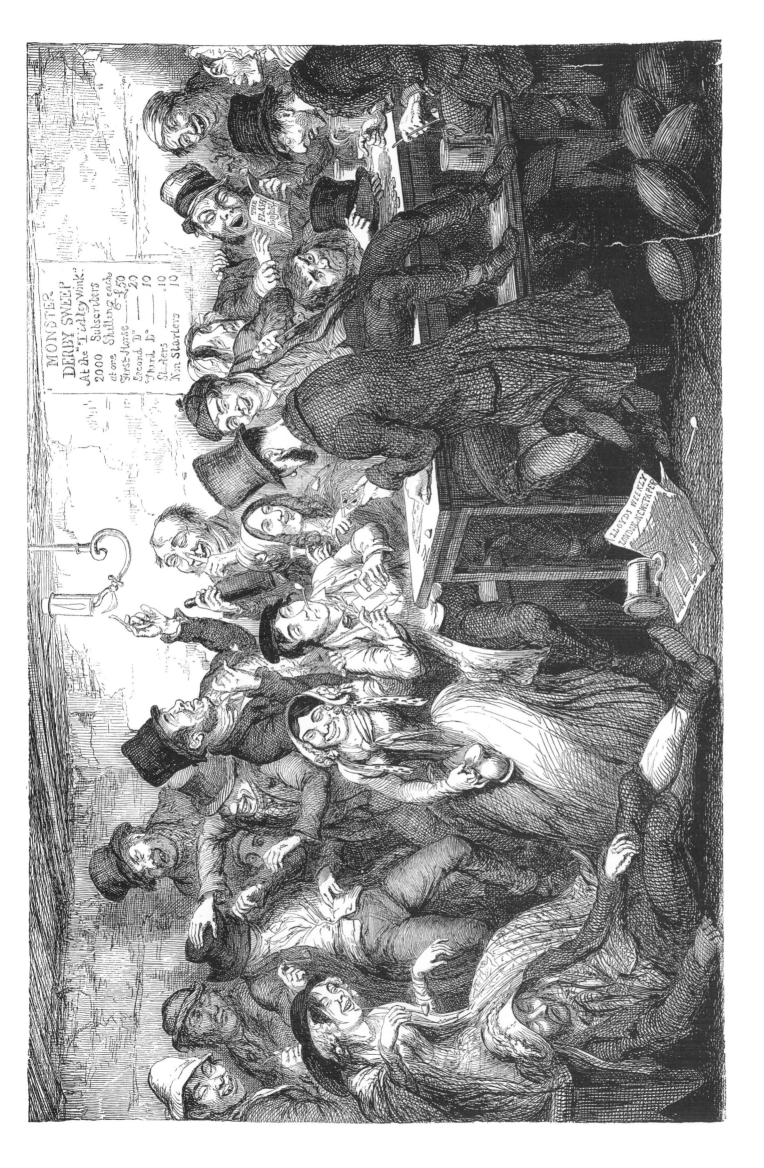

**229.** *The Drunkard's Children.* Plate II. Between the Fine Flaring Gin Palace and the Low Dirty Beer Shop, the Boy Thief Squanders and Gambles Away His Ill-Gotten Gains.

230. *The Drunkard's Children.* Plate III. From the Gin Shop to the Dancing Rooms, from the Dancing Rooms to the Gin Shop, the Poor Girl is Driven on in That Course Which Ends in Misery.

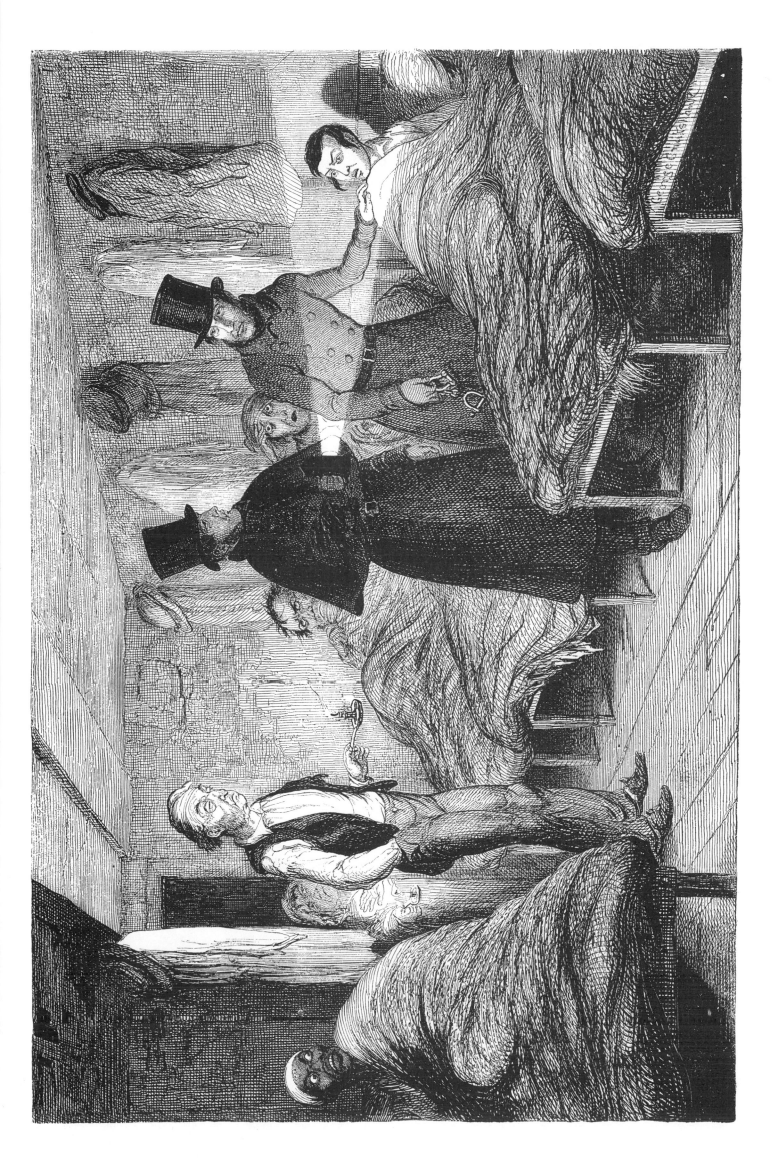

**231.** *The Drunkard's Children.* Plate IV. Urged on by His Ruffian Comparions, and Excited by Drink, He Commits a Desperate Robbery.—He Is Taken by the Police at a Three-Penny Lodging House.

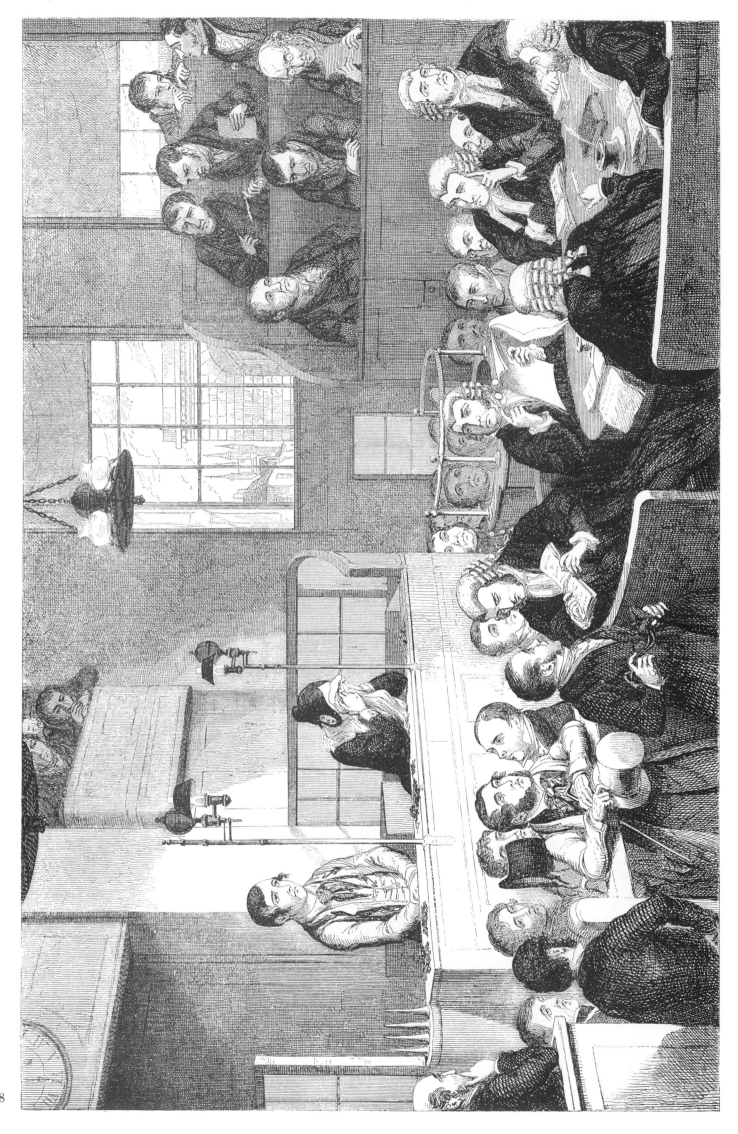

232. *The Drunkard's Children.* Plate V. From the Bar of the Gin Shop to the Bar of the Old Bailey. It Is But One Step.

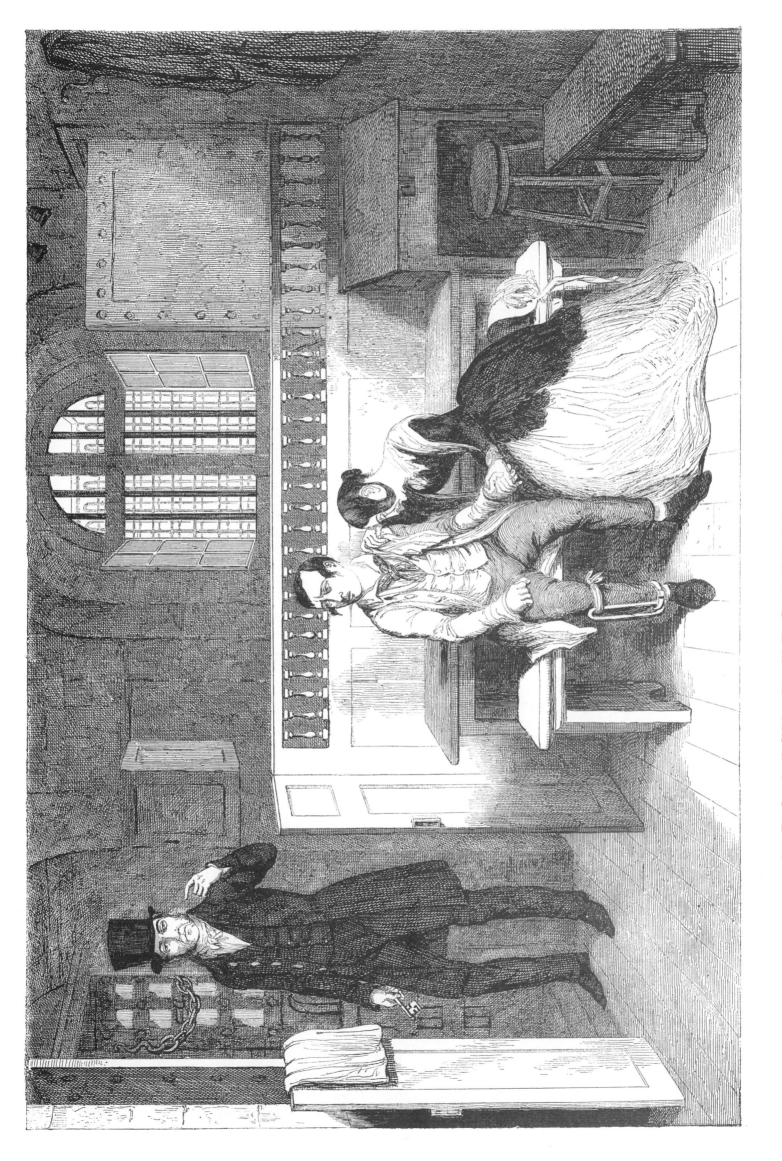

233. *The Drunkard's Children.* Plate VI. The Drunkard's Son Is Sentenced to Transportation for Life; the Daughter, Suspected of Participation in the Robbery, Is Acquitted.—The Brother and Sister Part For Ever in This World.

109

234. *The Drunkard's Children*. Plate VII. Early Dissipation Has Destroyed the Neglected Boy.—The Wretched Convict Droops and Dies.

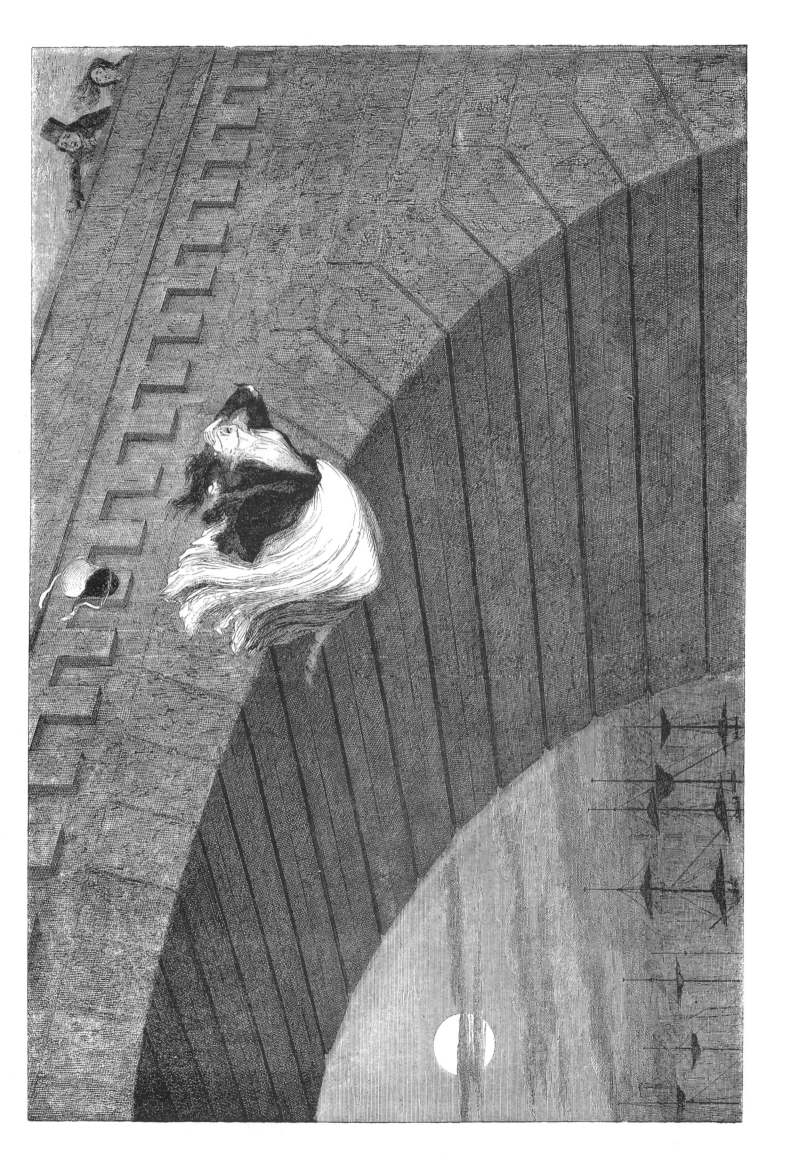

**235.** *The Drunkard's Children.* Plate VIII. The Maniac Father and The Convict Brother Are Gone.—The Poor Girl, Homeless, Friendless, Deserted, Destitute, and Gin Mad, Commits Self Murder.

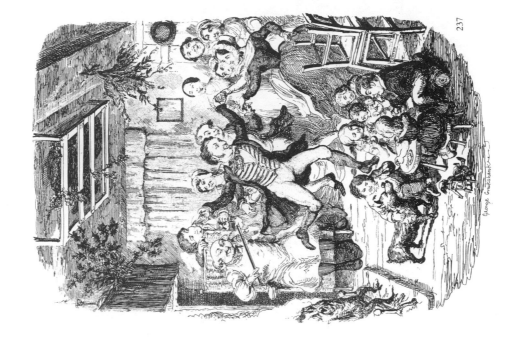

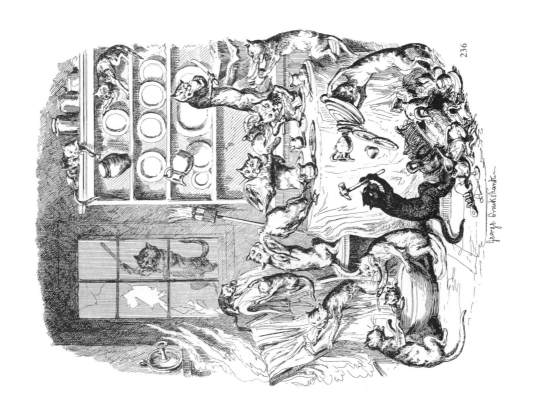

**236.** From *The Greatest Plague of Life* by the Brothers Mayhew: "The Cat did it!" **237.** From *The Yule Log* by L. S. Chamerozow: Abel himself again.

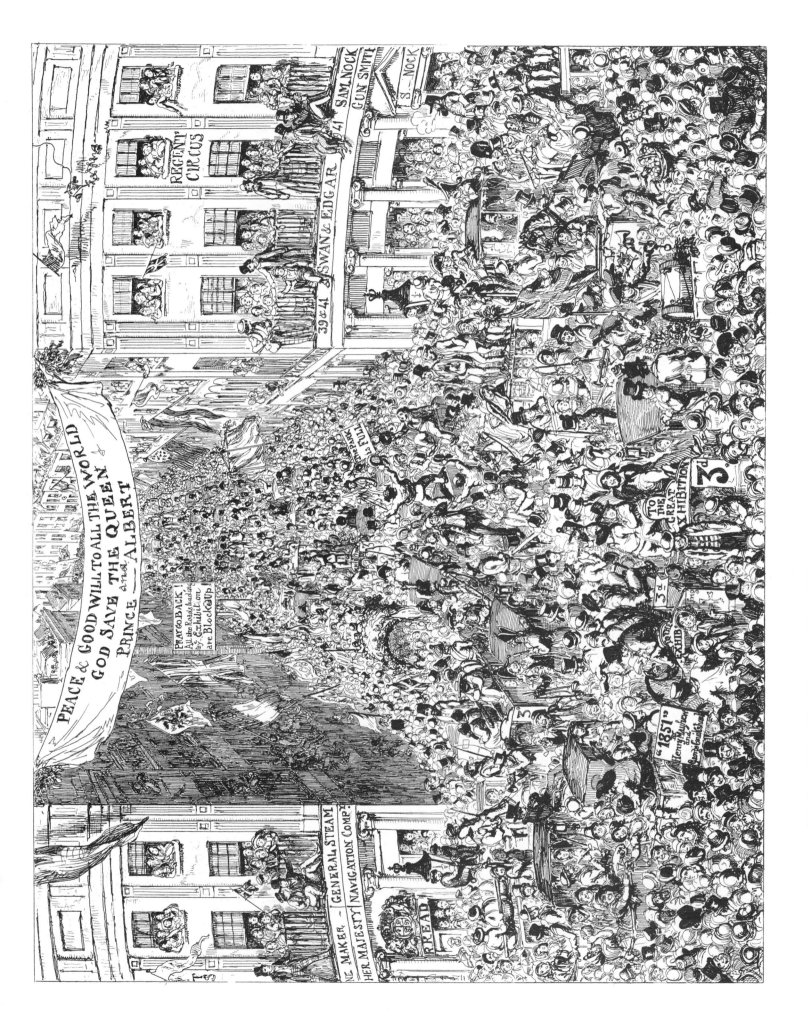

238. From *1851 or, The Adventures of Mr. and Mrs. Sandboys* by Henry Mayhew and George Cruikshank: London, in 1851.

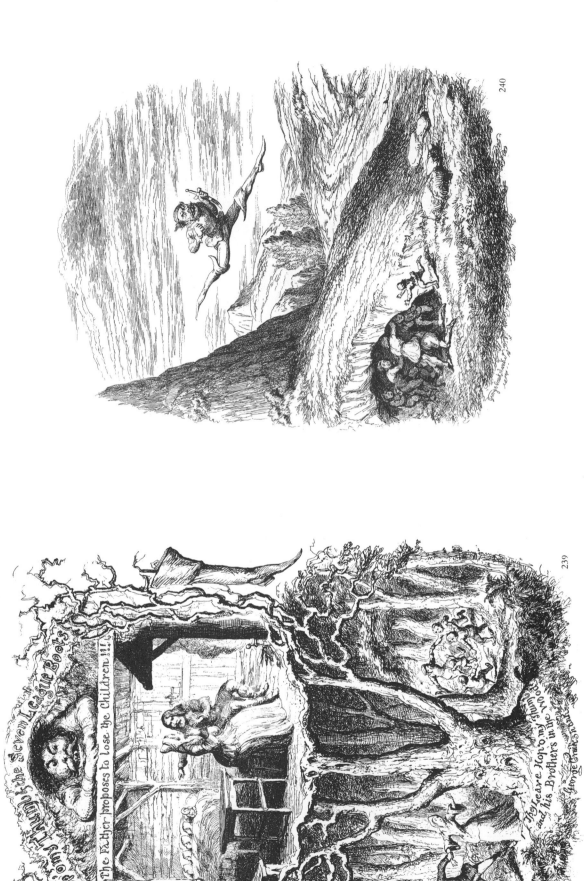

From *George Cruikshank's Fairy Library*. **239**. Title page of "Hop O' My Thumb." **240**. The Giant Ogre in his Seven League Boots pursuing Hop o' my Thumb & his Brothers, who hide in a Cave.

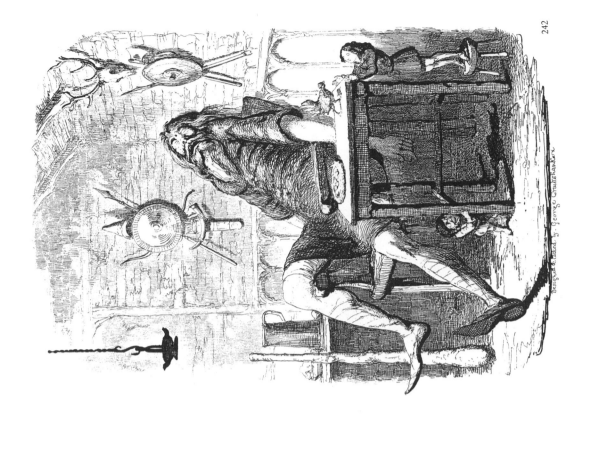

From *George Cruikshank's Fairy Library*. **241**. Jack climbing the Bean Stalk. **242**. Jack gets the Golden Hen, away from the Giant.

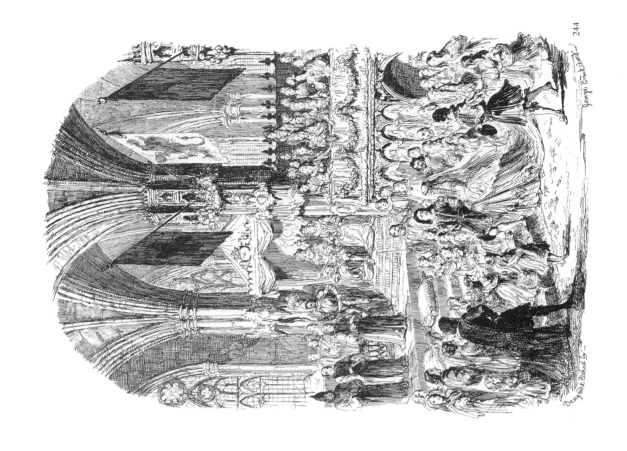

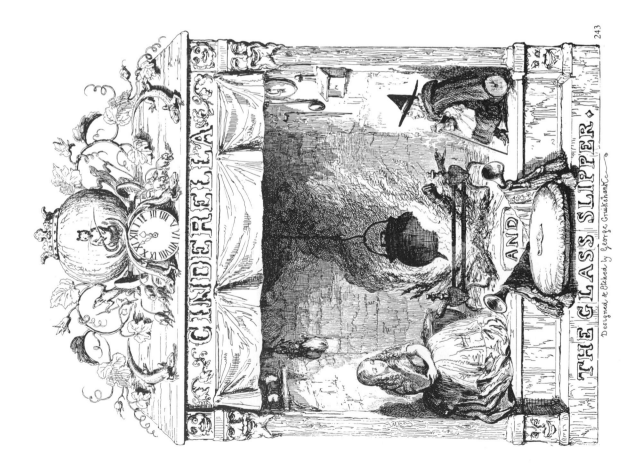

From *George Cruikshank's Fairy Library.* **243.** Title page of "Cinderella." **244.** The Marriage of Cinderella, to the Prince.

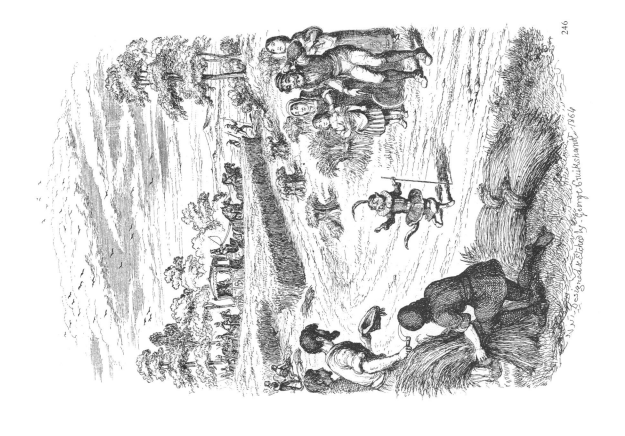

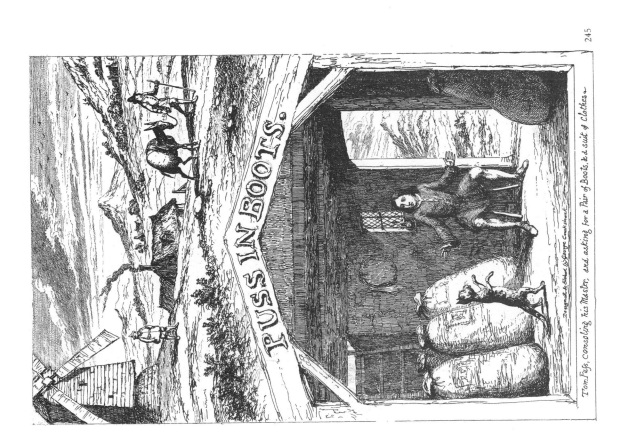

From *George Cruikshank's Fairy Library.* **245.** Title page of "Puss in Boots." **246.** Tom Puss commands the Reapers to tell the King that All the fields—belong to—the most Noble, the Marquess of Carabas.

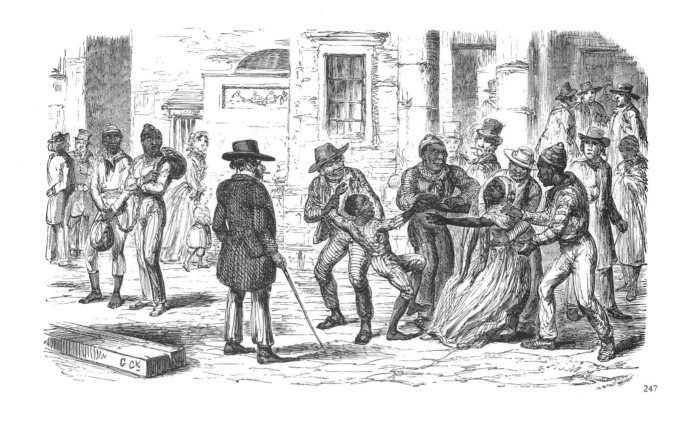

247

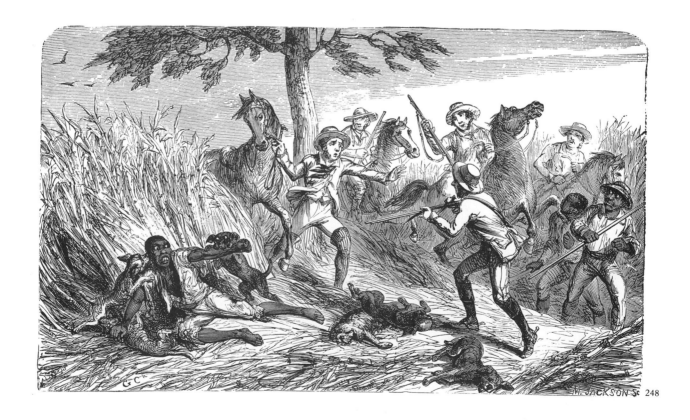

248

From Mrs. Stowe's *Uncle Tom's Cabin.* **247.** The Separation of the Mother and Child.
**248.** Scipio Hunted, "As Men Hunt a Deer!"

**249.** Frontispiece and title page of *Old Faces in New Masks*.

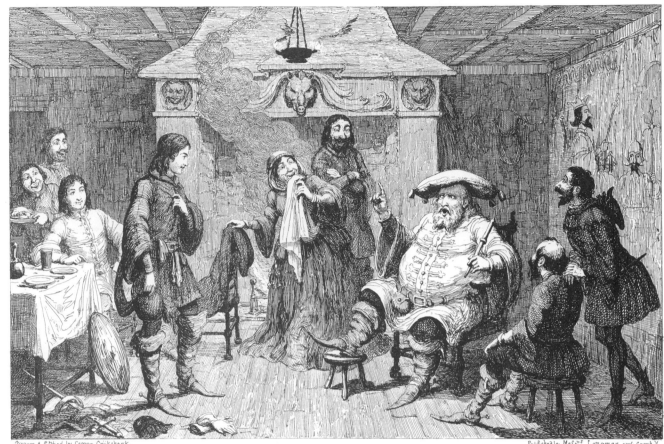

250

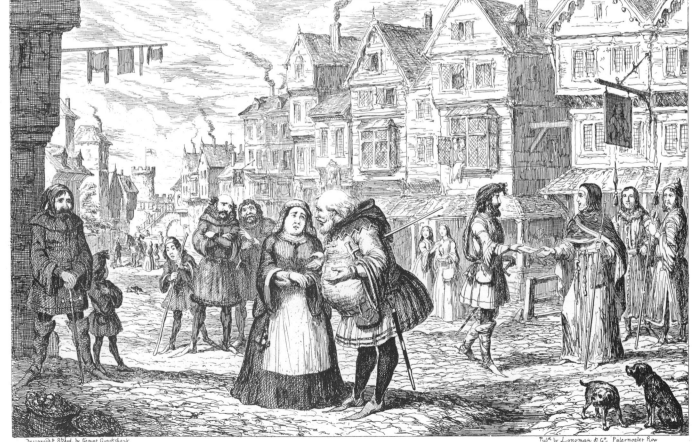

251

From *The Life of Sir John Falstaff.* **250.** Falstaff, enacting the part of the King. **251.** Sir
John Falstaff . . . induces Mrs. Quickly to withdraw her Action. . . .

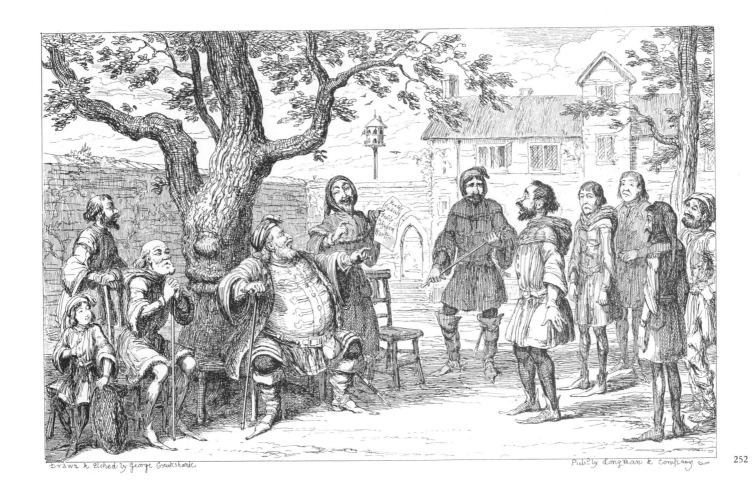

Drawn & Etched by George Cruikshank                                                    Pub.d by Longman & Company    252

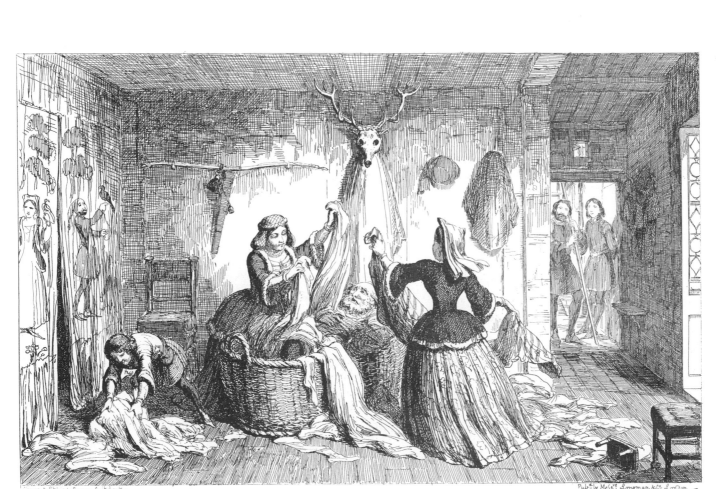

Drawn & Etched by George Cruikshank                                              Pub.d by Mess.rs Longman &C.o London    253

From *The Life of Sir John Falstaff*. **252.** Sir John Falstaff . . . exercising his wit & his judgement in selecting men to serve the King. **253.** Sir John Falstaff—in the Buck-basket.

**254.** Cover of "La Bagatelle" (song sheet).

**255.** Cover of *Fairy Songs & Ballads* by O. B. Dussek.

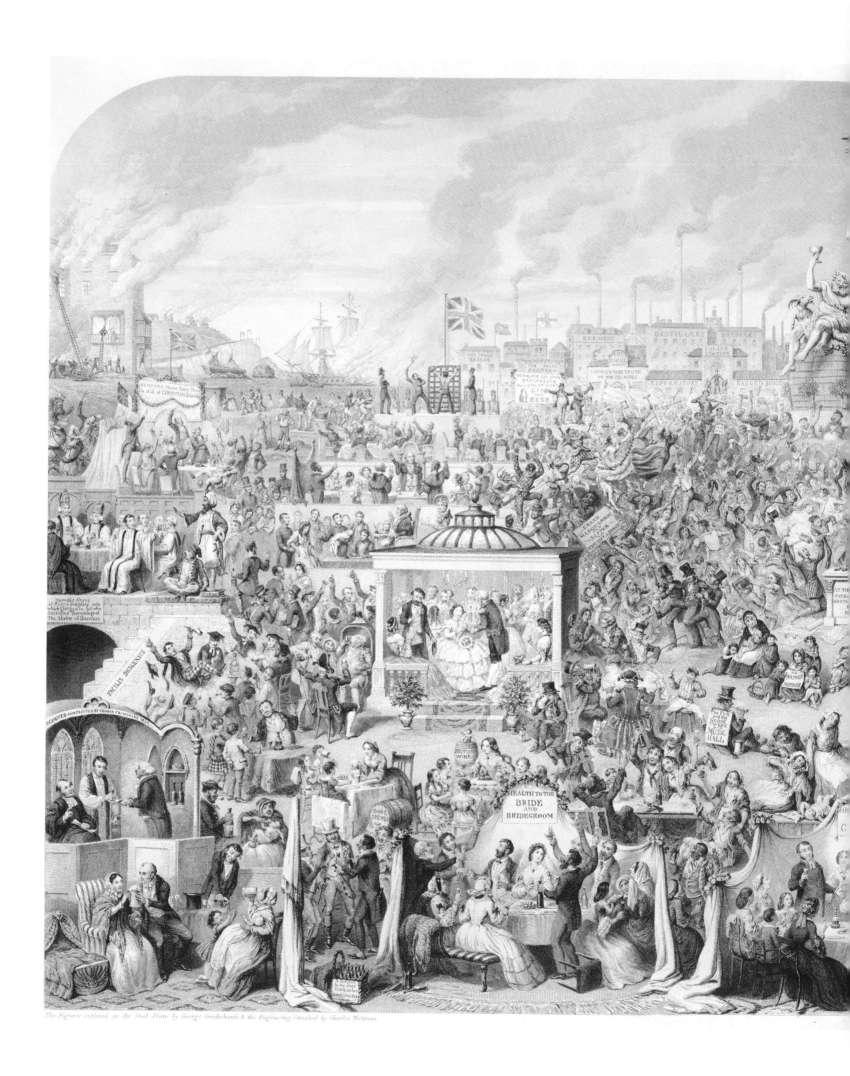

**256.** The Worship of Bacchus, or the Drinking Customs of Society (entire print).

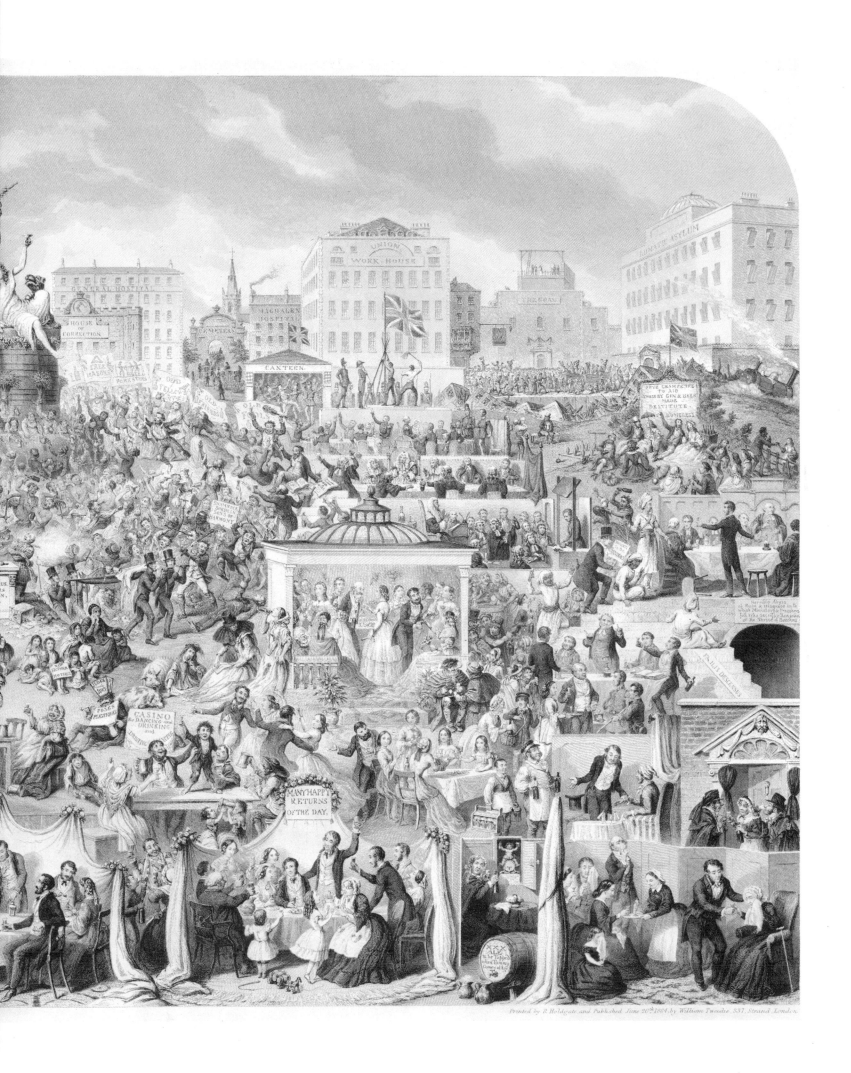

Printed by P. Holdgate, and Published June 20th 1861 by William Tweedie, 337 Strand London.

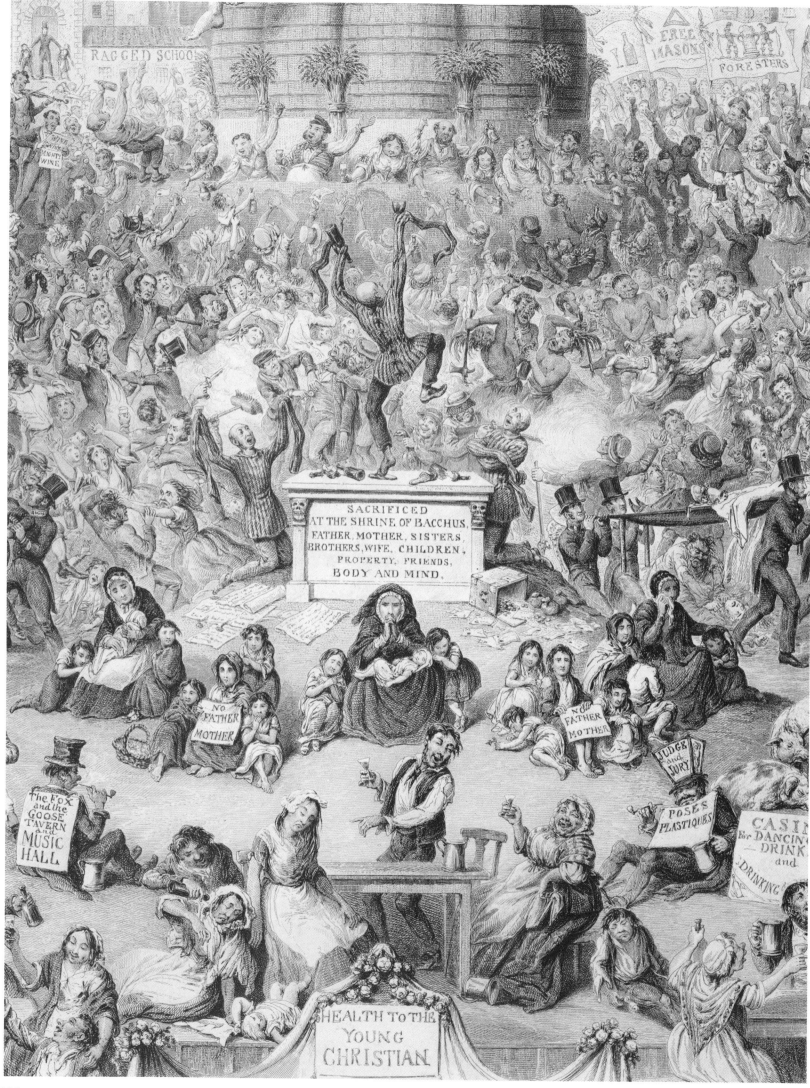

257. The Worship of Bacchus (detail at actual size).

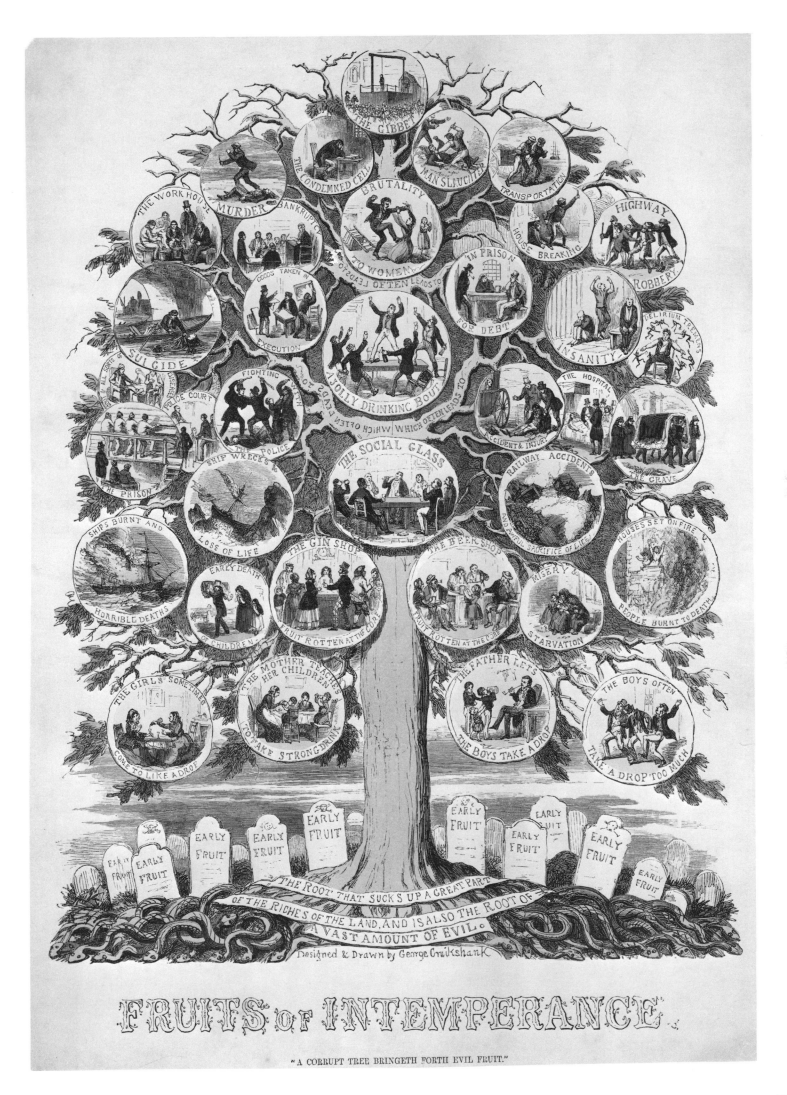

**258.** Fruits of Intemperance.

**259.** Design for a Ritualist High Church Tower and Steeple Dedicated to Dr. Pusey and the Vicar of Bray.

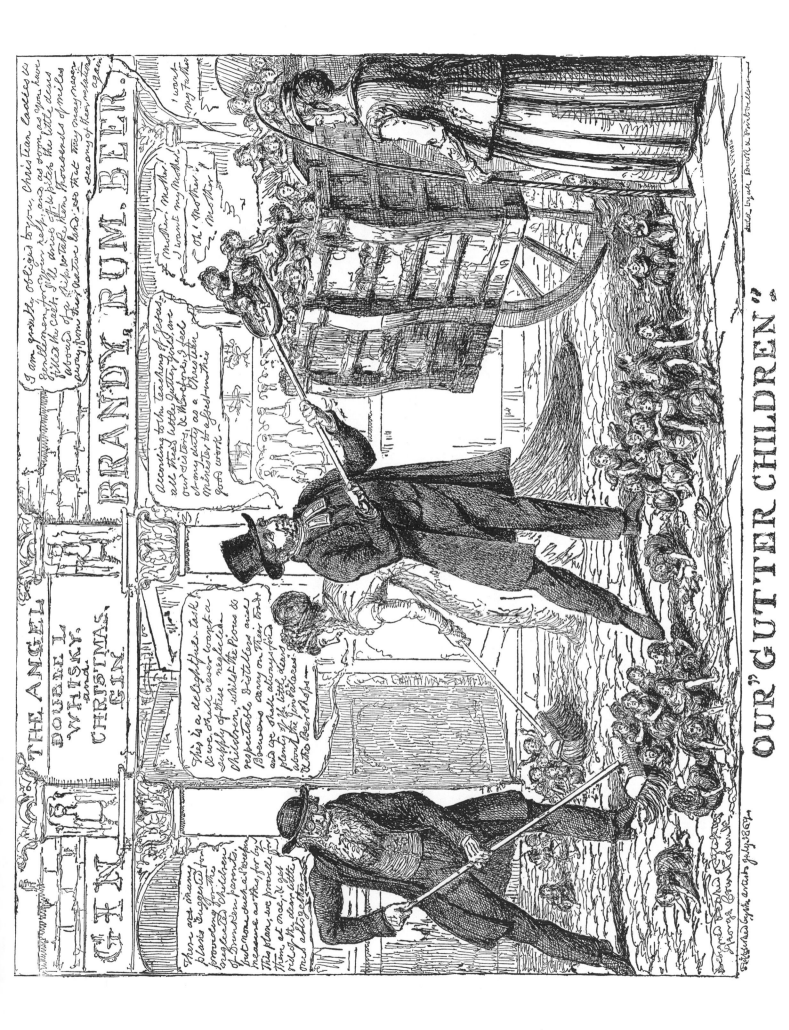

OUR "GUTTER CHILDREN."

260. Our "Gutter Children."

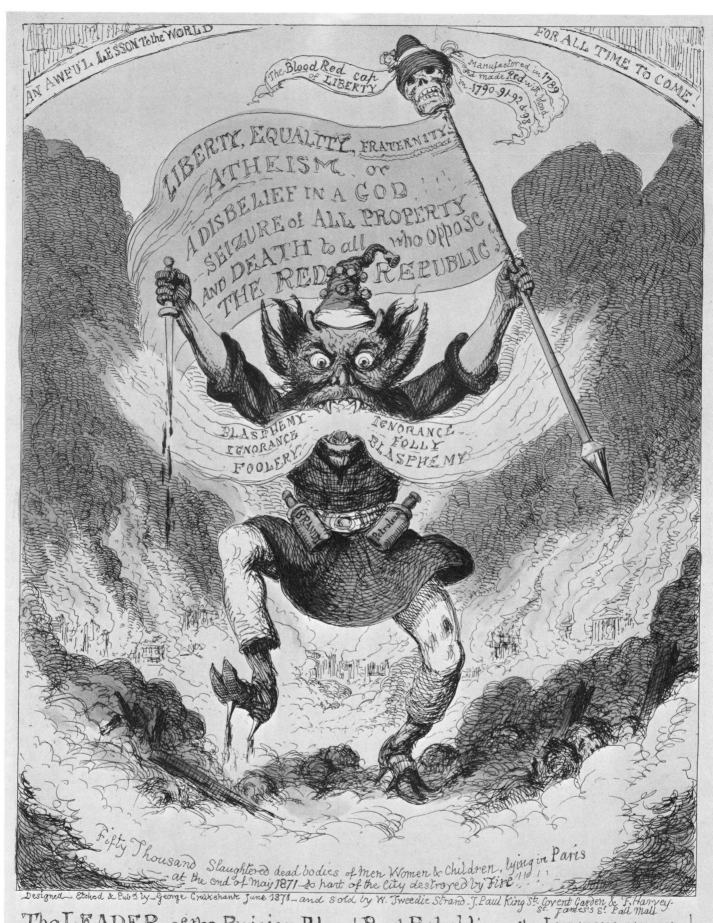

**261.** An attack on the Paris Commune of 1871.

# Notes on the Illustrations

The following notes briefly describe the subject matter of each illustration. Individually published works are listed by title followed by text author (where applicable), publisher, date, medium of artwork, and a citation to Albert M. Cohn's catalogue raisonné. Wherever applicable to caricatures, citations are included from volumes VIII through XII of Mary Dorothy George's *British Museum Catalogue of Political and Personal Satires* (London, 1949–1954), here cited as "B. M." In the case of multiple illustrations from a single series or a single illustrated book, the entire series or book is discussed first, before each item is discussed individually. Both caricatures and illustrations have been included in approximate chronological sequence but with some variation because of subject groupings and aesthetic considerations. The black-and-white illustrations are designated with Arabic numerals. The notes on the eight color plates (which are designated with Roman numerals) follow the notes to Plate 24, thus bringing to a close the section on caricatures.

**Frontispiece:** A JOURNEYMAN PRINTER'S DESCRIPTION OF THE ART OF ETCHING ON COPPER. 4 May 1859. Etching (Cohn 1268). At the time of this work the artist was 67 years old and had become a relic of his former self who occasionally lectured on the graphic process he had used during most of his long career, a process which had become outmoded for reproductive work. According to the inscription, Cruikshank did this demonstration etching when describing the process at a Hampstead *conversazione,* the term used by Victorians to describe a conversational gathering pertaining to art, literature, and science. Albert Cohn notes that the etching is extremely rare, as only a few copies were taken for distribution among the audience. This is probably true, but I have seen more carefully printed copies, which probably date from a later period. The journeyman's joke about *a-ke-ta-ke* refers to aqua-fortis, the acid traditionally used in the etching process. The word *aqua* is misspelled in the explanatory footnote in the etching itself. The journeyman points to a plate which is clearly a self-portrait of Cruikshank.

**1.** THE THEATRICAL ATLAS. Published by Hannah Humphrey, London, 7 May 1814. Hand-colored etching (Cohn 2029, B. M. 12325). This print portrays the famous actor Edmund Kean in the role of Richard III standing on a volume of Shakespeare, with his left arm on a sword labeled "A *KEEN* Supporter." He holds on his head and hunched back a model of Drury Lane, on the steps of which stands Samuel Whitbread, a brewer ("Whitbread's Entire Ale") and lessee of Drury Lane, who engaged Kean to save the almost bankrupt theater. It was in January 1814 that Kean made his triumphant debut there. The trumpets of the angel at the top are emitting "puffs"—adulatory critiques and publicity releases.

**2.** FARE THEE WELL. Published by J. Johnston, London, without date. Upper half, hand-colored etching; lower half, printed broadside (Cohn 971, B. M. 12827). This undated broadside probably appeared sometime after the publication of Byron's poem "Fare Thee Well" on 14 April 1816 and before the poet's departure from England on 24 April. The recognizable portrait of Byron is supplemented by his name on the skull-cup. His estranged wife, baby in arms, stands on the shore as he, accompanied by three women, is rowed to the waiting ship by a syphilitic sailor. The remark of the smug sailor at the railing—"I say Jack I hopes he's got enough on 'em aboard!"—refers to the women accompanying Byron, as does his companion's reference to the women as "fine vessels."

**3.** BONEY HATCHING A BULLETIN OR SNUG WINTER QUARTERS!!! Published by Walker & Knight, London, December 1812. Hand-colored etching (Cohn 940, B. M. 11920). Napoleon is shown up to his neck in snow, discussing with his officers what kind of falsely optimistic bulletin to release about his retreat from Moscow. The full extent of the retreat of the French army was not known in England until December, but it was suspected before that time. This particular caricature refers to a bulletin of 27 October in which the French speak of the beautiful weather at autumn's end, the excellent roads, and the new position they plan to take for their winter quarters. "Cut-us-off" is a clever reference to Field Marshall Mikhail Kutuzov, commander of the Russian forces. The "cowpoxed," forming a pun with "John Bull," refers to smallpox vaccination, first publicly practiced in the 1790s in England.

**4.** FRENCH CONSCRIPTS FOR THE YEARS 1820, 21, 22, 23, 24, & 25. MARCHING TO JOIN THE GRAND ARMY. Published by S. Knight, London, 18 March 1813. Hand-colored etching (Cohn 1123, B. M. 13486). This caricature depicts a wooden-legged French veteran recruiting small children for Napoleon's last army. Many of Cruikshank's caricatures for Tegg and for Knight in Sweeting's Alley represent English middle-class loathing for the French and are among his most ferociously satiric designs.

**5.** LITTLE BONEY GONE TO POT. Published by Thomas Tegg, London, 12 May 1814. Hand-colored etching (Cohn 1322, B. M. 12261). This caricature depicts Napoleon in

exile on Elba seated on a chamber pot inscribed "Imperial Throne." The devil offers him a gun and admonishes him to kill himself if he has any courage left. In the foreground is "A Treatise on the Itch! by Doctor Scratch," which refers to an affliction Napoleon suffered from while on Elba. The Imperial Eagle has been replaced by a crow nailed to a tree.

**6. THE PEDDIGREE OF CORPORAL VIOLET.** Published by Hannah Humphrey, London, 9 June 1815. Hand-colored etching (Cohn 1834, B. M. 12551). Caricatures and the ideas for them are often the result of involved collaborations. Cruikshank etched this design and credits "G. H.," George Humphrey, for the idea and for the original drawing. The concept of a person growing from a dunghill goes back probably more than two decades, at least to the time of James Gillray's 1791 caricature of Prime Minister Pitt as "An Excrescence;—A Fungus;—alias—a Toadstool upon a Dunghill." The use of the bouquet of violets originates from a statement that Napoleon supposedly made during the Hundred Days. When asked when he would return to Fontainebleau, he replied that he would be back in violet time. The outlined profiles of Napoleon, Maria Louisa, and their son had appeared earlier in England in a small caricature by Rowlandson. Cruikshank added more violets in this bouquet, as well as the hidden full-length profile of Napoleon. In the left background are small representations of Louis XVIII, Czar Alexander I, Blücher, and Wellington. The transformation of a toadstool cap of liberty into a dandelion, with an Imperial Sunflower and the Elba fungus hovering overhead, seems original to this design. The hidden portraits in this design may require further identification before they can be seen readily by an eye unaccustomed to "transformations" in visual representations. To locate Napoleon's profile, look at the central violet at the top of the bouquet, then at the melon-shaped leaf directly below: it forms the emperor's hat on Napoleon's head seen in left profile. The bust of Maria Louisa, seen in right profile almost directly opposite that of Napoleon, forms a part of the left-hand border of the bouquet. To locate the outlined head of Napoleon's son, find the budding violet between the Emperor and his wife and look down to the point where three stems come together. The head of the young son is revealed facing right. The full-length figure of Napoleon is more difficult to discern than the profiles, but his booted left foot dug into the top of the Elba fungus can be seen quite readily.

**7. BONEY'S MEDITATIONS ON THE ISLAND OF ST. HELENA— OR—THE DEVIL ADDRESSING THE SUN.** Published by Hannah Humphrey, London, August 1815. Hand-colored etching (Cohn 944, B. M. 12593). This caricature is an adaptation of Gillray's 1784 caricature, "Gloria Mundi, or—The Devil addressing the Sun," with Napoleon taking the place of Charles James Fox. The literary reference is to Satan's soliloquy after his fall in Book IV of *Paradise Lost,* and Cruikshank credits G. H. (George Humphrey) for the idea for this design. Many critics, most notably R. H. J. Douglas, one of Cruikshank's bibliographers, have considered this the most noteworthy of Cruikshank's Napoleon caricatures. Napoleon, depicted as Satan, stands as a colossus on the island of St. Helena. The sun is the Prince Regent, the future George IV, with the three plumes and "Ich Dien" motto emblematic of the Prince of Wales (the "G. P. Rt." in Napoleon's speech balloon stands for "George, Prince Regent"). The sunbeams are Napoleon's conquerors: Czar Alexander I, Friedrich Wilhelm III of Prussia, Franz II of Austria, the Dutch King Willem I, four heroes of Waterloo—

Blücher, the Duke of Wellington, the Marquess of Anglesey, and Viscount Hill—and Viscount Beresford, a commander in the Peninsular War. This caricature is another ingenious adaptation of previously used motifs.

**8. VILLAGERS SHOOTING OUT THEIR RUBBISH.!!!** Published by Thomas Tegg, London, 15 December 1819. Hand-colored etching (Cohn 2082, B. M. 13286). The caricature depicts the outskirts of a village with its gleeful inhabitants carting away in wheelbarrows a mortified barrister, a disgruntled apothecary, and a fat, gouty parson with "grog blossoms" on his face. In the middle distance, other rustics cheer as they watch the removal of these disturbing unwanted residents from their village. According to Mary Dorothy George, this is both a political caricature and a comic print. The classification of caricatures can be quite complex, however, since any single work can be placed in several categories, depending on one's point of view. This print, done for Tegg of 111 Cheapside, exemplifies Cruikshank's broad manner of etching. Cruikshank's career as a caricaturist was considerably influenced by his public, this work being an example of the cruder style that he used in works intended for a lower-class audience.

**9. AN INTERESTING SCENE, ON BOARD AN EAST-INDIAMAN, SHOWING THE EFFECTS OF A HEAVY LURCH,—AFTER DINNER.** Published by George Humphrey, London, 9 November 1818. Hand-colored etching (Cohn 1238, B. M. 13044). This print is after a design of an amateur (in this case Captain Francis Marryat, as can be seen by the use of an anchor in the lower left-hand corner). Like many of Cruikshank's Regency caricatures, this print has some indelicate motifs. It has been said that Cruikshank never did a work that would bring a blush to a young lady's cheek, but the bawdy details evident in this and many other Cruikshank caricatures serve to dispel such a notion.

**10. R-Y-L CONDESCENSION—OR A FOREIGN MINISTER ASTONISHED!—APRIL 1817.** Published by S. W. Fores, London, 15 September 1817. Hand-colored etching (Cohn 1914, B. M. 12890). This caricature is the second in a pair of prints dealing with Princess Caroline and her Italian lover Bartolomeo Bergami. In this design, Princess Caroline, accompanied by her two children Charlotte and William, introduces Bergami and two of his "suite" to Count Metternich, a meeting which took place in April 1817. The pictures on the wall offer captioned commentaries on the main characters. In case one misses the point, there are at least four—and perhaps up to eight—phallic representations in this composition, including the Princess' headdress. Caroline wears a diaphanous harem costume which was said to have shocked English ambassadors when she appeared in it during her European travels.

**11. ROYAL HOBBY'S, OR THE HERTFORDSHIRE COCK-HORSE!** Published by M. Clinch, London, 20 April 1819. Hand-colored etching (Cohn 1921, B. M. 13220). Although not signed, this caricature seems clearly to be Cruikshank's work. It is one of the artist's most scurrilous depictions of the Prince Regent; Lady Hertford and her cuckolded husband appear in illustration 23. There is another version by J. L. Marks which I personally feel can be assumed to postdate Cruikshank's composition. Although Cruikshank did adapt and copy other artists' designs, he generally is a source for other inferior graphic artists and seldom, if ever, uses a contemporary's design without credit.

**12. A Scene in the New Farce—as performed at the Royalty Theatre!** Published by George Humphrey, London, 14 February 1821. Hand-colored etching (Cohn 1964, B. M. 14118). This caricature depicts George IV as Henry VIII receiving a petition from his subjects, who are portrayed as oxen with their horn tips covered with tiny liberty caps. The incident pictured refers to the petitioning by the London citizens to have the King's ministers removed. The ministers standing on either side of the throne are all grotesquely satirized. In the background, beefeaters carry large forks and eye the oxen greedily. Even the stained-glass windows have symbolic meaning: the royal coat of arms contains an escutcheon with a decanter in its middle, and the three feathers at the top of each window have become peacock feathers of pride. The ceiling, which is decorated with antlers, seems to make reference to cuckoldry.

**13. The Royal Extinguisher, or the King of Brobdingnag & the Lilliputians.** Published by George Humphrey, London, 7 April 1821. Hand-colored etching (Cohn 1919, B. M. 14145). The invention of this design is credited to George's older brother, Isaac Robert. The theme derives from the famous incident in Swift's *Gulliver's Travels* in which Gulliver puts out a fire or, possibly, from Gillray's Brobdingnag caricatures. The Queen is depicted with the flaming torch of discord, surrounded by radicals and trouble-makers; the King is shown placing a bag shaped like an extinguisher over the Lilliputians. Much of the Queen's popularity diminished after she was offered £50,000 per annum, which she holds in one hand, labeled "Crumbs of Consolation." The ministers, including Wellington (upper right), watch the extinction of the Lilliputians with obvious delight. The painting on the wall, repeating a common device of the late eighteenth and early nineteenth centuries (often used by Gillray), represents the sun of enlightenment driving away the owls and snakes of obscurantism. The verses at the bottom are from a stanza of the British national anthem.

**14. The Cholic.** Published by George Humphrey, London, 12 February 1819. Hand-colored etching (Cohn 995, B. M. 13438). This caricature is part of a medical series of six plates dating from the years 1819–1825. (For others in this series, see illustration 15 and color plate VI.) "The Cholic" and "The Head ache" (color plate VI) were copied by Daumier while he was in prison, appearing in *Le Charivari* in 1833 in a series titled *L'Imagination*. The anchor next to Cruikshank's signature once again indicates that the series was done from subjects suggested by Captain Marryat. The picture on the wall depicting a stout woman presumably drinking gin perhaps offers a commentary on the cause of the cholic. In Cruikshank's work, as earlier in Hogarth's prints, wall hangings invariably offer added commentaries on the themes at hand.

**15. A Cure for Drowsiness—or—A Pinch of Cephalic.** Published by George Humphrey, London, 25 January 1822. Hand-colored etching (Cohn 1031, B. M. 14442). Cruikshank etched this plate from a sketch by James Gillray, who had died in 1815, and included a portrait of Gillray on the background wall. This caricature was published by Humphrey, Gillray's publisher, and is, in a sense, a tribute to the man who substantially influenced Cruikshank and whose place at Humphrey's was taken by Cruikshank after Gillray was no longer able to work. According to tradition, George Cruikshank even inherited Gillray's worktable. "Cephalic" refers to cephalic snuff, a remedy for head colds.

**16. Universal Suffrage or—The Scum Uppermost—!!!!!** Published by George Humphrey, London, 17 July 1819. Hand-colored etching (Cohn 2065, B. M. 13248). An allegorical representation of a trophy showing the consequences of the "radical reform" which Cruikshank believed to be nothing less than "Revolution." This caricature, done for Humphrey and his upper-class clientele, was etched after a suggestion by a gentleman whose cipher appears at the lower left of the design. The bird-like monster at the top of the design, typical of Cruikshank's grotesque creations, triumphs over the arts, royalty, religion, the Bill of Rights, the Magna Charta, and numerous other institutions cherished by the English. Perhaps the artist's use of only his initials on this plate, done when he was working on some radical pamphlets with William Hone, suggests that he was not entirely sympathetic with the political sentiments expressed in the design. It can be argued that Cruikshank, like some of his predecessors, takes a stand on an issue in accordance with the ideas of his employer without regard to his own opinion. It is, however, difficult to determine the artist's attitudes on many issues, since he seemed by nature to be a peculiarly English middle-class combination of the radical and the reactionary.

**17. Death or Liberty! or Britannia & the Virtues of the Constitution in danger of Violation from the grt. Political Libertine, Radical Reform!** Published by George Humphrey, London, 1 December 1819. Hand-colored etching (Cohn 1048, B. M. 13279). In this design, Death, wearing the mask of Liberty, attacks Britannia, who holds a sword labeled "The Laws" and leans one arm against a rock labeled "Religion." The British Lion, with a collar labeled "Loyalty," is approaching from the rear, and Death is accompanied by a number of demons holding up scrolls inscribed with crimes characteristically charged against radicals by their political opponents. One of these creatures, formed of chains and fetters and wearing a cap of liberty, is a good example of Cruikshank's brilliant use of animism. The figure of Death holds on a pike a cap of liberty which, since the French Revolution, had become a symbol of violent radicalism. This particular cap, toward its end, blends into a belled fool's cap. The designation "invt. et fect." indicates that Cruikshank both designed and etched this caricature, thus suggesting that he, like most middle-class Englishmen, was not in sympathy with radical reform even during the time he worked with one of England's most notable radical thinkers, William Hone.

**18. Monstrosities of 1821.** Published by George Humphrey, London, 20 May 1821. Hand-colored etching (Cohn 1751, B. M. 14310). Cruikshank caricatured the fashions of the day in a series of eight plates titled "The Monstrosities," beginning in 1816. A ninth plate, done in 1827, the year after Cruikshank's last plate, was executed by his brother Robert. A comparison of Cruikshank's depictions with illustrations then appearing in fashion magazines affords a study of the would-be sublime reduced to the ridiculous. Caricatures on fashions began in the eighteenth century and continued to be popular long after Cruikshank virtually ceased doing caricatures.

**19. A Lollipop—ally Campagne—a Bull's Eye and a Brandy Ball.** Published by George Humphrey, London, 20 March 1822. Hand-colored etching (Cohn 2018, B. M. 14444). One can see that this caricature, though its credit notation is partly obliterated, was etched by Cruikshank from an idea or rough sketch by "T. C." (lower left). This work

shows the interrelationship of text, primary composition, and supplementary visual reinforcement. Each of the four kinds of candy typifies one of the four women; each picture on the background wall depicts a scene identifiable with the character of the woman below the hanging. The Lollipop's name, then as now synonymous with a "sucker," well suits the pregnant condition of the young woman whose romantic inclinations are visualized in the upper-left picture of a woodside rendezvous. The love note on the floor, as well as the tomcat's pursuing the female cat, further establishes her plight. The stolid, staid domesticity of the "ally Campagne," a name probably derived from a type of country candy (French *à la campagne*), is mirrored by the reproof on her face, the mending of a stocking, and the picture above her head of a country squire amusing his baby while his wife, presumably another "ally Campagne," toils at her spinning wheel. The reproachful Bull's Eye, named after a hard globular kind of candy, wears glasses that transform her eyes into dot-like bull's-eyes. Her latent envy of the young Lollipop is suggested both by the reading matter sticking out of her pocket, "Tales of Scandal," and by the picture over her head of Aesop's fable of the fox and the grapes. The Brandy Ball, so named, possibly, for evoking images of liquor-centered candy, has a brandy bottle protruding from her dress, while the picture above her shows a pair of topers regaling themselves with a toast to friendship and drinking. The brandy-loving abortionist called in to alleviate the plight of the Lollipop is a stereotypic forerunner of a character like Sairey Gamp in Dickens' *Martin Chuzzlewit.* There is a second state of this plate with an etched title above the design reading "Symptoms of Misconduct, or Detection, Accusation, and Conviction."

**20. A Scene in the Farce of "Lofty Projects" as performed with great success for the Benefit & amusement of John Bull.—Anº D 1825.** Published by George Humphrey, London, 17 July 1825. Hand-colored etching (Cohn 1963, B. M. 14787). According to Cruikshank's note on the original drawing in the Print Room of the British Museum, the idea for this caricature, drawn and etched by Cruikshank, was suggested "by my friend, Tom Greenwood." Cruikshank here follows the long tradition in caricature, stemming from Hogarth in his 1721 print on the South Seas Bubble, of using the balloon as an emblem of the fraudulent and fantastic nature of certain speculative economic ventures. A caricature of this kind combines verbal commentary with visual representation in a complex, highly sophisticated way. Precisely because of its theme, this caricature has always been one of Cruikshank's most costly and sought-after designs. The etching in this plate is characteristic of Cruikshank's style one year before he virtually gave up caricature; it exemplifies a stylistic break with his earlier, more finished designs done for Humphrey in a style resembling that of James Gillray.

**21. The "System" that "Works so Well"!!—or The Boroughmongers Grinding Machine.** Published by S. Knight, London, 21 March 1831. Hand-colored etching (Cohn 2019, B. M. 16610). This work, executed after Cruikshank's production of caricatures had considerably dwindled, is an attack on the defenders of the borough system. It shows graphically, with cannons supporting the borough church and rifles with bayonets holding up the borough bridge, a chute dispersing public money to pensioners, or wallowers in the public trough. This is how Cruikshank felt about the practice of giving sinecures to one's friends. In this instance the cause was apparently important enough to Cruikshank to elicit another caricature.

**22. Beauties of Brighton.** Published by S. Knight, London, 1 March 1826. Hand-colored etching (Cohn 914, B. M. 15156). The design for this caricature is credited to Alfred Crowquill. A watercolor drawing by Crowquill in the Victoria and Albert Museum identifies each of the notables depicted in the caricature. The background consists of an exuberantly exaggerated depiction of the Brighton Pavilion. It is probable that many depictions in Cruikshank's caricatures represented actual people, as is the case with most of the persons in this design.

**23. The Court at Brighton á la Chinese!!** Published by J. Sidebotham, London, without date. Hand-colored etching (Cohn 1026, B. M. 12749). An undated caricature of George IV, done about March 1826 according to evidence within the caricature itself. Lady Hertford sits on the King's right, making the sign of cuckoldry above Lord Hertford, who appropriately holds a staff of deer antlers and is decorated with antlers from his chin to his crotch. One interesting touch on the right-hand side is a reference to the King's well-known interest in literature and the arts: a portfolio labeled "Curious Prints," a copy of *Fanny Hill,* and several caricatures of the King himself. At the top of the print the dragon holding a pagoda lamp very much resembles the actual fixture in the Pavilion dining room.

**24. The Four Mr. Prices.** Published by George Humphrey, London, 5 January 1825. Hand-colored etching (Cohn 1122, B. M. 14901). Cruikshank was assisted in the etching of this plate by his sister, Eliza Margaret Cruikshank, a fact acknowledged by her initials in the signature at the lower right. Possibly the plate refers to Stephen Price, an American who became the manager of Drury Lane for the season of 1826, but the more important and universal theme is changing prices in an unstable economy. Although this print was done for the publisher Humphrey and therefore typifies Cruikshank's most refined caricature style, the amateurish hand of his sister is evident in certain detail work.

\* \* \*

*A description of color plates I–VIII follows.*

**I. Inconveniences of a Crowded Drawing Room.** Published by George Humphrey, London, 6 May 1818. Hand-colored etching (Cohn 1229, B. M. 13046). This is one of Cruikshank's most famous caricatures. According to Mary Dorothy George, the scene is a reception in a drawing room at the Queen's House, now Buckingham Palace. The men wear court dress. The painting over the door represents the Queen; the portrait on the right, the Prince Regent. This print, with its marvelous delineation of faces, costume, and situation, ranks as one of the masterpieces of English caricature. The coloring, as in most of the designs published by Humphrey, seems to be consistent from one impression to another. Probably the artist himself tinted one impression for use by the house colorers as a model. At least two contemporary copies exist, one Irish and one done in reverse. (For further discussion of these, see the Introduction.)

**II. Hard Times or, O! Dear what will become of us O! dear what shall we do?!!!!** Published by Thomas Tegg, London, 10 February 1814. Hand-colored etching (Cohn 1178, B. M. 12185). This caricature depicts the increased unemployment toward the end of the Napoleonic Wars. Apparently it was the custom for the unemployed to walk the streets of London carrying the tools of their trade on a pole while holding out their hats for money, as is being done by

the poor gardeners who lead this procession. The third group consists of two artists, one of whom is a caricatured self-portrait. Cruikshank has literally given himself crooked shanks and has signed this caricature "Poor Shank's fect." "Poor Boney" is led by a devil and his emblem consists of a grotesque depiction of the Prince of Rome seated on the Imperial Eagle's head. The next group consists of four prostitutes titled "Poor Dolley's." The obese one, a Cruikshankian forerunner of Nancy in *Oliver Twist,* contrasts sharply with the young girl and the handsome woman seen in profile, the latter clearly derivative from Rowlandson's depictions of prostitutes. Cruikshank is working in his best broad manner for Tegg in this caricature. Unlike the coloring done for Humphrey, the Tegg coloring frequently differs from impression to impression. The etching is not always consistently well printed. The color, which is usually quite bright and deep, is not applied with the care or palette one finds in the Humphrey caricatures.

III. Review of the French Troops on their returning March through Smolensko. Published by Hannah Humphrey, London, 27 May 1813. Hand-colored etching (Cohn 1900, B. M. 12051). One of a series of prints done by Cruikshank after Russian originals, depicting Napoleon's retreat from Moscow. The original Russian inscription has been copied quite accurately by Cruikshank at the top of this print; it reveals the true date of the communication (from Warsaw) that appeared in the Hamburg journal—the 14th of *November* of 1812 (Napoleon was in Smolensk from the 9th to the 14th) rather than the impossible 14th of March given by Cruikshank at the bottom of the print. Although the general design derives from the poorly etched original, certain features of the costumes of the bedraggled troops, as well as Napoleon's dripping nose, were added by Cruikshank. Notable in this design is Cruikshank's delineation of Napoleon's officers as foppish.

IV. Snuffing Out Boney! Published by Thomas Tegg, London, 1 May 1814. Hand-colored etching (Cohn 1992, B. M. 12254). This caricature of a huge cossack getting ready to snuff out Napoleon, who is emerging from a flat candlestick on a stool, is done in Cruikshank's broad manner and shows that he had developed a unique style of etching as early as 1814. The picture on the wall is a variation on the main theme. The candle and snuffer idea had appeared numerous times in caricature before Cruikshank's use of it here. Adapting stock motifs in this manner, however, is quite characteristic of Cruikshank's modus operandi. The bright, almost opaque colors are once more typical of those used in Tegg caricatures, although they differ in various impressions. This caricature was done in facsimile by Pailthorpe, one of Cruikshank's protégés in etching who did a great number of copies of Cruikshank's rare works, presumably for inclusion in a revised edition of G. W. Reid's catalogue. Because the revised edition never appeared, the copies have often been mistaken for the originals.

V. The Genius of France Expounding Her Laws to the Sublime People. Published by Hannah Humphrey, London, 4 April 1815. Hand-colored etching (Cohn 1152, B. M. 12524). This print satirizes the Napoleonic Code. The butterfly on the large monkey's head represents emblematically the changeable nature of the French, as do the weathercock and the windmill with four conflicting labels on its vanes. Such symbols derive from long-standing tradition in both French and English caricature. The cap of liberty on some of the small monkeys and the elaborate foppish costume on many of them further emphasize Cruikshank's opinion of the French as stupid and fickle. In view of the forthcoming adoption of the metric system by the English-speaking world, the ridicule of the metric system indicated by the carefully spaced ribbons on the large monkey's tail now strikes a note of unintentional irony. This print, perhaps, as much so as any, exemplifies the scorn that Cruikshank and most of his English middle-class audience felt for their neighbors across the Channel.

VI. The Head ache. Published by George Humphrey, London, 12 February 1819. Hand-colored etching (Cohn 1186, B. M. 13439). The anchor at the lower left-hand corner indicates that the idea for this print was suggested by Captain Marryat (see note to illustration 9). This design, perhaps Cruikshank's most famous medical caricature, shows the artist working in his best Gillray style of etching. The limp arm with the empty medicine bottle, as well as the other arm and the legs, contrasts vividly with the agonized expression of the face. The demonic pleasure of the six tormentors and their various implements of torture contribute to the effectiveness of this print. As mentioned in the note to illustration 14, this design was copied by Daumier in the series entitled *L'Imagination.* Possibly Daumier derived from Cruikshank the use of a major character surrounded by several small figures, seen in this print and in "The Cholic."

VII. "Ah! sure such a pair was never seen so justly form'd to meet by nature." Published by George Humphrey, London, 23 June 1820. Hand-colored etching (Cohn 877, B. M. 13735). Cruikshank humorously credits the idea for this design to "Broom," thus referring to Lord Brougham's statement that if the King had a green bag the Queen might have one too. Early in June, George IV, England's most notorious adulterer, sent the evidence of Queen Caroline's immoral conduct to Parliament in two green bags, the customary means of conveying legal papers. The green bag thus became a kind of symbol for trumped-up or tainted evidence. The use here, as in caricatures by other artists, of a pear shape for the green bag and for the head of the Prince Regent himself, anticipates the use of that shape in French caricature of the following decade. The title of this print, deriving from a much-quoted song in Sheridan's comic opera *The Duenna* ("Sherry" was a nickname for the playwright), implies that if the Queen was guilty of immoral conduct, the King was just as much at fault. The smug countenance of the Queen contrasts sharply with the frightened face of the King. Interestingly enough, it is a matter of public record that George Cruikshank was paid £100 in June 1820 by George IV as consideration for the artist's promise not to portray His Majesty in any immoral situation. The fear of adverse publicity at the time the Queen was to be tried for adultery in the House of Lords presumably accounts for this outright bribe to silence one of England's most popular caricaturists.

VIII. Poor Bull & his Burden—or the Political Murraion!!! Published by Thomas Tegg, London, 15 December 1819. Hand-colored etching (Cohn 1857, B. M. 13288). This caricature shows John Bull as an animal with shackled limbs, a mouth muzzled by the Gagging Bill, and an enormous burden of taxation that supports civil, military, and ecclesiastical employees. Various ministers are portrayed in the pyramid; Lord Wellington is shown in front of the bull, wearing a butcher's apron and carrying an axe. This vitriolic satire on taxation, militarism, and civil and ecclesiastical cor-

ruption was copied by Henry Heath and, in at least one instance, by someone else in a penny broadside. The word "murraion" is a misspelled version of murrain, which denoted various cattle diseases, such as anthrax and hoof-and-mouth disease. The phrase "the land stank" is a reference to the plagues inflicted upon Egypt at the bidding of Moses. The "Gagging Bill" on the bull's muzzle refers to the Libels Act of 1819, which was one of many such statutes restricting freedom of speech and of the press.

\* \* \*

**25.** Mrs. Topper's Dream; or, Overboard She Vent. Published by Joseph Robins, London, without date. Upper half, hand-colored etching; lower half, printed broadside (Cohn 1969, B. M. 11988). George Cruikshank began his career in graphics by assisting his father Isaac in the production of song sheets for companies like Laurie & Whittle. This undated songhead is described by Cohn as "an extraordinarily characteristic etching." Here Cruikshank is working in his broad manner and the whole composition and style of etching are indeed characteristic of the commercial work of the artist's early days, perhaps as early as 1812. Usually such songheads related to performances at specific theaters in London, and one must assume that the artist had attended the theater and subsequently produced a song sheet to take advantage of the commercial success of a dramatic musical performance. Such song sheets were sold by street vendors as well as by the publishers themselves.

**26.** Frontispiece to "The Surprising History of Jack and the Beanstalk." Published by Dean and Munday, London, 1821 (Cohn 446). This is an unsigned, colored, etched frontispiece, folding in three sections. It offers an interesting contrast to Cruikshank's later depictions of Jack and the Beanstalk in his own *Fairy Library* (see illustrations 241 and 242). Many of these early commercial ephemera are credited to Cruikshank solely on the basis of his holographic authentication of items brought to him by collectors during the last few decades of his life. Because of their evanescent nature, such charming but rather crudely executed productions are now among the scarcest of all Cruikshank works.

**27.** Frontispiece to "Fairburn's Description of the Popular & Comic New Pantomime called Harlequin and Mother Goose, or the Golden Egg." Published by John Fairburn in London, late 1806 or early 1807 (Cohn 280). This extremely successful pantomine was produced at Covent Garden on 26 December 1806, with the famous Joseph Grimaldi as Clown and with Samuel Simmons as Mother Goose. According to a note in George Cruikshank's handwriting in Edwin Truman's copy, this colored etched frontispiece for a chapbook was the first etching done solely by the artist and shows his considerable ability at the age of 14. Not surprisingly, this style of etching resembles that of his father, Isaac Cruikshank, much more than the personal style the son evolved during the first decade of his career. The goose as a decorative motif in conjunction with Mother Goose occurs again in a woodcut advertisement for Warren's Blacking (see illustration 31).

**28-36.** [Lottery Puffs and Advertisements.] Wood engravings with letterpress. During his early career Cruikshank did over 360 designs for wood engravings subsequently used as "lottery puffs," or advertisements for forthcoming lotteries. These unsigned ephemeral productions are known to be by Cruikshank largely on the basis of his own holographic authentication done late in life at the request of

collectors. The bibliography of these items is tentative, since many were used more than once by a particular publisher and often by several different publishers. In his bibliography Cohn lists each woodblock once under individual publishers; as he himself says, this manner of classification is not entirely satisfactory. Clearly, much of the charm of these pieces depends on the craftsmanship of the wood engraver who translated the drawing into a print. The small selection here is typical but by no means exceptional in quality. Included with the puffs for lotteries are three advertisements for Warren's Blacking, two of which were probably used previously as lottery puffs. Although usually not dated, the majority of such compositions date from around 1810 to 1825.

**28.** Exact Representation of Drawing the State Lottery (probably Cohn 1567). Cohn suggests that this design was used in several different puffs and may have been cut on wood more than once. The design, showing little artistic invention, appeals primarily to someone interested in the history of the State Lottery in England. As seen here, Cruikshank took a great interest in historically accurate representations. This interest, seen here at an early period in his career, appears frequently in his later Victorian work.

**29.** Pomp./ Queen (probably Cohn 1397, 1414, 1482). This design may occur in as many as six lottery puffs cited by Cohn, but it is not listed there as an advertisement for Warren's Blacking. Here we see the use of a design done originally for a lottery puff reissued with new verses for Robert Warren's famous shoe polish.

**30.** The Cat and the Boot. (Cohn 2093). This design was originally executed to accompany verses for Warren's Blacking and occurs only in this form. It is not clear from the few examples I have seen whether it appeared only in this separate format or also in a periodical.

**31.** Mother Goose (Cohn 1465). Another design originally executed for a lottery puff and later used as an illustration for a Warren's Blacking advertisement. It offers an interesting contrast with Cruikshank's earlier treatment of the same subject (see illustration 27). Because of the strong resemblance of this design to that pantomime frontispiece and its prior use as a lottery puff, it is likely that Cruikshank's composition preceded the verses it accompanies.

**32-34.** [Lottery Puffs] (Cohn 1395, 1572, 1583). Although the letterpress is not as described by Cohn, all three of these designs otherwise correspond to Cohn's entries. Many of the stereotypic characters depicted in lottery puffs stem from theatrical, literary, or folk sources.

**35.** Fortune's Ladder (Cohn 1552). The use of the ladder in caricature goes back to Hogarth's narrative progresses and to even earlier visual precedents. Cruikshank's most famous use of this motif occurred in a pamphlet concerning the adultery trial of Queen Caroline (see illustrations 39, 40, and 42).

**36.** How To grow Fat (Cohn 1642). Here we see the use of stick figures; designs constructed of dots and lines, as the artist called them, are not typical of his work.

**37-42.** [Political Pamphlets] (done mainly for William Hone). For a short time, from about 1816 and during the adultery trial of Queen Caroline in 1820, Cruikshank did a number of wood engravings for the radical pamphleteer and publisher William Hone. This association with extreme liberal reformers and radicals had lasting effects in establish-

ing Cruikshank as a spokesman for the left-wing politicians in England, but it is difficult to determine from such pamphlet illustrations whether he is expressing his own views or his publisher's. Here we have a very small sampling of wood-engraved illustrations from two separate Hone publications and one frontispiece for a conservative pamphlet not published by Hone. For further reference to this material see the modern reprint, with an introduction, titled *Radical Squibs and Loyal Ripostes* (London, 1971).

37 & 38. FROM "THE POLITICAL HOUSE THAT JACK BUILT." Published by William Hone, London, 1819 (Cohn 663, B. M. 13292). Hone frequently used parody in his political pamphlets, as in this one parodying the well-known nursery rhyme. Since Tory policy restricted freedom of the press, it is fitting that an accurate depiction of a printing press should figure prominently in any attack on the regime. The scurrilous depiction of the Prince Regent wearing three peacock feathers and carrying a corkscrew in place of a watchfob is most effective even when seen only in a crudely cut wood engraving such as this one.

39–41. FROM "THE QUEEN'S MATRIMONIAL LADDER, A NATIONAL TOY WITH FOURTEEN STEP SCENES; AND ILLUSTRATIONS IN VERSE, WITH EIGHTEEN OTHER CUTS." Published by William Hone, London, 1820 (Cohn 680). This is the most famous pamphlet Cruikshank illustrated for Hone, issued with an accompanying cardboard ladder which is seen cut in half in illustration 40. The steps of the ladder are elucidated in the text with pictures, one of which is seen in illustration 41 depicting the King. The fact that the title page reproduced here (illustration 39) is from the 43rd edition shows the immense popularity of these pamphlets. Later Hone reissued many of them in a work titled *Facetiae and Miscellanies* (see illustration 45).

42. FRONTISPIECE TO "THE RADICAL LADDER, OR HONE'S POLITICAL LADDER AND HIS NON MI RICORDO, EXPLAINED AND APPLIED." Published by W. Wright, London, 1820 (Cohn 114). This Cruikshank etching most often appears as a hand-colored frontispiece to *The Radical Ladder,* although it was also used in another publication. This pamphlet, a Tory or conservative attack on William Hone, depicts the Queen leading the radicals and anarchists up a ladder in her attempt to grasp at the crown. Although the greater number of Cruikshank's graphics concerning the Queen are favorable, such anti-Caroline compositions also occur in his caricatures (see illustrations 10 and 13.)

43 & 44. FROM "POINTS OF HUMOUR." Published by Charles Baldwyn, London, 1823–1824 (Cohn 176). This work was originally issued in two parts, the first containing ten etchings and eight wood engravings; the second, ten etchings and 12 wood engravings. Along with *The Humourist* and the *German Popular Stories* by the Grimms, *Points of Humour* was crucial in establishing Cruikshank's reputation as the foremost book illustrator in England. In illustration 43 we see the full imaginative power of the artist in the portrayal of a doctor haunted by his dead patients. Illustration 44 is an example of the skillfully executed wood engravings that served as tailpieces to the various stories in the volume.

45. FROM "FACETIAE AND MISCELLANIES." Published for William Hone by Hunt and Clarke, London, 1827 (Cohn 405). This small wood engraving was used on the title page of William Hone's collection of pamphlets. According to the inscription, the drawing was done by Cruikshank at the suggestion of Hone and depicts the two men seated and working in collaboration. Throughout his career, the artist claimed that he always worked in collaboration with his authors, and his professional relationship with Hone serves as a good example of this. During Hone's trial for blasphemy in 1817 Cruikshank even assisted the accused in the preparation of his defense.

46. OUR LIBRARY TABLE (Cohn 22). This small wood engraving, appearing originally in the June 1842 issue of *Ainsworth's Magazine,* shows the editor William Harrison Ainsworth seated at his library table in conference with Cruikshank and offers a much later example of the artist's depiction of himself as a collaborator with an author. Cruikshank's fascination with his self-portrait began early, as is the case with many artists, and lasted throughout his career.

47–62. ILLUSTRATIONS FROM "GERMAN POPULAR STORIES, TRANSLATED FROM THE KINDER UND HAUS-MÄRCHEN, COLLECTED BY M.M. GRIMM, FROM ORAL TRADITION." The first volume was published by Charles Baldwyn, London, 1823; the second, by James Robins, London, 1826 (Cohn 369). The original Grimm fairy tales appeared in print in Germany from 1812 to 1815, and this translation by Edgar Taylor marked the first appearance of these world-famous stories in English. Cruikshank's etchings were copied both in Germany and France shortly after they appeared in their original editions. In England they became such classics that John Ruskin was later to refer to them as the finest etchings done since Rembrandt. In 1868 John Camden Hotten published a one-volume facsimile edition with a publisher's advertisement and an introduction by Ruskin. Although Taylor's literal translation of the Grimm tales was soon superseded by other translations, Cruikshank's depictions have remained the most popular of all illustrations for this work. These compact vignettes mark a transition in the artist's style of etching as well as in his adaptation of fantasy and the grotesque to subject matter quite different from his earlier efforts in caricature. The 16 illustrations selected, which have no specific titles and are therefore listed under the titles of the stories in which they appear, give a good idea of the range of Cruikshank's genius in such a small format.

47. [TITLE PAGE, VOLUME I.] This and the title page to the second volume (illustration 56) relate to no specific tale but establish the mood of the oral tradition from which the Grimm fairy tales derive. In this instance the paterfamilias is seen reading tales to the family in front of the fireplace. The umlaut on the *ä* in "Märchen" is not found in the earliest printings of this etched title page, thus increasing the value of these printings for collectors. Even before John Ruskin highly praised these illustrations, they had become very scarce, being the most sought-after items for all collectors of Cruikshank's books.

48. THE TRAVELING MUSICIANS OR THE WAITS OF BREMEN. Cruikshank has selected the moment at which the Bremen musicians crash into the room and frighten the robbers. This climactic point in the story has remained the popular favorite for most subsequent artists illustrating the Grimm fairy tales.

49. THE GOLDEN BIRD. The artist depicts the youngest son being carried on the tail of the fox. Since this scene occurs more than once in the story it nicely complements the repetitive plot pattern that is so appealing to children in juvenile literature. The inclusion of a Gothic castle in the background adds an appropriate Romantic note.

50. JORINDA AND JORINDEL. Cruikshank visualizes the moment in the tale when Jorindel catches the old fairy in the act of escaping with the bird cage containing Jorinda, who has been transformed into a nightingale. In this design the artist makes especially remarkable use of a kind of animism in which the legs of the table, parts of the chair, and even architectural details become human faces.

51. THE ELVES AND THE SHOEMAKER. The evident joy of the elves, who are trying on their new clothes, and of the shoemaker and his wife animates this most delightful genre scene. As in many of these etchings, there is a conscious attempt to depict the actual surroundings with accuracy and at the same time to create an antiquarian aura that captures Germanic folk tradition. Many feel this is the greatest of all Cruikshank's etchings for the Grimm tales.

52. THE TURNIP. This tale deals with the jealous brother who hires assassins to kill his sibling. The hired villains are frightened before they can hang their victim, who is left tied in a sack. He remains there until he persuades an unwary scholar to change places with him in what he alleges is the sack of knowledge. The illustration shows the recently freed brother callously but jovially waving goodbye as he rides off on the student's horse. This story typically exemplifies the cruel and often sadistic content of many of the original tales.

53. KING OF THE GOLDEN MOUNTAIN. Animistic architectural detail in the background adds a note of fantasy and charm to an otherwise gruesome depiction of the beheading of the traitors.

54. THE GOLDEN GOOSE. The illustration portrays the moment at which the unloved youngest son is passing by a manorial building carrying his golden goose, followed by the seven victims who, after having tried to steal the goose's feathers, trail after the young man. The princess, who has never laughed before, is shown in an upper window of the building, laughing heartily at the comical group. She subsequently becomes the young man's bride.

55. RUMPEL-STILTS-KIN. Rumpel-Stilts-Kin is shown pulling his foot out of the floor the moment after the queen has guessed his name. Taylor's translation indicates that he was not unaware of his illustrator, since on the second day of guessing the queen begins her recitation of comical names with "Bandy-legs, Hunch-back, Crook-shanks," and so on. The use of such internal verbal references to the artist himself is not uncommon in works that first appeared in print with Cruikshank's illustrations.

56. [TITLE PAGE, VOLUME II.] Whereas on the title page to Volume I a father reads to his family from a book, here an old woman is telling a story. These two illustrations thus contrast the written with the oral narrative tradition.

57. THE GOOSE-GIRL. Cruikshank pictures the moment at which the true princess recites the following verse while combing her hair:

> Blow, breezes, blow!
> Let Curdken's hat go!
> Blow, breezes, blow,
> Let him after it go!
> O'er hills, dales, and rocks
> Away be it whirl'd
> Till the silvery locks
> Are all comb'd and curl'd!

Since she repeats these verses three times during the tale, illustration of this verse complements the repetitive pattern of

the story. As is often the case in Cruikshank's etchings for the Grimms, use of a magnifying glass reveals numerous small details that escape the casual observer, such as the town gate and many of the town buildings shown at some distance. The more these designs for the Grimms are studied in detail, the more interesting they become.

58. THE YOUNG GIANT AND THE TAILOR. The artist juxtaposes the thumb-size dwarf with the giant, while contrasting both figures with the dwarf's father behind the plow. Curiously enough, the supposedly normal-size farmer is not correctly proportioned in relationship to the horses pulling his plow. Thus the illustration contains the kind of distortion frequently found in drawings done by children. This purposeful childlike distortion of size is found today in the works of many illustrators of children's books.

59. PEE WIT. The townspeople, lured on by the hopes of getting some sheep for nothing—as Pee Wit said he did—are jumping off the cliff into the "enchanted" lake. Cruikshank succeeds in capturing the gleeful greed of the Justice, the Constables, and their friends, as well as the fleecy quality of the clouds reflected in the water that suggest sheep supposedly grazing on the bottom of the lake.

60. CHERRY, OR THE FROG-BRIDE. The young prince is seen next to a pumpkin drawn by six large water rats shortly before the transformation of the frog into a princess. Those who question the propriety of translating such stories literally for children are alarmed by passages like the following: "The delighted father embraced his son, and named him the heir to his crown, and ordered all the other ladies to be thrown like the little dogs into the sea and drowned."

61. THE ELFIN-GROVE. Throughout his later life Cruikshank was renowned for his sensitive depiction of fairy lore. Nowhere does he better capture the mood of an enchanted forest scene than in this illustration.

62. THE NOSE. This etching is remarkable for its depiction of a human figure with a seemingly endless nose. Cruikshank, who himself had a rather pronounced Roman nose, had a lifelong fascination with noses (see illustration 96), a fact that has already attracted Freudian literary critics.

63–66. ILLUSTRATIONS FROM "PETER SCHLEMIHL. FROM THE GERMAN OF LAMOTTE FOUQUÉ" (Cohn 475). This translation by Sir John Bowring, published in London by G. & W. B. Whittaker in 1823, originally appeared with eight full-page etchings by George Cruikshank. These etchings are untitled, though all refer to specific scenes in this dreamlike, almost surrealistic Romantic story. Like the Grimm fairy-tale translation, this work was an immediate success and helped reinforce Cruikshank's reputation as a book illustrator, both in England and on the Continent. Perhaps the best way to point out the importance of the artist's share in this work is to quote Bowring's preface to the third edition, published in 1861:

> More than twenty years ago I translated "Peter Schlemihl." I had the advantage of the pen and genius of George Cruikshank, to make the work popular, and two editions were rapidly sold.
> At that time the real author was unknown. Everybody attributed it to Lamotte Fouqué, on whose literary shoulders, indeed, Adelbert von Chamisso placed the burden of its responsibilities.
> The appearance of the English edition, I have reason to know—thanks to the merit of Cruikshank's original and felici-

tious sketches—excited the greatest delight in the mind of Chamisso. In his autobiography he says that "Peter" had been kindly received in Germany, but in England had been renowned (volksthumlich).

In *Peter Schlemihl* Cruikshank renders visually some of the insights of German Romantic thinking and captures the essentially symbolic significance for Schlemihl of shadow, time, and space.

63. Peter is pictured immediately after he has sold his shadow to the strange man in black, who is seen folding up the shadow as the anti-hero looks uneasily over his shoulder. The disastrous consequences of his agreement seem to be dawning on him, for at this moment he finds no consolation in Fortunatus' purse, a source of unending wealth, which he limply holds in his left hand. In the central background a sundial complements the story's concern with shadows and time.

64. In this etching the shadowless Peter is in a bedroom seated before a candle that casts a profusion of shadows. He faces a clock that is about to strike 12. The year elapsed, he is awaiting the arrival of his antagonist to fulfill the terms of their compact. Here, while portraying an incident in the story, Cruikshank deals with the symbols of time and the opposed themes of the mortality of man and the immortality of his soul.

65. The man in black holds out the compact for Peter to sign away his soul. The elongated figure of the man in black eerily casts a double shadow that contrasts sharply with the absence of shadow for Peter.

66. Peter is in his flight through the world, possibly somewhere in the Southern Hemisphere. Although this illustration refers to a specific incident in the story, it also succeeds in visualizing the unending symbolic quest that haunts Peter during the latter part of the tale. Cruikshank's ability to indicate the magnitude of the horizon in a book illustration no more than three by four inches is most remarkable.

**67 & 68.** ILLUSTRATIONS FROM "GREENWICH HOSPITAL. A SERIES OF NAVAL SKETCHES, DESCRIPTIVE OF THE LIFE OF A MAN-OF-WAR'S MAN." By M. H. Barker. Published by James Robins and Co., London, 1826 (Cohn 53). This collection of naval anecdotes was originally published in four parts with 12 colored etchings and 16 wood engravings. The work also appeared in volume form with the plates hand-colored or plain. George Cruikshank's brother Isaac Robert Cruikshank served in the navy when young, and both men maintained a keen interest in English naval life throughout their careers. Of the several nautical books illustrated by Cruikshank, this is the best known. Its illustrations offer excellent examples of the artist's ability to depict the rollicking life of English sailors in the late eighteenth and early nineteenth centuries. Most of the plates in this volume illustrate specific animated moments in the naval yarns they accompany, but these etchings can be equally well understood and enjoyed without text.

67. SAILORS CAROUSING, OR A PEEP IN THE LONG ROOM. Sailors are shown drinking and dancing in one of the many dives that surround the harbor districts of the port cities of England. The specific story accompanying this etching, titled "Sir Isaac Coffin," deals with some of the predicaments that high-spirited sailors get into when on leave. As the narrator says, "We all bowled to the long-room with Mother Kilderkin, alias Will Ransom, mounted on our shoulders, and the evening was rattled away in jollity and punch. Ah,

them were the times, mess mates. I thinks I sees 'em all now jigging away, while the fiddlers scraped the cat-gut, and the grog flowed in purly streams, and the volumes of smoke rolled their columns to the ceiling." The Mother Kilderkin referred to here was a sailor named Will Ransom who had disguised himself as a woman in order to evade the authorities. The scene is a panoramic montage of English tavern life at its boisterous best, captured with incredible artistry.

68. SAILORS ON A CRUISE. This etching, like many companion works, depicts in a lighthearted and partially caricatured mood a Regency-period genre scene of the pastimes of British lower-class naval life. It accompanied a story titled "The Arethusa," recounting the adventures of a group of hard-drinking sailors, recently back from a long voyage, who spend a great deal of money carousing and riding around the countryside in hired coaches with their lady friends, regaling themselves before local onlookers. The banner of the *Arethusa* proudly unfurls from the side of the coach. The ship itself appears in the right background.

**69–74.** ILLUSTRATIONS FROM "MORNINGS AT BOW STREET. A SELECTION OF THE MOST HUMOUROUS AND ENTERTAINING REPORTS WHICH HAVE APPEARED IN THE 'MORNING HERALD.'" By John Wight (Bow Street reporter to the *Morning Herald*). Published by Charles Baldwyn, London, 1824 (Cohn 844). This collection of a journalist's stories about civic disturbances that ended up in criminal court originally appeared with 21 full-page vignette wood engravings by Cruikshank. The wood engravings, done in the finest "white line" Bewick tradition, are superb examples of the ability of both Cruikshank and the craftsmen who engraved the blocks to capture expression and specific detail in such a small format. It is worth noting that over a decade before Cruikshank illustrated Charles Dickens' early journalistic contributions to newspapers, collected under the title *Sketches by Boz*, he had already illustrated a similar kind of work for another journalist. Although this work was certainly not as popular as Dickens' collection of stories, the volume did reach a fourth edition by 1838.

69. A COOL CONTRIVANCE. The illustration depicts an incident that took place on the mall in Saint James's Park when an ageing and perhaps somewhat senile shoemaker decided to take off his trousers on a hot day. The man is seen with his trousers over his head just as he is about to be apprehended by a constable. A group of hooting children and onlookers can be seen in the background, as well as two horrified ladies seated on a park bench.

70 & 71. CHEAP DINING. These two wood engravings picture the fracas that occurs in a cheap restaurant when a gentleman orders a plate of roast beef and decides to depart without paying for it after making disparaging remarks about its quality.

72. A DUN AT SUPPER TIME. Heavy-set Mrs. Amelia Groutage filed an action against her neighbor John Dunn for bodily injury incurred when he picked her up and carried her from his house to hers after she requested payment of a debt. According to testimony given in court, Mrs. Groutage and several other guests had been invited to dinner by Mr. Dunn. After dining, she grew very "glumpish" and demanded that her host pay her some money. The wood engraving shows a very thin host lifting his heavy guest to the great amusement of the other guests standing in the doorway of their host's house. Needless to say, Mrs. Groutage did not win her case.

73. JONAS TUNKS. This wood engraving shows Jonas Tunks being turned out of a public house in Saint Giles, London. During the course of the story the author refers to Pierce Egan's *Life in London* (1821), an immensely popular work about two young men named Tom and Jerry who were constantly getting in trouble with the law through pranks, such as tearing off door knockers, attacking the watch, or otherwise disturbing the peace. A great deal of the popularity of Egan's work derived from its superb illustrations by Isaac Robert and George Cruikshank. This offers an interesting example of a verbal reference to a work closely associated with Cruikshank in a subsequent story also illustrated by him.

74. PIG WIT. The story deals with two stall keepers in Covent Garden Market—Richard Stewart, a dealer in pork and poultry, and the defendant, Ephraim Ephraim, a Jewish orange merchant, whom Stewart tormented in his neighboring stall by goading him to look at pigs' heads. Although the magistrate is sympathetic to the plaintiff's case, he does no more than request that the defendant apologize for insulting the religious feelings of the plaintiff.

75–82. ILLUSTRATIONS FROM "MORE MORNINGS AT BOW STREET. A NEW COLLECTION OF HUMOROUS AND ENTERTAINING REPORTS." By John Wight. Published by James Robins and Co., London, 1827 (Cohn 845). This sequel originally appeared with one etching, eight full-page wood engravings and 16 wood-engraved vignettes. As with its predecessor, the illustrations were also issued on India paper without the accompanying text, indicating the recognition given to Cruikshank's illustrations for these works. Some of the headpieces and tailpieces for this book are among the artist's best.

75 & 76. FLYING DUSTMEN. The head- and tailpieces for a short essay on the London "dustman" or trash collector. The work begins with a two-line quotation from John Gay: "The dustman's cart offends thy clothes and eyes,/ When through the street a cloud of ashes flies." This epigraph to the essay could well serve as a caption for the headpiece. The tailpiece literally depicts bandy-legged dustmen, with their hats, baskets, and shovels, flying in a cloud of coal dust. The tailpiece is preceded by two lines from Shakespeare's *Cymbeline:* "The sceptre, learning, physic, must/ All follow these and come to dust!"

77 & 78. WATCHING FOR WATCHES. These two wood engravings are untitled; so they are given the title of the story they accompany. They relate only thematically, but not specifically, to the narrative, which concerns a supposed watchmaker and repairman who is brought before the magistrate for having fraudulently deprived people of their watches. The epigraph, credited to "Bill Soames," reads: "A watch what won't *go*, is good for nothing." This line is visualized in the headpiece of the story by the animated watch that is running away. The tailpiece, showing an animated grandfather clock, suggests the inexorable march of time.

79. LABOUR AND LIBERALITY. The story tells of Covent Garden Market portress, Mrs. Kathleen Murphy, who was brought before a magistrate for destroying property after she felt that she had not been paid enough money for carrying a very heavy load. The vignette does not refer specifically to the story but perhaps most fittingly suits the epigraph credited to a "Milesian matron": "Oct! fait, never mind the weight of it, yer honour,—I'll step along under it, beautiful!"

80. THE THREE THIMBLES. This vignette shows a greenhorn being cheated out of money near the Ascot races after having been tricked into taking part in the "thimble rig," a variation of the old shell game. With the help of other sharpsters and the use of three thimbles and some sleight of hand, a victim is enticed to bet money on which thimble covers a peppercorn. After seeing a few setup wins, the innocent party bets and wins a few times before he begins to lose. One can clearly distinguish the victim, hat pulled down over his face, from the two culprits, one of whom holds his finger up to his nose as a sign of being in the know.

81. PIG, PARKINS, AND PIPKINSON. This headpiece accompanies the story of a dispute as to whether a gentleman tried to steal the pig that carried him off or whether he was, as he claimed, originally attacked by the pig.

82. TOM THE GARDENER. This is the title of the story that this vignette illustrates. Tom was a cat belonging to Mrs. Celestina Griggs Pinckerton. The lady claimed to have been injured by Mr. Barnabus Potter during a dispute concerning Tom's misbehavior: allegedly, he habitually entered Mr. Potter's backyard and urinated on his gooseberry trees. Cruikshank very genteelly shows Tom holding a watering can over a gooseberry tree.

83–90. ILLUSTRATIONS FROM "LONDON CHARACTERS. DESIGNED AND ETCHED BY GEORGE CRUIKSHANK." Published by Joseph Robins, London, 1829 (Cohn 182). These 24 etchings originally appeared in the *Gentleman's Pocket Magazine* for 1827 and 1829 (Cohn 349). Although in their separate printings they are credited on the title page to George Cruikshank, nine of the etchings are signed "Robert Cruikshank." The plates were hand-colored and are of extreme rarity in their first issue. Most of the copies in existence were made up from 6,000 colored impressions of these etchings sold in the Truman sale in 1906; the original plates were also included in this sale and many of the later copies include at least some modern impressions as well as those of the original issue. The reproductions here were made from black-and-white impressions. Cruikshank's London characters closely resemble, but are not identical to, the many series of "street cries" popular during the late eighteenth and early nineteenth centuries. Not all of the figures fit into the category of street vendors; in fact, it is even questionable how many of these types of people were still frequently seen in 1829. Possibly Cruikshank may have been delineating characters who already were beginning to be seen less often in the everyday scene in London. These depictions also raise the question whether Cruikshank was drawing from life, which in general he claimed not to do, or whether he recreated his characters from the recollection of individuals he had seen or from earlier graphic works by other artists. George William Reid, Cruikshank's first cataloguer and a Keeper of Prints and Drawings in the British Museum, comments briefly on each of these designs in a way that serves well as introductions to them. It should be remembered that Reid is writing in 1871 about etchings that had first appeared in print some 40 years earlier.

83. OLD CLOTHES MAN. "A Monmouth Street Jew, lean and cadaverous, near an area and calling 'Clow, clow'" (Reid). This portrayal of a Jewish type bears no resemblance to Cruikshank's later depictions of Fagin.

84. PARISH BEADLE. "The original Bumble, standing in all the dignity of office, and scowling at imaginary delinquents"

(Reid). Although Reid thinks the figure looks like Bumble in *Oliver Twist,* it is apparent that the resemblance derives primarily from the costume the Beadle is wearing.

85. WATERMAN. "He is both 'jolly' and 'young,' a sturdy and smart specimen of a Thames sculler, with one hand raised soliciting a fare" (Reid). This waterman, who, as is known from many eighteenth-century accounts, descends from a not very polite class of individuals, seems to show his sense of independence even while soliciting trade.

86. DUSTMAN. "Unshaven, unkempt, and knock-kneed, with bell in one hand, the other thrust into his jacket-pocket" (Reid). For other treatments of the same trade, see illustrations 75, 76, and 145.

87. STAGE COACHMAN. "A humorous specimen of this extinct species of the *genus homo,* whip and gloves in one hand, and a dram glass in the other" (Reid).

88. HACKNEY COACHMAN. "Another member of a past generation, standing half asleep near coach rank and smoking, while whip in hand he patiently waits for a job" (Reid). Cruikshank was fascinated with people and their vehicles. For another treatment of a similar type see illustration 144.

89. FOOTMAN. "A young and stately creature, leaning on his 'staff of office,' and complacently waiting his lady's orders" (Reid). For another portrayal of the same character see the vignette titled "Ignorance is Bliss," illustration 93.

90. WATCHMAN. "Another specimen of an extinct race, muffled up and useless, although armed with a baton and rattle, and swinging his lantern to time his shouting the hour" (Reid). We see here a London figure who appears frequently in Cruikshank's illustrations of roisterous "Tom and Jerry" types who spend their leisure hours tormenting watchmen.

91. FOLIO FROM "PHRENOLOGICAL ILLUSTRATIONS, OR AN ARTIST'S VIEW OF THE CRANIOLOGICAL SYSTEM OF DOCTORS GALL AND SPURZHEIM." Published by the artist and sold by James Robins, S. Knight and George Humphrey, London, 1826 (Cohn 178). This work in six oblong folios originally appeared plain and colored in sewn paper wrappers. Each of the compositions consists of a central vignette surrounded by four or five smaller ones. This publication marks an important shift in the artistic and commercial significance of Cruikshank's work. In these plates the artist displays a new style of etched composition, which differs markedly from that of traditional caricatures. Although the work was to be sold by three of the caricature shops for which Cruikshank had worked over a period of several years, here we see the artist, who normally was paid a fixed sum for doing an etched caricature, publishing a work himself and thus creating a source of steady income. This particular folio deals with phrenology, the popular nineteenth-century science of reading character through the study of bumps on the head. There is a printed title page as well as two pages of explanation of 33 "propensities," "sentiments," "knowing faculties," and "reflecting faculties" comprising this pseudoscience. The work is an ingenious and humorous parody of the various characteristics formulated by Gall and Spurzheim, the German founders of phrenology. There is no better way of elucidating the illustrated page from this work than by reprinting the appropriate commentary in the accompanying text. The upper left-hand vignette is titled "Ideality" and

entry XVI in the text under "Sentiments" explains it: "Organ of Ideality.—It is supposed that a peculiar development of this organ, which is remarkably conspicuous in all poets, occurs in persons who are disposed to have visions, see ghosts, demons, etc. Mr. Forster calls this the organ of *Mysterizingness.*" The upper right-hand vignette, titled "Wit—!," is explained in entry XXXII under "Reflecting Faculties": "Organ of Wit.—The essence of this faculty is said to consist 'in its peculiar manner of comparing, which always excites gaiety and laughter.' The artist hopes his effort in plate 5 [the etching reproduced here] may prove satisfactory." The central vignette is titled "Language" and item XXIX in the "Knowing Faculties" explains it: "Organ of Language.—The special faculty of this organ—the very spirit of language, may be seen in plate 5." Here Cruikshank shows two Billingsgate fishwives in heated argument. The lower left-hand vignette is titled "Imitation & Approbation" and is explained under entry XXXIII of "Reflecting Faculties" as "Organ of Imitation.—as this is a faculty *sui generis,* as it belongs to none of the four genera already noticed, as it acts upon them all, and as the individuals possessing it 'like to be actors,' the artist has taken the liberty of giving his illustration of it in the exhibition of the Phrenologist himself: plate 5." Item XI of the "Sentiments" also comments on this vignette: "Organ of Approbation.—Craniologists consider the possession of this organ essential to society, as exciting other faculties, and producing emulation and the point of honour. The Artist has endeavoured to illustrate this organ in a manner consonant to the wishes of the admirers of the Phrenological system. Plate 5." The picture may be an actual portrait of either Dr. Gall or Dr. Spurzheim lecturing to a London audience. The lower right-hand vignette is titled "Comparison" and is explained under entry XXX of the "Reflecting Faculties": "Organ of Comparison.—Whoever is so fortunate as to have an elevation in the midst of the superior part of the forehead, in the shape of a 'reversed pyramid,' is sure to possess the organ of comparison or analogy. Dr. Gall found the heads of two Jesuits to be remarkably distinguished by this organ. The Artist trusts it is not necessary to be a Jesuit in order to exercise this faculty on the example given in plate 5."

92. FOLIO FROM "ILLUSTRATIONS OF TIME." Published by the artist and sold by James Robins "and All Book and Print Sellers," London, 1827 (Cohn 179). The year after the appearance of *Phrenological Illustrations* the artist produced a similar work in oblong folio, again consisting of six etched vignette sheets plus an etched title page. No text accompanies these etchings; their theme and variations on the subject of time are to be interpreted in relationship to the etched texts or captions that appear on each page. The plate here bears the general title "Hard Times" and consists of five vignettes depicting financial difficulties. The upper left-hand vignette literally pictorializes the verbal expression "to keep one's nose to the grindstone"; whereas the etching at the upper right pictures lower-class working people holding up the symbols of their erstwhile professions, such as gardening, while begging (the same situation is portrayed in the similarly titled caricature reproduced as color plate II). The central motif repeats a well-known visual commentary on the pitfalls of going to law. A lawyer, with a bag of legal documents out of which sticks a paper titled "Noodle v[ersus] Doodle," holds out half a shell to each party with the comment shown in the bubble caption: "Gentlemen—It was a very fine Oyster! The Court awards you a shell each." The

lower left-hand vignette shows prisoners breaking stones. At the lower right is a butcher whose trade has so fallen off that he sits napping on his chopping block and has posted a "To Let" sign below his meat hooks—empty save for a bone—while a gaunt mother and her three starving children sing, "Oh! The Roast Beef of Old England."

**93–95.** FOLIOS FROM "SCRAPS AND SKETCHES." Published by the artist and sold by James Robins and Co., London, 1828, 1829, 1831, 1832 (Cohn 180). This work appeared in four parts, published in the years indicated, each with a printed title page and each sewn in paper wrappers. Like *Phrenological Illustrations* and *Illustrations of Time,* each part consisted of six plates, mostly with several designs on each. In 1834 Cruikshank did a design intended as plate 1 of part 5 of *Scraps and Sketches,* but no further parts were completed. In about 1854 Cruikshank planned a reissue in ten parts of this work together with *Phrenological Illustrations, Illustrations of Time,* and *My Sketch Book* (see illustration 96). But aside from a new title page and one part, the complete reissue never materialized. There are, however, many different printings of *Scraps and Sketches;* in fact, a careful examination of watermarks will often show that alleged first issues of the fourth part were printed several years after that part originally appeared. *Scraps and Sketches* deals with a variety of themes, resembling those of the two preceding works and yet differing from them by being closer to the traditional themes of an artist's sketchbook. Some of Cruikshank's most memorable designs occur in the 25 plates done for this series. As was the case with the two preceding works, these prints were originally issued both plain and hand-colored; there is a noticeable superiority in the carefully hand-colored versions of the first or early issues. Once again, *Scraps and Sketches* was an attempt on the part of the artist to become his own publisher and thus derive continued royalties by reissuing earlier works. Some of the designs in this and the two preceding works were pirated in crude wood-engraved copies in *Bell's Life in London* in "The Gallery of 140 Comicalities." According to contemporary accounts, Cruikshank very much resented the use of his name and designs without remuneration. From all that can be gathered, these carefully printed etchings done on the finest paper available were never financially successful. Yet they did much to enhance the artist's reputation, a few of the designs becoming so well known that they were even used as models for cartoons in *Punch* (which did not commence publication until 1841).

93. [PLATE 3 IN PART 1.] The central vignette, titled "Ignorance Is Bliss," shows two comfortably cared-for footmen standing outside the double-door entry of an opulent house with the corpulent family bulldog seated on the front steps and the equally obese master inside partially visible through the doorway. This single design became one of the best known in the entire series. The vignettes at the upper right and left depict chimney sweeps and dustmen discussing their social life, while the very small upper central vignette makes fun of the then current women's fashion of oversize hats. The vignette at the lower left, "A jolly companion," shows a punch bowl and glasses, a wine decanter, a corkscrew, a lemon, and tongs, all ingeniously disposed to form the head and face of a person. The central lower design is an anthropomorphic dinner bell wearing an oversized bonnet with flowers. The design at the lower right, "Tooth Powder," shows a man with a toothache in the act of firing a gun. The bullet, attached to his tooth by means of a barely

visible string, has indeed extracted the tooth, which—upon close examination—can be seen flying through the air.

94. [PLATE 6 IN PART 1.] This etching, consisting of a central vignette surrounded by five smaller compositions, deals with learning and education. The upper left-hand vignette, "The Grand 'March of Intellect,'" depicts a group of youngsters, wearing inkwells for hats and carrying quills for rifles, vigorously marching off in quest of knowledge. In the foreground of the upper right-hand vignette, "The Pursuit of Letters," three infants in walkers attempt to catch animated letters of the alphabet. On the horizon, two men on horseback preceded by four dogs pursue an animated series of letters that spell "literature." This literary creature predicts that "We shall all be run down & devoured!!—there wont be a bit of us left for succeeding ages!—the dogs now a days have got such large Capacities!" The central and best design, "The Age of Intellect," depicts a grandmother, holding a book of nursery rhymes, amazed by the precocity of her granddaughter, who stands before a toy basket filled with great works of literature and a table of scientific apparatus. The child is literally "teaching its grandmother to suck eggs" (a proverbial command given to a child who thinks it knows better than its elders), but the child's instruction consists of using long words; the grandmother mistakenly believes she is learning something new. The three bottom vignettes, almost self-explanatory, show a dandified, educated, liveried footman, a birch switch, and a walking advertisement for a cheap restaurant. All of these designs refer to specific changes in education which were taking place in about 1829 when the etching was first published.

95. [PLATE 1 IN PART 2:] LONDON GOING OUT OF TOWN.—OR—THE MARCH OF BRICKS & MORTAR! Unlike any of the other etchings selected for reproduction from this series, this plate consists of a single design that pictures in energetic animation the rapid expansion of the city limits in London. According to the sign carried by one animated figure fashioned of construction tools, a chimney top, and a mortar-filled hod carrier, Brixton is the suburb being overrun, adding, of course, an extra pun on bricks. On the right farm animals, haystacks, and tree trunks are seen as they attempt to flee the onward military march of row after row of buildings. This ingenious battlefield visualization of civic expansion is an example of a preoccupation Cruikshank displayed more frequently in his later work. Here, however, the moral content of the later works is not found. Perhaps nowhere in all of Cruikshank's work does his characteristic use of animism produce more brilliant effects than in this etching of 1829.

**96.** "A CHAPTER OF NOSES," FOLIO FROM "MY SKETCH BOOK." Published by the artist and sold by Charles Tilt, London, 1834–1836 (Cohn 181). This work is of the same type as the preceding three. It appeared in sewn paper wrappers, just like the others, but with four etchings in each of its nine parts and with a printed title on the paper covers. The format is again an oblong folio but of slightly smaller dimensions than those of its predecessors, and the parts appeared both plain and hand-colored. The work was reprinted in a much inferior form from stereotype plates many times during the nineteenth century. In its reprinted form the 36 plates are all numbered consecutively and preceded by the etched title page, which originally was an etching included in one of the later parts. The illustration chosen is Plate 1 of Part 5. Cruikshank is here desirous of getting even with a publisher who used his name on the title page but omitted the forename

in order to sell works illustrated by one of Cruikshank's lesser-known relatives. The metaphor "pulling a person's nose" refers to getting back at someone for behaving improperly, and this is literally the situation in this self-portrait of the artist holding the offending publisher, Mr. Kidd of Chandos Street, by the nose with a pair of tongs. The lower right-hand vignette depicts St. Dunstan in the process of pulling the devil's nose with tongs. Just above this is a caricatured couple with nosegays. On the opposite side are three more nose scenes, one showing a man fingering his nose and winking as a sign of being in the know (for further examples of this gesture, see illustrations 80 and 153). Across the top of the page is a varied assortment of over 30 profiles of persons with grotesque noses. From the early years of his career, Cruikshank had been plagued by inferior artists copying his works and by publishers using his surname in order to sell works illustrated by his brother and later by his nephew. In this instance he explained in more detail on an inserted sheet at the beginning of Part 4 of *My Sketch Book* the circumstances involved in Mr. Kidd's unauthorized use of his name: "Mr. KIDD, a Bookseller of *Chandos Street,* having published a work, which he calls 'CRUIKSHANK AT HOME,' I take the earliest opportunity of informing my Friends and Public generally, that I have no connexion whatever with that work. I have also been so repeatedly questioned about the various works published by Mr. KIDD, as 'Illustrated by CRUIKSHANK,' that I think it will be as well to state, once for all, that the only work I ever illustrated for Mr. KIDD, was, '*The Gentleman in Black.*' Mr. KIDD's other publications, (of the greater part of which I here subjoin a list,) are ALL illustrated by my Brother, ROBERT CRUIKSHANK, and IN NOT ONE OF THEM HAVE I ANY CONCERN. GEORGE CRUIKSHANK." His signature is followed by a list of 16 works, ten of which use the name Cruikshank in their titles.

97–100. ILLUSTRATIONS FROM "CATALOGUE RAISONNÉ OF SELECT COLLECTION OF ENGRAVINGS OF AN AMATEUR." By John Wilson. Printed privately, London, 1828 (Cohn 854). This catalogue of old master prints appeared in both small and large formats in a limited number of copies with the illustrations on India paper. The catalogue contains 40 engravings, tailpieces, and vignettes, of which five are by Cruikshank. The four reproduced depict connoisseurs in various activities associated with the collecting of graphic art. These etchings were always favorites with Cruikshank collectors, from the artist's last years into the first 35 years of the twentieth century, by which time he had become one of the most collected of all English graphic artists. The original plates from this work at one time belonged to the most omnivorous of all Cruikshank collectors, Edwin Truman, and were included in the auction of his collection in 1906.

97. THE PRINT ROOM IN THE BRITISH MUSEUM. This small etching, which serves as the tailpiece for Mr. Wilson's collection of engravings of the English School, shows a keeper of the British Museum Print Room and several crotchety connoisseurs looking at a print with eyeglasses.

98. CONNOISSEURS AT A PRINT SALE. This tailpiece to the section on the German School shows a print sale of the period with the auctioneer on the right and the various bidders seated at a long table. Again, eccentricities of collectors are shown in exaggerated form.

99. CONNOISSEURS IN A PRINT SHOP. This tailpiece to the French School portrays would-be collectors being shown a portfolio of prints, looking at prints on the wall, and leafing through the contents of a print stand. Through the open door one can see the general public, including a dustman, looking at prints hanging in the window.

100. CONNOISSEURS AT A PRINT STALL. This tailpiece to the Flemish and Dutch School depicts a typical nineteenth-century print stall with various books displayed on tables, framed prints, and sheaves of prints hanging at the door. Two collectors eagerly search for treasures. The two schoolboys, bookbags in hand, who look at the merchandise remind one of Thackeray's comments in his famous essay on Cruikshank about how he first became enchanted with the artist's work when he was a small schoolchild. The butcher chatting with a neighborhood housewife and the wary dog being hissed at by the printseller's cat add further touches of London street life to the scene.

101–104. ILLUSTRATIONS FROM "LETTERS ON DEMONOLOGY AND WITCHCRAFT ADDRESSED TO J. G. LOCKHART, ESQ." By Sir Walter Scott. Published by John Murray, London, 1830 (Cohn 731). Cruikshank's 12 etchings appeared not only in the above-mentioned volume form accompanying Scott's entire work but also in a separate publication, accompanied by short excerpts for the text, under the title *Twelve Sketches Illustrative of Sir Walter Scott's Demonology and Witchcraft,* published for the artist by James Robins and Co., London, 1830 (Cohn 188). As both are dated 1830, it is not clear which came out first. With his genius for creating grotesque images, it is natural that Cruikshank should illustrate a work dealing with demons, fairies, goblins, and elves. The work did not appear originally with the prints hand-colored, but at least some of the numerous reprintings during the century came out with colored plates. Since they originally appeared with quotations from Scott's work, there is no better way to explain each than by reprinting the text which they illustrate.

101. THE "CORPS DE BALLET." "But, alas! no sooner had the furniture of the London drawing-room been placed in order in the gallery of the old manor-house, than the former delusion returned in full force! the green *figurantés,* whom the patient's depraved imagination had so long associated with these movables, came capering and frisking to accompany them exclaiming with great glee, as if the sufferer should have been rejoiced to see them, Here we all are—here we all are!!"

102. ELFIN ARROW MANUFACTORY. "In their caverns the fairies manufactured those elf-arrow-heads, with which the witches and they wrought so much evil. The elves and the archfiend laboured jointly at this task, the former forming and sharpening the dart from the rough flint, and the latter perfecting and finishing, or, as it is called, *dighting* it."

103. FAIRY REVENGE. "The common nursery story cannot be forgotten, how, shortly after the death of what is called a nice tidy housewife, the Elfin band were shocked to see that a person of different character, with whom the widower had filled his deserted arms, instead of the nicely arranged little loaf of the whitest bread, and a basin of sweet cream, duly placed for their refreshment by the deceased, had substituted a brown loaf and a cobb of herrings. Incensed at such a coarse regale, the elves dragged the peccant housewife out of bed, and pulled her down the wooden stairs by the heels, repeating, at the same time, in scorn of her churlish hospi-

tality, 'Brown bread and herring cobb!/ Thy fat sides shall have many a bob!'"

104. WITCHES FROLIC. "Another frolic they had, when, like the weird sisters in Macbeth, they embarked in sieves with much mirth and jollity, the fiend rolling himself before them upon the waves, dimly seen, and resembling a huge haystack in size and appearance. They went on board of a foreign ship richly laden with wines, where, invisible to the crew, they feasted till the sport grew tiresome, and then Satan sunk the vessel and all on board."

105–118. ILLUSTRATIONS FROM "THREE COURSES AND A DESSERT. THE DECORATIONS BY GEORGE CRUIKSHANK." By William Clarke. Published by Vizetelly, Branston and Co., London, 1830 (Cohn 144). This collection of stories contains 51 wood engravings, of which eight were originally printed on separate sheets with the remainder used as head- or tail-pieces. The book reached a fourth edition by 1850. The author tells his readers "that even if the *dishes* be disliked, the *plates,* at least, will please: but he feels bound to state, that whatever faults the decorations may be chargeable with, on the score of invention, he, alone, is to blame, and not Mr. George Cruikshank; to whom he is deeply indebted for having embellished his rude sketches in their transfer to wood, and translated them into a proper pictorial state, to make their appearance in public. They have necessarily acquired a value, which they did not intrinsically possess, in passing through the hands of that distinguished artist; of whom it may truly, and on this occasion especially, be said, QUOD TETIGIT ORNAVIT [whatever he touched, he embellished]." The stories are grouped into a first "course" of West Country Chronicles, a second of Irish stories, a third of "My Cousin's Clients," followed by "The Dessert." As the author suggests, Cruikshank's wood engravings are indeed the most distinguished feature of this uneven collection. The untitled wood engravings are listed below by the title of the stories they accompany.

105. [VIGNETTE ON THE TITLE PAGE.] Beneath the humanized pudding is the quotation "Sit down and feed, and welcome to our Table" from Shakespeare's *As You Like It.*

106. THE COUNTERPART COUSINS. This is the story of two cousins who by family tradition are destined to bring misfortune to each other. The illustration of two men separating a pair of fighting dogs by pulling their tails visualizes the author's metaphor for a battle between the cousins when "each . . . carried away his hold, like a couple of bulldogs."

107. TIMBERLEG TOE-TRAP. A man in debt who has recently landed in England is shown at the moment "when one of his creditors had a bailiff to give him a grip by the shoulder. As soon as a man gets clawed, long bills generally come pouring in upon him from all quarters." In the wood engraving the man, still near the harbor district, is seen being clawed by a gigantic bird as several other birds with prominent beaks approach him. As in the previous design, Cruikshank has visualized, and hence literalized, figures of speech in the text. This illustrative technique was used by William Blake. It also calls to mind the surrealistic designs of the French artist Grandville.

108. INDUCTION. This depiction of a crocodile weeping in the pulpit serves as the tailpiece to the author's "induction" or introduction.

109. THE NATIVE AND ODD FISH. This tailpiece is a portrait of the talking oyster, represented as a quaint man wearing a pearl around his neck. The story itself consists chiefly of a dialogue between an Irishman and an oyster which has been dropped on a rock high above the ocean. "Native" in the title meant local oyster.

110. CADDY CUDDLE. This tailpiece illustrates a tale about a man who falls asleep in a castle and wakes up terrified by an imp on his nose "whose figure was, at once, more grotesque and horrible, than any of those which had flitted before his mind's eye, during his slumbers. The creature seemed to be staring at him with terrific impudence, and jockeying his feature, as though it were actually capable of running a race." When Caddy fully awakens, he realizes that he had gone to sleep without removing his spectacles. They had become displaced on his nose in such a way that he mistook them for an imp.

111. "MY COUSIN'S CLIENTS," INTRODUCTION. This headpiece of a fox with two geese in his mouth bears no reference to the text other than to the general theme of eating.

112. BAT BOROO. A man is humorously perched on the end of a spiked fence with a bull on one side and two barking watchdogs on the other. The incident is described in the story for which this wood engraving serves as the tailpiece.

113. UNDER THE THUMB. This small wood engraving surrealistically visualizes the theme of the story it accompanies.

114. WANTED A PARTNER. Showing a man hauling a very heavy burden uphill, this wood engraving establishes the validity of the sign in the background—"Wanted An Active Partner   No Capital Required"—and thus symbolizes the theme of the story.

115. "THE DESSERT," INTRODUCTION. The arresting human-faced lemon halves and orange serve as the headpiece for "The Dessert," in which they are described.

116. THE MUSHROOM. This human mushroom depicts the nickname given to one of the characters in this story.

117. ADAM BURDOCK. A duck carrying an umbrella during a rainstorm visually epitomizes the wet day described at the end of this story.

118. TAILPIECE. This punning wood engraving, the tailpiece for the entire book, shows a shoemaker's last and an awl ("that's all") supporting a small pennant inscribed "Finis."

119. SALUS POPULI SUPREMA LEX. ROYAL ADDRESS OF CADWALLADER AP-TUDOR AP-EDWARDS AP-VAUGHAN, WATER KING OF SOUTHWARK. TO HIS SUBJECTS OF THE BOROUGH. An undated broadside of 1828, published by S. Knight, London (Cohn 1952). This etching at the top of the sheet, done after Cruikshank had virtually given up working in caricature, was probably executed because of his own interest in pollution of the Thames. In fine print the design contains at the top left-hand corner the words "Time,—Midday," and at the upper right "Tide, Low Water at London Bridge." In addition to the Latin title at the top ("public health is the highest law") there is a quotation from Alexander Pope at the bottom. The rather lengthy text in this mock royal proclamation begins with a scatological list of titles for the director of the Southwark Waterworks,

followed by eleven stanzas of verse with four footnotes in small print at the bottom of the sheet. The most humorous part of the text lists the "Water King of Southwark" as "Sovereign of the scented streams,—Autocrat of all slushes,—Raining Prince of the Golden Showers, Protector of the confederation of the (U)Rhine,—Appropriator of the Diet of Worms, Palatine of the Lower Issues,—Margrave of Offals—Lord of the Stray Oils,—Agitator-in-chief of the Intestinal Canals, Night-chair-man of the board of Flux-ions,—Lord of the Man-ure of Shetland." As a footnote explains, the Thames' water was horribly polluted because of vast quantitites of sewage dumped into the river on the north side of the city. The inhabitants of Southwark had to boil their water and skim off the scum to make it potable. The etched text in bubble captions relates to the efforts of three women to extricate themselves from Thames mud and to the complaints of lower-class citizens of Southwark about the impurity of their water and the dangers of cholera. This print is an early example of the type of subject Cruikshank turned to as he grew older and his social conscience developed. Cruikshank had shown interest before in social reforms and domestic problems, but his earnest concern with these matters increased substantially during the first decade of Victoria's reign, culminating in his conversion to the Temperance Movement in the late 1840s (another example showing social interest is found in illustration 122).

**120 & 121.** ILLUSTRATIONS FROM "PUNCH AND JUDY. WITH ILLUSTRATIONS DESIGNED AND ENGRAVED BY GEORGE CRUIKSHANK. ACCOMPANIED BY THE DIALOGUE OF THE PUPPET SHOW, AN ACCOUNT OF ITS ORIGIN, AND OF PUPPET PLAYS IN ENGLAND." By J. P. Collier. Published by S. Prowett, London, 1828 (Cohn 150). Cruikshank did 24 etchings, which, except for the frontispiece, show scenes from the puppet theater. These etchings, both colored and plain, were reissued numerous times during the nineteenth century and have been one of Cruikshank's most commonly reprinted works during the twentieth. As the introduction explains, the artist and author literally hired a Punch and Judy man to do a private performance to allow them to take down the text and stop the performance at any point to help the artist draw pictures of the action. Accordingly, the illustrations are set up in the format of the stage itself, each depicting a different scene in the performance. This set of etchings shows Cruikshank's interest in accurate historical documentation of popular culture and traditional character types rapidly disappearing from England. The work has become a classic study of a Punch and Judy performance and has always been sought after by puppet enthusiasts.

**120.** FRONTISPIECE: MR. PUNCH. A straightforward portrait of Punch.

**121.** PUNCH AND THE DOG TOBY. As the accompanying dialogue relates, Toby bites Punch and holds on to his nose.

**122.** THE VOICE OF HUMANITY. THE KNACKERS YARD, OR THE HORSES LAST HOME! This etching appeared originally in a publication titled *The Voice of Humanity: For the Communication and Discussion of all Subjects Relative to the Conduct of Man towards the Inferior Animal Creation*, published by J. Nisbet, London, 1830–1833 (Cohn 285). The bibliography of the publication is complex, and it is hard to differentiate the states of the print. Such a design has its antecedents in William Hogarth's print series *The Four Stages of Cruelty*, dating from 1750. The maltreatment of

horses and disposal of old horses continued to hold the interest of humanitarians, including Cruikshank, throughout the century. We see once again an early example of the artist's growing concern with social evils which required public attention and correction.

**123 & 124.** ILLUSTRATIONS FROM "COMIC ALPHABET." Published by the artist, London, 1836 (Cohn 189). This small accordion book had 24 etchings representing the letters of the alphabet. Reissued in 1837 and later by Tilt and Bogue, this work appeared both colored and plain, with most of the colored copies dating from later issues. Once again Cruikshank tried to issue a work himself and apparently found he had to rely on a publisher in order to achieve sufficient sales. The book has always been a favorite of collectors of Cruikshank and collectors of alphabet books. We see in this work another facet of the artist's genius during a stage in his career when he had become the most famous book illustrator in England.

**123.** N/ NIGHT-MARE. This composition is based on Fuseli's famous painting of the same subject, which had already been the basis of a Cruikshank political caricature in 1816 (Cohn 1789). Here the artist approaches the theme from a comic point of view and portrays a nightmare resulting from overeating.

**124.** O/ ORPHEUS. Orpheus plays a violin in front of Hades and Persephone, who are seated on their throne with Cerberus bellowing alongside. The violinist may be a caricature of Paganini. Other letters in the alphabet refer to classical mythology, although the artist draws his subject matter from a variety of sources.

**125–128.** ILLUSTRATIONS FROM "ROSCOE'S NOVELIST'S LIBRARY." Mainly published by James Cochrane, London, 1831–1833 (Cohn 701–711). Cruikshank did 74 etchings for 17 volumes of this 19-volume series of illustrated novels, including works by Smollett, Fielding, Goldsmith, Sterne, and Cervantes. In undertaking such a large number of illustrations for novels that had become classics of the genre, Cruikshank followed in the tradition of artists like Thomas Stothard and Thomas Rowlandson, both of whom had illustrated some of the same works. Every artist who illustrates books feels that there are certain major works which he should interpret in order to place himself among the first rank of illustrators. Here we have Cruikshank's interpretations of some of the standard reading fare of the English public of his day. For works by Smollett, he did four etchings for *Humphrey Clinker*, five for *Roderick Random*, and eight for *Peregrine Pickle*. For Fielding, the artist did eight illustrations for *Tom Jones*, four for *Joseph Andrews*, and eight for *Amelia*. The general rule seemed to be four etchings for each volume in the series.

**125.** FROM "HUMPHREY CLINKER": HUMPHREY'S INTRODUCTION TO THE BRAMBLE FAMILY. Humphrey Clinker is seen riding on a horse shortly after being befriended by Mr. Mathew Bramble. In the novel Tabitha is greatly horrified at a tear in the back of Humphrey's trousers and develops an immediate distaste for her brother's new protégé. Cruikshank shows Tabitha looking at the young man's exposed posterior through the slats of her fan. She is reminiscent of the woman in the last plate of William Hogarth's *Rake's Progress* who is visiting Bedlam and looking through the slats of her fan into the cell of a nude man who is urinating against the wall.

Cruikshank, who was eminently familiar with Hogarth's works, is drawing on a visual heritage which he thinks gives him the license to add a detail in his illustration not to be found in Smollett's text.

126. FROM "HUMPHREY CLINKER": HUMPHREY'S ZEAL FOR HIS MASTER. The etching shows both Humphrey's valor in rescuing his master and Mr. Bramble's obvious discomfort. As the text narrates, Mr. Bramble is at first infuriated with Humphrey but later decides that he acted from motives of fidelity and affection even though he did not use good judgment in deciding to grab his master by the ear instead of rescuing him in a more conventional and less painful way.

127. FROM "JOSEPH ANDREWS": PARSON ADAMS & THE HOG'S PUDDINGS. Parson Adams is pictured just after he has been hit in the face with a pan full of hog's blood. This scene is one of the most memorable in the novel and had been illustrated more than once prior to Cruikshank's version. The choice of such famous scenes enables Cruikshank to show his ability in dealing with a subject already treated by others and demonstrates that his skill at humorous illustrations is greater than that of his predecessors.

128. FROM "JOSEPH ANDREWS": ADAMS'S VISIT TO PARSON TRULLIBER. The gullible, unsuspecting Parson Adams steps into Mr. Trulliber's pigpen and, after grabbing one of the animals by the tail, is suddenly thrown into the mire. The evident amusement of Mr. Trulliber, as expressed in Fielding's text, is captured by Cruikshank's etching.

129–134. ILLUSTRATIONS FROM "SUNDAY IN LONDON. ILLUSTRATED IN FOURTEEN CUTS, BY GEORGE CRUIKSHANK, WITH A FEW WORDS BY A FRIEND OF HIS; WITH A COPY OF SIR ANDREW AGNEW'S BILL." By John Wight. Published by Effingham Wilson, London, 1833 (Cohn 846). For this work Cruikshank did 11 full-page wood engravings and three vignettes, one of which is repeated on the title page. According to Cohn, George Cruikshank's own copy contained the note, "This work is my own original Idea; My dear friend Wight (the author of 'Mornings at Bow Street') wrote the text from my suggestions—George Cruikshank, 1874." This pamphlet is a criticism of a bill introduced repeatedly by Sir Andrew Agnew "to promote the better observance of the Lord's day." Each year the bill was defeated, but its author continued to attempt to seek approval for his biased and discriminatory bill dictating what the lower classes should and should not be allowed to do on Sundays. Cruikshank was neither the first nor the last person to express feelings against the proposed law. In 1836, Charles Dickens authored a small pamphlet on the same subject under the title *Sunday under Three Heads*. All of the wood engravings can be appreciated without reference to the rather complex text, which consists of 86 pages plus a copy of the original bill.

129. "WHY SHOULD THE VULGAR MAN,/ THE LACQUEY, BE MORE VIRTUOUS THAN HIS LORD?" This vignette of a policeman brusquely sending market people away, used both on the title page and in the text, refers to Agnew's provision that no market selling or labor of any kind should be allowed during Sunday services. Like so many other provisions in the bill, this measure was directed primarily against the lower classes and had little effect on the lives of the wealthy, since Agnew specifically exempts their household servants and delivery men from any of the restrictions placed on the other common people.

130. THE PAY-TABLE. A half-drunken workman, with his children and unhappy wife behind him, settles his account at a local tavern. His account, evidently amply overdrawn, is being exasperatingly reviewed by the standing tavern keeper for the worker's foreman, who sits stolidly at the pay table holding an account book. The enterprising foreman has arranged for the workman to have credit and thus fall further under the control of his employer.

131. THE SUNDAY MARKET. Here are seen the "lower orders" buying food on Sunday at their local markets. The advantage of a Sunday market for poor people who lead a meager day-to-day existence is pointed out in the text. According to the provisions of the new bill, the hours of such Sunday markets would be carefully regulated.

132. CORDIAL WORKINGS OF THE SPIRIT. Street fighting and drunken behavior result when lower-class persons are turned out of gin palaces and other drinking places just before the commencement of Sunday services.

133. GIN-TEMPLE TURN-OUT AT CHURCH-TIME. A crowd at an advanced state of merrymaking is being shut out of a gin shop, presumably to attend Sunday services.

134. "MISERABLE SINNERS!" In contrast to illustration 133, the artist here depicts the higher orders, comfortably seated in their choice pews, who refer to themselves, and are designated by their ministers, as "miserable sinners."

135 & 136. ILLUSTRATIONS FROM THE "WAVERLEY NOVELS." By Sir Walter Scott. Published in 48 volumes by Fisher, Son & Co., London, 1836–1838 (Cohn 730). Cruikshank was only one of the artists who contributed to this ambitious illustrated edition of Sir Walter Scott, originally issued in yellow-paper printed wrappers and subsequently in green-cloth volumes. In all, he did 35 etchings for the work. While other artists did landscape and portrait engravings, Cruikshank was generally assigned humorous scenes from the novels themselves. The two illustrations selected here were taken from *The Heart of Midlothian*, one of the group of novels titled *Tales of My Landlord*. Since this novel contains numerous ethnic character types, suitable for comedic interpretation, it is indeed well suited to Cruikshank's abilities.

135. "JEANIE—I SAY, JEANIE, WOMAN." Here we see the Laird of Dumbidikes speaking to Jeanie Deans in his accustomed manner—half entreating her and half ordering her to do his bidding. Dumbidikes is a typical provincial Scots laird who, in his narrow-minded and crude way, expects to win the hand and heart of Jeanie Deans. The plain but attractive Scots heroine is seen barefoot and peasant-like tending to her daily chores. The laird holds his ever-present pipe in one hand while his other hand is seen outstretched in mid-air after an unsuccessful attempt to grab Jeanie. As Scott describes it, "the paw remained suspended in the air with the palm open, like the claw of an heraldic griffin." The laird's horse, Rory Bean, stands just beyond the entrance at the right.

136. THE CAPTAIN OF KNOCKDUNDER. The sacrilegious captain smokes during church services. Reuben Butler, now the husband of Jeanie Deans, is seated next to her in the front row during this induction service for the newly appointed minister. The subject is humorously handled in Scott's novel and lends itself well in this etching to genre treatment.

**137 & 138.** ILLUSTRATIONS FROM "THE LOVING BALLAD OF LORD BATEMAN. ILLUSTRATED BY GEORGE CRUIKSHANK." Published by Charles Tilt, London, 1839 (Cohn 243). Cruikshank did 11 etchings and a cover for this printing of a folk ballad which he wrote down after hearing it in London. There has always been much confusion about the editorship of this edition, the names of even Charles Dickens and William Makepeace Thackeray often being associated with it. Apparently Cruikshank did ask Charles Dickens to write the notes to accompany the printing of the ballad, and Dickens did write to Cruikshank telling him to use cockney spelling and revise the last stanza. A study of earlier printings of the ballad and Cruikshank's original manuscript indicates that the artist chose not to accept Dickens' revision of the last stanza. In addition, several presentation copies of this work give evidence that Cruikshank took major credit for this ballad's publication. He is also known to have sung the ballad with appropriate gestures on numerous occasions throughout his life. A page of musical notations indicating the tune for the ballad was always retained in the many nineteenth-century reprints of this small book in both England and America. The story tells of Lord Bateman, the ruler of Northumberland, who travels to Turkey, is imprisoned but finally set free by the ruler's daughter Sophia, to whom he promises marriage. Many years later, he is about to be married to another, when the Turk's daughter shows up. He thereupon sends away his bride-to-be and marries Sophia, his true love.

**137.** LORD BATEMAN AS HE APPEARED PREVIOUS TO HIS EMBARKATION. In the first etching in the series the dapper and balletic Lord Bateman is seen just before his departure for foreign shores.

**138.** LORD BATEMAN, HIS OTHER BRIDE, AND HIS FAVORITE DOMESTIC, WITH ALL THEIR HEARTS SO FULL OF GLEE. This, the concluding etching of the series, shows the happy lord just after marrying his Turkish love.

**139.** ILLUSTRATION FROM "BENTLEY'S MISCELLANY": SAINT ANTHONY. Published by Richard Bentley, London, 1837–1864 (Cohn 69). Cruikshank was the chief illustrator for this periodical from its beginning in January 1837 to December 1843. In all, he did 126 etchings and four wood engravings for the text. Included among the etchings were the 24 designs for *Oliver Twist* (see illustrations 148–159). He also did illustrations for William H. Ainsworth's novel *Jack Sheppard* and Richard Harris Barham's *Ingoldsby Legends* (Cohn 50), a work to which his first cataloguer, Reid, wrongly assigns this etching. Cruikshank also did etchings for articles and poems written by a variety of authors on many different subjects. The etching reproduced here, titled "Saint Anthony," originally appeared in the January 1838 issue of *Bentley's*, accompanied by four and one-half pages of verse titled "The Temptations of St. Anthony" and signed with the initials "T. H. S." The etching shows a humorous interpretation of the saint's temptation by a siren who causes him to look up from his book. She may lack some of the seductiveness usually found in such figures, but this lack is more than compensated for by the astonishing variety of monsters and goblins surrounding the saint. Most of these creatures can be traced back to such progenitors as the monsters in Bosch paintings and graphics, but each bears the inimitable stamp of Cruikshank's own humorous bestiary. Several of the creatures in the etching are described in detail in the poem, such as the quaint imp in an earthen pot perched on a lectern, another imp with a trumpet snout, and the sharp-beaked beast on the left with exophthalmic eyes, a fishbone corona, and a body of bird bones.

**140–147.** ILLUSTRATIONS FROM "SKETCHES BY BOZ." By Charles Dickens (Cohn 232–235). The first series was published in two volumes by John Macrone, London, 1836; the second series, in one volume, by John Macrone, London, 1837; and a new complete edition, in 20 parts, by Chapman and Hall, London, 1839. The bibliography of this work, as concerns both text and illustrations, is one of the most complex in the entire canon of Dickens' work. For the first series Cruikshank did 16 etchings; for the first issue of the second series, ten more etchings; and for the second issue of the second series, two additional etchings—a total of 28 etchings for the original edition. For the edition in parts, Cruikshank re-etched in a larger format 27 of the original etchings and added 13 new plates, a total of 40 etchings. Of the eight etchings selected for reproduction here, six originally appeared in the one-volume second series, whereas two were originally done for the edition in parts. Most of the sketches by Dickens originally appeared in newspapers; all in the first series were written before Dickens met Cruikshank. Since ten of the 12 etchings in the *Sketches by Boz*, Second Series, were to accompany stories that first appeared in print after the two men met, these illustrated stories could have been written at the suggestion of or with some advice, unwanted or not, from the artist. There seems to be no appreciable difference in the quality of the etchings that may have stemmed from Cruikshank's suggestions, as can be seen by comparing the first two illustrations (140 & 141), executed for text already in print before the artist and author had met, with the next four illustrations (142–145). The two final etchings in larger format were first done for the edition in parts, even though the stories had originally appeared in print before the two men met.

**140. THE STREETS—MORNING.** This etching marvelously captures the feeling of the early morning in the almost deserted London streets. Although it follows Dickens' text, the design adds details of its own and very successfully captures the mood of the story. Cruikshank has incorporated parts of several descriptions in his picture: ". . . the more sober and orderly part of the population have not yet awakened to the labours of the day, and the stillness of death is over the streets; its very hue seems to be imparted to them, cold and lifeless as they look in the grey, sombre light of daybreak. . . . An occasional policeman may alone be seen at the street corners, listlessly gazing on the deserted prospect before him; . . . An hour wears away; the spires of the churches and roofs of the principal buildings are faintly tinged with the light of the rising sun; and the streets by almost imperceptible degrees, begin to resume their bustle and animation. . . . and little deal tables, with the ordinary preparation for a street breakfast, make their appearance at the customary stations." To these motifs the artist adds his own touches: the policeman leaning against a street post; the woman serving tea or coffee at the deal table, wearing clogs because of the cold; one scruffy customer drinking from the saucer; another, the little chimney sweep, who is mentioned in a different context in Dickens' narrative, digging into his pocket for money. These small but incisive details contribute significantly to the atmosphere in Cruikshank's etching. Another interesting touch is the building sign above the serving cart: "The Rising Sun." This refers ostensibly to a newspaper or insurance office, but it also works on another level, alluding to the early morning scene described in the text.

141. SEVEN DIALS. This design, illustrating Dickens' story of the same name, shows two women quarreling in the foreground while at least two others in the background fight. A group of onlookers urge on the principal combatants. The story tells about a well-known London intersection of seven streets and the inhabitants who live in and around this landmark. Dickens describes the kinds of quarrels they have and records typical dialogue accompanying such quarrels. For his part, Cruikshank visualizes a specific altercation as well as the general atmosphere of the setting. (For an earlier but similar portrayal of women arguing, see the central vignette in illustration 91.)

142. A PICKPOCKET IN CUSTODY. This etching was executed to accompany a story titled "The Hospital Patient." The narrative was first published after Dickens met Cruikshank and deals primarily with a visit to a hospital to take testimony from a dying woman who has been badly beaten by a young man. The pickpocket being carried to a magistrate in a wheelbarrow serves chiefly to bring the narrator to the courtroom hearing about the beating. The passage introducing the incident of the pickpocket states: "About a twelve month ago, as we were strolling through Covent Garden (we had been thinking about these things over-night), we were attracted by the very prepossessing appearance of a pickpocket, who having declined to take the trouble of walking to the Police Office, on the grounds that he hadn't the slightest wish to go there at all, was being conveyed there in a wheelbarrow to the huge delight of the crowd. Somehow, we never can resist joining a crowd, so we turned back with the mob and entered the office in company with our friend the pickpocket, a couple of policemen, and as many dirty-faced spectators as could squeeze their way in." The gentleman in the top hat behind the two police officers has often been taken as representing young Charles Dickens. The surrounding crowd is comprised of the usual Cruikshankian collection, and the pickpocket looks like Sikes in Cruikshank's *Oliver Twist* illustrations. The clothing of the pickpocket could well have been a pictorial prototype for Dickens' own description of Sikes' costume. Further, the beating of the woman in this story reminds one of Sikes' murdering of Nancy in *Oliver Twist*.

143. MONMOUTH STREET. This etching, for a story of the same title which appeared for the first time after Dickens met Cruikshank, shows old-clothes dealers, portrayed by both author and artist as Jews. As in the case of Fagin, the ethnic traits are suggested by superficial visual motifs and verbal labels. Cruikshank's interest in Monmouth Street existed before he met Dickens, for in the last plate he did for *Scraps and Sketches* (intended to be the first plate of Part 5), titled "The Anticipated Effects of the Tailor's Strike" (Cohn 180), he depicts one man handing another the card of "Levy— Monmouth Street." This is apparently the same Moses Levy who appears in the etching here under his shop sign. Although Dickens describes inhabitants of Monmouth Street much as they are portrayed by Cruikshank, the author goes on to tell another story about the people who wore the second-hand clothes, his central interest not being reflected in the scene depicted here. The name "P. Patch" over the right-hand doorway of an old-clothes dealer and the sign "Clipp Tailor" on the wall above are intended as puns.

144. THE LAST CAB-DRIVER. This etching was done for a story titled "The Last Cab-driver, and the First Omnibus Cad," published in part before Dickens met Cruikshank. The

material dealing with the last cabdriver did not appear with the story as first published and was not introduced until the second series of *Sketches by Boz*. The omnibus cad in the left background watches the cantankerous cabriolet driver in the foreground hail an off-scene fare. In the narrative the cabdriver fights with the client and winds up in solitary confinement in Coldbath Fields Prison. Correspondence from Dickens indicates that Cruikshank obtained permission from the director for Dickens to visit this prison.

145. SCOTLAND YARD. The story illustrated by this etching originally appeared after Dickens and Cruikshank met. It deals with a section of the city close to the old London Bridge and traces the changes in the people and the area during the construction of the New London Bridge. In the etching, the artist closely follows the narrator's description of an evening in a tavern where "coal heavers" (laborers who carry coal) congregate and sing. The kind of antiquarian interest displayed here is strong in Cruikshank's graphic works but seems to be equally prevalent in Dickens' writings. Cruikshank's depiction of coal heavers is reminiscent of his earlier interest in dustmen (see illustrations 75, 76, and 86). An interesting point about the text is that a passage about the destruction of an elephant at the Exeter Change was omitted by Dickens in the volume form of this story. At the time this event actually took place on 1 March 1826, Dickens was 14 years old. Cruikshank did an etching to accompany a broadside on the topic (Cohn 1056). Possibly the digression had been inserted in the first publication of the story at Cruikshank's suggestion and was then omitted by Dickens when the story was printed in volume form.

146. EARLY COACHES. This is one of the large-format etchings that first appear in the edition of *Sketches by Boz* published in parts. It was done for a story, written by Dickens before he met Cruikshank, about the trials and tribulations of traveling in England on the early coach. As a newspaper reporter, Dickens was quite familiar with this kind of travel and thus was writing from personal experience. Cruikshank has inserted a portrait of the writer at the counter trying to get his ticket before the coach departs. A piece of luggage located on the counter even bears the name "Mr. Boz/ London."

147. PUBLIC DINNERS. This large-format etching, appearing first in the parts edition of *Sketches by Boz*, was executed for a story written by Dickens before he met Cruikshank. The story deals with the English practice of giving large banquets to raise money for charity. In this instance the orphans of the charity are shown in the illustration being led into the banquet room by the stewards. Once again the artist includes personal, humorous touches in his design which are not in the original text. Some authorities have associated the first two stewards leading the children with Edward Chapman and William Hall, the publishers of *Sketches by Boz* in parts, but a comparison of this work with contemporary portraits of these two men does not appear to substantiate this claim. The next two stewards consist of a self-portrait of Cruikshank pointing his finger at a likeness of Dickens.

148-159. ILLUSTRATIONS FROM "OLIVER TWIST, OR THE PARISH BOY'S PROGRESS." By Charles Dickens (Cohn 239-241). Starting in February 1837 in *Bentley's Miscellany*, this novel began to appear in monthly installments, each with two illustrations by Cruikshank; the last installment appeared in March 1839. A few months before its completion in serial

form, the novel was published in three volumes by Richard Bentley. The author and publisher hoped to capitalize on the popularity of the work by enticing readers to buy the three volumes in order to find out how the novel was going to end before the final installments appeared in magazine form. In all, Cruikshank did 24 etchings for this work. They have always remained among his best-known and most admired illustrations. Late in life Cruikshank was incensed to find that the books he had illustrated for Charles Dickens and William Ainsworth were considered the sole creations of the authors and contained no mention of his contribution to these now famous works. He then became embroiled in a bitter controversy over this matter with Dickens' official biographer, John Forster. (For a review of this still controversial matter, see this writer's article in the *Princeton University Library Chronicle* cited in the bibliography at the end of this volume.) The question of whether Dickens told Cruikshank what to do or vice versa will never be settled definitively because Dickens or his friends destroyed much of the primary evidence, including Cruikshank's written communications with Dickens. Suffice it to say, Dickens at age 25 was a strong-willed, dominating young author who before he met Cruikshank had already, according to Jane Seymour, contributed to the suicide of Robert Seymour, the first illustrator with whom he had worked on *Pickwick Papers*. On the other hand, it is equally true that the 45-year-old Cruikshank had been a celebrity in the world of caricature and illustration almost since the year Dickens was born and there was little chance that he would allow himself to be dominated by any author no matter how talented. However, any work that originally appears in print with illustrations must necessarily be collaborative, no matter who plays the dominant role in producing the finished illustrated work. Some kind of collaboration is even more likely in a work like *Oliver Twist*, since the author was writing his novel in monthly installments, and, as we know from Dickens' letters to Cruikshank, the author did get behind with his work and had to settle, via consultation with Cruikshank, on subjects for illustrations even before he had written the passages to be illustrated. Cruikshank's letters or notes to Dickens, with the exception of one on the back of an original drawing, have all been destroyed. According to the artist's comments about his working practice with authors, he preferred to settle on an illustration by consultation—as he is seen doing in illustrations 45 and 46 in this volume. Subsequent to a consultation the artist would send a drawing to the author to assist him in producing his text. Apparently Dickens did not wish to work in this manner and preferred sending finished text to his illustrator along with instructions, but the pressures of his heavy work load as editor and chief contributor to *Bentley's Miscellany* sometimes prevented him from finishing his text far enough ahead of deadlines to carry out his preferred method of work. The titling of the *Oliver Twist* plates has always offered a particularly intriguing example of the different approaches of the two men. It would seem that whereas Cruikshank favored clever verbal captions for his illustrations, as might be expected for someone trained in the tradition of caricature, Dickens preferred rather bland, generic titles. As the novel progresses, one finds fewer Cruikshank-like catchy titles and more generic ones. The illustrations for *Oliver* have received more attention than any of the other works created by the artist, but unfortunately much that has been said about them deals only peripherally or superficially with them as artistic creations, being concerned chiefly with how well they illuminate the text or carry out Dickens' wishes. Certain

notable differences between characters described in the novel and those pictured in the plates are evident to even the most casual viewer. For example, Cruikshank pictures the prostitute Nancy as a fat, drab slattern. Cruikshank undertook the illustration of *Oliver Twist* with a visual prototype for almost every major character in the book, as would seem natural for an artist who had been drawing such London types for over a quarter of a century. Perhaps more interesting, however, than such discussion of controversy or of pictorial prototypes in *Oliver Twist* is the remarkable way in which Cruikshank's etchings capture visually major themes in the novel. Not until the twentieth century have literary critics, notably J. Hillis Miller, pointed out the significance of the theme of strangulation or hanging regarding the orphaned Oliver and his attempts to find love and a place in a society that had no room for children from the workhouse. Clearly, Cruikshank was well aware of this major theme since he depicts it repeatedly in one way or another in his illustrations.

148. OLIVER ASKING FOR MORE. This plate in the first installment in *Bentley's Miscellany* has become the most famous illustration ever done to accompany a novel. The concept of an orphaned child asking for more when forced to live on a legally fixed diet insufficient to sustain life somehow caught the fancy of Englishmen of all classes, and the theme of "asking for more" was used repeatedly in later decades of the last century in *Punch* cartoons. More recently it was utilized by a cartoonist during the Watergate scandal in connection with Congressional requests to see more tapes. In the narrative, after Oliver draws the deciding lot and is compelled to carry out the wishes of his fellow sufferers, he approaches with his bowl in hand and says, "Please, sir, I want some more." The famous title itself appears only beneath the etching and probably was originally suggested by Cruikshank since the words "asking for more" have quotation marks around them in one of the preliminary drawings. Cruikshank's tendency to put quotation marks around a part of a title can be seen more than once in the caricatures illustrated in this volume (see illustrations 20 and 21). Apparently the quotation marks were edited out of all the engraved titles for the *Oliver Twist* illustrations except one (see illustration 150). A letter from Dickens to Cruikshank establishes the fact that the author was behind in producing this first installment and thus asked Cruikshank to "say until what day you can conveniently give me; and I will call on you at your own time, and settle our illustration." Referring to this installment of *Oliver Twist* in another letter to publisher Richard Bentley, Dickens expresses himself in a quite different tone: "I am very happy to say that I think the next No. will be an exceedingly good one. I have bestowed great pains and time upon it, and shall consider the arrangement, well. Moreover, I think I have hit on a capital notion for myself, and one which will bring Cruikshank out." An understanding of the author-illustrator relationship depends on how one chooses to interpret these two different versions about the first illustration to *Oliver Twist*. Cruikshank claims that he originally suggested to Dickens that he write about the maltreatment of a farmed-out orphan child and that he called the author's attention to a pamphlet written about a year earlier by a physician friend of his, T. J. Pettigrew, who had been horrified by the treatment of orphan children. An examination of the actual parish records indeed reveals that the children in the parish involved were so maltreated that great numbers of them died. Among other gruesome details the

records show that they all suffered from severe dysentery and ringworm. The latter affliction caused the doctor to request that the heads of all the children be shaved, and in Cruikshank's illustration Oliver's companions do look as though they recently had had their heads shaved. The use of a large spoon with a small bowl is another visual comment that adds to the irony of Oliver's innocent but audacious request for more. The use of such humorous details in a serious attack on the newly enacted inhumane Poor Laws in England equally pervades the written as well as the visual content of the early chapters of *Oliver Twist*.

**149. OLIVER INTRODUCED TO THE RESPECTABLE OLD GENTLEMAN.** In this etching Oliver and the reader see Fagin for the first time. In the original installment accompanying the illustration there is no mention of the motif of hanging portrayed over Fagin's mantelpiece—only disclosure later that some of Fagin's thieves have been arrested and hanged. The somewhat vague but repeated references by Dickens to Fagin as a figure representing or connected with the Devil has led some scholars to assume that Fagin's three-pronged toasting fork may be related to the Devil's pitchfork. The Jewishness of Fagin is not very convincing either in Cruikshank's illustrations or in Dickens' text. It seems highly unlikely that a practicing Jew of the period would be cooking sausages of any kind. More than likely neither Cruikshank nor Dickens knew very much about the actual religious practices of London Jews. The ramshackle and claustrophobic quality of Fagin's den comes off quite clearly in Cruikshank's etching. It is possible that the original titling had quotation marks around "the respectable Old Gentleman." Correspondence establishes the fact that Dickens sent his finished text to Cruikshank before the artist did his illustration, but this still does not explain Cruikshank's visual reference to hanging before the theme is introduced in the novel.

**150. OLIVER AMAZED AT THE DODGER'S MODE OF "GOING TO WORK."** In this single instance quotation marks did get into the engraved title accompanying Cruikshank's etching. Although this scene may be a creation of the artist's imagination, it could just as easily be based on one of the actual bookshops located in Clerkenwell, near Pentonville, the neighborhood in which both Dickens' fictional Mr. Brownlow and Cruikshank lived. Oliver's amazement at seeing the Artful Dodger and Charley Bates picking a pocket expresses the rather colorless, namby-pamby character of the little hero who was brought up in a workhouse surrounded by criminals but who speaks English better than most high-achieving schoolboys of his time. The theatrical pose assumed by Oliver resembles closely the stereotypic stance of horror or amazement seen in dramatic handbooks. Since this illustration happens to be the only one for which there is any extant correspondence from Cruikshank to Dickens, it is worth while to quote the note inscribed on the back of one of the preliminary sketches for this design. "My Dear Sir—Can you let me have a subject for the second Plate? The first is in progress. By the way, would you like to see the Drawing? I can spare it for an hour or two if you will send for it." The second illustration referred to here must be the other Cruikshank etching to be used in the monthly installment for *Bentley's Miscellany*, which was done for a non-Dickensian contribution to the magazine. This note, significantly, refutes the notion that Cruikshank was required to send all drawings to Dickens for the author's approval. This idea has become prevalent because one of the final illustrations in the novel was rejected by Dickens on aesthetic grounds, the artist being

asked to do a substitute etching with the same title. However, this note indicates that Cruikshank felt he was sending the drawing to Dickens to assist him somehow with the episode involved. Anyone required to send drawings for approval would hardly express himself in these terms and would certainly have his own messenger deliver the drawing rather than have the author send for it.

**151. OLIVER CLAIMED BY HIS AFFECTIONATE FRIENDS.** No correspondence concerning this etching has survived, but three preliminary drawings are extant. The etching itself shows Sikes and Nancy for the first time, both figures for which Cruikshank had pictorial prototypes. Although Nancy is certainly not in harmony with Dickens' concept of her, Sikes is described in Dickens' text much as he is pictured in Cruikshank's illustration. Of all the character types in the novel, that of Sikes occurs most frequently in Cruikshank's earlier work. Dickens' original description of Sikes may have been based on the author's recollection of his illustrator's prototype: "a stoutly-built fellow of about five-and-thirty, in a black velveteen coat, very soiled drab breeches, lace-up half-boots, and grey cotton stockings, which enclosed a very bulky pair of legs, with large swelling calves;—the kind of legs, that in such costume, always look in an unfinished and incomplete state without a set of fetters to garnish them. He had a brown hat on his head, and a dirty belcher handkerchief round his neck: with long frayed ends of which he smeared the beer from his face as he spoke." The other lower-class London types in this etching, notably the butcher boy on the far right, the tavern keeper, and the two housewives, also occur repeatedly in Cruikshank's depictions of London streets. Since the signs over the tavern also appear in other Cruikshank compositions, it is safe to say that the artist found ironic humor in the required outside sign for a tavern—here with double-entendre interest: "To Be Drunk on the Premises." This etching also shows Sikes' dog Bull's-eye for the first time. Although it is not readily apparent because so little of the dog is seen in this illustration, Cruikshank even had a prototype for Bull's-eye. The incident portrayed is the moment when Oliver, who has now recovered from his illness under the good care of Mr. Brownlow and his housekeeper, Mrs. Bedwin, has been sent on an errand to return some books to a bookseller. He is apprehended by Nancy, who carries both a market basket and a latchkey to make her look more like a respectable woman.

**152. MASTER BATES EXPLAINS A PROFESSIONAL TECHNICALITY.** Oliver is now back with Fagin and his gang, being held in confinement. He is helping the Artful Dodger dress. At this point Charley Bates suggests that all thieves are very much in danger of being "scragged" and illustrates the process of getting hanged to the naïve Oliver, who has not understood the underworld term for hanging. More than any other etching for the novel, this one visualizes the hanging motif, as well as the theme of suffocation or enclosure (through the use of the locked door with its bolt on the back wall of the room). Apparently the artist and author settled upon this illustration through consultation, since in an undated note from Dickens to Cruikshank the author says, "Shall you be at home at two o'clock to-day? I have been prevented from writing Oliver, so perhaps had better settle the Illustration with you at that time if Convenient." There is a page of preliminary sketches relating to this illustration in the Widener Collection at Harvard on which Cruikshank in his old age wrote in ink: "Sketches for 'Oliver Twist'—suggestions to Mr. C. Dickens—the *writer*." These two docu-

ments, a letter and a comment on a sketch, seem to confirm the thesis that Cruikshank's later comments on this sheet could indeed be true. Apparently this design pleased both Cruikshank and his author, for a few days later Dickens wrote the artist, "I am delighted with the drawing, which is most admirable."

153. THE JEW & MORRIS BOLTER BEGIN TO UNDERSTAND EACH OTHER. Noah Claypole (see commentary to illustration 155) has run away from the parish in which he and Oliver were born and has come to London accompanied by Charlotte (see 155). Claypole has now assumed the name of Morris Bolter and is shown here meeting with Fagin, who is interested in putting Bolter to work for him. Both Morris Bolter and Fagin have their fingers beside their noses, the traditional sly gesture of being in the know which occurs more than once in Cruikshank's work (see illustrations 80, 96, and 229.)

154. MR. BUMBLE AND MRS. CORNEY TAKING TEA. This illustration and the next one (155) offer a pair of visual contrasts. Here Mrs. Corney, the matron of the workhouse, is having tea with Mr. Bumble, the beadle, whose amorous inclinations cause him to move his chair closer and closer to that of Mrs. Corney. In a letter to Cruikshank, Dickens offers some directions for composing this plate: "I have described a small kettle for one on the fire—a small black teapot on the table with a little tray & so forth—and a two ounce tin tea cannister. Also a shawl hanging up—and the cat & kittens before the fire." There are many more details in both the text and the etching which are not mentioned in the note, such as the two bottles on the bureau and the placing of Bumble's hat on the chair and his cane against it, which leads one to believe that Cruikshank may have seen the text or had some kind of conference with Dickens before he did this illustration. The note states that Mrs. Corney's shawl is seen hanging and Cruikshank so depicts it in his illustration, but the text of the novel fails to mention the shawl except that when Mrs. Corney was called out of the room she made her exit after "muffling herself in a thick shawl which she hastily caught up." The failure to mention the location of the shawl in the text could indicate that Dickens has not written the text at the time he wrote his short note to Cruikshank or that he later revised his text and removed any reference to the shawl. In any event there is no justification for referring to this note, as one critic has, as a "detailed précis of the incident to be depicted." On the mantel, far left, is a porcelain figure of a well-known dramatic character named Paul Pry (from the 1825 play of that name by John Poole) who turns up repeatedly at the most inopportune moments, hat and umbrella in hand, saying "I hope I don't intrude." This visual detail not mentioned in the text offers a good example of an instance in which the illustration elaborates on the theme in the passage being visualized. According to the text, when Mrs. Corney leaves the room, Mr. Bumble begins to pry, opening her cupboards and counting her silver. He also pries in the next illustration when he discovers Noah Claypole and Charlotte in the little parlor.

155. MR. CLAYPOLE AS HE APPEARED WHEN HIS MASTER WAS OUT. As suggested in the preceding commentary, this etching offers an ironic counterpart to the tête-à-tête enjoyed by Mrs. Corney and Mr. Bumble. Undertaker Sowerberry's maid Charlotte is feeding oysters to her fellow employee, Noah Claypole, the charity boy, while their master is out. No nineteenth-century reader would be unaware of the sexual

overtones in this etching, since oysters were thought to have great aphrodisiac power. Also, it seems to be a bit of intentional irony that Cruikshank shows Mr. Bumble glaring at the two miscreants, who are involved in a romantic intrigue similar to that just attempted by him with Mrs. Corney. On the original drawing for this etching Cruikshank has written, "Dr. Dickens, 'Title' wanted—will any of these do? Yours, G. Ck." The three titles listed are the one inscribed on the finished plate and two alternates: "Mr. Claypole Astonishing Mr. Bumble and 'the natives'" and "Mr. Claypole indulging." "Natives," of course, refers to the local oysters, as in illustration 109.

156. THE MEETING. Morris Bolter, alias Noah Claypole, is seen spying on Nancy while she confers with Mr. Brownlow and Rose Maylie near London Bridge. By this time Dickens was well ahead of Cruikshank since he was trying to finish his text early to bring out the book in three volumes before its completion in serial form. Cruikshank's obvious difficulty in making Nancy appear sympathetic is most apparent in this illustration. The bland generic title is in marked contrast to the earlier humorous ones.

157. SIKES ATTEMPTING TO DESTROY HIS DOG. The murder of Nancy has already taken place and Sikes has fled from London, the outline of which can be seen on the horizon. He has become particularly annoyed by the fact that Bull's-eye keeps following him, thus making him more easily recognizable. He decides to catch the dog and drown it in a nearby pond, but the animal senses that he is about to be destroyed and avoids his master. In the end, Bull's-eye is the very one who leads the pursuers to Sikes' hiding place. No doubt the text which this illustrates, suggesting once again the strangulation leitmotif, was written in advance of the composition of Cruikshank's etching.

158. THE LAST CHANCE. After Dickens had written the text for this illustration, he wrote to Cruikshank "that the scene of Sikes' escape will not do for illustration. It is so very complicated, with such a multitude of figures, such violent action, and torch-light to boot, that a small plate could not take in the slightest idea of it." Notwithstanding this comment, the artist was able to catch in roughly a four-by-five-inch etching a great deal of the atmosphere surrounding Sikes' escape. Although the crowd below is not shown, its presence and mood are sensed and the dynamics of the scene felt because of the window watchers and the expression on Sikes' face. The theme of hanging is dramatically foreshadowed in this scene, as are the themes of confinement and suffocation in the next.

159. FAGIN IN THE CONDEMNED CELL. Fagin bites his fingernails in the death cell just a few hours before he is to be hanged. There are a number of unverifiable stories about how Cruikshank decided on the exact pose for Fagin in this memorable illustration of fear. According to the most popular, the artist was puzzled and sat in front of a mirror biting his fingernails. The style of etching itself contributes masterfully to the effect achieved—Fagin's abject terror at his impending doom. The intensity of mood of this composition is heightened not only by the cramped energy of its heavily textured etching but also by key details, such as the cell window with its heavy iron grating. The claustrophobic sparseness of the cell itself focuses the viewer's attention on the stark fear seen in Fagin's transfixed stare and crouched, cowering posture.

**160–187.** ILLUSTRATIONS FROM "THE COMIC ALMANACK." By "Rigdum Funnidos, Gent." Published by Charles Tilt, then Tilt and Bogue, and finally David Bogue, London, 1835–1853 (Cohn 184). From the start of this series in 1835 through 1847, Cruikshank produced 12 etchings for each annual issue and a repeating style of design for each cover. In 1848, the format of the series was changed; it now had only six etchings, a different cover design, and a lower price, probably with a view to increased sales and a better competitive position. The following year a similar format was used, containing a folding frontispiece and five etchings. For its last four years, the publication appeared in cloth covers; it was of the same size and price as earlier issues but had a folding frontispiece and six etchings per issue. In sum, Cruikshank did 196 etchings for this remarkable periodical during its 19 years of publication. There seems little doubt that his designs were the main attraction of the almanac and that it could not have continued for so many years without them. The series' eventual decline in sales was probably due not to a lack of interest in the aging artist's work or to his late espousal of temperance but rather to changes in the economics of printing which made the use of etchings in publications of this type more costly and less profitable. The dominance of *Punch* and its rival publications may also have contributed to a lessening interest in Cruikshank's etchings. Although there was no fixed plan for the almanac, it was from the outset divided into monthly divisions, one etching done for each month. In regard to style and content, these small etchings epitomize Cruikshank's transformation of the Regency caricature into the format of Victorian book illustrations. Public taste had changed, and it now could be said without hesitation that nothing in this publication, when shown in the family drawing room, would bring a blush to the face of even the most modest young person. Nevertheless, these small compositions evidence many characteristics of the caricature and can be categorized in types the same way caricatures are classified. Some are essentially societal in a Regency sense (i.e., dealing with manners, mores, etc.); others, political or historical; and a few deal seriously with Victorian social issues. A thorough study of the origins of many of these designs would go back to Cruikshank's own work in caricatures or, further, to the work of some of his predecessors; but doubtless he was also greatly influenced by illustrations then appearing in many English and French publications. Presumably, almanacs for the new year went on sale at the end of the old year so publishers could take advantage of Christmas sales. For this reason, an almanac print may often deal with outdated events. Many of the etchings show London and its street people, offering views of buildings and sections of the city identifiable by specific London landmarks. Since the etchings are usually linked to specific months in the year, they deal with English holidays or particular events associated with each month. In this way they serve as exaggerated but generally accurate depictions of some of the celebrations in England for the years covered by these remarkable almanacs. The work was issued originally in paper covers but was then collected every few years in volumes. Later in the century, the entire series was reissued in two volumes with very inferior stereotype printings of the etchings. The work has even been reissued in part in this century with a small selection of etchings. The *Comic Almanack*, covering the first two decades of Victoria's reign, offers a panoramic view of changing popular interests. For example, more and more of the etchings in the later volumes deal with scientific topics. It is to be hoped that a scholarly study will be made one day to accompany a complete reissue of this impressive work.

**160.** MARCH [1835]. The scene shows a very windy day in Fleet Street outside of the shop of Tilt, the bookseller and publisher of *The Comic Almanack*. People are chasing hats and trying to protect themselves from the strong March wind. Tilt's shop windows display a variety of pictorial works. The two men seen conversing by the open doorway are usually identified as a self-portrait of Cruikshank—with his back facing the door—and a three-quarters portrait of Tilt himself.

**161.** MAY [1835]. This etching shows the traditional May Day procession with "My Lord," "My Lady," the "Green," a clown, a chimney sweep, and musicians. Cruikshank, who customarily gives shopkeepers names keyed to their wares, here appropriately selects "G. Budd" for a florist. (For another treatment of this subject by Cruikshank and for a discussion of this English celebration, rapidly disappearing in Cruikshank's day, see the story titled "The First of May," by Dickens, in *Sketches by Boz*.)

**162.** AUGUST [1835]. In this typical summer street scene in London, dustmen and servants are seen lining up to buy oysters while a middle-class couple are pestered by children asking for money, presumably as a reward for building the oyster-shell grotto seen in the right background.

**163.** FEBRUARY [1836].—TRANSFER DAY AT THE BANK. In the foreground of this bank scene two men are conversing. The man first in line is transferring money while a pickpocket has removed the man's wallet from his coat and is passing it on to a receiver of stolen goods. A police officer, handcuffs ready, is about to apprehend the thieves. This etching, published a year before *Oliver Twist*, shows pictorial prototypes for four of the characters in that novel. The figure in the front of the line is an unmistakable prototype for Mr. Brownlow; the pickpocket is a wiry variant of the Sikes type; the receiver of stolen goods resembles Fagin; and the police officer suggests Blathers, the Bow Street runner, who investigates the attempted robbery of the Maylie household.

**164.** JANUARY [1837].—LAST YEAR'S BILLS. The head of the household sits dozing before the fireplace with stacks of spindled bills at his feet, surrounded by emblematic depictions of various tradesmen, who include the oilman, the coal merchant, the china man, the greengrocer, the bootmaker, the wine and spirit merchant, the butcher, the baker, the ironmonger, the tailor, and others. This composition is another example of Cruikshank's skill in the use of animism.

**165.** FEBRUARY [1837].—VALENTINE'S DAY. Varied types of men and women are seen shooting arrows at select targets from upper-story windows or rooftops, uninhibitedly indulging themselves in the amorous license associated with this special day.

**166.** NOVEMBER [1837].—ST. CECILIA'S DAY. This small etching, reminiscent of Hogarth's "The Enraged Musician" of 1741, shows a crowd of motley types at a London thoroughfare (identified by Reid, Cruikshank's original cataloguer, as Charing Cross), all engaged in the production of sound—musical or otherwise. The resulting din includes sounds produced by street singers, a bagpipe player, a braying jackass, a Punch and Judy show, a band, and an omnibus bugler. The traditional celebration to honor the patron saint of music is thus reduced to a comic cacophony of London street noises.

**167.** JANUARY [1838].—NEW YEAR'S EVE. Fiddlers assist a typical middle-class family to usher in the new year. The full

cornucopia of 1838 is contrasted to the empty one of 1837, right, accompanied by an aging Mother Time. The bifurcated parlor chandelier is probably intended to be a comic representation of the two-headed god Janus.

168. MARCH [1838].—ST. PATRICK'S DAY. Throughout his career Cruikshank exhibited the often-held English prejudice against the Irish. A wild brawl is under way in which women attempt to curb combatants by wielding a chair or a shovel or by throwing water on them. Elsewhere other participants attack with shillelaghs, while children drink liquor and young adults do the Irish jig. (For a second handling of this same holiday, see illustration 177.)

169. OCTOBER [1838].—BATTLE OF A-GIN-COURT (PETTY FRANCE). A large group of people are shown in various stages of drunkenness and brawling. As in many caricatures, the meaning of this plate becomes clear only after one understands the play on words in the title concerning the historic Battle of Agincourt and a battle in a London gin court located on a street named Petty France. Even upper-story inhabitants of the court are shown joining in the fracas.

170. DECEMBER [1841].—A SWALLOW AT CHRISTMAS (RARA AVIS IN TERRIS). Along a cliffside path and across fork-supported planks marches a procession of miniature Christmas treats into the mouth of a Christmas celebrant. To his right, on a small staircase, are lined up ready for his glass an array of tempting drinks. Most prominent among the main dishes are roast beef, plum pudding, and turkey. Floating in the background and completing this gustatory procession are boats with loads of spices, sugar, coffee, and tea. This unique food-and-drink depiction of the English Christmas celebration demonstrates Cruikshank's ability to use animation to vitalize his designs.

171. SCIENCE UNDER DIVERS FORMS [1843]. A pre-Jules Verne vessel designed to carry people along the floor of the ocean causes great consternation among the aquatic inhabitants. This print may refer to speculative scientific writing appearing about this time on the development of the submarine. The accompanying text, a letter from the bottom of the ocean, calls the vessel a "submarine steamer." The double-edged use of the word "divers" is obvious.

172. BEFORE DINNER AND AFTER [1842]. Five couples are seen in a taciturn, somewhat awkward scene at the start of a dinner party. Except for two women, who seem to be gossiping, only the host and hostess are conversing. The after-dinner scene shows the participants in animated conversation, as a bottle of port is passed around. The accompanying poem makes it clear that drink has had its part in mixing the sexes and livening up the conversation.

173. OVER-HEAD AND UNDER-FOOT [1842]. In an upstairs apartment decorated with typically Regency masculine scenes, a group of young men animatedly and boisterously celebrate. In the apartment below, an older man sits before the fireplace in evident distress, unable to retire to his adjoining bedroom. According to the story accompanying this etching, Bailie Mucklescratch has secretly rented the flat below his son in order to see how the young Scot goes about pursuing his medical career in Edinburgh. The father's displeasure with his son ultimately leads to the youth's being sent to jail for debt. Curiously, the story does little to increase one's appreciation of the humor in a design which is as applicable today as it was in Cruikshank's time.

174. THE HEIGHT OF SPECULATION—GROUNDLESS EXPECTATIONS [1844]. Assorted flying machines—one serving to accommodate the inhabitants of the Castle of New St. Cloud and another being the "Parish Engine" used to put out fires—fill the sky in this depiction of the future success of the "Aerial Building Company," whose prospectus accompanies this etching. Cruikshank draws upon speculative scientific writing about future inventions to illustrate here the theme of high-risk investments. (For an earlier treatment in caricature of a similar theme, see illustration 20.)

175. AIR-UM SCARE-UM TRAVELLING [1843]. This etching ridicules the nineteenth-century fad for aerial balloons. Although the dangers of ballooning are evident in the left background, signs proclaim that balloon travel includes trips, not only to Paris and Mont Blanc but even to Peking and Canton. Cruikshank derided aerial travel in several other etchings (see illustrations 174 and 184).

176. THE FALL OF THE LEAF [1845]. A family dinner party has just turned into a calamity because the leaf of the table on the hostess' side has collapsed, sending food and dishes crashing to the floor. As is usual in Cruikshank etchings, the wall hangings here become adjuncts to the "fall" theme of this scene and include the Falls of Niagara and of the Clyde. Gibbon's history of Rome, the *Decline and Fall*, lies open on the floor.

177. THE DAY AFTER—ST. PATRICK'S DAY IN THE MORNING [1845]. A courtroom is filled with bandaged, bruised, injured individuals who have been brought in to try to explain their predicament. (For another depiction of this holiday, see illustration 168.)

178. TAURUS—A LITERARY BULL [1846]. The almanac for 1846 utilized astrological signs for each month. A bull represents April and is shown here in the middle of a printing shop terrifying the compositors, who hurriedly take safe positions to escape a feared rampage. The signs on the wall, all semantically bull-cued, include advertisements for the Bull Inn, the famous comedy *John Bull*, an account of the Pope's Bull, and a cock-and-bull story. The stark contrast in expressions—that of the indignant bull ready to strike and that of the frightened men awaiting the bull's next move—creates a singularly intriguing composition. The accompanying verse, titled "Bull in the Printing Office," and signed "W. Wordsworth, Poet Laureate," equates the bull with John Bull, the long-suffering English public that ought to attack the "sad trash" that issues from the press.

179. BORN A GENIUS AND BORN A DWARF [1847]. This etching was probably inspired by a passage in Benjamin Haydon's *Diary* in which he contrasted his own lack of success as a painter with the incredible wealth and success of Tom Thumb, the well-known midget, who had been brought to England by the American circus manager P. T. Barnum. Haydon, who committed suicide in 1846, starves in a garret studio before an unsold painting, while Tom Thumb, relaxing in elegant surroundings after a champagne dinner, admires a trinket taken from a jewelry box next to several bags of gold.

180. THE DESECRATION OF THE BRIGHT POKER [1847]. In a Victorian sitting room, a middle-class family group, including spinsters, display utmost alarm because a gentleman is about to stir up the fire with a bright poker made of shiny Britannia metal—a poker intended for decoration, not for use.

181. "MY WIFE IS A WOMAN OF MIND" [1847]. An intellectual woman, wearing blue glasses, her hair pulled back to reveal a high forehead, composes at a table. Her husband holds a baby while an older child pulls her brother from the hearth and her sister sits weeping over a spilled plate of food. The house is a shambles. The poem accompanying the etching indicates that the woman has large intellectual bumps on her head identifiable via the science of phrenology as "ideality" and "causality." She is not interested in caring for her family since she "loves the whole human fam'ly, For *she* is a woman of mind." This etching, clearly a response to the Victorian controversy over women's rights, reflects a prevailing male attitude seen in many cartoons of the day.

182. A SPLENDID SPREAD [1850]. Gentlemen at a party are passing refreshments on trays whose extended-length handles were necessitated by women's skirts of considerable volume. The print ridicules the crinoline dresses which came into fashion at the time.

183. FELLOWS OF THE ZOOLOGICAL SOCIETY [1851]. Various animals from the "zoological society," grouped in pairs, converse learnedly. This composition is a good example of Cruikshank's remarkable ability to delineate animals as human beings. Close study of the print reveals that, in each pair, one member is an animal dressed like a man and the other a man who resembles the animal. (For a reproduction of the original drawing and a discussion of Cruikshank's methods of composition, see the introduction to this volume.)

184. MODERN BALOONING OR THE NEWEST PHASE OF FOLLY [1851]. This is a satire on life-endangering yet thrilling pastimes such as the nineteenth-century fad of ballooning. A jackass seated on a horse rises in a balloon while a group of jackasses cheer him on from the ground. The accompanying text discusses the annoyances and dangers associated with the balloon mania.

185. OVER POPULATION [1851]. The effects of potential overpopulation inspired this etching. To provide living space for a plethora of people, boats on the Thames are used as residences, balloons are transformed into buildings and villas are suspended in the air.

186. AN EXTRAORDINARY MOVEMENT—IN CHINA—OR AN ALTERATION IN "THE WILLOW-PATTERN"—AT LAST!! [1853]. This composition parodies the famous blue-and-white design used for china during the nineteenth century. From the banners on a few of the boats filled with teapot-headed Chinese, it is evident that the artist is commenting on the Chinese emigration to California and Australia then occurring because of discoveries of gold in those areas. Modifying a well-known design and using it for new purposes is a technique Cruikshank learned very early in his career as a caricaturist.

187. WILL YOU BE—OUR VIS À VIS? [1853]. An exaggeratedly dressed middle-class couple hold hands and extend a somewhat questionable invitation. He wears an oversized tie; she carries a disproportionately large bouquet. This composition contrasts interestingly with Cruikshank's earlier satires on fashion. By this time in his career he is no longer so concerned with ridiculing the fashions of the day. Sharp satirical details of the type found in illustration 18 have been notably softened in this Victorian composition.

188 & 189. ILLUSTRATIONS FROM "THE TOWER OF LONDON. AN HISTORICAL ROMANCE." By William Harrison Ainsworth. Published by Richard Bentley, London, 1840 (Cohn 14). Cruikshank did 40 etchings and 58 wood engravings for this book, originally issued in 13 parts in 12 numbers (the last part being double as was customary in such publications of the period). For this work Cruikshank created a new, dark manner of etching which does not occur very often outside of this and some other Ainsworth novels. The blackness of these sometimes macabre compositions is best seen in early proofs; later editions give only a slight idea of their original impact. The novel's historical subjects, including Lady Jane Grey, Queen Mary, and Queen Elizabeth, provided a compatible challenge for the talents of Cruikshank and Ainsworth, both of whom toured the Tower in order to get the historical settings accurate in the novel. Most of the wood engravings are concerned not with scenes in the novel but with actual rooms and historical documentation relating to the Tower of London. Certainly Cruikshank's illustrations contributed to the novel's success at the time of its publication. Indeed, playbills for dramatic interpretations of Ainsworth's work frequently include mention of the illustrator as well as the author.

188. QUEEN JANE & LORD GUILFORD DUDLEY BROUGHT BACK TO THE TOWER THROUGH TRAITORS GATE. In an eerie night scene foreshadowing their eventual fate, the two would-be conspirators are being brought back to the Tower as prisoners. This is one of Cruikshank's most successful attempts to catch the historic atmosphere of the novel he was illustrating.

189. MONGER SHARPENING HIS AXE. The executioner sits in a dark cell at his grinding wheel and tests the sharpness of his axe. The chopping block at the right awaits its next victim. This plate, like others in the volume, demonstrates the limitations of a comic artist like Cruikshank in dealing with serious themes. Some compositions of this kind are successful; but others, influenced by then prevalent Victorian social customs, verge on the melodramatic.

190 & 191. ILLUSTRATIONS FROM "THE MISER'S DAUGHTER. A TALE." By William Harrison Ainsworth. Published by Cunningham and Mortimer, London, 1842 (Cohn 17). Cruikshank did 20 etchings for this novel, which originally appeared in monthly installments in *Ainsworth's Magazine* (Cohn 22) before coming out in three volumes. Like all of Ainsworth's works, it was reprinted numerous times during the last century. The novel deals with eighteenth-century London and, like *The Tower of London*, attempts to present within a work of fiction an accurate historical account of an earlier age. In 1870 the artist read about a dramatic performance of this work in which no mention was made of his name or of his contribution to scenes portrayed on stage. He reacted in a letter to the *Times* and ultimately wrote his pamphlet *The Artist and the Author* (Cohn 202) in which he claimed that he had created several of Ainsworth's stories and assisted Dickens with *Oliver Twist*. Until very recently it has customarily been said that Cruikshank's "senile delusions" about assisting authors extended to Ainsworth as well as Dickens; but with the publication of an original letter from Cruikshank to Ainsworth detailing what the author was to put in a scene in *The Tower of London*, it would appear that the artist did execute drawings before the author wrote his scenes. Both of the examples chosen from *The Miser's Daughter* prove that Cruikshank is right on this point and

that he sent the tracings for the etchings to assist the author in the composition of his text. Two letters from Cruikshank to Ainsworth detailing what is to be put in each scene appear in print here for the first time. Ainsworth may have written many scenes before Cruikshank executed the corresponding drawings, but in these two cases, at least, the reverse took place, as the artist claimed.

190. THE SUPPER AT VAUXHALL. Cruikshank's letter of instructions and Ainsworth's text corresponding to this etching show how the author-artist collaborative process works in certain instances:

My Dear Ainsworth.                                July 15/42
    I have been hoping that you would have call'd and did *expect* you would have sent or I should have forwarded the enclosed tracing before. The Beau, Cripps and the Bravo are in the background—Sir B Price is seated by the side of Clementina—Kitty Conway might be singing in the orchestra.—talking of singing reminds me of a *note* of mine which comes rather *sharp* upon me, and I want you to help me over the bar by sending me your cheque for *fifty*—by tomorrow or Monday.
    I hope you are at work, recollect that you are now in a position to smash old B's Miscellany if you *like* to do so, and that you may be so disposed and effectually carry out your intentions is the sincere wish of yours truely
                                            Geo Cruikshank

The illustration and text in question appeared in the August 1842 issue of *Ainsworth's Magazine*, which was a rival publication to *Bentley's Miscellany* alluded to in the letter. Cruikshank as illustrator would be paid by the editor, Ainsworth, which accounts for his request for money. Cruikshank always claimed that he settled illustrations by conference and then sent a tracing of his drawing (such tracing served to reverse and transfer drawings from paper to the surface of plates preparatory to etching) to assist the author in writing his text. Comparing the etching with excerpts from the text of Book II, Chapter 5, makes clear how, to use Cruikshank's expression, the author in this instance "writes up" the text:

    It was nearly ten o'clock when Randolph reached the gardens. He proceeded along the grand walk, which was brilliantly illuminated, and filled with company, as far as the obelisk, but he could see nothing of Sir Norfolk or Hilda. He then turned into one of the side walks, and approached the orchestra, in front of which stood Kitty Conway preparing to sing. She instantly detected him, and made a slight movement of recognition. As he passed the range of alcoves beneath the orchestra, he perceived Jacob, who instantly came toward him . . . .
    "But where is your mistress?" cried Randolph.
    "There," replied Jacob, pointing to a party seated at supper beneath the grove of trees in front of the orchestra.
    "I see," replied Randolph. "By Heaven!" he cried, "Mr. Villiers [the Beau mentioned in the letter] is coming this way. Two persons stop him. As one of them is his valet [the Cripps mentioned in the letter] and the other Captain Culpepper, a fellow whom my uncle Trussell told me was a sort of bravo, and would cut any man's throat for hire. . . ."
    Randolph, meanwhile, felt irresistibly drawn towards the table where Hilda was seated, and as he kept behind the trees, he was not noticed by the party, though he *was* noticed by Kitty Conway, from the orchestra, who, guessing his intention, was so much agitated that for the first time in her professional career, she made some false notes in her singing. Hilda's seat was placed against a tree. On her right was Sir Norfolk Salusbury; and on the right of the baronet, Lady Brabazon; next to her ladyship was a vacant chair—no doubt just quitted by Beau Villiers; then came Lady Fazakerly; then Sir Bulkeley

Price; and lastly, Clementina Brabazon, who occupied the seat on the left of the miser's daughter. Partly screened by the tree against which Hilda was seated, Randolph bent forward, and breathed her name in gentlest accents. Hilda heard the whisper, and looking round, beheld the speaker. . . .Randolph was transported; he could not resist the impulse that prompted him to advance and take her hand, which she unresistingly yielded to him.
    All this was the work of a minute, but the action had not been unobserved, either by Kitty Conway or Lady Brabazon. Both had felt a similar pang of jealousy, but revenge instantly occurred to the latter. While Randolph was in the act of raising Hilda's hand to his lips, she touched Sir Norfolk's arm, and pointing in the direction of the lovers, whispered, "Look there!"
    Sir Norfolk arose, and in a stern and peremptory voice, said to the young man, "Set free that lady's hand, sir!"

This lengthy example of a particular kind of collaborative process has been included to demonstrate the importance of Cruikshank's influence over at least one of his authors. Probably the details of this scene had been worked out by the two men in a conference. The letter and corresponding text make clear how Ainsworth has verbalized what Cruikshank has visualized in his small composition.

191. DISPERSION OF THE JACOBITE CLUB, AND DEATH OF CORDWELL FIREBRAS. The composition is so filled with detailed action that it would hardly seem possible that the author could be following an artist's instructions and drawing, but the letter relating to this and another etching in the novel, titled "The Death of the Miser," establishes the contrary. The entire letter is reproduced below; because of its lengthiness, however, the related passage in the novel is not included here. Once again it seems certain that some lengthy conferences must have preceded Cruikshank's work on the drawing. Perhaps such collaboration did little to assist either artist or author, for both Ainsworth's prose in such instances and Cruikshank's work are not among their best.

                            Monday Evng.  Sept. 12th/42
My Dr Ainsworth.
    Herewith are the tracings of "The Death of Firebras." and "The Death of the Miser." Of the first I have merely to say that I suppose Randolf to be supporting Sir. A. Salisbury—who is wounded (badly) and whom he has assisted into the boat—Randolf at the same time is receiving the packet from Firebras—who has just been shot whilst speaking to Randolf by Long Tom—the grenadier—who supposes that Firebras has killed his officer. The wooden rails are broken away in the ferocious struggle. Sir. B Price has hold of the stern of the skiff—the priest is clinging to the post & the steps—He might *creep* into a *small sewer*—and never be seen or heard of more! In the background the soldiers are on a rude plank bridge connecting the summer house garden with the water wheel & mill—Some of the Jacobites are crying out for quarter—or surrendering themselves to the troops—
    Pl 2$^{nd}$   The miser has brought some bags of gold to conceal, in digging, he misses his box of treasure—his candle goes out, he feels about for his gold, and dies. His hands convulsively grasping the earth—or rather with his hands firmly holding a portion of the sandy soil which he has been disturbing—The tracing of Mr. Cripp's I hope to be able to send you tomorrow and "The Wedding" in the course of a day or two.
    Hoping you are now quite well—and going bravely
                                            I remain
                                            yours truly
                                            George Cruikshank

192–198. ILLUSTRATIONS FROM "GEORGE CRUIKSHANK'S OMNIBUS." Published by Tilt and Bogue, London, 1842

(Cohn 190). This periodical was originally issued in nine monthly parts, from May 1841 to January 1842, and in volume form many times later in the century. For this work Cruikshank did "One Hundred Engravings On Steel And Wood." Most of the etchings were done to accompany stories appearing in the periodical; they are by no means as interesting as his later etchings for the *Table Book*. Cruikshank's genius is most evident in the many wood engravings done for the *Omnibus*, a small selection of which are included here.

192. OUR PREFACE. Children are shown looking at an itinerant penny peepshow bearing the title "All the World's a Stage." This design served as the headpiece for the preface to the first issue.

193. MONUMENT TO NAPOLEON! This is Cruikshank's last Napoleonic composition, a fittingly mordant final design for the man he so savagely caricatured early in his career. The occasion for this macabre monument was the return of Napoleon's body to France. The text accompanying this design reveals Cruikshank's ability to provide excoriating copy as well as graphics:

> On the removal of Napoleon's remains, I prepared the above design for a monument; but it was not sent, because it was not wanted. There is this disadvantage about a design for *his* monument;—it will suit nobody else. This could not, therefore, be converted into a tribute to the memory of the late distinguished philosopher, Muggeridge, head master of the grammar-school at Birchley; nor into an embellishment for the mausoleum of the departed hero Fitzhogg, of the Pipeclays. It very often happens, however, that when a monument to a great man turns out to be a misfit, it will, after a while, be found to suit some other great man as well as if his measure had been taken for it. Just add a few grains to the intellectual qualities, subtract a scruple or so from the moral attributes—let out the philanthropy a little and take in the learning a bit—clip the public devotion, and throw an additional handful of virtues into the domestic scale—qualify the squint, in short, or turn the aquiline into a snub—these slight modifications observed, and any hero or philosopher may be fitted to a hair with a second-hand monumental design. The standing tribute "We ne'er shall look upon his like again," is of course applicable in *every* case of greatness.

194. TWO OF A TRADE. This butcher boy, whose dog has a face resembling his, is a variation on a character type appearing repeatedly throughout Cruikshank's career (for other butcher boys, see illustrations 151 and 213). This wood engraving is accompanied by a poem signed with the initials "L. B.," which are those of the editor of the *Omnibus*, Laman Blanchard. The subtitle for the poem is a Wordsworth quotation, "With such a dear companion at my side."

195. AS BROAD AS IT'S LONG. In the postscript accompanying this tailpiece to the final installment of the *Omnibus*, Cruikshank explains that he will no longer be publishing the journal in its present form but hopes that it will someday appear annually "and if he and his literary associates herein should meet the reader as agreeably in an Annual, as in a Monthly form, he trusts it will be [here the wood engraving is inserted] as broad as it's long."

196. [UNTITLED.] This wood engraving, accompanying an article titled "My Portrait," is labeled in the index as "G. C. in a drawing room." Cruikshank, shown with hair wildly askew and hat in hand, wears Hessian boots whose oversized tassels contribute to the general effect of a Regency dandy.

The terrified observers do not know what to make of the intruder. The article concerns Cruikshank's interest in pictures done of him by others; it contains detailed comments on some of these portraits.

197. PHOTOGRAPHIC PHENOMENA, OR THE NEW SCHOOL OF PORTRAIT-PAINTING. The verses accompanying this scene of a photographer's studio, signed "L. B." (Laman Blanchard), discuss this newly popular art. The man being photographed has the then customary armature support for his head to prevent unwanted movement during the long exposure time. Cruikshank took an interest in photography and sat for numerous portraits, including one in which the head support is unintentionally revealed.

198. THE HEIGHT OF IMPUDENCE! The wood engraving of this elongated man, who looks into a third-floor window and asks to be permitted "to light his cigar at your candle, as the gas light has gone out," accompanies a short paragraph on degrees of impudence.

199–211. ILLUSTRATIONS FROM "GEORGE CRUIKSHANK'S TABLE BOOK EDITED BY GILBERT ABBOTT À BECKETT." Published by the "Punch" Office, London, 1845 (Cohn 191). First issued in 12 monthly numbers and subsequently published in volume form several times during the century. All of the illustrations are by Cruikshank, including 12 etchings on steel and 116 wood engravings and glyphographs (a type of electroplate invented about 1843). This is Cruikshank's second and perhaps more successful attempt to produce a periodical with his name in the title. The first, titled *George Cruikshank's Omnibus*, which originally appeared in 1841 and lasted nine months, is dealt with in conjunction with illustrations 192–198. Cruikshank had the help of an editor in both periodicals and although he presumably had some say concerning the literary content, he was primarily occupied in producing illustrations. Both the *Omnibus* and the *Table Book* were intended to be Victorian parlor-table periodicals containing a variety of humorous social and political subjects of appeal to all members of the family. With these works Cruikshank once again attempted to become his own publisher or, at any rate, to exercise a greater control over the publications in which his works appeared, so as to escape the dilemma of doing piecework for which he was paid only once but from which a publisher derived income for quite some time. As a master etcher, Cruikshank lavished great attention on the etchings in the *Table Book*, which contains some of the finest graphics done during this period of his life. He used a larger format than had been his custom in most book illustrations and put a tremendous number of details into these etchings. In these plates he starts showing true virtuosity as an etcher. This technical mastery continues to appear in his etchings for the remainder of his career. He apparently believed he had gone as far as he could in his earlier manner and was now trying to improve the artistic merit of his work by including greater detail. This tendency seems in direct contrast with contemporary technological changes aimed at simplification for the sake of more economical production of illustrations. The newly invented and economical glyphograph, which though produced from metal plates resembles a wood engraving, does make its appearance in this publication but the chief attraction then as now was the virtuosity Cruikshank lavished on the steel etchings. Apparently both of Cruikshank's periodicals found many admirers, but they seen to have been more popular when reissued as books, the success of their sales in

parts not justifying a very long existence for either periodical. Illustrations 199–204 are etchings; 205–211 are wood engravings.

199. THE TRIUMPH OF CUPID, A REVERIE. This frontispiece for the first issue consists of a self-portrait of the artist, seated before the fire and smoking a meerschaum, the multitude of figures in the design having emerged and coiled around him like smoke from the pipe. The family lapdog sleeps peacefully on his right knee. In the text that accompanies the periodical's opening page, Cruikshank explains how he conceived of doing this design:

> If my brain is ever illuminated by an electric spark, the bowl of my meerschaum is the place in which it is deposited; the pipe acting as a conductor, along which flashes of inspiration are conveyed with every whiff, while the smoke curls itself into a variety of objects.
>
> Having taken up my usual position in my easy-chair, I fell into a reverie, with my eyes, like those of an expectant for a Government situation, fixed on vacancy. I began to ponder on the possibility of finding for the first plate of my TABLE-BOOK a subject in which the greatest number should take the greatest interest, especially that sex which I have often thought it hard should be called soft, and which it will always be my endeavour to propitiate. My policy as well as my gallantry would prompt me to do so; for the ladies form, according to the Population Returns, a large majority of the public; and the single as well as the married constitute the better half of the inhabitants of this country. . . .
>
> The power of the gentler sex naturally led me to a reflection on the manner in which it is used, and on the ministers through whom their sovereignty is exercised. Cupid is their undoubted premier; who, indeed, performs his office in a manner that renders their sway universal and absolute. What conqueror can boast of a victory so complete as the triumph of Cupid?

Continuing, the artist mentions numerous people from all classes of society who, having fallen victim to the power of Cupid, are portrayed in his design. These include a blind beggar, a baker, a dustman, a lamplighter, an old-clothes man, a Harlequin, an old sailor, a nabob on his elephant, and at the lower left, near the rear of his chair, a tiny depiction of himself doing a large self-portrait. A design of this type stimulates the viewer to study the myriad figures, to speculate about the victors and the vanquished, and to savor details such as the dancing figures in the marble patterns of the fireplace or the animated fire tools. Even the top and bottom etched titles are incorporated in the theme of the design, adding yet another dimension to an already highly sophisticated and intricate composition. The Latin phrase at the very bottom means "To give light from smoke."

200. A HORRIBLE BORE IN THE COMPANY. THE LION OF THE PARTY! This dual composition portrays via animal transformations two types found in Victorian society, the bore and the social lion. The accompanying letterpress, titled "Social Zoology," spells out in much greater detail the different species of lions and the ways in which they dominate every event they attend. Singled out for particular mention is the Literary Lion, who is "chiefly remarkable for the contrast between the ferocity of his aspect and mildness of his demeanor. People are apt to be more afraid of him than any other of the Lion tribe, and many fancy that he contemplates tearing them to pieces, but he is generally a most inoffensive creature." As for the bore, the text states that of all the animals included in the full range of social zoology, none is more objectionable than this beast whose snout is useful to him in more ways than one, "for his scent is truly wonderful ena-

bling the brute to smell out a good dinner at three or four miles distance." The reader is assured that the bore is not dangerous, although the expression "bored to death" would seem to indicate otherwise.

201. HEADS OF THE TABLE. This composition shows dinner hosts and guests, all delineated as portrait busts in the process of conversing (by means of bubble captions). The accompanying letterpress generally discusses tables, including railway tables, winds up mentioning the heads of the table, and closes with the comment that "Among the Heads of the Table may be found some to whom the viands are of no less importance than the wines; for there are critics of the *cuisine* as well as *connoisseurs* of the cellars. We leave the Heads, however, to speak for themselves through the pencil of GEORGE CRUIKSHANK."

202. THE FOLLY OF CRIME. The central vignette pictures a murderer, knife still in hand, falling into an abyss. A bevy of monsters jeer at him while at the lower right, inside the abyss, a Blackamoor with arms like bat wings holds aloft a treasure basket from which rise necklace-snakes ready to strike. The central vignette is bordered by fetters, or leg irons, and surrounded by smaller designs, including prisoners on a treadmill, upper left; the uneasy sleep of a criminal with a guilty conscience, upper middle: and a jailer coming into a cell, upper right. On each side are men in irons; just below these, criminals trying to flee from justice. At bottom left and right are two men carrying their prison sentences in casket form, and between them is a fleeing purloiner about to be caught in a trap. The fool's cap on every criminal figure reinforces the moral of the composition, which is spelled out in the accompanying poem.

203. PREMIUM, PAR, DISCOUNT. The composition is comprised of three scenes with a locomotive-like machine occupying the central position in each. The upper composition, titled "Premium," is accompanied by the phrase "Steam-up." People are shown blowing the boiler fires with bellows. The animated locomotive blows bubbles from a double-stemmed pipe. Here again the motif of bubbles refers to unsound economic schemes (see illustrations 20 and 174). In the middle design, the pipes have gone out and the railway engine, now labeled "Par," elevated and holding a balancing bar, is seen tightrope walking. The bottom design, titled "Discount" and additionally captioned with the words "Boiler Burst" seen in the steam, shows the human engine in the process of blowing up and producing havoc for all those surrounding it. This and several other designs in the *Table Book* refer to stock-market troubles during 1845, particularly the great number of railroad bankruptcies and panics in England. The text accompanying this design explains its emblematic implications.

204. THE RAILWAY DRAGON. An animated locomotive invades the family dining room and starts to devour John Bull's roast beef and plum pudding to the horror of his wife and four children. The bubble-caption comment of the locomotive—"I come to dine, I come to sup/ I come. I come—to eat you up!!"—is faintly reminiscent of "Fee, fie, foe, fum." The accompanying text, signed by Angus B. Reach and titled "The Natural History of the Panic," details the way this monster has destroyed Englishmen by gobbling up their money.

205. PRACTICAL MESMERISM: RELIEVING A GENTLEMAN FROM A STATE OF COMA. Cruikshank again uses the well-

known nose-pulling motif to express his doubts about the newly popular fad of mesmerism. The composition was used as a headpiece for an article written by the editor. (For further references to this motif, see the note to illustration 96.)

206. MY OPINIONS ON UMBRELLAS. This vignette is one of six used to illustrate an article with this title by Angus B. Reach.

207. LETTER TO THE PRESIDENT OF THE SUBURBAN ASSOCIATION FOR THE ADVANCEMENT OF SCIENCE IN THE OUTSKIRTS. FIGURES 1–4. This letter spoofing scientific investigation, signed "Hethincs Henosemutch," details the four appearances of a passerby in front of the writer's parlor window. The obvious distortions result from irregularities in the window glass, a device which over the years served the uses of more than one Victorian cartoonist.

208. A FRIGHTFUL NARRATIVE. This double wood engraving accompanies a short story, supposedly written by a bachelor, concerning a friend of his youth, "Felix Williers," whom he has not seen for years and whom he dropped from his acquaintance after the friend's marriage. This union has proved most fruitful, as revealed by the humorous portrait of a model Victorian family.

209. GUY GREENHORN'S WANDERINGS. This charming wood engraving illustrates a poem on the many different kinds of bells heard by a cockney Londoner born within the sound of Bow Bells.

210. A COLD LOVE LETTER. This comic portrait of a would-be lover writing to his lady is one of a pair used in a short article with this title.

211. RECREATIONS IN NATURAL HISTORY. The accompanying article, signed by Horace Mayhew, includes two other wood engravings. This design illustrates a story of a famous Saxon dentist who helped his ailing tortoise-shell cat by pulling its tooth. The dentist was subsequently besieged by cats from all directions. Nothing would stop this feline onslaught until he accidentally broke the jaw of an old tabby. "The news of this spread like wildfire. Not a single cat ever came to him afterwards. It is extraordinary how the cats, in the above instance, acted like human beings!"

212–215. ILLUSTRATIONS FROM "THE BACHELOR'S OWN BOOK. BEING THE PROGRESS OF MR. LAMBKIN (GENT.), IN THE PERSUIT OF PLEASURE AND AMUSEMENT, AND ALSO, IN SEARCH OF HEALTH AND HAPPINESS." Published by the artist. Sold by David Bogue, "and all booksellers," London, 1844 (Cohn 192). This oblong octavo book with 24 etchings on 12 plates was originally published with an etched title in stiff paper wrappers. This original issue appeared both colored and plain; a spelling error ("Persuit") on the title page was corrected in the second issue. Subsequent editions reproduced each design on a separate page from poorly printed stereotypes of the originals. An edition containing lithographic copies of the illustrations appeared in America shortly after the work was published in England. Some authorities have felt that the work was not a commercial success, but its number of reprintings would indicate that this may not have been the case. In a later edition, Cruikshank wrote that "'Out of sight, out of mind' is a very truthful adage, in most cases, but it does not fully apply in the case of

Mr. LAMBKIN, for although he has been 'out of sight' for a long time, he has not been altogether 'out of mind,' for many have been the inquiries made about him." He ends by expressing the hope that all the young Lambkins of the new generation may terminate their bachelor career as happily as the hero of this story. The theme of a dandy in pursuit of pleasure as well as a wife runs throughout the work of Cruikshank's early career, as does the influence of the Hogarthian progress. The character sketch of Mr. Lambkin first occurs in a broadside caricaturing a dandy and his creditors. Titled "Put it down to the Bill," it was published by R. Harrild, probably around 1815 (Cohn 1879). Mr. Lambkin runs the course of courting, drinking, gambling, quarreling with the police, falling into the hands of predators, becoming ill through dissipation, and finally, after many trials, returning to his original love and marrying her.

212. [FIRST PLATE, FIRST ETCHING.] The hero is seen contemplating himself in a mirror. Cruikshank indicates his attitude toward Lambkin by placing on the wall a picture of Narcissus contemplating his image in the water. The hero is attired as a dandy of the day who obviously is on his way to visit a young lady.

213. [FIRST PLATE, SECOND ETCHING.] The companion plate shows Lambkin a few minutes later, shortly after a young wag has placed an embarrassing sign—"Going a Courting"—on his back. He is jeered by several children and the ubiquitous Cruikshankian butcher boy.

214. [TWELFTH PLATE, FIRST ETCHING.] After a sad series of misadventures, the hero returns to propose to his first love who, after some hesitation, accepts him. The proposal takes place before portraits of her parents, who smile approvingly.

215. [TWELFTH PLATE, SECOND ETCHING.] The final illustration shows Mr. Lambkin making a speech at his wedding banquet before the approving guests. The large mirror in the background reflects the faces of several of the assembled guests as well as a large painting of an elegant church wedding. The cluttered banquet table offers an interesting example of what table decor looked like in Victorian times. All the designs in this series are humorous but accurate portrayals of social behavior during the 1840s.

216 & 217. ILLUSTRATIONS FROM "OUR OWN TIMES. ILLUSTRATED BY GEORGE CRUIKSHANK." Published by Bradbury & Evans, London, 1846 (Cohn 193). Cruikshank did four etchings, 35 glyphographs and six wood engravings for the four issues of this periodical which appeared from April through July in 1846. The magazine was concerned with social issues of the "Hungry Forties" and gave Cruikshank ample opportunity to display his talents at their best. With these designs the artist places himself in the mainstream of nineteenth-century humanitarianism. The two chosen for reproduction deal with the maltreatment of workers in the clothing industry and the futility of the so-called "Ragged Schools" established for street children. The obscurity of the magazine in which these etchings appeared has caused them to remain virtually unknown to most scholars concerned with the Victorian age—a regrettable situation since they so aptly chronicle major social problems affecting nineteenth-century Englishmen.

216. TREMENDOUS SACRIFICE! A seemingly unending procession of women climb into a huge meat grinder operated by

a cat-like fiend who turns out women's clothing while contemplating the march of animated money bags "To the Bank." Bubble captions record a conversation between two of the prospective seamstresses: "I understand that it is impossible to get a liveing at this work," says one to another, who replies, "So I have heard. Never the less, we *must* try!" On the other side of a curtain, women examining and buying various items of clothing fill the "Cheap House." One of them ironically says, "I cannot imagine how they can possibly be made for the price!!" This design clearly inveighs against abuses in the clothing industry which were beginning to be widely criticized in England during this period. It is an example of the type of incisive serious commentary that can be achieved by a comic artist who chooses to deal with social problems. (For a further reference to this issue, see Charles Kingsley's famous essay, "Cheap Clothes and Nasty," or his novel *Alton Locke*, published in 1850.)

217. THE RAGGED SCHOOL. IN WEST STREET (LATE CHICK LANE) SMITHFIELD. The ragged school was established for children of the street, supposedly to educate them but also to keep them off the streets and out of trouble. Public education in England during this era was grossly inadequate and a grievous blot on the fabric of Victorian life. The design is divided into two compartments, one showing a school for girls which, despite overcrowding and some lack of discipline, seems to promote some scholastic progress. In contrast, the boys' school presents the kind of hopeless picture that has always given nightmares to teachers. The problems of overcrowding, inadequate facilities and supplies, and the lack of trained professional teachers—all seem evident in Cruikshank's etching.

218 & 219. ILLUSTRATIONS FROM "HISTORY OF THE IRISH REBELLION IN 1798: WITH MEMOIRS BY THE UNION, AND EMMETT'S INSURRECTION IN 1803." By W. H. Maxwell. Published by Bailey Brothers, London, 1845 (Cohn 541). This work, originally issued in 15 parts in 12 numbers and later in volume form, contains 27 plates, of which 21 are by Cruikshank. All of Cruikshank's designs in this series portray atrocities committed by the Irish during the rebellion. These works reveal a side of the artist seldom seen in his other book illustrations. Whether or not the events of the rebellion depicted are historically accurate, the plates present a picture of the horrors of war that calls to mind Goya's *Disasters of War*.

218. THE LOYAL LITTLE DRUMMER. Three men jab pikes into a young drummer while a fourth is about to smash him with the butt of his rifle. The heavy lower jaws and brutish physiognomies of the Irishmen contrast sharply with the sympathetic expression on the face of a captured British soldier in the left background.

219. MASSACRE AT SCULLABOGUE. The Irish attack and burn a building and pike the occupants who try to escape. The etching presents a world given over to mayhem, sadism, and murder.

220–227. "THE BOTTLE. IN EIGHT PLATES BY GEORGE CRUIKSHANK." Published for the artist by David Bogue, 1847 (Cohn 194). Each of the prints bears in the lower foreground a signature legend "Designed and Etched by George Cruikshank." This folio-size Hogarthian progress on the evils of drink marked a turning point in Cruikshank's career. In this suite and its sequel, *The Drunkard's Children* (dealt

with in greater detail in notes 228–235), the artist sought to use a crude, inexpensive medium for didactic purposes. He succeeded so well that never before or after did he reach as wide an audience. The designs were reproduced from etchings by means of glyphography, a cheap form of graphic reproduction inferior to etchings, enabling the publisher to sell the entire series of eight prints for one shilling. The work appeared in numerous editions, the best printed on heavy, imperial folio with a tint block added for shading. The prints are most impressive when seen with hand coloring from the period, although there is some question as to whether many hand-colored sets were ever done for sale. Sometime subsequent to the first issue of both suites, verses were written to accompany them. These poetic interpretations add no information about the designs and contribute little more than a moral commentary. Over a hundred years later it is hard to realize how enormously popular this work was at the time it first appeared. Records show that dramatic versions played simultaneously in at least eight different theaters in London alone. No less a poet than Matthew Arnold wrote the following sonnet about the work within two years of its initial appearance:

> To George Cruikshank, Esq.
> On Seeing for the First Time His Picture of 'The Bottle', in the Country
>
> Artist, whose hand, with horror wing'd, hath torn
> From the rank life of towns this leaf: and flung
> The prodigy of full-blown crime among
> Valleys and men to middle fortune born,
> Not innocent, indeed, yet not forlorn:
> Say, what shall calm us, when such guests intrude,
> Like comets on the heavenly solitude?
> Shall breathless glades, cheer'd by shy Dian's horn,
> Cold-bubbling springs, or caves? Not so! The Soul
> Breasts her own griefs: and, urg'd too fiercely, says:
> "Why tremble? True, the nobleness of man
> May be by man effac'd: man can control
> To pain, to death, the bent of his own days.
> Know thou the worst. So much, not more, he *can*."

At a much later date an edition half the size of the original was issued. It sold for sixpence and contained the following notice on the cover:

Mr. GEORGE CRUIKSHANK thinks it right to state that the first edition of this "BOTTLE" (the title of which ought to have been "*THE BLACK BOTTLE*,") was first published in 1847, *double* the size of this edition, and sold at One Shilling. And he wishes it to be further understood that these *smaller plates* are taken from the *original Etchings*, which he has in his own possession. And MR. GEORGE CRUIKSHANK'S object to producing this work of "THE BOTTLE" was to assist, if possible, in putting a stop to the poverty, misery, wretchedness, insanity, and crime which are caused by strong drink. And this "BOTTLE" was published before G. C. became a Teetotaller; but upon mature reflection he came to the conclusion that nothing would ever stop these dreadful evils but UNIVERSAL TOTAL ABSTINENCE from all intoxicating liquors; and thus having come to the belief that it was of no use preaching without setting an example, GEORGE CRUIKSHANK in the same year, 1847, became a Total Abstainer.

Cruikshank's suites of eight designs each finally realized the artist's lifelong desire to do a Hogarthian progress in a contemporary setting. In both *The Bottle* and *The Drunkard's Children* the artist abandoned his comic approach and his usual practice of caricaturing many of the subjects in his designs. The strong element of moralistic melodrama in both of these series made them seem to be self-

parodies to succeeding generations, and most viewers found Cruikshank's attitude toward drink laughable. But both series have found enough admirers in the last few decades to have been reprinted more than once, even though one suspects that it is not their seriousness so much as their sociological and historical interest that has once more made them popular. The designs for *The Bottle* were initially so popular that they were copied on children's dishes. At least four china companies used Cruikshank's designs while another picked up his theme for a set of plates of its own design. In *The Bottle*, the first three designs and the fifth, sixth, and seventh all take place in the same or a similar room, thus enabling the artist to change the scene as in a stage setting to reflect the changes taking place in the family. At the time the designs first appeared, Charles Dickens stated that alcoholism grows out of misery and poverty and that, therefore, the artist's treatment of the theme starts off on the wrong foot. Recent studies of alcoholism, however, indicate that the illness, by no means confined to the poor and miserable, most often is the result of deep-seated psychological problems rather than economic ones. Thus, Cruikshank is not necessarily wrong to start with a seemingly healthy, happy family and then show its disintegration through alcohol.

220. PLATE I. THE BOTTLE IS BROUGHT OUT FOR THE FIRST TIME: THE HUSBAND INDUCES HIS WIFE "JUST TO TAKE A DROP." The midday meal has just been completed, as the time shown on the grandfather's clock indicates. The husband holds a bottle of gin in one hand and offers a glass to his wife. A neatly organized working-class room with many attractive accessories serves as a pleasant background. The Bible sits on the bureau, a picture of a church hangs in the background, and the china figurines on the mantel include miniature portraits of Victoria and Albert. A kitten plays with its mother's tail in front of a glowing fireplace. Two smaller children sit at their own table, while the older daughter helps clear the dishes. Although Cruikshank's prints do not involve as much detail as Hogarth's, they certainly do offer a more complicated visual narrative than meets the eye at first glance. Of particular interest in the first three designs of this series is the symbolic use of setting and ornamentation to convey the theme of a "home sweet home."

221. PLATE II. HE IS DISCHARGED FROM HIS EMPLOYMENT FOR DRUNKENNESS: THEY PAWN THEIR CLOTHES TO SUPPLY THE BOTTLE. The flowers on the bureau now droop. The family Bible is gone, possibly moved to the top drawer. The hungry mother cat looks for food but finds the plate empty—a motif reminiscent of the last plate of Hogarth's *Marriage a-la-Mode* (1745). It is seven-fifteen in the evening. The oldest daughter is being sent out with some personal belongings to pawn and a bottle for more gin. The room now looks a bit disorganized, one of the china figures on the mantelpiece being on its side. The barely open cupboard shows that most of the dishes have been pawned; the unlit fireplace, that there is no longer money for coal. The disheveled appearance and stupor of the husband give evidence of his disintegration; the anxious looks on the faces of the children demonstrate their distress. Half of the dried flowers over the small oval portrait below the church painting are gone. The tea chest, seen on the table in the first print, is now only half visible on the table behind the father, the suggestion being that it is no longer in daily use—at least for the master—since gin has taken its place in the household.

222. PLATE III. AN EXECUTION SWEEPS OFF THE GREATER PART OF THEIR FURNITURE: THEY COMFORT THEMSELVES WITH THE BOTTLE. Drunkenness and unemployment lead to debts that bring legal action in the form of an "execution" against the remaining family belongings. Familiar objects are being checked against an inventory prior to removal, as the family huddles disconsolately on the right. The parents seated by the hearth look most dispirited. The gin-drinking husband now appears more dissolute than before. With keen regret, the wife regards for the last time their household possessions. The sad event occurring in this design is represented emblematically by the now broken china house on the mantel. The *angst* of the three children is painfully evident.

223. PLATE IV. UNABLE TO OBTAIN EMPLOYMENT, THEY ARE DRIVEN BY POVERTY INTO THE STREETS TO BEG, AND BY THIS MEANS THEY STILL SUPPLY THE BOTTLE. The mother, father, and older daughter stand at the side entrance of a liquor store, through which is seen a young child buying liquor. The young son, now barefoot and unkempt, begs from a respectably dressed woman as two healthy and prim children walk by. The present condition of the family is not much better than that of the stray dog eating street refuse. The father, who has just replenished his bottle, wears a hardened expression in contrast to that of grief showing on his wife's face. Partially obscured in the background by a portico post, a porter carries a bundle which apparently contains a load of printed material intended for the publisher of *The Bottle,* since part of Bogue's name and address can be seen on it. Ironically, the words "Family Wines and Spirits" and "Best Cream Gin" are to be seen on the side of the liquor store. The family's stance over the street-level hatch for receiving deliveries foreshadows their imminent fall into a living hell. The graveyard in the background indicates their ultimate fate.

224. PLATE V. COLD, MISERY, AND WANT, DESTROY THEIR YOUNGEST CHILD: THEY CONSOLE THEMSELVES WITH THE BOTTLE. The family is again seen in a room identical in size and shape to that of their original abode, but all of the possessions are gone except for one broken toy. This apparently belonged to the smallest child, now dead and resting in the wooden casket near the rear wall. The daughter weeps. The son, hand on head, looks understandably anguished. The wife, with a glass of gin in one hand, holds a rag to her tearful face. The husband holds the infamous black bottle in his right hand, his look of despair foreshadowing his inevitable doom—insanity.

225. PLATE VI. FEARFUL QUARRELS, AND BRUTAL VIOLENCE, ARE THE NATURAL CONSEQUENCES OF THE FREQUENT USE OF THE BOTTLE. The children try to prevent their father from physically harming his terrified wife, who stands between him and the ominous-appearing bottle on the mantel, while a distraught neighbor looks in through the half-open door. The frenetic scene shows the few remaining household possessions overturned on the floor. A shawl has fallen too near the fireplace and, like the family, is being destroyed.

226. PLATE VII. THE HUSBAND, IN A STATE OF FURIOUS DRUNKENNESS, KILLS HIS WIFE WITH THE INSTRUMENT OF ALL THEIR MISERY. A doctor takes the pulse of the murdered wife, now stretched out on the floor and surrounded by neighbors. One policeman interrogates the daughter, who points to the broken bottle while another officer seizes the hopelessly disturbed father.

227. PLATE VIII. THE BOTTLE HAS DONE ITS WORK—IT HAS DESTROYED THE INFANT AND THE MOTHER, IT HAS BROUGHT THE SON AND THE DAUGHTER TO VICE AND TO THE STREETS, AND HAS LEFT THE FATHER A HOPELESS MANIAC. The insane father stares blankly into space next to a cage of iron bars designed to prevent prisoners from harming themselves. The two children, now rather gaudily and cheaply dressed, look at their father for the last time. The rakish stance of the son and the dandy-like sprig of flowers in his mouth suggest an impending course of dissipation. This design immediately recalls the last, or Bedlam, plate of Hogarth's *The Rake's Progress* and again shows Cruikshank's use of an earlier motif for new and different purposes. The blank look on a seated prisoner in the left background is a further echo from Hogarth's Bedlam scene.

**228–235.** "THE DRUNKARD'S CHILDEN. A SEQUEL TO THE BOTTLE." Published for the artist by David Bogue, London, 1848 (Cohn 195). This suite appeared in similar size and editions to that of *The Bottle*, but it was never reissued in smaller format. By this time Cruikshank had become a convert to the temperance movement and thus had an assured audience for this work regardless of whether it attained the success of its predecessor. The majority of the designs in this suite of eight glyphographs are not individually signed. Once again the work is most effective in the expensive hand-colored issues. There seems to be no appreciable difference in the artist's attitude toward his subject in the two suites. The sequel, neither more nor less doctrinaire than the original work, is more dramatic and creates more historical interest than the original because its designs portray a variety of settings and are replete with character types. The drunkard's son appears in six of the designs; the daughter, in only five. Since the captions for *The Drunkard's Children* are longer and of more importance than those for the first series, the second suite becomes more of a narrative. In the past some critics deemed the sequel disappointing, but recent opinions seem more favorable. For some, Plate VIII of *The Drunkard's Children* is one of Cruikshank's masterpieces. This suite gives scenes of lower-class Victorian life that were seldom portrayed in the arts of the period. No doubt Gustave Doré was familiar with Cruikshank's designs before coming to England to create his great illustrated work *London: A Pilgrimage*. His scene in the threepenny lodging house may have been directly inspired by Plate IV of this suite.

229. PLATE I. NEGLECTED BY THEIR PARENTS, EDUCATED ONLY IN THE STREETS AND FALLING INTO THE HANDS OF WRETCHES WHO LIVE UPON THE VICES OF OTHERS, THEY ARE LED TO THE GIN SHOP, TO DRINK AT THAT FOUNTAIN WHICH NOURISHES EVERY SPECIES OF CRIME. The scene is a typical low-class tavern. The daughter stands in the middle of the crowd. The son, who has now taken up smoking, stands on the right, facing two older, hardened, and, perhaps, criminal types, one of whom offers the youngster a mug of ale. A wretched family huddles in the right foreground, the mother pouring gin into the mouth of her daughter, as was commonly done to pacify children and ward off their hunger pangs. Behind the counter a rotund, evil-looking publican drops money into his coin purse. As is usual with Cruikshank, all of the names of the liquor in the shop are intended to show the irony of the wretched-looking group disporting themselves before encomiums such as "Cream of the Valley," "The Celebrated Double Gin," and "Families Supplied with Wines and Spirits." On the left a drunken gin lover spills his drink and drops the money probably intended to entice the tipsy woman picking it up, while a snaggletoothed cripple already in his cups looks on with envy. The young daughter, holding a glass of gin but looking strangely aloof, is being counseled by an older woman, her face hidden by a large bonnet, and ogled by a young man on her right. The meaning of this scene becomes clear after scrutiny of Plate III. With this series the prints become more meaningful when studied in sequence and when carefully compared with one another.

229. PLATE II. BETWEEN THE FINE FLARING GIN PALACE AND THE LOW DIRTY BEER SHOP, THE BOY THIEF SQUANDERS AND GAMBLES AWAY HIS ILL-GOTTEN GAINS. The son, seated between two prostitutes, plays cards with a bearded man. Others are seen in various stages of inebriation. A man on the left, his hat pushed down over his face, is having his pockets picked. A man in the center, gin bottle in hand, holds his finger to his nose (for other depictions of this motif, see illustrations 80, 96, and 153). A man on the right sings from "The Flash Songster." The general scene is one of drunken disorder and abandon. Several of the ruffian types, including the man playing cards with the son, resemble Sikes—or, more precisely, Cruikshank's Irish ruffian who had earlier served as the model for Sikes.

230. PLATE III. FROM THE GIN SHOP TO THE DANCING ROOMS, FROM THE DANCING ROOMS TO THE GIN SHOP, THE POOR GIRL IS DRIVEN ON IN THAT COURSE WHICH ENDS IN MISERY. In this composition the pattern of the dancing itself is made to show the instability of the life now led by the daughter. The same woman seen in the first plate, now appears mixing drinks behind the bar and the young man who stood next to the girl in the first plate, here leaning against the counter, cigar in mouth, looks on leeringly as she dances with another young man, who caresses her fingers in such a way as to indicate his sexual desire. The same gesture can be seen occurring between another dancing couple in the background. As is often the case with Hogarth, later plates in a series confirm vague suggestions contained in an earlier plate: the woman talking to the girl in the first plate is her procuress; the young man, her pimp. As usual the various signs and posted notices contribute to the theme of the design. Despite the notice that no gentleman is to dance with his hat on or smoke except at refreshment time, it is clear that these rules, along with the general and more significant principles of Victorian morality, are not being observed. The "Poses Plastiques" advertised on one of the signs indicate that the dancing girls can be seen posed in the nude each night before the ball.

231. PLATE IV. URGED ON BY HIS RUFFIAN COMPANIONS, AND EXCITED BY DRINK, HE COMMITS A DESPERATE ROBBERY.—HE IS TAKEN BY THE POLICE AT A THREE-PENNY LODGING HOUSE. The bleary-eyed porter has just led the police to the cot of the drunkard's son. They awaken and arrest him. The low ceiling and the tawdriness and squalor of the lodging house contribute to the mood of surprise and shock. As with the final plate in this series, the general atmosphere of this composition is more significant than its small details; unlike Hogarth's, Cruikshank's details sometimes do not contribute to the narrative content of the plates.

232. PLATE V. FROM THE BAR OF THE GIN SHOP TO THE BAR OF THE OLD BAILEY IT IS BUT ONE STEP. The girl weeps and the boy sadly looks straight ahead toward the judge whose presence is felt but whose person is not visible in

this almost photographically accurate depiction of a nineteenth-century English courtroom. The jury is seen on the right; the lawyers, in the foreground. A few spectators look down from the upper gallery. Judging from the look on the boy's face, one concludes it almost inevitable that he will be found guilty.

**233. PLATE VI. THE DRUNKARD'S SON IS SENTENCED TO TRANSPORTATION FOR LIFE; THE DAUGHTER, SUSPECTED OF PARTICIPATION IN THE ROBBERY, IS ACQUITTED.—THE BROTHER AND SISTER PART FOR EVER IN THIS WORLD.** The distraught girl holds the hand of her brother, who appears stunned and remorseful. The warden summons the girl to leave. The convicted criminal has an iron on his right leg, but it is temporarily tied at the top with a piece of cloth, apparently because the authorities had allowed him to see his sister without wearing the full set of leg irons. At this point in the narrative the pair separate, their sad destinies being portrayed in two final scenes.

**234. PLATE VII. EARLY DISSIPATION HAS DESTROYED THE NEGLECTED BOY.—THE WRETCHED CONVICT DROOPS AND DIES.** Aboard a prison ship named *Justitia Hulk,* the young man is pictured just after the moment of death as the preacher closes his Bible and looks at him for the last time. Two indifferent prisoners place a screen around the dead boy as an attendant shuts his eyes; two other prisoners turn away from the scene. As in Bruegel's painting *The Fall of Icarus* and W. H. Auden's famous poem interpreting it, human tragedy makes little impact on the way of the world.

**235. PLATE VIII. THE MANIAC FATHER AND THE CONVICT BROTHER ARE GONE.—THE POOR GIRL, HOMELESS, FRIENDLESS, DESERTED, DESTITUTE, AND GIN MAD, COMMITS SELF MURDER.** The darkness of the night and the massive bulk of the bridge contrast sharply with the falling woman. Her billowing skirts and hair give her the appearance of a macabre butterfly or moth. Above, a woman looks on helplessly and a man reaches out in vain toward the plummeting figure. Below on the left, the masts of several ships rest beneath a full moon partially obscured by clouds. This remarkable composition gains most of its effect from the sense of dynamic space created by the underside of the bridge whose strong downward arc dramatizes the precipitous fall of the girl. In this surreal scene of suicide, the world of the living is confined to the small triangle of space at the top of the bridge. Details in this final portrayal of the daughter—the jacket sleeves worn through at the elbows, the thrust-back position of the head, the dramatic hand-covering of her eyes, even the upturned bonnet which floats aloft free, ribbons fluttering—contribute to the eerie effect of this nightmarish vision.

**236. "THE CAT DID IT!,"** illustration from "THE GREATEST PLAGUE OF LIFE: OR THE ADVENTURES OF A LADY IN SEARCH OF A GOOD SERVANT . . . ." Edited by the Brothers [Horace and Augustus] Mayhew. Published by David Bogue, London, 1847 (Cohn 544). This work was first issued in six monthly parts with yellow wrappers and subsequently in volume form with 12 etchings and a glyphograph on the title page. The design "The Cat did it!"—showing a multitude of cats wreaking all kinds of household destruction—illustrates a chapter in the text in which the housekeeper Mrs. Burgess persuades the lady of the house to take her tomcat to catch mice and then blames various breakages and thefts on the cat. Cruikshank shows in his design food items stolen and kinds of damage mentioned in the text, but introduces a large group of rampaging cats whereas the text talks of one. Thus, instead of specifically illustrating one scene in the chapter, Cruikshank has created a composite portrayal of all the alleged misdeeds of the cat in the story.

**237. "ABEL HIMSELF AGAIN,"** ILLUSTRATION FROM "THE YULE LOG FOR EVERYBODY'S CHRISTMAS HEARTH: SHOWING WHERE IT GREW; HOW IT WAS CUT AND BROUGHT HOME; AND HOW IT WAS BURNT." By L. S. Chamerozow. Published by T. C. Newby, London, 1847 (Cohn 128). Cruikshank did four etchings, two glyphographs, and a cover design for this book. "Abel himself again" shows a festive English Christmas celebration. An elderly man plays a violin while people dance in front of a hearth containing a human-like yule log that seem to smile back at the merrymakers. In the lower foreground, children enjoy Christmas treats around a child's table. Large bunches of mistletoe and holly hang from the ceiling. This composition and its theme, reminding one of Cruikshank's earlier work in caricature, here show clearly his ability to translate the charm and detail of Regency caricature into Victorian book illustration.

**238. "LONDON, IN 1851,"** ILLUSTRATION FROM "1851 OR, THE ADVENTURES OF MR. AND MRS. SANDBOYS AND FAMILY, WHO CAME UP TO LONDON TO 'ENJOY THEMSELVES,' AND TO SEE THE GREAT EXHIBITION." By Henry Mayhew and George Cruikshank. Published by David Bogue, London, 1851 (Cohn 548). Cruikshank did ten etchings and a wood-engraved title page for this work, originally issued in eight parts and subsequently in volume form. The story deals with the problems of a family who come to see the Great Exhibition in London in 1851. In addition to his illustrations for this book, Cruikshank did a large print of the opening of the Exhibition by Victoria and Albert in the Crystal Palace (Cohn 1814). The etching reproduced here, "London, in 1851," shows thousands of people crowding into the streets by Regent Circus and trying to go to the exhibition. This book is best appreciated when seen in one of its original forms wherein this folding plate opens opposite another, titled "Manchester in 1851," showing a completely deserted city street. Because Victorians partook of innocuous pastimes, it would not be at all unusual to learn that more than one person in the last century undertook a count of the heads in this plate. One of the placards held in the crowd at the lower left is an advertisement for the book in which the etching appeared. In this work Cruikshank again shows his virtuosity as an etcher by including many figures and interesting details in a design of small size.

**239-246. ILLUSTRATIONS FROM "GEORGE CRUIKSHANK'S FAIRY LIBRARY."** This series of four fairy tales began appearing in 1853 and concluded in 1864. Each of the works was originally issued in green cardboard covers with a wood-engraved design; most issues contained six etchings per story. The bibliography of the work as originally published is complex, and the stories are generally known much better in their later collected editions in volume form. The book was reprinted several times during the last century, and the illustrations have appeared with some of the stories a few times in recent years. These versions of the fairy tales, written by George Cruikshank himself, brought down the wrath of Charles Dickens, who criticized him for moralizing and bowdlerizing in these children's stories as well as working in his temperance beliefs. Dickens published his comments, "Frauds on the Fairies," in his own journal *Household Words.* Cruikshank replied in a statement titled "A Letter

from Hop-O'-My-Thumb to Charles Dickens, Esq.,'' published separately in the second issue of *George Cruikshank's Magazine* (Cohn 185), and in an abbreviated form in a later volume of *The Fairy Library*. The controversy over the text has often caused readers to neglect the merit of the etchings themselves. The original issues are as follows:

*Hop O' My Thumb and The Seven League Boots. Edited and illustrated with six etchings by George Cruikshank.* Published by David Bogue, London, 1853 (Cohn 196).

*The History of Jack & The Bean-Stalk. Edited and Illustrated with six etchings by George Cruikshank.* Published by David Bogue, London, 1854 (Cohn 197).

*Cinderella and the Glass Slipper. Edited and Illustrated with ten subjects designed and etched on steel by George Cruikshank.* Published by David Bogue, London, 1854 (Cohn 198). A modified version of Cruikshank's rebuttal to Charles Dickens' criticism of his edition of the fairy tales is contained in the first issue of this part of the *Fairy Library*.

*Puss in Boots. Edited and Illustrated with etchings on steel by George Cruikshank.* Published by Routledge, Warne & Routledge, and F. Arnold, London, 1864 (Cohn 199). The ten-year lapse between this final volume of the *Fairy Library* and its predecessors, plus the change in publisher, indicates that the sales must have been off for the third volume and the project abandoned for some years. The fact that this is by far the scarcest and most costly volume of the series indicates that the artist's popularity had so diminished by this time that very few copies of the work in its original printing were sold.

239. TITLE PAGE OF "HOP O' MY THUMB." This etched title page shows Cruikshank's ability at incorporating narrative and titling in a unified design. The etched title appears across the top of the page. Underneath is a vignette illustrating the heading "The Father proposes to lose the Children!!!" Also at the top of the design is to be seen, hovering menacingly, part of a giant, whose boots hang on the side branches of the tree in whose crown all these design elements are incorporated. The same tree also divides the lower composition into two sections. On the right, the children dance in the forest; on the left, their mother and father run away from them. The etched caption around the lower trunk of the central tree describes these events: "They Leave Hop o' my Thumb and his Brothers in the Wood." The trunk and a central branch of the tree have knotholes that suggest two human faces.

240. THE GIANT OGRE IN HIS SEVEN LEAGUE BOOTS PURSUING HOP O' MY THUMB & HIS BROTHERS, WHO HIDE IN A CAVE. This remarkable etching reminds one of some of Cruikshank's earlier illustrations for *Grimm's Fairy Tales* and *Peter Schlemihl* since it again includes almost surrealistic distortions of scale for expressive purposes. The giant strides in the background while the children, lower left, hide in a cave.

241. JACK CLIMBING THE BEAN STALK. Jack climbs up the beanstalk, which reaches up to an overhanging ledge high in the sky. Background mountains, high- and low-lying clouds, and an eagle in flight add to the composition's sense of space and height. For an interesting comparison of this etching with the artist's youthful treatment of a similar design, see illustration 26. Not only has he here solved the problem of creating a more realistic setting for the giant's off-scene castle, but also in his maturity he has achieved a much greater sense of dramatic space and dynamic juxtaposition of motifs, two highly desirable elements of design for fairy tales.

242. JACK GETS THE GOLDEN HEN, AWAY FROM THE GIANT. The giant sleeps in his large chair by his oversized table while Jack, on a stool, reaches up for the golden hen. The artist placed his story in the time of Alfred the Great and in this design attempted to create a sense of historical accuracy through the use of Anglo-Saxon or Celtic shields, spears, bows, and a hunting horn hanging on the wall. The hanging lamp also adds to the historical atmosphere. The giant's size is skillfully contrasted with that of Jack and the dwarf holding on to a table leg. (For an interesting comparison of Cruikshank's youthful treatment of this subject, see the central vignette in illustration 26.)

243. TITLE PAGE OF "CINDERELLA." The entire etched title page is contained within the framework of an enormous, fanciful fireplace. On the left sits Cinderella, lovely and demure; on the right, the fairy godmother, by tradition a dwarf and a witch and so depicted by the artist here. For most persons familiar with the Disney portrayals of this century, Cruikshank's version comes as a rather jarring surprise. At the top of the design sits a crowned pumpkin, around which in symmetrical arrangement are seen scampering mice and acrobatic lizards and intertwining foliage; in front a clock shows the approach of midnight. The title reaches from "Cinderella" on the mantel to "the Glass Slipper" on the lowest step. The all-important glass slipper rests imperially on a pillow. The fireplace includes six separate smiling faces worked into the pilasters on the right and left. Cruikshank's masterful design of title pages continues a tradition best exemplified in earlier periods by William Blake and still followed in children's illustrations to the present day.

244. THE MARRIAGE OF CINDERELLA, TO THE PRINCE. The lavish wedding scene, including the seated King and Queen with the Prince leading Cinderella up a staircase, takes place in a Gothic church with fan vaulting. Although the cathedral reminds one of Westminster Abbey, it is apparently based on no specific model. The spatial complexity of the design shows Cruikshank's ability to give depth and grandeur to a small plate. The composition evokes a spectacular stage setting and brilliantly costumed assemblage at a highly dramatic moment of a traditional ballet performance of this story.

245. TITLE PAGE OF "PUSS IN BOOTS." The upper half of the title page, a landscape with a mill, shows a miller watching a young man lead his grain-laden donkey away. The lower half reveals a wooden shed framed by a proscenium arch. Its top members are lettered with the title; its bottom member contains the subtitle "Tom Puss, consoling his Master, and asking for a Pair of Boots & a suit of Clothes." A typical Cruikshankian cat standing on its hind legs in front of the bags of grain converses with a young man. The open door reveals a countryside similar to that in the upper scene.

246. TOM PUSS COMMANDS THE REAPERS TO TELL THE KING THAT ALL THE FIELDS—BELONG TO—THE MOST NOBLE, THE MARQUESS OF CARABAS. Tom, staff in hand, strides majestically along the winding road at harvest time and converses with the bewildered, awestruck peasants. The royal carriage approaches in the background. This design, signed by the artist and dated 1864, shows that even at the age of 72 Cruikshank was capable of producing etchings of merit.

247 & 248. ILLUSTRATIONS FROM "UNCLE TOM'S CABIN." By Harriet Beecher Stowe. Published by John Cassell, London, 1853 (Cohn 777). This first English edition

appeared originally in 13 weekly parts in yellow printed wrappers. Immediately afterwards it came out in volume form, of which there were many later editions, both in England and in America. The 27 wood engravings were printed from stereotyped plates and are of inferior quality. According to Cohn, there was also a French edition in which the illustrations, printed from the original woodblocks, were much superior in quality. Cruikshank is not at his best in this work, and it can be argued that his delineation of black people was based on stereotypes of stage minstrels. This fault plagues a number of other English artists whose delineations of blacks also look like comic stage types or white people with dark faces. Cruikshank's purpose in illustrating the book no doubt stemmed from his growing interest in a great number of social problems besides temperance and can be related to what has been termed the "common cause" of the reform movements of the day. The artist did a memorial portrait of Harriet Beecher Stowe (Cohn 2007) in which he included words to the effect that she was the person who first taught the English about the true evils of slavery.

247. THE SEPARATION OF THE MOTHER AND CHILD. The moment illustrated is Haley's refusal to buy Aunt Hagar along with her son Albert. Cruikshank is here doing the kind of realistic wood-engraved illustration that began to be popular in England at this time. The artist's initials appear at the lower left; those of the wood engraver, at the lower right.

248. SCIPIO HUNTED, "AS MEN HUNT A DEER!" This illustrates St. Clare's story about his faithful slave Scipio; St. Clare is seen preventing the death of the runaway by offering to buy him. A year after this illustrated edition appeared, Cruikshank contributed three wood engravings to a publication titled *The Uncle Tom's Cabin Almanack, or Abolitionist Memento for 1853* (Cohn 816). For their contributions to this work encouraging support for the cause of abolition in England, the artists probably were not paid.

249. FRONTISPIECE AND TITLE PAGE OF "OLD FACES IN NEW MASKS." By Robert Blakey. Published by William Kent & Co. (late D. Bogue), London, 1859 (Cohn 75). These pages are included chiefly to show how the artist's mastery of etching continued long after etched illustrations accompanying works of literature became unpopular. The example shown here is from an undivided hand-colored proof that shows the full extent of the quality of this work. The frontispiece pictures several incidents from the stories in the volume. Since Cruikshank was aware of the growing need for publishers to be able to print larger editions, he had for many years etched on steel; but, as graphic artists know, the softness of copper enables an etcher to create an image with finer detail. In this instance the artist signed his composition "Designed & Etched on Copper by George Cruikshank—and faced with Steel by F. Joubert's Acierage process." By this means the fineness of a copper etching is combined with the hardness of steel, thus enabling the printer to produce thousands (instead of hundreds) of impressions without showing wear or loss of detail. Even though Cruikshank continued to make use of technological improvements, including glyphography, etching on glass and even a process similar to photolithography, he was never able to recapture a wide public for his many book illustrations executed in the last few decades of his long career.

250–253. ILLUSTRATIONS FROM "THE LIFE OF SIR JOHN FALSTAFF. ILLUSTRATED BY GEORGE CRUIKSHANK. WITH A BIOGRAPHY OF THE KNIGHT FROM AUTHENTIC SOURCES." By R. B. Brough. Published by Longman, Brown, Green, Longman and Roberts, London, 1857–1858 (Cohn 96). First published in ten parts, this work subsequently appeared in volume form containing 20 etchings plus a wood-engraved design for the wrapper of the parts. An edition of the etchings without the text was published separately. Cruikshank's Falstaff illustrations have been considered by many to be the best etchings of his later years. Shakespeare's most memorable comic creation definitely provided an artistic challenge that was compatible with Cruikshank's genius; further, he was able to include for this work the sort of historical detail that had always fascinated him. The etchings illustrate specific scenes, acted or described, from both parts of Shakespeare's *King Henry IV* and from *The Merry Wives of Windsor*.

250. FALSTAFF, ENACTING THE PART OF THE KING—HENRY 4TH PART 1ST SCENE 4TH. In this scene from Act II, Falstaff sits with one foot on a stool and a pillow for a crown while he lectures Hal, who stands across the room facing him. Various other habitués are enjoying the performance in this famous scene in the Boar's Head Tavern, the emblem of which hangs over the fireplace in the back of the room. The tapestry on the right wall, a depiction of the King seated on his throne holding his scepter, provides a note of sobriety in contrast to this comic scene. Cruikshank's visualization of Falstaff is particularly successful and has become the archetypal portrayal of him. As was his custom for such assignments, the artist has followed the text of the play carefully but adds small details of his own that contribute importantly to the theme of his design.

251. SIR JOHN FALSTAFF BY HIS EXTRAORDINARY POWERS OF PERSUASION NOT ONLY INDUCES MRS. QUICKLY TO WITHDRAW HER ACTION BUT ALSO TO LEND HIM MORE MONEY!!!—HENRY 4TH PT. 2ND SCENE 4TH. In this scene (Act II, Scene 1 in modern editions) Cruikshank has lavished great care on historical detail, both in the dress of the many figures shown and in the half-timbered Elizabethan architecture of the buildings. The result could almost serve as a theatrical backdrop in a stage presentation. Cruikshank's depictions were so highly thought of that in 1873 seven of these designs were reproduced in colored wood engravings in an edition of Shakespeare's plays (Cohn 738).

252. SIR JOHN FALSTAFF, AT JUSTICE SHALLOWS, EXERCISING HIS WIT & HIS JUDGEMENT IN SELECTING MEN TO SERVE THE KING—HENRY 4th PART 2ND ACT 3RD SCENE 2ND. In a scene of this kind Cruikshank was able to put to good use his ability to delineate comic figures. The rotund Falstaff, with kingly gestures, questions a bewildered recruit much to the amusement of the other onlookers. The roster of recruits in the design includes Mouldy, Bullcalf, Feeble, Shadow, and Wart, all characters in the play, here appearing on the right.

253. SIR JOHN FALSTAFF—IN THE BUCK-BASKET—MERRY WIVES OF WINDSOR. ACT 3RD SCENE 3RD. Falstaff is being covered up in the dirty linen before being carried down to the river and dumped. The theme of cuckoldry, which prompted Falstaff to undertake his romantic exploits in the first place, is symbolized by the deer head and antlers hanging directly over Falstaff's head. Falstaff, who hopes to have an intrigue with Mistress Ford, has been led to believe he must hide in the buck-basket swaddled in dirty linen because of the imminent return of her husband. John and Robert, who are

to carry out the would-be "buck" in the basket and dump the contents in the river, stand in the doorway at the right.

**254.** COVER OF "LA BAGATELLE." Composed by G. Cook. Published by Leader & Cook, London, without date (Cohn 161). This song sheet, dating from about the middle of the century, is here shown in an impression printed separately from the music it was designed to accompany. It is an excellent example of the artist's ability to do etched music covers far superior to the ordinary variety of the day. It is regrettable that he did such compositions only on special occasions, apparently chiefly at the request of friends. For this cover sheet Cruikshank uses musical notes and other elements to spell out the composer's name and to give his own initials; these appear above and below portraits of the composer playing a reed woodwind and the artist holding out a hat for offerings. According to Reid, Cruikshank's first cataloguer, the other four vignettes on the cover refer to the four situations depicted, respectively, in the comic songs contained in the song sheet. The upper vignette shows Mr. Duval trying to tell the stranger in the tavern, Mr. Thompson, that he is standing so close to the fire that his coat tail is on fire. The left-central vignette refers to a song titled "Medical Consultation" and shows a practitioner who is obliged to walk while his rivals ride. The vignette on the right, titled "A Fine Stroke at Billiards," shows Teddy Ross "missing the cannon" (carom shot). The lower vignette, titled "The Black Mare," pictures Dean Swift dumbfounded by the farmer's reply that he would look quite as black in the face as the mare if he had looked as long through a halter.

**255.** COVER OF "FAIRY SONGS & BALLADS FOR THE YOUNG. WRITTEN, COMPOSED, AND DEDICATED TO HER ROYAL HIGHNESS THE PRINCESS ROYAL." By O. B. Dussek. Published by D'Almaine & Co., London, without date (Cohn 256). Although undated, the cover appeared after the birth of the Princess Royal in 1840 and before the death of Olivia Dussek (presumably the O. B. Dussek given as composer) in 1847. This music cover appeared in its first edition with 22 pages of text and in its second with 42 pages. According to the inscription on the etched cover, the publication was originally planned to have been issued "In Two Books Price 4s each Book." The cover was issued plain and with a tint block added but was never originally issued in colored copies. Following Reid's notation, the 12 vignettes in borders of branches, starting at the upper left and proceeding in horizontal layers, illustrate Little Red Riding Hood, Dick Whittington, Robin Hood, Blue Beard, The Three Wishes, Jack the Giant Killer, Jack and the Bean-stalk, The Children in the Wood, Cinderella, Hop O' My Thumb, Puss in Boots, and Old Mother Goose.

**256 & 257.** THE WORSHIP OF BACCHUS, OR THE DRINKING CUSTOMS OF SOCIETY. Printed by R. Holdgate. Published by William Tweedie, London, 1864 (Cohn 2110). The figures were outlined on the steel plate by Cruikshank and the engraving finished by Charles Mottram. The print was issued plain and in india proofs, signed by the artist. The graphic was based on a watercolor of the same size done as a model for an oil painting measuring 13 feet, four inches, by seven feet, eight inches. When the painting was originally shown in London, a comprehensive selection from Cruikshank's graphic works was also exhibited. The print itself did not appear until a couple of years after the painting was shown in 1862. But a pamphlet on the work appeared in 1862 "with a critique of the above painting by John Stewart," a descriptive

lecture by George Cruikshank explaining the painting, and excerpts from press reviews of the painting. This pamphlet appeared in at least eight editions, and Cruikshank's lecture was diagrammatically printed on a large sheet titled "A Key to the Worship of Bacchus painted and etched by George Cruikshank as Described by Himself." This sheet is dated 1865 and bears the imprint of the National Temperance Publication Depot. In the introductory remarks to this key and in the earlier pamphlets the artist stated the following:

> In early life I was struck with the amount of misery, wretchedness, and crime, occasioned by the use of strong drink, and I may look back to my earliest productions, when I endeavoured to check the progress of the evils arising from intoxication, and it is indeed upwards of half a century since I first began to use my humble abilities with pencil and with pen against the vice of drunkenness, and in the vain attempt to shut up drinking shops, and to establish moderate drinking as a universal rule, and I now sincerely regret that it is only seventeen years since I first discovered that "Teetotalism," or the totally abstaining from all intoxicating liquors, is the only real remedy for the entire abolition of intemperance and drunkenness. Ever since I became a teetotaler, I have used every possible means in my power to assist the Temperance cause, producing some things with pen and pencil which I hope may have done some good, and, as my thoughts worked on in this direction, one day this subject of the "Worship of Bacchus" flashed upon my mind.
>
> "THE WORSHIP OF BACCHUS, OR, THE DRINKING CUSTOMS OF SOCIETY," is intended to show how universally the intoxicating drinks are used upon every occasion in life, from the CRADLE to the GRAVE. I have not the vanity to call it a picture, it being merely the mapping out of certain ideas for an especial purpose; and I painted it with a view that a lecturer might use it as so many diagrams, so that the mind might be operated upon, through the ear as well as the eye, at the same time.

The artist's detailed explanation of this composition extends to ten pages of fine print and indicates the meaning of the numerous vignettes and characters in this enormous composition of over a thousand figures.

**256.** [THE ENTIRE PRINT.]

**257.** [DETAIL.] The major part of Cruikshank's text explaining the contents of this portion of the painting and print, the latter reproduced here in actual size, follows:

> This part is intended as the "high altar" of the Pagan deity, and below the statues are the priests officiating, or, in other words, the *publicans, their wives, potboys, and barmaids, handling the intoxicating liquors* over the bar, and taking money from the worshippers. One of these publicans is worshipping so devoutly himself that he is falling a sacrifice to his deity, as well as many of his customers. This is unfortunately too often the case and there is a disease of the viscera called the "publicans' disease," and very many of these persons also die from *delirium tremens*. . . .
>
> The too-numerous Breweries and Distilleries, throwing their smoke over, and at the same time, poisoning the length and the breadth of the land: and the drink they make is taken to such an extent, and in such excess, that even moderate drinkers designate *drunkenness* as the *Great Curse of the Country*.
>
> "*The Angel*," "licensed to be drunk on the premises," [not included in the detail] and adjoining that is a building containing a "*Police Station*," the right wing of which is a "*Reformatory*," [only partially included in the detail] and the left wing a "*Ragged School*." Do away with strong drink and the police—as they themselves say—would have little to do, and there would be very few poor children to reform, and no scholars for the "Ragged Schools."

*Men and Women Drinking and Fighting. Dreadful cruelty to children* by their parents; *a man sacrificing his wife and child*; a *"jolly Jack Tar"* under the influence of "grog," offering up the *hard earnings* of a long voyage, is about to be robbed and perhaps murdered by a ruffian who is himself under the influence of drink. Below this is a *man beating a woman till her face is one mass of blood and bruises*; this represents a scene that I witnessed in broad daylight on a Sunday afternoon—the man and the woman both under the influence of drink.

"*Freemasons,*" the "*Foresters,*" the "*Odd Fellows,*" the "*Old Friends,*" [only partially seen in the detail] and I may add the "Old Fools." I introduce these societies because so many hold their meetings at gin-shops, and, by so doing, many, many of their members are brought to ruin—yes, go to destruction, dragging their wives and children after them.

Thieves handing up handerchiefs, pocket-books, and stolen plate. A soldier offering up his medal to Bacchus, and a woman offering up her child; a man stabbing his wife, a fellow shooting a girl.

Soldiers Fighting the Police with their Belts. Indians Splitting each others' Skulls with their Tomahawks, fighting for and under the influence of the "firewater." Next to these are the "Prize-fighters" and below them is a Man Knocking his Wife Down with a Baby in her arms. I saw this at eleven o'clock one day in the "City of London," and I heard the poor woman's skull crack on the pavement.

. . . A Poacher Shooting a Gamekeeper. A ruffian kicking a girl in the face; a woman stabbing her husband; two thieves, primed with gin and beer, garrotting and robbing a gentleman, who has been "dining out." The Police are carrying off a Drunken Policeman [only partially visible at the left] . . . the police carrying away a woman dead drunk upon a stretcher [only partially visible at the right]. I am informed upon good authority that upon an average there are eighteen drunken women carried upon stretchers every week to the police station in Bow Street, Covent Garden.

A Madman in "Strait Waistcoat" "Mad Tom:" and his "mad companions" of the bottle, worshipping in their insane ecstacies. It may, indeed, be said that madness prevails over the whole of this mass of worshippers; for excitement from strong drink and drunkenness is, in fact, temporary insanity. "Mad Tom" is dancing on the tomb of his relations, having sacrificed at the shrine of Bacchus, father, mother, sister, brother, wife, children, property, friends, body and mind. Many families are destroyed by one of their members being a drunkard.

Widows and Orphans brought to misery, starvation, and perhaps, death, through the husbands' or the parents' drinking the liquor sold by the publican and manufactured by the distiller and the brewer—the respectable publican, and the highly respectable and very wealthy brewers and distillers.

A reduced Public-house Customer, whom the publican has turned into a "sandwich," and upon whose backboard may be seen the advertisement of "The Fox and the Goose Music Hall"; and on the front of this sandwich I would suggest that the *sign* might be denominated, with perfect truth, "The Rogue and the Fool."

**258. FRUITS OF INTEMPERANCE.** Published by John Cassell, London, without date (Cohn 1141). This rare colored wood engraving, apparently issued only in hand-colored copies, consists of a large tree which is surrounded by tombstones labeled "Early Fruit," and whose roots comprise snakes, with the message: "The root that sucks up a great part of the riches of the land, and is also the root of a vast amount of evil." Thirty-six medallions showing the destructive results of the use of alcohol hang on the branches. This propagandist broadside is one of several similar items by Cruikshank, including six placards (Cohn 2028) done for the Temperance Movement. The final results of alcohol are pictured at the upper reaches of the tree: murder, imprisonment, brutality to women, robbery, and, at the very top, execution by hanging.

**259. DESIGN FOR A RITUALIST HIGH CHURCH TOWER AND STEEPLE DEDICATED TO DR. PUSEY AND THE VICAR OF BRAY.** The inscription at the bottom of this etching on glass reads, "Pubd. for the artist by Fredk. Arnold. 86 Fleet St. Dec. 24th. 1868. Price one shilling plain & one & sixpence col'd" (Cohn 1055). The design shows a country church entrance resembling an ass's or ox's head with large ears and a steeple shaped like a fool's cap with bells. Devotees of high-church ritual are marching into each nostril. The design was done in response to Cruikshank's critical reaction to the spread of high-church practices fostered earlier in the century by men such as Edward Pusey and other members of the Oxford Movement. "The Vicar of Bray" is the title of a ballad about the ecclesiastical office holder whose beliefs change with the politics of the day, enabling him to retain office indefinitely. Apparently Cruikshank alludes to Pusey's espousal of high-church ritualist practices while still remaining in the Church of England and retaining his position at Oxford. The design was produced by drawing on a darkened glass and then reproducing the image through photomechanical means in what is normally called the *cliché verre* process, or etching on glass. Cruikshank experimented with this technique late in his career and found in the first example he produced that, as he did not have to reverse lettering, he could draw directly on glass. He is quoted as saying that, had this process been discovered earlier, it would have changed his whole career as a graphic artist. He did a number of designs in this technique for his intended autobiography. This design has never been reproduced, probably because few copies of it were sold and thus few scholars of Victoriana ever came to learn about it.

**260. OUR "GUTTER CHILDREN."** Published by William Tweedie, London, 1869 (Cohn 211). This design was executed for a four-page folio; the text at the bottom of the fourth page names the publisher and date of publication and indicates that "prints may be had without the letterpress, Plain 6d; Colored 1/-." The reproduction is made from one of the separately published uncolored prints of this etching on glass which bears the inscription "Published by the artist July 1869." This work, included primarily as a curiosity, shows the artist in his seventy-seventh year criticizing what he considers the ill-advised, though well-meant, efforts of upper middle-class women and clergymen to send England's "gutter children" (but only the little girls) to other countries, including the United States, to find a better life. His righteous indignation about hypocritical solutions to social problems that involved separating children from their parents and relatives again places Cruikshank in the mainstream of humanitarian reform in the Victorian period. By this time the artist directed his attention toward social purposes only when particularly moved to speak out. This print helps to provide a more complete portrait of a man glibly termed a fanatic by a number of writers after his conversion to the cause of temperance.

**261. THE LEADER, OF THE PARISIAN BLOOD RED REPUBLIC, OR THE INFERNAL FIEND!** Published by the artist and sold by William Tweedie, London, June 1871 (Cohn 1312). This very late etching was created in response to the excesses of the Paris Commune in 1871 and includes a self-explanatory text below the design as well as captions within it. It obviously takes a conservative, even reactionary, view toward the "Red Republicans" and the events in France at that time. Some of the attitudes expressed here go back to ideas promulgated in Cruikshank's antirevolutionary caricatures of his early career, and so perhaps this last illustration makes a fitting close to a representative collection of his work.

# Some Books on Cruikshank

The following list, not intended to be comprehensive, consists of the major printed works dealing with George Cruikshank. References to more extensive bibliographical resources are given in the annotations to the plates. Works are listed by category in chronological order.

## Books Cataloguing Cruikshank's Works

Reid, George William. *Descriptive Catalogue of the Works of George Cruikshank.* London, Bell & Daldy, 1871. Published in an edition of 135 sets, this work has served as the basis for all other catalogues, notwithstanding its omissions and errors. Reid, who was Keeper of Prints and Drawings at the British Museum, knew Cruikshank personally and thus had the advantage of consulting with the artist. Reid's explanations accompanying individual prints are often more detailed than those given in later catalogues. This work also commands interest now because two of its three volumes consist of illustrations, many of which were pulled from the original plates.

Marchmont, Frederick. *The Three Cruikshanks. A Bibliographical Catalogue Describing More Than 500 Works . . . Illustrated by Isaac, George, and Robert Cruikshank.* London, W. T. Spencer, 1897. Issued in an edition of 500 copies, this work is chiefly of interest for its listing of secondary materials, notes about various editions, and comments about scarcity and prices. This catalogue is useful despite its inaccuracies.

Douglas, Richard John Hardy. *The Works of George Cruikshank: Classified and Arranged with References to Reid's Catalogue.* London, printed by J. Davy & Sons at the Dryden Press, 1903. Although this was published in a number edition of 1000 copies, a penciled notation signed by Charles H. Davy in copy 262 (property of Peggy Christian) states that over 700 copies of this edition were burned in a fire in February 1905. Compiled by a noted Cruikshank collector, this work was intended as a supplement to Reid's catalogue. In it books are listed chronologically, and single prints are organized chronologically by medium within subject categories. Although the catalogue itself has been superseded by Cohn's, its system of classification makes the volume very useful.

Cohn, Albert Meyer. *A Bibliographical Catalogue of the Printed Works Illustrated by George Cruikshank.* London, Longmans, Green, and Co., 1914. Cohn's definitive Cruikshank catalogue published in 1924 supersedes this volume, making what dealers sometimes erroneously call the first edition of Cohn's catalogue virtually useless.

Cohn, Albert Meyer. *A Few Notes Upon Some Rare Cruikshankiana.* London, Karslake & Co., 1915. Issued in an edition of 250 copies, of which 225 were for sale, this pamphlet contains some supplementary information not in the 1914 catalogue. This item of Cruikshankiana contains a colored and plain impression of two hitherto unpublished etchings and five other illustrations.

Cohn, Albert Meyer. *George Cruikshank, A Catalogue Raisonné of the Work Executed During the Years 1806–1877; with Collations, Notes, Approximate Values, Facsimiles, and Illustrations.* London, Office of "The Bookman's Journal," 1924. Published in an edition of 500 copies, this work remains the definitive catalogue raisonné despite a few omissions, errors and problems in organization. Cohn utilizes all available previous catalogues and supplements them with his own knowledge of Cruikshank. The system of classifying books by author is misleading and not helpful to anyone researching a book or magazine written and illustrated by Cruikshank or by an anonymous author, but the index is organized by title and thus is invaluable. An appendix includes a 1½-page bibliography listing the more important essays or articles dealing with George Cruikshank. This catalogue has been reprinted in a facsimile edition. Citations to the Cohn numbers follow entry titles in the notes in the present volume.

George, Mary Dorothy. *British Museum Catalogue of Political and Personal Satires,* Volumes VIII–XII, 1949–1954. This comprehensive listing of English caricature is essential for the study of George Cruikshank's caricatures as well as the relationship of his works to those of his contemporaries. Citations to the British Museum numbers follow entry titles in the notes to the caricatures in the present volume.

### Individual Published Works about George Cruikshank

Thackeray, William Makepeace. *An Essay on the Genius of George Cruikshank*. London, H. Hooper, 1840. This edition, the text of which originally appeared in the *Westminster Review* in June 1840, contains particularly well-printed illustrations and more of them than were included in the essay's first publication. It was followed by an 1884 edition containing a prefatory note by W. E. Church on Thackeray as artist and art critic. This perceptive essay still provides the best contemporary interpretation of the artist's genius.

Bates, William. *George Cruikshank: The Artist, the Humorist, and the Man, with Some Account of his Brother Robert*. London, Houlston and Sons, 1878. This monograph is most often found in an octavo paper-covered edition but the 1879 hardbound second edition of it contains some revisions, additions, and new important bibliographical references. This is an important early study written by a friend of the artist.

Hamilton, Walter. *George Cruikshank, Artist and Humorist, with Numerous Illustrations and a Bank Note*. London, Elliot Stock, 1878. This pamphlet, published the year Cruikshank died, is an extended version of a lecture by a contemporary and friend.

Jerrold, Blanchard. *The Life of George Cruikshank, in Two Epochs*. London, Chatto and Windus, 1882. A one-volume edition of this biography, published in 1883, contains an index and a few omissions from and changes in the original text. Later reprintings contain no textual changes. Jerrold, who was not on friendly terms with Cruikshank's widow, wrote his biography without her encouragement or help. Approximately forty per cent of his work, a standard Victorian biography, is quoted directly from other sources. The book cannot be ignored, however, as it unfortunately standardized a number of misleading ideas about Cruikshank. Its appended list of Cruikshank works is neither accurate nor complete.

Stephens, Frederic G. *Memoir of George Cruikshank*. London, Sampson Low & Co., 1891. This biography was written as part of a "Great Artists Series" by a man who catalogued the early caricatures in the British Museum. A reprint of Thackeray's essay is included at the end of the work. A second printing was published in 1895 with a biography of William Mulready.

Layard, George Somes. *George Cruikshank's Portraits of Himself*. London, W. T. Spencer, 1897. This book, having an issue of fifty copies on large paper signed by the author, is informative and contains numerous illustrations.

Chesson, Wilfred Hugh. *George Cruikshank*. London, Duckworth & Co., and New York, E. P. Dutton & Co., n.d. Though undated, Chesson's book was published in the early part of this century. This duodecimo volume containing 251 pages of text and an index was part of "The Popular Library of Art" series.

McLean, Ruari. *George Cruikshank, His Life and Work as a Book Illustrator*. London, Art and Technics, 1948. This small volume was part of the "English Masters of Black and White" series.

*The Inimitable George Cruikshank: An Exhibition of Illustrated Books, Prints, Drawings and Manuscripts from the Collection of David Borowitz, with an Essay by Richard A. Vogler*. Louisville, Kentucky, 1968. Though its bibliography is not complete and not always accurate, this exhibition catalogue contains the most complete bibliography on the artist done to date.

*Charles Dickens and George Cruikshank*. Papers read at a Clark Library Seminar on 9 May 1970 by J. Hillis Miller and David Borowitz. Los Angeles, William Andrews Clark Memorial Library, University of California, 1971. This publication of the Borowitz lecture, with an introduction by Ada B. Nisbet, contains new information about Cruikshank's long-standing liaison with Adelaide Archibald (also known as A. Atlee), who presumably had ten children by Cruikshank.

Cruikshank issue of *The Princeton University Library Chronicle*, Vol. XXXV, Nos. 1 and 2, 1973–1974. Subtitled "George Cruikshank: A Revaluation." This study (also published in volume form) contains a foreword by the general editor, Robert L. Patten, an introductory note by John Fowles, and ten individually authored essays.

*George Cruikshank*. Arts Council of Great Britain, London, Victoria & Albert Museum, 28 February–28 April 1974. This Cruikshank exhibition was organized by William Feaver, who wrote the introduction and commentary.